THOMAS MORAN

ARTIST
OF THE
MOUNTAINS

By Thurman Wilkins

UNIVERSITY OF OKLAHOMA PRESS : NORMAN

By Thurman Wilkins

Clarence King: A Biography (New York, 1958)
Thomas Moran: Artist of the Mountains (Norman, 1966)

Library of Congress Catalog Card Number: 65–11235

Copyright 1966 by the University of Oklahoma Press, Publishing Division
of the University. Composed and printed at Norman, Oklahoma, U.S.A.,
by the University of Oklahoma Press. First edition.

To
the memory of
Thomas Gilcrease

PREFACE

M y mother, formerly a school teacher in a rural school, sub-
scribed to the *Mentor* when I was a boy, in the hope that it
would provide my sisters and myself with intellectual stimu-
lation. Ordinarily the *Mentor* offered no real competition against a
boy's life outdoors, along a dry wash-bed in a semi-rural countryside
in southern California, or along trails in the neighboring San Gabriel
Mountains. Now and then, however, an issue would pique my imagi-
nation, as that number did which ran articles on Thomas Moran,
then a very old man in Santa Barbara, illustrated with numerous
reproductions from his works. It is no exaggeration to say I pored over
that copy of the *Mentor*. I soon became aware, too, of the artist's
paintings on current calendars—which paintings I don't recall now;
I remember only that I seemed at home with his work when at last
I saw original examples in all their vibrant color at the Biltmore
Salon in downtown Los Angeles.

I can remember, too, the excitement with which I heard more
about Moran, then only a few years dead, on a certain visit to the
studio of an artist friend, Frank Tenney Johnson. That excitement
recurred more acutely years afterwards when I stood before Moran's
work in the National Museum during World War II. I was already
contemplating a biography of Clarence King, who had led the
Fortieth Parallel Exploration during the 1860's and 70's. During
the years that followed the war, in preparation for writing on King,
I dug deeply into the history of the four Western surveys that culmi-

nated in the U.S. Geological Survey, and on learning more of Moran's connection with two of them, my interest in him grew. One day while again standing before his paintings in the National Museum, the old excitement having returned, I suddenly knew that some day I would write about him, even if only an article.

That day came years afterwards when, during my researches on an entirely different theme at the Gilcrease Institute, Mr. Dean Krakel, then director, suggested that I write a life of Thomas Moran under the auspices of the Museum. Such a book, he explained, would bring to realization a hope that Thomas Gilcrease had felt while making the most extensive collection of Moran drawings and paintings in existence—the hope that his collection might stimulate someone to prepare a book about the artist. At Mr. Krakel's suggestion, various experiences over years of my life crystallized into a desire to prepare just such a book, a desire so compelling that I found I must defer the project in hand, even though I had spent a number of years at work upon it.

In writing on Moran I have run so heavily in debt, both to persons and to institutions, that no amount of gratitude can be sufficient payment. But when I recall the generosity and the kindness of those who aided me, I can only think of my debts as a pleasure; it becomes a double pleasure to make specific acknowledgments. Without question my greatest obligation is to Mr. William S. Bailey, Jr., who literally made it possible for me to travel on successive occasions to the several depositories, especially to the Gilcrease Institute at Tulsa, where my sources were concentrated; nor shall I forget the pleasant Sunday afternoons when, as a relief from my absorbed researches, Mr. Bailey and his late wife showed me about Tulsa and the surrounding countryside. I appreciate, too, the encouragement I received from other trustees of the Institute, in particular Mr. Otha Grimes, Mr. E. Fred Johnson, and Mrs. W. R. Holway. My obligations are great to various staff members of the Museum, especially to Mr. Krakel and to Mr. Paul Rossi, the present director, as well as to Mr. Martin Wenger, Mrs. Marie Keene, Mr. Daniel McPike, and Mr. Bruce Wear, among others.

Second only to the hospitality I enjoyed at the Gilcrease Institute

was the welcome I received at the East Hampton Free Library, where Mrs. Amy O. Bassford made the entire Moran Collection available to me in three different visits. I recall with especial gratitude the kindness shown me by her and Mrs. Robert Cheney, who recognizing the pressure of my schedule, allowed me to work at the Library before and after official hours, a courtesy certainly beyond the bounds of duty. I am indebted to Mrs. Bassford, too, for several pleasant hours while she drove me about the environs of East Hampton, where Thomas Moran so loved to walk and sketch, as far indeed as Montauk Point.

An attempt has been made, in the credit lines beneath Moran's paintings, to acknowledge my gratitude to the present holders or owners of the paintings. Where the owners are not known, the institution or individual supplying a suitable print has been cited. Color transparencies for all the color plates were furnished by the Gilcrease Institute, Tulsa, Oklahoma.

As in most extended research projects, more libraries and librarians have contributed to my fund of information than I have space to mention. Only the more important debts can be recognized here, but they are many: to the staffs of various libraries at Columbia University; the New York Public Library; the Frick Art Reference Library; the National Archives; the File Room of the U.S. Department of the Interior; the U.S. Park Service Library; the Library of Congress; the Queens College Library of the City University of New York; the Archives of American Art, in Detroit; the State Historical Society of Wisconsin; the Library of the University of Wisconsin; the Historical Society of Pennsylvania; the State Historical Society of Colorado; the Bureau of American Ethnology, of the Smithsonian Institution; the New Jersey Historical Society; the Library of the Southwest Museum; the California State Library; the Santa Barbara Public Library; the Bancroft Library; the Henry E. Huntington Library; the Free Library of Philadelphia; the Newark Public Library; the Princeton University Library; the Department of Records, City of Philadelphia; the Western History Department of the Denver Public Library; the Los Angeles Public Library; the University of Pennsylvania Library; the Western History Research Center of the

University of Wyoming Library; the Arizona Pioneers' Historical Society; the Wyoming State Archives and Historical Department; and the American Philosophical Society.

Various museums and art galleries were prompt in response to my queries: the Metropolitan Museum of Art; the Brooklyn Museum of Art; Guild Hall, in East Hampton; the Heckscher Art Museum; the Museum of the Fine Arts, at Boston; the Gallery of Modern Art; the Berkshire Museum; the Corcoran Gallery of Art; the Washington County Museum of Fine Arts, at Hagarstown, Maryland; the Georgia Museum of Art, University of Georgia; the High Museum, at Atlanta, Georgia; the Montclair (New Jersey) Art Museum; the Cooper Union Museum for the Arts of Decoration; the Philbrook Art Center, at Tulsa; the Cleveland Museum of Art; the National Collection of Fine Arts, and the Graphic Arts Division, of the Smithsonian Institution; the National Academy of Design; the Rockwell Gallery of Western Art; the Pennsylvania Academy of the Fine Arts; the Albright-Knox Art Gallery, at Buffalo; the New Britain (Connecticut) Museum of American Art; the Parrish Art Museum, at Southampton, Long Island; the Worcester Art Museum; the Museum of the U.S. Department of the Interior; the Jefferson National Expansion Memorial, at St. Louis; the Grand Teton National Park Museum; the IBM Gallery of Arts and Sciences; the Davenport Municipal Art Gallery; the St. Petersburg (Florida) Museum of Fine Arts; and the Los Angeles County Museum of Art. I am also indebted to Mr. Douglass H. Hubbard, chief naturalist of Yosemite National Park, to Mr. G. Bryan Harry, assistant chief naturalist of Yellowstone National Park, and to Mr. Fred D. Fagergren, superintendent of the Grand Teton National Park.

Art dealers, though loath to reveal the names of clients, have otherwise been extremely helpful. I am under particular obligation to personnel at the following: the Kennedy Galleries, M. Knoedler and Company, the Babcock Gallery, the Berry-Hill Gallery, the Hammer Galleries, the Newhouse Galleries, the Robert Sloan Gallery, Chapellier Gallery, Parke-Bernet Galleries, M. R. Schweitzer, and Hirschl and Adler, Inc. I have also received courteous assistance from the public relations officer of the Santa Fe Railroad and from cor-

responding personnel at the following corporations; the Thomas D. Murphy Company; the Diamond National Corporation, which has absorbed into one of its current divisions the American Lithographic Company; Brown and Bigelow; and Osborne-Kemper-Thomas, Inc. The following photographers have likewise been of service: Taylor and Dull; Peter Juley and Sons; the Photographic Service of Columbia University; the Reproductions Division of the New York Public Library; Stefan Congrat; and Richard and Edward Muno, of the Gilcrease Institute, especially the latter, who made most of the black-and-white photographs and all of the color transparencies supplied by that museum. My obligations also extend to the editor of the *New York Times* "Book Review" for running in his columns a most helpful author's query.

Lack of space forbids my indicating all the individuals who have responded to my appeals, and I beg the leniency of those whose names, either through arbitrary decision or the inadvertence of memory, fail to appear here. First, I am grateful for the generosity of certain individuals who, from having known Thomas Moran in person, as well as his family, have given me the benefit of their reminiscences. They include Mrs. W. W. Hoppin, Mr. Albert Gallatin, and Mr. Thomas G. Gallatin. Thomas Moran's grandniece, Mrs. Mark D. Dodd, has also been most kind. My gratitude extends to numerous others as well: Mr. Alfred Werner, Mr. Lawrence W. Fleischman, Mr. Graeme Lorimer, Mr. Paul Vanderbilt, Mr. Sam Alschuler, Mr. M. W. Batchelor, Mrs. Julia McCleod, Mrs. Morris Bishop, Mrs. Frieda Langer, Professor Cloyd H. Marvin, Mr. Daggett Harvey, Mr. Andrew Wallace, Mr. Gordon Hendricks, Miss K. Florence Hill, Dr. John R. Hilsabeck, Professor John Francis McDermott, Mr. C. S. Cone, Jr., Mr. David B. Goodstein, and Mrs. Henry S. Jacobus, Jr.

I have had no personal dealings with Professor Fritiof Fryxell, but no one can work on Thomas Moran without contracting obligations to him for his pioneer writing and research and for his having arranged the Moran Collection of the East Hampton Free Library; he has my thanks. I wish that I were even deeper in debt to him, for access to a series of Moran letters that he plans to publish soon,

but having withheld these from other scholars, he did not deem it proper to show them to me when queried on my behalf by Mrs. Bassford, of the East Hampton Free Library.

To Mr. Cecil Scott, editor-in-chief of the Macmillan Company, I am grateful for permission to interrupt work upon a project on which his company holds an option. My appreciation also includes the staff of the University of Oklahoma Press, from whom I have received only the kindest and most helpful consideration. And finally there remains my wife Sophie, who has been constant in her encouragement, and who has read the entire manuscript with a meticulous eye; the work can only be better for her suggestions.

<div align="right">T. W.</div>

New York City
July 15, 1965

CONTENTS

	Preface	page	vii
	Introduction		3
I	Boyhood		10
II	Apprentice Years		20
III	Europe		35
IV	Yellowstone		57
V	Canyon Country		72
VI	Mountain of the Holy Cross		95
VII	Where the Bittersweet Orange Grows		108
VIII	The Tetons: Mountain Glory		120
IX	Etching: East Hampton		131
X	Railroad Artist		144
XI	A British Summer		158
XII	Old Mexico		166
XIII	The Studio, East Hampton		174
XIV	An American in Venice		185
XV	The Nineteenth Century Ends		196
XVI	Spokesman		215
XVII	Dean of American Painters		230
	Appendix		243
	Bibliography		261
	Index		295

ILLUSTRATIONS

~✤~✿~❀~✤~✿~❀~✤~✿~❀~✤~✿~❀~✤~✿~❀~✤~✿~❀~✤~✿~❀~✤~✿~❀~✤~✿~❀~✤~✿~❀~✤~✿~❀

Black-and-White Plates

following page

Spit Light, Boston Harbor, England 16
The Haunted House
Summer on the Susquehanna
The Wilds of Lake Superior
Vandermarck
Study of an Italian Pine
In the Forest, Wissahickon
Solitude

Cliffs of Green River, Utah 48
The Chasm of the Colorado
South Dome, Yosemite
Valley of Babbling Waters, Southern Utah
The Mountain of the Holy Cross
The Narrows of the Rio Virgin, Utah
Ponce de León in Florida, 1512
The Empty Cradle

Fort George Island, Coast of Florida 96
Lower Manhattan from Communipaw
Luray Cave

{xv}

Bridge of Three Waters, Pass of Glencoe, Scotland
Spectres from the North
The Grand Canyon of the Colorado
The Opal Venice
The Entrance to the Grand Canal, Venice

In the Teton Range 176
In the Teton Range (sometimes called *Rocky Mountains*)
Shoshone Falls of Snake River, Idaho
Coconino Pines and Cliff, Arizona
Mount Moran, Teton Range, Idaho
Autumn, Near Peconic Bay, Long Island
Ácoma
Cockington Lane, Torquay, England

Cypress Point, Monterey 208
Fiesta at Cuernavaca
The Owls
California Landscape: Autumn
Sinbad Wrecked
Yosemite Falls
Autumn, Long Island
Thomas Moran, by Hamilton Hamilton

Color Plates

following page

The Glory of the Canyon 128
San Juan d'Ulloa, Vera Cruz
Tower Falls
The Grand Canyon
Upper Yellowstone Falls
Summit of the Sierras
The Mosquito Trail
The Grand Canyon of the Yellowstone

Thomas Moran: Artist of the Mountains

Nor are any descriptions of the Valley of Diamonds, or the Lake of the Black Islands, in the "Arabian Nights," anything like so wonderful as the scenes of California and the Rocky Mountains . . . represented with most sincere and passionate enthusiasm by the American landscape painter, Mr. Moran.

—JOHN RUSKIN

INTRODUCTION

On May 2, 1872, Thomas Moran's *The Grand Canyon of the Yellowstone* drew a curious throng to Clinton Hall in New York City. The directors of the Northern Pacific Railroad were there, including the resplendent Jay Cooke; and so were "the press—the literati—the artists—the rich"; indeed it seemed to the dazzled artist that "all New York" had come to see his large, seven-by-twelve-foot panorama before it was sent on to Washington.[1] The effect of the painting was convincing, even by gaslight.

Visitor after visitor paused, as if beside the painter himself, upon the canyon's brink, two miles or so below the Lower Falls of Yellowstone River. The flashing cataract seized attention, while farther to the right glowed a phalanx of Gothic cliffs. In foreground shadows cast by the gnarled pines which gave the gorge its proper scale, a small exploring party rested, dwarfed by their awesome surroundings, their horses tethered among the rocks. Even deeper in the shade, and therefore not as plain to see, lurked a grizzly bear, as surprised no doubt by the human strangers as they themselves were amazed at the yawning gorge. Shimmers of steam jetted from geysers on the distant plateau, high above and beyond the chasm, while far along the horizon gleamed those silvery peaks which *voyageurs* had named the Tetons.

[1] *New York Tribune*, May 4, 1872, p. 2, col. 1; *New York Times*, May 5, 1872, p. 4, col. 6; Thomas Moran to F. V. Hayden, April 26, 1872, Letters Received, Hayden Survey, R. G. 57, National Archives.

{3}

It was a scene of wild grandeur, of inspiring sublimity, perhaps too grand, too sublime to make a really successful picture—or so certain friends had warned the artist. It was an old objection, now still current, as in a statement made by Aldous Huxley shortly before his death: "Mountains exist, and we have learned to love them. Then why are there so few good mountains in art? Why so few adequate pictorial renderings of one of the most rewarding religious experiences still accessible to the modern mind—the Wordsworthian mysticism of heights and mists and distances, of storm and sunrise, of chasms apocalyptically illumined and lights abruptly quenched by the shadows of passing clouds?" Huxley's answer comes quickly and a little too easily: "If mountains are so seldom painted, it is because, except for a few unusually gifted artists, they are just too much of a good thing." Attempts to paint the sublime in nature have all too often been brought to the edge of disaster by "what Coleridge called 'nimiety,' or too muchness."[2]

No such doubts or hesitations troubled Thomas Moran. "I have always held," he insisted to the explorer, Dr. F. V. Hayden, "that the grandest, most beautiful, or wonderful in nature, would, in capable hands, make the grandest, most beautiful or wonderful pictures, and the business of the great painter should be the representation of great scenes in nature. All the above characteristics attach to the Yellowstone region, and if I fail to prove this, I fail to prove myself worthy the name of painter. I cast all my claims to being an artist into this one picture of the Great Canyon and am willing to abide by the judgment on it."[3]

Public reaction justified Moran's faith; the response of spectators to his canvas was quick and cordial and full of respect. Only a few critics who insisted on applying laws they had "codified from the practice of contemporary French artists" raised objections; the rest approved. Clarence Cook, a leading writer on art, found that Moran had handled the composition with masterly finesse, "and the harmony of color," running to smoldering yellows tinged with red,

[2] Aldous Huxley, "Unpainted Landscapes," *Encounter*, Vol. XIX, No. 4 (October, 1962), 45.

[3] Moran to Hayden, March 11, 1872, Letters Received, Hayden Survey.

"had its instinctive centre—as unconsciously and happily felt, not reasoned, as the keyword of a true poet's verse—in the glint of the sapphire river that swept with all its garnered sunshine down to the bottom of the monstrous world."[4] Cook placed the work in a class with Frederick Church's imposing *Niagara*—gratifying praise for an American landscape in 1872—and detractors notwithstanding, "C. C.'s" judgment became a widely held opinion. All present at Clinton Hall must have heard of the Yellowstone—that "savage place" which seemed, although it was then so much in the news, as mythical as the measureless caverns of Alph, the sacred river; and now seeing it glow so warmly there before them, they could at last accept its tangible existence. Moran had given the public a credible vision of the fantastic region that Congress had just decreed a national park.

The morning after its triumph at Clinton Hall, Moran shipped the panorama to Washington. It hung first in the Smithsonian galleries, attracting crowds of viewers and warm press notices. Two weeks later it was removed to the Speaker's office in "the old Hall of Representatives," where congressmen stopped to admire it, along with visitors to the Capitol. There, as Moran reported to Hayden, "it has created quite a sensation. . . . Many of the members have expressed the opinion that Congress should purchase it";[5] and so the matter was brought before the proper joint committee, which framed a resolution for Congress to approve. On June 10 Moran was voted ten thousand dollars (a large sum for a painting in those days), and after display in several major cities *The Grand Canyon of the Yellowstone* came to hang in the Senate lobby, the first landscape to join the congressional collection, and "the only good picture," Cook decided, ". . . to be found in the Capitol."[6] "There is no doubt," Hayden wrote Moran, "that your reputation is made."[7] The Yellowstone scene, Moran's first spectacular success, though he had painted in oils since 1855, made him an artist of national importance and the leading portrayer of the American West.

[4] "Art," *Atlantic Monthly*, Vol. XXXIV, No. 203 (September, 1874), 377; see also *ibid.*, Vol. XXX, No. 179 (August, 1872), 246–47.

[5] Moran to Hayden, May 24, 1872, Letters Received, Hayden Survey.

[6] "Art at the Capitol," *Scribner's Monthly*, Vol. V, No. 4 (February, 1873), 499.

[7] Hayden to Moran, August 29, 1872, C4 (photostat), Moran Papers, Gilcrease Institute.

His work led to his being styled "the father of the park system,"[8] a development that had begun even before his Yellowstone painting reached the capital. Its impact there merely climaxed the effect produced by the various water colors and woodblock designs which he had made to illustrate, or supplement, the reports of Hayden and N. P. Langford, instigators of the park bill. They had circulated Moran's sketches in Congress, along with William H. Jackson's photographs. The pictures had served better than words to dramatize the grandeur of the Yellowstone. Jackson claimed that the "wonderful coloring" of Moran's sketches "made the convincing argument" to preserve that weird area "for the benefit of posterity,"[9] and William H. Holmes, later curator of the National Collection of Fine Arts, called Moran's work the "important factor in bringing the project to a successful issue."[10] Friends began to call him Tom "Yellowstone" Moran, and he claimed that fabulous region as "his love." But during his long career he would paint scenes from at least one dozen other national parks or national monuments, all before Congress set them aside as trusts for the nation. Stephen Tyng Mather, while director of the Park Service, described Moran as "revered" in park circles. And the reason: "More than any other artist he has made us acquainted with the great West."[11] Few if any landscape painters have done more to make Americans *see* the beauties of their natural heritage and prove to the plain citizen "that he did not have to leave his native shores to look on something more wonderful than the Alps."[12]

However, recognition of Moran's work as great Americana did not necessarily serve his reputation as an artist. For years, as the movements and schools that he scorned gained in prestige, his work was called "slick," "grandiose," and "pretentious," and Moran himself was called "the post card painter." A staff member of the Metropolitan Museum recently dismissed his "vast, slick canvases of Western

[8] National Park Service press release, December 22, 1936, B14 (typescript), *ibid.*
[9] William H. Jackson, *The Pioneer Photographer*, 101.
[10] William H. Holmes, Remarks before the National Parks Conference, February, 1917, D3, Moran Papers, Gilcrease Institute.
[11] *New York Times*, January 2, 1927, Section VII, p. 10, col. 5.
[12] *Reports . . . of the Century Association for the Year 1927*, 14.

scenic monuments" as—shall we say embarrassments?—"popular fifty years ago."[13] But Moran's eclipse in critical esteem has little to do with the intrinsic value of his work. The tendency of critics and historians to deny a fair share of attention to conservative and traditionalist painters and concentrate on "trail-blazers," often to the neglect of significant values in favor of mere inventions or devices, is well known.

Thomas Moran was never *avant garde*. Coming to maturity at a time when British tradition was still a force in American art, he trained himself in that tradition, especially as it converged in the work of J. M. W. Turner. Although travel in Europe exposed him to the work of continental schools, and his pictures sometimes reflected the influence of Corot and Rousseau or to a lesser degree Caleme or Ziem or the naturalistic Dutch, Moran never departed in essentials from an Anglo-American style and technique. When winds from France at last prevailed in American studios, he let them blow, unmoved, and held aloof from the currents they set in motion. He remained the obdurate romantic. He looked to nature for his inspiration, not to serve up slavish copies of natural scenes, but to present "the spectator [with] the impression produced by nature on himself."[14] His own response to nature was his real subject. Like his master, Turner, he became a tireless traveler in the search for nature's variety. His friend, Richard Henry Stoddard, wrote: "He climbs the steepest Rocky Mountains; descends the deepest canyons; follows the wild streams of Utah to their sources; penetrates great forests and studies Indian life; voyages on the Atlantic; roams in Europe; plunges into the Adirondack wilderness and explores the savannas of the tropics."[15] The result was a teeming accumulation of impressions caught by paint brush or pencil, the lithographer's crayon, or even the etcher's needle. He believed that pictures painted according to the standards of the old masters, with a high, impeccable finish, stood the best chance of surviving. He ignored as merely fashionable the new art movements, which condemned finish as gloss, extolled

[13] Albert Ten Eyck Gardner, *Winslow Homer*, 132.
[14] *National Cyclopaedia of American Biography*, XXII, 24.
[15] *Aldine*, Vol. IX, No. 8 (1879), 242.

the rough and the slashing, the blemished and the crude, in the name of spontaneity, and preferred the unabashed, self-conscious flaunting of techniques over a smoothed perfection that all but concealed artistic means. No doubt some sympathetic attention to the newer European techniques, such as the use of thick impasto, the mastery of the broad, full-loaded brush, the dissolving of clear, exact outlines in the vibrations of color and atmosphere, or the impressionistic trick of putting "little bits of paint alongside each other to try to make them twinkle,"[16] would have bolstered his later reputation and made him seem less antiquated at the height of his career. But he regarded such methods as fads and persisted in his "archaic" technique (archaic, and yet as Virgil Barker says, a "most fluid and variable technique"),[17] carrying his nineteenth-century style far into the twentieth.

He lived to become the senior member of the National Academy of Design, and when he died in 1926, he was called the dean of American painters. By then landscape was slipping from esteem, cubism was no longer ultramodern, and soon gallery goers would be faced, in Aldous Huxley's phrase, "with endless monotonies of abstract expressionism."[18] In such an atmosphere the landscapes of Moran's period clog the basements of museums, and many an honored contemporary has been forgotten. Yet no matter how dim his reputation may have grown, Moran has never been in danger of oblivion. His work can be found in the Metropolitan Museum and in the Gallery of Modern Art in Manhattan. It can be found at municipal museums in Brooklyn and Newark; in the Heckscher Museum at Huntington, Long Island; in the Gilcrease and the Philbrook galleries in Tulsa; in the Smithsonian Institution in Washington; in the Walker Art Center of Minneapolis; in the Los Angeles County Museum on the West Coast; in the collections of the Santa Fe Railroad and the IBM Corporation, as well as in those of many private collectors. Its creative vigor has always had the power to rouse interest afresh, and at intervals people suspect, as Arthur Millier once observed, that

16 Homer Martin's phrase, quoted by Suzanne LaFollette, *Art in America*, 193.
17 *American Painting: History and Interpretation*, 588.
18 "Unpainted Landscapes," *Encounter*, Vol. XIX, No. 4 (October, 1962), 41.

in him we have "an 'old master' not incomparable with Turner and Claude Lorrain." Millier continued:

> Moran did not "date" in quite the same manner as, for instance, Bierstadt. There was an imaginative element in his work that was able to transcend a style of painting itself successively outmoded by the Barbizon, impressionist and finally the hydra-headed post-impressionist importations. . . . To this day no artist has more grandly and truly seen and painted the typical mountain landscape.[19]

Now that the stylistic wars that once obscured Moran's name are half-forgotten history, one can better appreciate the merits of his work as art. If not of the very loftiest order, it still is important art by any reasonable standard. Eugen Neuhaus found it "superb in draughtsmanship and finish" and suggested that Moran himself would have been "one of our greatest artists" except for excessive gloss and a certain facile cleverness and oversweetness of color;[20] and as Wolfgang Born declared:

> The world [which], rightly or wrongly, accepts Richard Wagner has no right to belittle Thomas Moran. He displays a true mastery of the panoramic style. His space feeling is akin to [that of] men who covered the ceiling of Baroque churches with illusionistic frescoes—only they raised their eyes to the heights of the sky, whereas Moran, placing his easel on a choice observation point, looked down into the crevices of the earth.[21]

[19] Quoted in "Finding Moran," *Art Digest*, Vol. II, No. 19 (August, 1928), 6.
[20] *The History & Ideals of American Art*, 85.
[21] *American Landscape Painting: An Interpretation*, 109.

I *Boyhood*

When the editor of the *American Cyclopaedia* asked for the facts of his life, the artist began a sober, third-person statement with "Thomas Moran was born in the city of Bolton, Lancashire, England, on the 12th of January 1837."[1] Bolton, at the outset of Queen Victoria's reign, was not a pleasant place, a city full of tall chimneys thrust against a smoke-filled sky, with dreary moors stretching all about it. As the earliest home of Thomas Moran, it lends credence to Philip Hamerton's theory that the best milieu to produce a landscape painter was an ugly city with no ready escape to the countryside, leaving the sprouting artist "tormented with that aching of the heart which is the nostalgia of the lovers of nature."[2]

Bolton was a center of the British cotton industry, the home of Samuel Crompton, whose famous "mule" had worked a revolution in the spinning trade. It was a city of looms. That was why the elder Thomas Moran settled there; he was a skilled hand-loom weaver. Not much is known about him, though it was said that the "keen blue eyes" of his son Thomas and "the whimsical turn of his wit" were "the gift of his Irish father."[3] Schooled as well as most in the weaving trade, the elder Moran performed acceptably by the standards of his class; by working long hours he could earn over a pound

[1] To the Editor, *American Cyclopaedia*, December 17, 1874, MSS Division, Library of Congress.
[2] *The Life of J. M. W. Turner, R.A.*, 7.
[3] Unidentified clipping ("Thomas Moran, Dean of American Painters, Now Seventy-Eight"), Envelope 179, Moran Collection, East Hampton Free Library.

a week. So on falling in love with an English girl named Mary Higson, he felt that he could afford to marry, except that he was an Irish Catholic, and she was a Methodist. Mary loved him, however, so "she not only entered the Catholic church," as her granddaughter, Ruth Moran, declared, "but her artistic soul blossomed under the the beauty of [its] ritual . . . and she became a stronger Catholic than her husband."[4]

When Mary Moran was twenty-one, her first son, Edward, was born. Two years later came John, then James, destined to die young, then Sarah, followed two years afterwards by Thomas, Jr. The Morans still lived in Bolton when first Elizabeth, then Peter, were born. Of the seven children, three of the sons—Edward, Thomas, and Peter—would make their names as painters, while John took up photography as a career.

The family's growth must have brought increased economic stress. If the home was at all like the typical hand-loom weaver's house, it was a miniature factory, in a time when the domestic and the factory systems still existed side by side, but the domestic weavers were more hard pressed in competing with the power looms. All the father's skill, the long hours of toil shared by his wife and later by Edward, who was put to the loom early, meant only a poorer living as conditions worsened in the industry. The Moran brothers knew "by long and emphatic experience the meaning of the word 'poverty' "[5] —a poverty exacerbated by squalor: "For when the home was a work shop for cotton, it could be neither clean nor comfortable, and the housewife who was in fact a manufacturer could only give odds and ends of her time to cooking and household duties."[6]

Mary Moran, however, was a "strong-minded, decisive woman," who, despite great odds brought her children up well in a home described as "very strict," where the Catholic atmosphere was strong. "She was artistic in her tastes,"[7] and Thomas, Jr., later attributed to her influence the flair for art so manifest in himself and his brothers.

[4] Miscellaneous notes, Envelope 52, *ibid.*

[5] *Ibid.*, Scrapbook, p. 40 (unidentified clipping).

[6] G. M. Trevelyan, *English Social History*, 389.

[7] Ruth B. Moran, Miscellaneous notes, Envelope 52, Moran Collection, East Hampton Free Library.

It has also been said that the sturdiness of Thomas Moran's wiry physique and his abundant vitality were a heritage from his mother and his English forebears.

Both parents were ambitious for their children. Weaving was a curious trade, it seemed to Thomas Moran—it produced dreams as well as cloth, dreams for the future. But Bolton seemed to hold no future for the children of weavers. There seemed to be no way for them to break from the bitter grinding straits in which they were trapped by the solidified class structure. So in search of a future free of the shackles of British class distinctions, and "the starvation of being a hand-loom weaver," Thomas, Sr., turned to America, as so many Britons did in the "hungry forties."[8] He sailed sometime in 1843 to look the new land over and gauge its promise at first hand. He was happily impressed and sent for his family one year later.

They embarked in Liverpool in April, 1844. Years later Thomas Moran jested about the crossing—alas, for him it was not in the *Mayflower*, "but in a sailing ship not much more comfortable."[9] Such was his recollection of the *Thomas P. Cope*, the Cope line's trim, two-masted packet bound for Philadelphia (a ship of which in later years his brother, Edward, made a painting which was shown at the Pennsylvania Academy of the Fine Arts). Soon the passage grew too hard for Thomas's aged grandmother, who sickened and died and was buried at sea. But the grace of a sailing ship under full sail and the roll of waves in open sea made a happy impression on the boy himself, now seven years old, frail and delicate, with gray-blue eyes and yellowish hair that would later darken. He spent long hours watching the waves, and their forms and their colors were fixed in his memory. Some of his first successes, as a schoolboy artist with a pencil, were to come from his drawings of waves like those he had watched in the open ocean. The *Thomas P. Cope* was at sea for six weeks; then on the last day of May the ship made port in Philadelphia.[10]

[8] *Ibid.*

[9] *Ibid.*

[10] Neil Franklin (National Archives) to writer, July 19, 1963, quoting data from passenger list of the *Thomas P. Cope*.

{12}

Thomas Moran, Sr., who had continued as a weaver in America, now took the family to Baltimore, full of textile mills owing to its nearness to the cotton-bearing states. He had secured a house there, but as the schools of Baltimore proved a disappointment, the family's stay in Maryland was short. Setting immense store by education, the elder Morans had resolved that their children should have at least good grammar-school training—that was one of their main reasons for coming to America. So in 1845 they returned to the Philadelphia area to take advantage of the fine school system there, or so Thomas Moran's daughter Ruth would explain the move in after years. She denied the story that Edward, then about sixteen, had led the way back to Philadelphia, that with only twenty-five cents in his pocket and all his belongings tied in a big red handkerchief he had walked the entire distance from Baltimore, begging food along the way. How the legend had gotten started Ruth Moran professed not to know, ignoring the plausible account which John Moran, her uncle, put into print concerning Edward's flight from Baltimore and the looms on which he had been put to work. According to John's account:

[Edward's] artistic faculties [had] cropped out even here, how, Heaven only knows, and he used to spin out sufficient white surface on which to draw. On three occasions he ran away from home, being captured and brought back on the first two, the third proving successful. . . . After divers adventures, he found his way to Philadelphia, and his trials and straits here were numerous. He lived in a small attic, in a *cul-de-sac* off some back street, the furniture of which consisted of one dilapidated chair and an easel, the occupant sleeping on the bare floor. Food was a rarity with him, although, unlike Mr. Toots, he was by no means "a stranger to appetite." One old gentleman, of exceedingly benevolent intentions, doubtless, used occasionally to visit him and advise him to go out on the roof and study the sky, this same liberal individual afterwards reminding the artist how much he contributed to his success by such sage counsel. Success at length dawned on him after the following fashion: He had "traded two pictures to a frame-maker, taking in exchange for them frames of very small value." Some days afterwards he observed that one of these pictures had disappeared from the window in which the dealer had exhibited it, and on inquiry he

learned that it had been purchased by a gentleman whose name, however, the astute trader declined to reveal. The artist, by some indirect means, managed to obtain the information he wanted, and set out forthwith for the house of the purchaser. He himself says that he resembled nothing so much as a tramp. His threadbare coat was tightly buttoned to conceal the absence of a vest, his stocking-less feet were touching the ground, which was covered with snow at the time; he had had nothing to eat for two days. Pausing before the imposing edifice where the picture buyer resided, he summoned up all the courage which, like the valour of Bob Acres in Sheridan's *Rivals*, he felt oozing out at the palms of his hands. Finally, acting on the "nothing venture, nothing have" principle, he boldly ascended the steps, and rang the bell. It was answered by a servant, who catching a glimpse of him, abruptly informed him in an Irish brogue that there was nothing for him, and slammed the door in his face.

Edward rang the bell again, according to his brother; and, "I'm no beggar," he insisted when the servant opened the door once more. He demanded to see the master of the house "on business," and after a few moments had passed a grave-looking man came down the stairs and studied Edward over the rims of his spectacles.

"Dost thou want me?"

Had he bought a certain picture, Edward asked; and at the other's reply, he burst out: "I painted that picture."

"Thou? Come in—here, into the parlor. Thou lookest hungry, lad." The servant was told to bring some meat and bread and beer, and the Quaker host would hear no talk of business till his guest had eaten his fill. Soon Edward secured his first commission "in the amount of two hundred and fifty dollars, and, to use his own words, he was the richest man in Philadelphia that day."[11] The rest of the family soon followed Edward to the Quaker City, according to this version of its history; legend, according to Ruth Moran—legend that brought only a skeptical twinkle to the gray-blue eyes of her father. It was Thomas Moran, Sr., she repeated, who, with his insist-ence on schooling, had decided upon the move and, by it, insured

11 "Artist-Life in New York," *Art Journal* (New York), n.s. IV (1880), 59–60.

that all the surviving children except Edward should earn common school diplomas.[12]

The family took quarters in a rear building on Germantown Road, in the busy suburb of Kensington, a little north of Philadelphia proper. There they lived for the next two years, but though they moved periodically thereafter, it was never to any great distance, but always within Kensington, where Thomas, Sr., pursued his trade. There the family continued to grow, with two more children born— a daughter, Mary, and another boy, who died in childhood. On October 2, 1849, the father became a naturalized American, a step which gave citizenship to the entire family.

Weavers had no trouble in finding work in the Philadelphia area, since it was one of the textile centers of the country. The sound of looms could be heard throughout Kensington, and in many parts of the city proper, in the apartments of weavers, in garrets and cellars and outhouses, not to mention the numerous factories. Many of the weavers were English immigrants like the Morans. They still had to work long hours—sixty hours a week was the rule in America—but the pay was better than in England, and the workers enjoyed a sense of freedom, a lack of social constraint unheard of in the British Isles.

The new atmosphere had remarkable effects on the Moran children. In the relative absence of class distinctions, ambition stirred in them, and they began "to dream of weaving more beautiful colors and designs in paint than any they had seen growing on their father's loom in their old home." They owed much, of course, to the encouragement of their parents. "Hand loom weavers have always been imaginative folk; they have time to think and dream as they throw their shuttles," and Ruth Moran, who spoke thus, was sure that the

[12] Marginalia to Frances M. Benson, "The Moran Family," *Quarterly Illustrator*, Vol. I, No. 2 (April–June, 1893), 67–84, filed in Envelope 134, Moran Collection, East Hampton Free Library. Benson's version was doubtless based in some measure on John Moran's account. Of it Ruth Moran declared: "All this about Edward Moran is not true. He lived in Philadelphia with his father and mother, was never hungry & came to Philadelphia with his family when they were brought there by their father . . . in search of better educational facilities than Maryland offered." Fritiof Fryxell, a friend of the Moran family and therefore in a favorable position to judge, accepts Ruth's position. Yet there seems to be no reason for John Moran to manufacture such a tale out of whole cloth. This writer is inclined to accept his story in general.

dreams of the parents had somehow inspired the children, so that their talents had blossomed when they were "transplanted to a richer soil and a more liberating atmosphere."[13] Evidently Thomas, Sr., worked in a factory now. The Moran home was no longer a workshop, nor were the children put to the loom as Edward had been as soon as he could reach the web. "Thomas Moran," his daughter wrote, "was never . . . a weaver's apprentice."[14] He began his schooling at once, perhaps at the Sansom St. School, as his daughter claimed,[15] more likely at the Harrison Boy's Grammar School, in a three-story red-brick building not far from where the Morans lived in Kensington. He did well in his studies, winning prizes in geography, where his agile pencil came into play. "I so clearly remember you . . ." a classmate wrote him years later, "and your fondness for drawing Indians on the margins of your maps."[16] Evidently the maps were not a regular part of the curriculum but his extra contribution; he made them things of beauty and to the Indians added Russians, Chinese, or Dutchmen as the case required. He adorned the oceans by carefully sketching ships and waves the way he remembered them from his days aboard the *Thomas P. Cope*. The maps "intrigued the teachers, and he was famed in the school" for them.[17] Very likely a book which he kept for the rest of his life—*Flora's Lexicon*, by Catherine H. Waterman—was a prize that he won for such work; it was presented by "A. C. Jenkins, 4th Assistant Teacher in Harrison Boy's Grammar School."[18]

Thomas had thus revealed his characteristic bent while still a student. He was spurred no doubt by the example of his brother Edward, who made charcoal sketches and painted pictures when not tending a power loom. "It is scarcely probable," Thomas Moran

13 Notes, Envelope 53, Moran Collection, East Hampton Free Library.

14 "The Real Life of Thomas Moran," *American Magazine of Art*, Vol. XVII, No. 12 (December, 1926), 645.

15 Miscellaneous notes, Envelope 52, Moran Collection, East Hampton Free Library.

16 John Russell Goury to Thomas Moran, March 8, 1898, C12, Moran Papers, Gilcrease Institute.

17 Nina S. Stevens, Untitled MS, B30, *ibid.*

18 Inscription on flyleaf, Moran Collection, East Hampton Free Library.

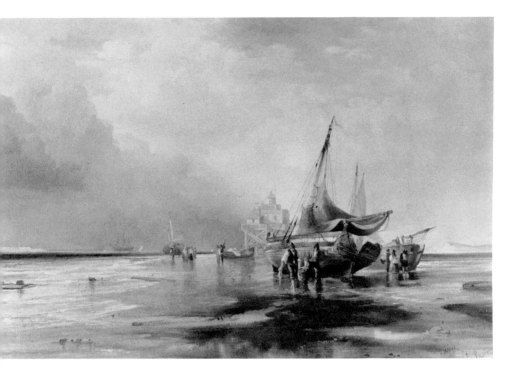

Spit Light, Boston Harbor, England, 1857. Oil, 24x36 inches.

Courtesy Kennedy Galleries, Inc.

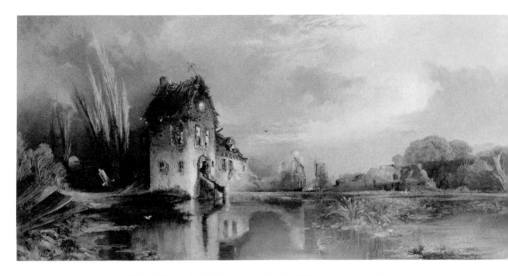

The Haunted House, 1858. Oil, 22x45 inches.

Summer on the Susquehanna, 1860. Oil, 24x20 inches.

Gilcrease Institute, Tulsa

The Wilds of Lake Superior (sometimes called
Western Landscape), 1864. Oil, 29x44 inches.

New Britain Museum of Art
New Britain, Connecticut

Vandermarck, July 30, 1865. Pencil study from nature,
9½ x 6¼ inches.

Gilcrease Institute, Tulsa

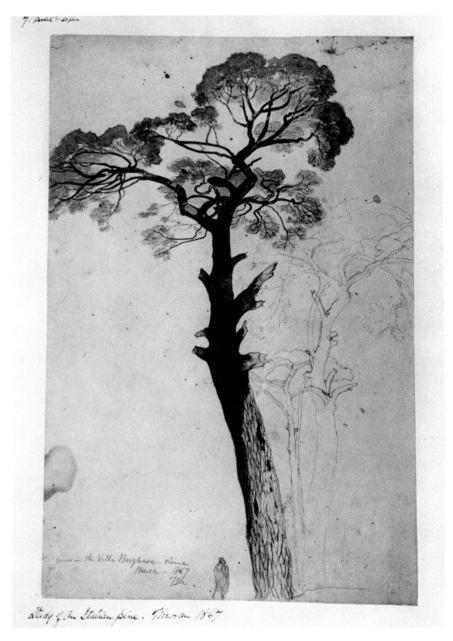

Study of an Italian Pine, 1867. Pencil and wash, 13½ x 8¾ inches.

Gilcrease Institute, Tulsa

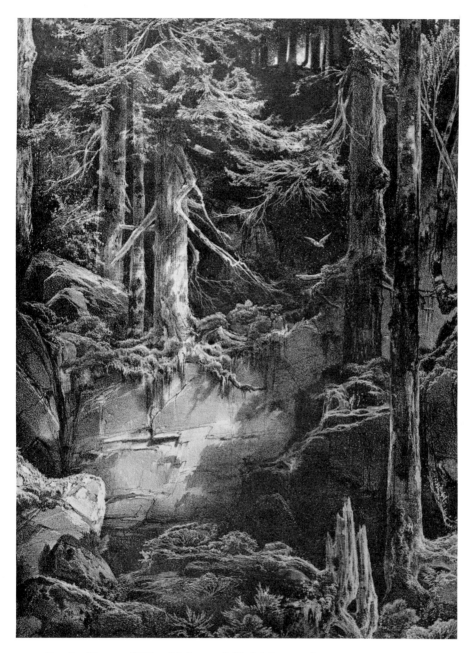

In the Forest, Wissahickon, 1868. Lithograph, 12½ x 9 inches.

Gilcrease Institute, Tulsa

Solitude, 1869. Lithograph, 20⅜x16 inches.

Gilcrease Institute, Tulsa

acknowledged years afterwards, "that [the rest] of us would have been painters had it not been for Edward's encouragement and assistance."[19] But exactly when the urge seized him to become an artist was beyond Thomas Moran's later recollection. He once confessed, "I don't know why I took to painting. . . . I guess I always had the desire." He remembered how as a small boy he had talked with other youngsters about what they wanted to do when they grew up. "I said I was going to be a painter, and make pictures like those on the banknotes then."[20]

There was much about Philadelphia to nourish a boy's esthetic bent. The city had an old and distinguished art tradition, had been the home, at one time or another, of such painters as Thomas Sully, John Neagle, Alexander Wilson, George Catlin, and the family of Peales. There was the old Academy of the Fine Arts on Chestnut Street, a bit dank and gloomy, but there you could see *Death on a Pale Horse* by Benjamin West and other "grand" paintings, and down in the basement stood many casts of classical statues. The Academy's greatest drawback was the twenty-five-cent admission fee, not a trifling sum for a weaver's son. Luckily, pictures hung in some other places free for the looking, as at the store of James S. Earle on Chestnut Street, with its sign "Paintings and Looking Glasses." The exhibitions of the Art Union of Philadelphia were held there, and Thomas often went to look at the pictures on the walls. "He learned to know the style and technique of each exhibitor and pick out the several paintings without ever looking at the catalog."[21] But such delight could not last long, when the proprietor looked on boys as his "natural enemy." When Thomas arrived one day with several companions, Earle met them with a scowl and ordered the "young rapscallions" out. Too sensitive to risk a further rebuff, Thomas never returned, and so he lost one of the choice pleasures of his school days. His exposure to art continued, however, owing to the custom of Philadelphia artists to show their pictures,

[19] Quoted in Hugh W. Coleman, "Passing of a Famous Artist, Edward Moran," *Brush and Pencil*, Vol. VIII, No. 4 (July, 1901), 191.

[20] Interview by Gussie Packard Dubois, *Pasadena Star-News*, March 11, 1916, p. 6, col. 3.

[21] Stevens, Untitled MS.

usually one at a time, in the windows of certain shops. Sometimes he stood for a long while before a window, gazing at the picture behind the pane, and in that informal manner he became familiar with the work of artists such as John Sartain, Isaac L. Williams, James Hamilton, and Rembrandt Peale. He had a wide though scarcely systematic knowledge of the work of local painters by the time he finished grammar school at the age of fifteen.

His father wanted him to enter Central High School, where he could have taken drawing courses, but eager to make his way in the world, Thomas preferred to go to work. He set about finding a job; he scanned the newspapers and settled on an advertisement that seemed to have possibilities: it called for a boy to help an English potter decorate chinaware. But on going to the address he found that part of the work was tending a baby, and he promptly lost interest. Next he answered the advertisement of a lawyer named William Small, though he had not the least desire to become a lawyer. He went to the office at 89 South 5th Street and was asked to wait in the reception room. Several fine engravings hung on the walls, apparently of paintings by James Hamilton and Isaac Williams, and Thomas was deeply absorbed in them when Mr. Small stepped into the room.

When Thomas turned, the lawyer asked if he were fond of pictures. In the conversation that followed the boy showed such a sensitive appreciation for the engravings that Mr. Small remarked: "You don't want to work for a lawyer; you want to work for an artist." And he suggested that if Thomas came back the next day, he would take him to the studio of James Hamilton. "We'll see what he can do for you."[22] Hamilton was then a famous man, described as "the ablest marine painter of this period" and "unquestionably an artist of genius."[23] His technique was freer than was common in the 1850's, and his vision approached what would later be termed impressionism. He had now become an idol for Thomas, and the thought of approaching him was too unsettling for the boy's native shyness, a

[22] *Ibid.*
[23] S. G. W. Benjamin, "Fifty Years of American Art," *Harper's Magazine*, Vol. LIX (September, 1879), 490.

diffidence that remained a permanent trait of his character. He would always be a reserved person, prone to withdrawal, "wrapped in the mantle of his own aloofness."[24] Of the lawyer's invitation he remarked years later: "This so frightened me that I never went back." He was "afraid to meet so great a man."[25] Yet the meeting was merely deferred, as circumstances developed. It was destined that James Hamilton would have a direct effect on Thomas Moran's career.

[24] Ruth Moran, "In Memoriam" (MS), B39, Moran Papers, Gilcrease Institute.
[25] Miscellaneous notes, A25, *ibid.*

II *Apprentice Years*

⤙※⤚◉⤙※⤚◉⤙※⤚◉⤙※⤚◉⤙※⤚◉⤙※⤚◉⤙※⤚◉⤙※⤚◉⤙※⤚◉⤙※⤚◉⤙※⤚◉⤙※⤚◉⤙※⤚◉⤙※⤚◉⤙※⤚◉

Moran's career may be said to begin in 1853, sometime after his sixteenth birthday, when he decided to enter an engraver's shop—the "asylum of almost all American youths of that time of an incorrigibly artistic bent."[1] Philadelphia was then famous for its publishing. *Godey's Lady's Book* and the *Saturday Evening Post* were only two of the magazines issued there, and J. B. Lippincott and Company was a venerable publisher of books. Consequently the city abounded with engravers, especially wood engravers now that wood engraving had become the most esteemed method of illustration; among their number was the firm of Scattergood and Telfer at 57 South Third Street, where Thomas was bound by his father in seven years' indenture. The firm received three hundred dollars to teach him the craft, if the usual terms were followed, and a few dollars a week would be his due after the first year.

"I was fortunate in getting into Scattergood and Telfer's engraving office," he once admitted; "I never worked very hard for them, in fact did not take to engraving easily."[2] The process, which he found tedious in the extreme, meant taking a block of smooth-grained boxwood, on whose polished surface was a picture sketched in reverse, and with great care graving away the bare white spaces, to let the lines and darkened areas stand in relief. These when printed gave

[1] Montgomery Schuyler, "George Inness," *Forum*, Vol. XVIII (November, 1894), 302.

[2] Miscellaneous notes, A25, Moran Papers, Gilcrease Institute.

{20}

a reproduction of the original sketch. He never really mastered the burin; indeed he had no need to, for when David Scattergood saw the quality of his drawing, he was kept busy sketching designs on the blocks for other hands to engrave. These blocks, formed from many squares of boxwood bolted together end-grain up, and polished until no joints could be detected, he rubbed with Chinese white on the palm of his hand. Then upon the whitened surfaces he drew his pictures with sharp pencil and India ink. His drawings improved with time and practice, but the routine subjects he was obliged to sketch became an intolerable bore. He took more interest in his own compositions, to which he devoted his spare time; he filled his free daylight hours with painting in water colors and his evenings with drawing in black and white. Thus absorbed, he began to reach the shop later in the mornings and to leave earlier in the afternoons, so that Mr. Scattergood complained to his father. Thomas resented the charge that he was wasting the company's time, and his "Irish temper" flared up, at which the engraver, who valued the boy's talents and had no wish to lose him, allowed him to continue on his own terms.

In the shop thereafter, according to Moran's recollections, "[I] spent a good deal of time painting water colors, which I gave to Scattergood," and in turn the engraver sold them for nice sums. One day Thomas saw a few of them at the store of "C. J. Price & Co., importers of English books," and he went to Price's office on the second floor of the Hart Building "and had a talk with him. He was a dealer in fine editions . . . and we made an arrangement by which I was to take books in trade for water colors."[3] In this way he acquired a small collection of books, including considerable English poetry (Cowper's *The Task*, to name a single instance), and volumes of engravings such as Turner's *Liber Studiorum* and *The Rivers of France*. He lingered at book stores and read not only about art but also in science and literature. "He was at all times an indefatigable reader,"[4] wrote a friend. He was fond of the romantic poets and, in time, came to value Browning. The result of his book-

[3] *Ibid.*
[4] Gustave H. Buek, "Thomas Moran," *American Magazine*, Vol. LXXV, No. 3 (January, 1913), 30.

ishness was a self-acquired education that frequently surprised those about him. Later at Yellowstone, according to William H. Jackson, "He astonished every member of the party, including Dr. Hayden, with the extent of his knowledge. It reached into every field."[5] The direct effect of books on his development as an artist must have been immense. At that time much of an artist's education came from books and magazines, with their steel engravings, mezzotints and acquatints, lithographs, and wood engravings that acquainted him with pictures that would not have been available otherwise and afforded him models to copy. That the British tradition was so strong in such sources helped it to prevail in America through the seventh decade of the nineteenth century.

Thomas remained at Scattergood and Telfer's for nearly three years, a slim youth of middle height, who smoked cigars, wore his light-brown hair in rather long waves about his ears, and grew a mustache and a silken imperial, the promise of a full beard to come. Then sometime in 1856 a severe siege of rheumatic fever, with resultant pleurisy, interrupted his apprenticeship. A hacking cough wracked his light frame and aroused fears of consumption. But he recovered and, once again in good health, refused to return to the engraving shop and got his indenture cancelled—a sensible solution: not only had he failed to learn engraving properly there, he no longer had the slightest intention of spending his life as a wood engraver. By now his water colors, "charming allegorical sketches,"[6] were selling for encouraging sums—from ten to fifteen dollars apiece— and this, with the growing success of his brother Edward, gave him hope that he might become a landscape painter himself. What he had learned at Scattergood and Telfer's would be useful; even what little work he had done with the burin was not waste motion—it had helped to sharpen his sense of line and increased his sureness of touch. The medium mattered little to him, he once declared, because of his early mastery of the line.

He now shared the cramped studio that Edward had rented on Callowhill Street, at the advice of James Hamilton, who had taken

[5] *Time Exposure*, 200.
[6] Richard Ladegast, "Thomas Moran, N.A.," *Truth*, Vol. XIX, No. 9 (September, 1900), 212.

an interest in Edward's painting and urged him to find a place where he could work without interruption. So, leaving his job as a power-loom boss, Edward had opened "as ill equipped a studio as ever sufficed the purposes of an aspirant for fame."[7] It was "an attic room above a cigar store, with an entrance up a back alley."[8] Soon Edward's oils began to sell, and by 1855 one had hung at the Academy of the Fine Arts. To join him in that crowded studio was, for Thomas, an act of commitment—both brothers were now dedicated to the artist's life, and their close and congenial association, which soon included their younger brother Peter, lasted for several years, through several changes of address. They soon rented a more spacious studio on Locust Street, then another on Castle Street, and at last a house at 915 Sergeant Street, where Edward lived and worked for a number of years.

Under Edward's guidance Thomas took up oil painting and made rapid progress; he produced the historical *First Ship, San Salvador* as early as 1855. *Absecon*, a view along the New Jersey coast, was accepted by the hanging committee of the Academy of the Fine Arts, along with five water colors, nearly as many pictures as Edward himself had submitted in 1856. His frailness notwithstanding, ambition and a fear of becoming "just another penniless artist"[9] drove Thomas so relentlessly that he "averaged thirteen hours a day of close work."[10] —a schedule that would continue for most of his life. He learned not only from Edward but from other artists in their circle, especially from one he had shrunk from meeting years before—Hamilton, a kindly Irishman, who took a keen interest in his pictures and had helpful criticism for everything Thomas thought fit to show him. He was a man of "extraordinary knowledge in art,"[11] and his "wholesome advice" accompanied wise remarks on esthetic principles and

[7] Hugh W. Coleman, "Passing of a Famous Artist, Edward Moran," *Brush and Pencil*, Vol. VIII, No. 4 (July, 1901), 188.

[8] Benson, "The Moran Family," *Quarterly Illustrator*, Vol. I, No. 2 (April–June, 1893), 72.

[9] Samuel Sachs II, "Thomas Moran—Drawings and Watercolors" (Master's thesis, New York University, 1963), 33.

[10] Benson, "The Moran Family," *Quarterly Illustrator*, Vol. I, No. 2 (April–June, 1893), 67.

[11] Scrapbook, p. 40 (unidentified clipping), Moran Collection, East Hampton Free Library.

theory. He set Thomas moving along lines of his own particular kind of luminism and perhaps encouraged the youth to adopt his own Turneresque objective: "the interpretation of Nature by recording the impression she makes on the mind. . . ."[12] He intensified the boy's enthusiasm for the works of Turner, already awakened by the *Liber Studiorum.* And "out of his scanty purse he sometimes purchased some of the young artist's water colors,"[13] no doubt the most heart-warming encouragement of all. Along with Edward, he was the most effective guide in Thomas' early career. It was Hamilton "to whom," Moran later wrote in third person, "he owed, more than to any other artist, the direction and character that afterward marked his works."[14] Yet Hamilton was never formally his teacher. As Moran himself declared, "[I] was never under any master."[15] He was essentially self-taught; his best counselor was common sense, his surest reliance a resolute will.

He came, in fact, to believe that instructors in the arts were largely futile and unnecessary, and when he himself became well known, and could have secured many students, he was rarely tempted to take one in. "You can't teach an artist much how to paint," he once said. "You can tell him what not to do, but if he has the ability, it will work out. I used to think it was teachable, but I have come to feel that there is an ability to see nature, and unless it is within the man, it is useless to try to impart it. If he sees, he will strive to express it, through melody, literature or painting, and if he is a good artist he makes a masterpiece."[16] For him nature was the real, the supreme master, and this he realized early.

All his trial work in the studio, all his study of pictures, either in books or in the galleries, all his earnest discussions with artist friends,

[12] John I. H. Baur, "A Romantic Impressionist: James Hamilton," Brooklyn Museum *Bulletin,* Vol. XII, No. 3 (Spring, 1951), 6, quoting E.S., thought to be Emily Sartain.

[13] S. G. W. Benjamin, "A Pioneer of the Palette: Thomas Moran," *Magazine of Art,* Vol. V (February, 1882), 90.

[14] Untitled autobiographical sketch, A18, Moran Papers, Gilcrease Institute.

[15] To the Editor, *American Cyclopaedia,* December 17, 1874, MSS Division, Library of Congress.

[16] Interview, *Pasadena Star-News,* March 11, 1916, p. 6, col. 2.

were but part of his strenuous effort at self-instruction. He knew that none of this, however important, could make him a landscape painter worthy of the calling unless he went directly to nature. "I must know the rocks," he said, "and the trees and the atmosphere and the mountain torrents and the birds that fly . . . above us."[17] He was in complete agreement with the conception of the "big artist" which another Philadelphia painter, slightly his junior, was soon to frame—the big artist who, according to Thomas Eakins, "keeps a sharp eye on nature and steals her tools. He learns what she does with light, the big tool, and then color, then form, and appropriates them to his own use. Then he's got a canoe of his own, smaller than Nature's but big enough for his own purpose."[18] In his effort to find his own canoe Thomas often forsook the studio and made excursions to the outskirts of the city, along the shores of the Schuylkill, or more often beside the Wissahickon, a stream that wound through a narrow glen between steep hills, wooded to their summits. Here he often found a picturesque scene which he memorized as one would memorize a poem, to take it back to the studio to compose from memory into a picture. He would often return to the same spot and sketch it from nature, then make a close, critical comparison of the composition, atmosphere, and color effects of the two pictures.

His early works often contained too much minutiae, but discipline fostered that special faculty of the landscape painter, a tenacious memory for scenic details, including all sorts of transient forms and effects. "In working," Moran later declared, "I use my memory. This I have trained from youth up, so that while sketching and coloring, I impress indelibly upon my mind the features of the landscape and the combinations of coloring, so that when back in my studio the water color will recall vividly all the striking peculiarities of the scenes visited."[19] His memory for cloud forms, rocks and trees, and moving water, in all their varied moods in sun and shadow, struck

[17] *Washington Star*, August 27, 1926.
[18] Quoted in F. O. Mathiessen, *American Renaissance*, 606.
[19] Scrapbook, p. 46 (clipping dated June 9, 1900), Moran Collection, East Hampton Free Library.

even his fellow artists as extraordinary—a memory so retentive that it enabled him to portray intricate landscapes months, even years after he had fixed the images in mind. "He could always see clearly what he wished to remember," wrote his daughter Ruth, "and he never forgot a once loved impression."[20] On one occasion late in life, after reading a magazine piece on Zion Canyon, he proceeded to paint an effective picture of the canyon, although he had not set eyes on it for over forty years. With time and increasing skill his pictures lost their early cluttered look.

From the outset his love of nature was for the pristine state, landscape unspoiled by encroachments from civilization. There was little charm for him in the commonplaces of human life, either urban or rural. "A monotony of cabbage rows and a girl with a hoe, a country lane with a clodhopper and a goose," one critic observed, "were to him not landscapes. Barnyards, docks, fallow lands, trim fields were to him the *et ceteras* of civilization, not the materials of art."[21] That enthusiasm of genre painters of his time, "a stiff, red, square barn on a muddy slope with a brook greasy and discolored by refuse from the desolate houses of the poor" was for him "only a mutilation" of what, perhaps, had once been a beautiful place.[22] He preferred the natural scene before it was reduced or marred by the hand of man. But the young artist could not afford to go beyond a radius of one hundred miles or two from Philadelphia. Hence, between painting scenes on the Schuylkill or the Wissahickon, the Delaware, Susquehanna, or Raritan Bay, he moved in imagination to places that were wilder, more distant, more exotic. He was stirred, for instance, by his reading in Shelley, especially the melancholy quest of the poet in *Alastor*, moving through "the awful ruins of the days of old"— through Athens and Tyre and Baalbek, Babylon, Memphis, and Thebes:

Among the ruined temples there,
Stupendous columns, and wild images

[20] B28 (MS), Moran Papers, Gilcrease Institute.
[21] Quoted by Edmund Buckley, *Fine Arts Journal*, Vol. XX, No. 1 (January, 1909), 12.
[22] Ruth Moran, Miscellaneous notes, C25, Moran Papers, Gilcrease Institute.

Of more than man, where marble daemons watch
The Zodiac's brazen mystery, and dead men
Hang their mute thoughts on the mute walls around.
He lingered, poring on memorials
On the world's youth. . . .

Thomas transferred the scene to canvas as it took shape in his mind, neither Athens, Tyre, nor Baalbek—neither Babylon, Memphis, nor Thebes—but his imagined impression of all fused, a spacious scene of ruined temples, sharded columns, glimmering through a pale half light. "*Among the Ruins—there he lingered,*" completed sometime in 1856, he regarded as his first significant canvas. "The subject was highly characteristic of his mental cast," wrote the painter-critic, S. G. W. Benjamin, "for imagination is perhaps his master quality."[23] It was hung in the next year's exhibition at the Academy of the Fine Arts, where it was followed in a later show by its sequel "*On the Lone Chorasmian Shore,*" which showed the poet paused in his wanderings at a "*wide and melancholy waste / Of putrid marshes.*"

> *A swan was there,*
> *Beside a sluggish stream among the reeds.*
> *It rose as he approached, and with strong wings*
> *Scaling the upward sky, bent its bright course*
> *High over the immeasurable main.*
> *His eyes pursued its flight——*

Perhaps in these soarings of fancy he followed the lead of Hamilton, who had painted scenes from *The Rime of the Ancient Mariner.*

Perhaps, too, Hamilton's plates for Colonel Frémont's *Memoirs* (which were not to be published for years, but which Thomas Moran probably saw on visits to Hamilton's studio) sent him roving west in spirit, because in 1857 he painted an imagined "western" scene now known as *The Waterfall*, with a stream in the foreground spilling wildly down from a broad plateau, while sheep grazed to one

[23] "A Pioneer of the Palette, Thomas Moran," *Magazine of Art*, Vol. V (February, 1882), 90.

side, on a rolling knoll. There were pale green trees, and beyond the glint of a lake in the middle distance tall crags receded behind a bluish haze. The style was rather free for the time, perhaps owing again to Hamilton's example. The attention he now paid to marine painting may also have been stimulated as much by Hamilton as by his brother Edward. Who knows from what model or suggestion he painted such supple seascapes as *Storm on a Rocky Coast* or *The Coast of Newfoundland*. His *Spit Light, Boston Harbor* was a work of quiet dignity, in the muted tones of a Dutch marine, the sand wet and gleaming on which the fishing boats were beached as the center of interest, with Spit Light in the background and the sky a pearly gray above. Surprisingly well drawn, in view of Moran's usual indifference to the human figure, were the fishermen lugging wickers of their catch. The scene pointed to his growing interest in Turner, who had found similar boats and men at the fishing village of Hastings. At intervals now Moran made water colors from Turner's black and white engravings, all good practice, though it scarcely hewed to his idea of going directly to nature.

In 1858 he completed *The Haunted House*, an eerily Quidoresque scene, strangely moving. Perhaps he intended it as a rather free conception of the House of Usher. It offered plenty of Gothic gloom, with "vacant, eye-like windows," some of them round as if to accentuate their occular quality; there were also "a few white trunks of decayed trees." To the left of the mansion, "ghastly tree-stems" swept toward the sky, like whitened wisps of witch's broom. The pallor of the walls suggested the glaze of "minute fungus," such as the narrator in Poe's tale had observed over the whole exterior, but intensified in Moran's picture the farther one's gaze was lowered toward the "dark and lurid tarn" that lapped along the foundations of the house. Sedges choked the farther margin of the pond, as in Poe's description, but when one looked for the telltale fissures down the livid façade, he could hardly be sure if the dark lines he noticed there were refts in the masonry or merely the pattern made by leaf-less stems of creeper. The inconclusive effect made little difference; whatever Moran's theme, *The Haunted House* remained one of the most evocative examples of the illustrative part of his work. He con-

tinued to paint imagined literary scenes—*Macbeth and the Three Witches*, for example, or "*Childe Roland to the Dark Tower Came.*" In the latter Moran revealed the valley where Browning's "round squat tower" rose as "blind as the fool's heart," and he made the region so drear and desolate that a resourceful art dealer could later sell the picture as *The Lava Beds of Idaho*, the only real difficulty turning on the need of taking Childe Roland for a Bannock Indian. Neither dealer nor purchaser boggled over the fact that the painting antedated Moran's first Idaho trip by one dozen years. Such a switch in title would seem scarcely more strained than others over the years, as when later in his career he would discover certain of his Mexican scenes relabeled as Venice. It was true, as dealers might argue when pressed, Moran need never visit a place to paint it convincingly. In his career as free-lance illustrator he would often be required to sketch scenes he had never laid eyes on, and his imagination, for better or worse, rose to the challenge, but he was not satisfied now to stay confined at home, often to work at second hand, or to be restricted to a journey of a day or two roundabout in country which usually failed to stir him. "Eastern mountains I have no use for," he later told a friend. "The Alleghenies are mountains to be sure, but they are covered with trees. The others in the East are but foothills."[24] He longed for scenes of greater majesty and grandeur, for views as wild and sublime as those depicted in the Turner engravings.

It was in the summer of 1860 that he managed to take his first extended trip in search of scenic magnificence, the first of many that would make him seem to one writer as "the most energetic seeker after the picturesque in nature that ever climbed a mountain or took a yawning chasm at a single leap."[25] He left the city on July 23, in company with Isaac L. Williams, twenty years his senior.[26] Once a pupil of John Neagle, Williams had begun his career as a portrait

[24] Quoted in Buek, B22, Moran Papers, Gilcrease Institute. Draft for "Thomas Moran, N.A.: The Grand Old Man of American Art," *Mentor*, Vol. XII, No. 7 (August, 1924). The sentences here quoted were deleted from the published article.

[25] J. G. Pangborn, *Picturesque B. and O.*, 20.

[26] Ruth Moran mentions the Lake Superior trip in Miscellaneous notes, Envelope 52, Moran Collection, East Hampton Free Library; also in undated letter to William H. Jackson, B26, Moran Papers, Gilcrease Institute.

painter, but his enthusiasm had shifted to landscape, and he was now as eager to find scenic wonders as Moran himself. He was a pleasant companion, "tall and slender . . . wise, witty, with a vocabulary that was wonderful . . . and a voice clear and musical." He was "genial in disposition . . . well informed and easy of approach,"[27] apparently an ideal comrade for the days of nature sketching that lay ahead. Their destination: "the shores of *Gitchee Gumee* . . . the shining Big-Sea-Water"—more soberly known as Lake Superior.

Ten years or so before, the geologist J. W. Foster and J. D. Whitney had run a survey line along the southern shore of the lake, and on viewing the Pictured Rocks there, or what the voyageurs had called *Les Portails*, some seventy miles west of Sault Sainte Marie, they could scarcely believe that such a "romantic portion" of the shore could be so little known to the American public, especially after the notice Schoolcraft had paid its folklore in *Algic Researches*. It was "a matter of surprise," they wrote, "that, so far as we know, none of our artists have visited this region and given the world representations of scenery so striking, and so different from any which can be found elsewhere. We can hardly conceive of anything more worthy of the artist's pencil."[28] Longfellow's best seller of 1855, *The Song of Hiawatha*, having mined Schoolcraft among other sources, had made the aboriginal legends of the area a household treat, best loved by children but seemingly devoured by all. *Hiawatha* would be put into Latin by Cardinal Newman's brother, and the intrepid Major John Wesley Powell was to choose it for reading aloud to his men during their descent of Green River. It was a favorite poem of Moran's, one whose pictorial possibilities were to occupy him for years. He delighted in its naïve primitivism, in its rehearsing of Chippewa myth, in its warm and colorful pictures of a pristine wilderness; and now full of its Indian-summer romance, he and Williams invaded the haunts of its hero, Manabozho, whose name the poet had changed, just as he had reshaped the legends and pared from them all of their aboriginal malice. On the twenty-ninth of July the two

[27] Adaline B. Spindler, "Isaac L. Williams, Artist," Lancaster County [Pennsylvania] Historical Society *Papers*, Vol. XVI, No. 9 (1912), 269.

[28] *Report on the Geology of the Lake Superior Land District*, Part II, 124n.

artists began sketching at the western end of the Pictured Rocks, accessible by small boat from Grand Isle.

It was a somewhat hazardous venture, as Foster and Whitney suggested:

> The traveler should lay in a good supply of provisions, if it is intended to be absent long enough to make a thorough examination of the whole series. In fact, an old voyageur will not readily trust himself to the mercy of the winds and waves of the lake without them, as he may not infrequently, however auspicious the weather when starting, find himself weather-bound for days together.[29]

The bluffs fronted the lake high and sheer for fifteen miles, dropping steeply into the waves, and the geologists added:

> To the voyageur coasting along their base in his frail canoe, they would, at all times, be an object of dread; the recoil of the surf, the rock-bound coast affording for miles no place of refuge—the lowering sky, the rising wind—all these would excite his apprehension, and induce him to apply a vigorous oar until the dreaded wall was passed.[30]

But no mishap occurred to the artists, nor were their expectations disappointed.

Not far from Grand Isle harbor high cliffs of yellowish sandstone had loomed up vertically from the water. The cliffs were capped with dense evergreens, and small cascades flashed down at intervals from the verge, sometimes in unbroken curves, sometimes "gliding down the inclined face of the cliff in a sheet of white foam." The rocks assumed fantastic forms, with high colors, reds and yellows, browns and greens, laid in bands, from iron and copper-stained seepage. Just beyond the mouth of Miner's River with its patch of friendly beach the artists had come to what the geologists, in their wonder, had called "one of the grandest works of nature"—a great Gothic pile named Miner's Castle, "from its singular resemblance to the turreted entrance and arched portal of some old castle—for instance, that of Dumbarton."[31] They camped, probably, like the geologists before them, on the right bank of the river, a sandy plain overgrown

[29] *Ibid.*, 125n. [30] *Ibid.*, 125. [31] *Ibid.*, 126.

with Norway and Banksian pines—"the only place of refuge to the voyageur until he reaches Chapel river, five miles distant, if we except a small sand beach about midway between the two points, where, in case of necessity, a small boat may be beached."[32] Moran made pencil sketches of both the castle and the river, and sometime later they must have ascended the stream, penetrating the dense forest south of the lake, where he continued to sketch. "Bears, deer, beaver and mink are numerous here," ran an article which the *Aldine* carried years later with engravings from his sketches; "wild grapevines and other creepers decorate the great trees with festoons of fruit and flowers; and a picturesque waterfall tumbles from a high cliff into a forest of primitive growth."[33]

August 6 found the artists at the Great Cave, *le Grand Portail* of the old *voyageurs*, miles to the east of Miner's River. They must have rowed their small boat along the intervening line of cliffs that plunged straight down into deep water ("woe to the unfortunate vessel caught there by a nor'wester"[34]), then made camp, if they followed the geologists' example, on an open pine plain near Chapel River. They sketched the vast mass of sandstone that jutted out into the lake, whose ceaseless waves had quarried from its interior an immense cavern, its main entrance leading through an impressive arch one hundred and fifty feet in height. Inside they found the cave partly filled with debris from the crumbling walls, mined with hundreds of smaller caverns, the sandstone draped with green moss, its color made more intense by light reflected from the water below. The water was of a deep emerald cast, so clear that agate pebbles could be seen at a depth of forty feet. Vertical bands of red, green, and yellow marked the neighboring cliffs from the top to the heaving surf below, making them smolder like "Venetian carpets of the richest dyes."

The artists sketched at the Great Cave for at least two days, then moved one-half mile farther to the Grand Chapel, which marked

[32] *Ibid.*

[33] "The Pictured Rocks of Lake Superior," *Aldine*, Vol. VI, No. 1 (January, 1873), 14.

[34] *Ibid.*

the eastern end of the Pictured Rocks. This curiosity—*la Chapelle* of the *voyageurs*—had struck the geologist as about "the most grotesque of nature's architecture here displayed."[35] Moran's pencil caught its bizarre shape—a huge, arched roof of sandstone resting on immense columns, so weathered as to leave a curiously formed vault inside, and in the woodblock which the *Aldine* ran years later a shipwrecked man could be seen in the surf that pounded below, raising his arm in hopeless distress. According to the attendant article:

> The chief feature of the Pictured Rocks can only be represented by *color*, and must, therefore, be left to the imagination of the reader; enough remains, however, when this is subtracted, to startle the artist, and to call forth the utmost skill of his pencil. What they are, translated into black and white, Mr. Moran has shown us. His illustrations are full of power, and are strikingly suggestive of the wild and magnificent scenes in which the Pictured Rocks are set— the old forests by which they are crowned, and the stormy waters from which they rise. We understand, now, why the Indians considered the neighborhood haunted, and can almost realize the hunting of Pau-Puk-Keewis [who, the writer explained, was] the Storm Fool—an incarnation of the sudden tempests to which the Lake is subject, and which, raging far and wide, end, in this particular myth, in the Pictured Rocks.[36]

"This must have been his first camping experience," wrote Moran's daughter Ruth, but it lasted longer than the "very few days" which she surmised. No one knows, apparently, when the painters actually left the Pictured Rocks, but they must have retraced their way to Grand Isle harbor, to "take advantage of one of the propellers which navigate the lake."[37] Perhaps they voyaged through the Soo, then down Lake Huron; at any rate, on August 22 they were making sketches of St. Clair Flats at the head of Lake St. Clair, on their way home. There before them as far as they could see stretched the low,

[35] Foster and Whitney, *Lake Superior Land District*, Part II, 129.

[36] *Aldine*, Vol. VI, No. 1 (January, 1873), 14; Ruth Moran to William H. Jackson, B26, Moran Papers, Gilcrease Institute.

[37] Foster and Whitney, *Lake Superior Land District*, Part II, 125n.

green land that was hardly land, a mass of flowing reeds, intersected by a maze of channels, broad and narrow, lined with golden sand, running with water as clear and green as the green of their banks. Herons waded in the streams; bitterns sounded in the reeds.

Moran had gathered impressions that would serve his work for years. Besides his designs on wood for the *Aldine* more than a decade later, his Lake Superior jaunt provided notable illustrations for *Hiawatha,* and themes for lithographs and oils. The following year he exhibited at the Academy of the Fine Arts *The Grand Portal of the Pictured Rocks* and *The Pictured Rocks from Miner's River.* It would seem, too, that from this journey derived *The Wilds of Lake Superior,* now called *Western Landscape,* which he painted in 1864. The picture enjoys quiet favor today (Virgil Barker commends it "for its spirited composition, its crisp brush work, and most of all its animated illumination"[38]) and is now one of Moran's better known works—a glimpse of a brawling stream plunging into a fall whose end is not revealed, but which strikes one as not unlike the leap Moran saw Chapel River make into the restless waters of Lake Superior.

[38] *American Painting,* 589.

III *Europe*

✦✶✦✶✦✶✦✶✦✶✦✶✦✶✦✶✦✶✦✶✦✶✦✶✦✶✦✶✦✶✦

B y 1861 Thomas Moran had made a local reputation as an artist of promise. There was nothing in his manner to offend the traditionalist tastes of art lovers in Philadelphia, working as he did within the dominant British mode. His style was romantic, but it gave promise of escaping the blight that seemed, to discerning eyes, to have settled over the whole romantic movement. Anglo-American materialism had encouraged smart, conventional techniques applied to subjects filled with trivial sentiment, but against this decadence a small circle of British artists had rebelled, with John Ruskin as their principal advocate. The Pre-Raphaelites, as they styled themselves, demanded a new sincerity in art, a return to the truth of nature, or as Sir John Millais put the matter: they "had but one idea—to present on canvas what they *saw* in nature."[1] Yet that was an oversimplification; as Holman Hunt said of himself and Rossetti: ". . . we agreed that a man's work must be the reflex of a living image in his own mind and not the icy double of the facts themselves."[2]

The influence of the Pre-Raphaelite brotherhood had spread to America, and at the same time certain highly vocal "American Pre-Raphaelites," such as William J. Stillman, gave *Modern Painters* almost as great a vogue in the United States as it enjoyed in England. Ruskin became a prophet for hundreds of young Americans, artists and intellectuals alike, who thought of themselves as lovers

[1] Quoted in John Piper, *British Romantic Artists*, 40.
[2] Quoted, *ibid.*, 41.

of nature. Thomas Moran, whose mind teemed with memories of Turner's engravings, inevitably leaned toward a movement whose ideals were so close to his own, and in his oil painting he adopted one of Rossetti's practices, the creation of brilliant effects by glazing over a white ground. He could never follow the later eccentricities of the group, much less move with it into the camp of estheticism, but as one critic observed, "He was a real Pre-Raphaelite in the sense that throughout his youth and early maturity he was essentially his own man, one who put on canvas his own reactions and responses to the beauties of nature, painting from the innocence of his heart rather than from academic formula and routine."[3] Moreover, he could agree with the great panjandrum of the movement in idolizing Turner.

Acquaintance with that artist's painting of Conway Castle stimulated Moran's ambition to see more of Turner's work in color. To study the color, in that day before adequate color reproduction, meant going to the originals in England. Not even the Civil War seems to have affected Moran's course of action; as soon as he had accumulated the necessary money, he sailed for the British Isles with his brother Edward.

They arrived sometime in early summer, their ship docking at Southampton. At least that seems to be the first English scene that Thomas sketched, the ancient town walls with great Norman towers and gates overlooking the river with its boats. "He loved England," wrote his daughter Ruth; "it was in his blood—the beautiful landscape and fierce coastline."[4] The last of July found him following Turner's trail through the Isle of Wight and sketching the ruins of Carisbrooke, a castle of Charles Stuart. Romantic as he was, England meant for him old ruins, the older, the more ruined and Gothic the better, with clinging creeper and moping owls. But he had come to England to see the pictures of Turner, and so he headed for London and the National Gallery, where he spent months poring over the works of his idol, while Edward studied at the not-so-attractive school of the Royal Academy.

[3] *New York American,* January 16, 1937.
[4] Ruth Moran, "Thomas Moran, N.A.," B5(b), Moran Papers, Gilcrease Institute.

Familiar as Thomas was with Turner's engravings, he was not prepared for the brilliant riot of color in the oils—for what the irreverent Autocrat at the Breakfast Table had signalized as

golden dirt,—
The sunshine painted with a squirt.

He was at first "stunned by the radiance which he had not imagined but which he, himself, found literally glowing in the Yellowstone country, later on in his life."[5] Everything else in Turner's work seemed subservient to his color, but Moran decided that Turner "would falsify the color of any object in his picture in order to produce what he considered to be a harmonious whole."[6] Soon he began to make faithful copies of the master's work. When the keeper of the pictures there saw the quality of Moran's drawing and painting, he gave the slim young artist warm encouragement, provided him with an empty room where he could paint undisturbed by visitors, and brought him paintings by Turner and even drawings that had been "honored by decent burial in a sort of crypt, where [they had been arranged] in such order as Turner himself could never have imagined or desired, thanks to the devotion of Mr. Ruskin."[7] Moran gained new insights into his idol's effects; he grasped underlying truths at first obscured by the artist's peculiar "impressionism," and he felt a new appreciation for Turner's subjective use of nature, the approach his Turnerian friend James Hamilton had already impressed upon his mind. He felt surer than ever that Turner was "a great artist."

"But he is not understood," Moran claimed afterwards, "because both painters and public look upon his pictures as transcriptions of Nature. He certainly did not so regard them. All that he asked of a scene was simply how good a medium it was for making a picture; he cared nothing for the scene itself. Literally speaking, his landscapes are false; but they contain his impressions of Nature, and so

[5] Ruth Moran, "The Real Life of Thomas Moran," *American Magazine of Art,* Vol. XVII, No. 12 (December, 1926), 645.

[6] Quoted in George W. Sheldon, *American Painters,* 124.

[7] Hamerton, *Turner,* 390.

many natural characteristics as were necessary adequately to convey that impression to others."[8]

Not that Moran could follow Turner to his last subjective extremity. He came, in fact, to believe that a large part of the public judged Turner not by his best works, "but by his latest and craziest ones, in which realism is entirely thrown overboard. 'The Fighting Temeraire,' for example, which even Ruskin praises so extravagantly, is the most inharmonious, crude, and disagreeable of all his productions. Its merit lies only in its plan and composition."[9]

But a favorite of Moran's, and one that he placed among Turner's finest paintings, was Crossing the Brook, a subdued work that marked a shift from the artist's early manner to the style of his maturity. "It is simple, quiet, gray in color; the harmonies of its grays are wonderful. It is perhaps the most suggestive of Claude of all his canvases."[10] Another favorite was Ulysses Deriding Polyphemus, a work whose glory was its sky—such a sky as Turner alone excelled at—"pure reminiscence of nature," in Hamerton's phrase.[11] Moran so cherished it that he made a meticulous copy, which hung for years in his studio. He also studied Turner's water colors and caught the qualities of his idol's style so well that one of his own studies, a view of Arundel Castle, was mistaken in London for a sketch by the master.

Turner's example confirmed Moran's interest in the dynamic effects of nature, even in their fleetest manifestations, not merely cloud changes and shifts in light and shade from the motion of clouds, but subtler, swifter movements, and more violent ones; and their instant fixation became a concern for life—the torment of bush and tree under the wind's lash, the dart of spray in headlong streams and waterfalls, the pound of waves against a rocky shore or on the pale-green ramparts of an iceberg, the mountainous roll of groundswells on an open sea, the beat of rain in dark sheets against arête or precipice: how varied the natural phenomena he studied and fixed in memory.

Yet, for all the fascination of such wild and ever-changing ef-

[8] Quoted, Sheldon, American Painters, 123.
[9] Ibid.　　　　　　　[10] Ibid., 123–24.　　　　　　　[11] Turner, 226.

fects, Turner's example also strengthened Moran's appreciation of the calms of nature. Not even George Inness would instill an atmosphere more quiet and suffused with peace than that Moran would bring to certain scenes along the Delaware, the Wissahickon and the Susquehanna. How deftly he would suggest the midday stillness of the forest when the wind had died and foliage glowed like green fire, how deftly register the shimmer of bursting buds in spring, the full, green glory of trees in summer, the red and golden smolder of their leaves in the fall, or their branches tipped with flame at dawn, or the smooth, unrippled surface of some marshy pond, ablaze with sunset afterglow. Some observers thought of Moran's skill with such webs of light and color as obtrusively Turnerian. Indeed his debt to Turner included much he had learned about color and light, and the debt would remain long after he had discovered his own distinctive style.

That his work had long held something of Turner's manner was suggested years later when the widow of Thomas Nast prepared to sell her husband's art collection. Moran, then a recognized authority on the English artist, was asked to authenticate a small landscape which Nast had framed with Turner's name inscribed on a plaque. He had bought the picture from a reputable dealer, and several connoisseurs had called it genuine. On looking at it Moran felt a "tantalizing sense of familiarity,"[12] but not until he had found some markings on the back could he identify it. It was a picture he himself had painted in 1858 and taken to London three years later. How it had come into the dealer's hands as Turner's work was harder to explain: fraud or someone's honest error? Whatever the answer, the incident underscored how rightly Moran could be called "the American Turner." He was frank to admit that Turner's influence was long perceptible in his work, especially in the handling of color, but never so much as to overwhelm its individual character.

But Moran studied other models too. From Lorrain he learned composition, wrote a close friend, "and he always held that Claude has given us all necessary rules of construction and composition in

[12] Scrapbook, p. 38 (unidentified clipping), Moran Collection, East Hampton Free Library.

landscape picture-making. From Constable he acquired that solidity of painting which in later years helped develop that technique which has ever been the marvel or despair of his follow artists."[13] But it was the work of Turner that left the deepest stamp, "the work of Turner that more than all others completely satisfied his mind and that implanted in him that enthusiasm for the grander aspects of nature, and that stimulated in him the desire for the heroic and dramatic."[14]

After Moran's death a critic would write perceptively:

> It hardly yet is fully recognized that this period of saturation in the study of that master gave him his clue to the quality that sets him apart from his contemporaries. With frequent divergences, as one or another problem occupied his mind, he moved slowly toward the great goal of impressionist painting: the attenuation of shadow, the domination in a picture or drawing of light and atmosphere. He became as much of an impressionist as it was possible for an American painter in those early years to be. In studying Turner he grasped the essential of his interpretation of the outdoor world, and the beautiful luminous passages in his work flow with limpid directions from their source in Turner's sunlight.[15]

Meanwhile Moran varied his work at the National Gallery with studies at the new South Kensington Museum. Then when nearly a year had passed, he devoted summer days to sketching out of doors. First came a trip to his native Lancashire, where in Liverpool he drew windmills with their white sails whirling, like those he would later find on eastern Long Island. Two days later he was at Bolton, making sketches of Forthill Bridge, with cows plodding under the Gothic arch and the chimneys of the city in the background. Then back in London, late in June, he roamed the city and its green environs, recording picturesque scenes. There was Windsor Castle, which crowned its hill like a natural formation and had the beauty of a ledge of rocks (he would later paint a distant view of it from

13 Gustave H. Buek, B22, Moran Papers, Gilcrease Institute.

14 *Ibid.*

15 "American Etching Indebted to Moran," *New York Times*, September 19, 1926, Section IV, p. 15.

near a point which Turner himself had selected, in meadows beside a quiet stream); or Greenwood Park as green in summer as its name; or Richmond on its hill, viewed from a silvery Thames alive with boats; or the Houses of Parliament, reflected in a Thames which showed no silver at all; or St. Paul's as seen from under Waterloo Bridge, its dome white and shining at the top, but fading into vast stains and blotches left by London smoke borne down by the rains and fog.

During the warmth of July he followed Turner's trail to the sea, to sketch where the master had sketched, in Ramsgate with its lighthouse and pier of Purbeck stone, on the bay where the Stour emptied and where one could almost believe that Hengist and Horsa had landed; or in Margate, with its lighthouse and its long sea front overrun by displaced Cockneys; then at Sandown Castle on the Isle of Wight, which would be razed for building stone before he could ever see England again; then in Dover with its Roman pharos twice as old as the ancient castle that loomed on the height above the harbor, while beyond gleamed the high, white wall of Shakespeare's Cliff. Then on he went to Hastings, where he sketched East Cliff, and Rock Cliff also, as well as the old town with its redolent fishing quarter and its boats and nets, which appeared much the same as when Turner painted them. The harbor had disappeared during the great storm in Queen Elizabeth's reign, and there were only traces of the pier. Still a busy fishing trade flourished there, and he found much use for his pencil when the boats were beached at half ebb-tide and the fish brought out and sold by Dutch auction. He returned to Hastings at least three times and made numerous studies of the boats. Then he wandered across the Downs, reaching Lewes with its sprawling ruin of a castle on the twenty-fourth of July. Two days later found him at Arundel, for at least a second visit there. Its castle, a favorite subject of Constable and Turner alike, soared above the town on a hill so steep its towers seemed to thrust into the sky; a suitable culmination for Moran's summer sketching, one of the noblest piles of towers and bastions, keep and castellated walls in all of England.

Such were the scenes he sketched in June and July of 1862. But

much as England pleased him with her aged ruins, he felt little inclined to resettle there. He thought of himself only as an American; he had "become as thoroughly native to America as if he had drawn his first breath on its soil,"[16] and now, though war continued between the states, he thought of going home. His funds were all but exhausted, but there was a way: he had painted a canvas of singular topical interest, *The Slave Hunt,* one of his rare excursions into genre. It showed a Negro and his wife and child who were chased by men and dogs. The trunk of a gigantic tree leaned above their heads, and they seemed dwarfed by the immensities of the rank, green forest behind them. That luxurious growth tipped Moran's hand; he was still the landscape painter, more interested in his scene than in its tragic figures, but his picture told enough story to meet the current rage for genre. Overtaken with his woman and child as they crossed a stagnant pool, the slave clutched a knife that dripped with blood; he had just killed the foremost dog and waited for the rest to spring. Moran sold the canvas (he would later paint a smaller one) for what it would bring: nine pounds, but that was enough to take him home.[17]

There was a highly personal reason for his eagerness to return: a young woman who waited in the small town of Crescentville not far from Philadelphia.

When his parents had moved there in 1858, he had paid them visits from the city, and soon he had met their neighbor, Mary Nimmo, a bonnie girl of sixteen, who had not quite lost the burr of her native Scotland. She was born in Strathaven, Lanarkshire, in 1842. At five she had come to America with her father and her brother, her mother having died. She sang songs by Robert Burns ("Scottish songs to break your heart," according to her daughter[18]). Her face was as sweet as her voice, open and sympathetic, with dark

[16] Alfred Trumble, "Thomas Moran, N.A.; Mary Nimmo Moran," pamphlet, p. 3 (also gathered in Christian Klackner, *A Catalogue of the Complete Etched Works of Thomas Moran, N.A., and Mary Nimmo Moran, S.P.E.*).

[17] Ruth Moran, Note clipped to a photograph of *The Slave Hunt,* Moran Collection, East Hampton Free Library.

[18] Ruth Moran, "Notes on the Tile Club" (MS), JG 104, Long Island Collection, East Hampton Free Library.

eyes set fairly wide apart, ready to light up whenever anything caught her interest. Her broad forehead was framed with hair that fell to her shoulders in dark curls. Like Bolton her birthplace was a hand-loom weaving town, so similar to the "Thrums" James Barrie later described that she felt sure "that Thrums was her native town" and that Sentimental Tommy had been her playmate. "Anyone who loves Barrie's women," wrote Ruth Moran in after years, "and under-stands their simplicity and nobility of soul, their indescribable charm and humor, that humor that keeps them so free from priggishness and vanity, no matter what their gifts, can picture Mary Nimmo as her friends knew her."[19]

Soon Thomas had begun to court Mary, and there was a happy response from her. They became engaged so early that several years went by before they could get married. Mollie, as he preferred to call her, later wrote: ". . . from him came all my first impressions of art and of nature as applied to art; up to that time I had never thought of using the brush or pencil."[20] She respected his ambitions and waited patiently during the years of their engagement, years that brought "companionship and understanding." Then on his return from England in the summer of 1862 came their wedding in Phila-delphia, and they set up housekeeping at 806 Coates Street, with a studio for Moran. He now faced the problem of making a living, a problem that became pressing when children began to arrive: their son, Paul Nimmo, was born in 1864.

Moran continued to paint his pictures, and to show them in the Academy of the Fine Arts, or in James Earle's gallery, from where he had been expelled as a boy—British subjects like the old town of Hastings or Kilchurn Castle (perhaps after Turner), as well as scenes along the Wissahickon or the Delaware. There were also views of Lake Superior. His titles now included *Evening on the Susquehanna, Summer Moonlight, View of Windsor Castle, A Frosty Morning, Interior of Woods, Okehampton, Ripening of the Leaf,* and *A Green-*

[19] Ruth Moran, Notes, Envelope 59, Moran Collection, East Hampton Free Library.

[20] Autobiographical Note, Envelope 60, Moran Collection, East Hampton Free Library.

land Glacier, which he painted from the sketch of another artist.

Sometimes when he produced a picture merely to sell instead of from love of the subject, he would draw a small pot after his signature. In August, 1863, he had begun to number his more important canvases, though as it developed no Opus 1 occurred in the series. In July and August of that year he worked on *The Wissahickon in Summer*, painting at the scene depicted; and though he claimed to have gotten "more knowledge of nature in painting this than [from] any other study he ever made,"[21] he failed to complete it. Instead, he traded the canvas to Edward, who not only finished the work, but sold it as wholly his own. So Moran's series of opus numbers began with No. 2, which he assigned to *Autumn on the Wissahickon*, "incited by a most glorious autumn." "In finishing it," he noted, "[I] decided that my forte lay in color and would prove my strongest point."[22] He continued to number his most significant pictures, but on reaching No. 42, five years later, he let the practice lapse.

During the 1860's it was easier for an artist of drive and talent to make his way than it would be later. Still Moran found it necessary to turn to other means than painting for a living. He taught for a while at the Philadelphia School of Design for Women, on Walnut Street. It was a practical school, aimed primarily at preparing its students in the industrial arts, but there was a painting department, where Moran, presumably, assisted. Nor was it surprising, in view of his years at Scattergood and Telfer's, that he should turn to illustration; indeed he had attempted it as early as 1860 with two designs for the *Sacred Poems* of N. P. Willis. He engaged in the work sporadically at first, but within a decade he was to become one of the busiest illustrators of the day. His sense of line, sharpened by long practice with the pencil, enabled him to draw fine designs directly on wood, a skill that was by no means common. Not many artists had tried drawing on the block; those who had, regarded it as a cramping task, and the few who had developed adequate skill "could almost be counted on the fingers of

21 "Old Book of Lists, 1863," Moran Papers, Gilcrease Collection.
22 *Ibid.*

the two hands."[23] Moran's understanding of the engraving process, as well as the peculiar demands it made upon the artist, was a help too; hence the success he came to enjoy in this field. *Harper's Magazine* eventually cited him, along with Harry Fenn, as the first among the illustrators who specialized in landscape.

Meanwhile Mollie began to take an active interest in art. It made no difference that, as she herself conceded, her esthetic sense had remained dormant until she met Thomas. Soon after their marriage, with the thought at first of making herself a better companion, she began to study drawing and painting under his guidance; "and from that time on," she later wrote, "I have always been my husband's pupil."[24] At first she worked with water colors, and Moran recognized her talent, indeed the originality that always kept her work so different from his, with an individuality all its own. He encouraged her to work with oils, and she made such rapid progress that soon one of her landscapes, *A Wood Scene*, was accepted for exhibition at the Academy of the Fine Arts. As her skill developed, she became Moran's most trusted critic. "When she criticized my work," he liked to say, "she knew why and she was always right."[25] Their mutual encouragement and sympathy helped to sustain his enormous capacity for work.

Sharing each other's enthusiasm, they were happy together; "in their home there was always music and laughter," wrote their daughter Ruth. "Working most of the evening as well as day, they still had time with their friends and the 'clan Moran,' all of whom were fair musicians, for wonderful evenings of plays and poetry and song."[26] Moran played the violin by ear, with zest, though when he had "picked up the art of fiddling, the forefinger of his left hand happened to be out of commission—with the singular result that ever afterward he played with three fingers only."[27] He liked to sing too, for his light tenor voice was pleasing to the ear, and he often

[23] *Scribner's Monthly*, Vol. XVII, No. 3 (July, 1879), 456.

[24] Autobiographical note, Envelope 60, Moran Collection, East Hampton Free Library.

[25] Draft for sketch of Mrs. Moran, Envelope 62, *ibid.*

[26] Ruth Moran, Notes, Envelope 59, *ibid.*

[27] J. B. Gilder to the Editor, *New York Times*, September 1, 1926, p. 22, col. 6.

joined Mollie in her songs. He also liked to talk, and there were lively conversations in their house. "To spend an evening with Thomas Moran," wrote a friend in after years, "is something not easily forgotten. Let the subject of . . . discussion be what it may, he is ever ready to enter the arena, and with his vast fund of information, his positive opinions, and his fluency of expression, enlivens the conversation.";[28] and thus he commanded deep respect from an intimate circle of friends.

He continued his sketching tours during the summers, usually in July or August. July 26, 1864, found him in the Alleghenies, on the upper Juniata: "This paradise of landscape artists"—so the *Aldine* exulted when long afterward he offered drawings of the scenes there.[29] He spent several days about the town of Huntington, where two branches, hardly more than a trout stream each, came together to form the river. During early August he moved up the Little Juniata, its famous blue color lost because of sluice from nearby mines; and by the eighth he came to Willmore at the juncture with Spruce Creek, then over the ridge to the Conemaugh ("that favorite of artists"[30] too), which he sketched at various points about Bolivar and Johnstown. A few days later he was back on Spruce Creek, sketching Tussey's Mountain—"a great turtle-backed monster several thousand feet tall."[31] And by the twenty-fifth he had wound down the Juniata as far as Mill Creek, where the record ends, if not the journey itself. The following summer he explored another part of Pennsylvania in his pursuit of sketches—Pike County with its creeks that brawled into the Delaware, "streams [in the words of the poet Stedman] as virginal as when they were the Indian maiden's bath and mirror. They tumble[d] over great bluffs into the lowlands and the welcoming river. . . . Shut in with woods and buttressed with mighty walls of rock [were] cascades lovely as any in the world."[32]

[28] Buek, "Thomas Moran," *American Magazine*, Vol. LXXV, No. 3 (January, 1913), 30.

[29] "River Scenery of Pennsylvania," *Aldine*, Vol. IX, No. 5 (1878), 157.

[30] *Ibid.*, 158.

[31] R. E. Garczynski, "The Juniata," in *Picturesque America; or, The Land We Live In* (ed. by William Cullen Bryant), II, 143.

[32] "The Raymondskill," *Aldine*, Vol. V, No 8 (August, 1872), 154.

Making his base at the parklike village of Millford, Moran prowled through Sawkill Glen, cool and tree-arched, and sketched the falls which, after successive leaps, vanished into a chasm that was dark, no doubt, on the sunniest day. He found scenes for his pencil in neighboring glens—Adams Creek, where the underwoods were dark and thick and trout abounded in pools; and Raymonds Kill, which rose miles above all other brooks roundabout "in a vast wilderness [Stedman's words again] where springs outlast summer drouth and winter cold, and yield a constant torrent for its craggy bed."[33] And he drew great twisted masses of hemlock roots in woods along the Vandermarck.

His sketches, some highly finished, some no more than shorthand notes for future pictures, usually done by pencil, but with broad washes sometimes added, were accumulated in a studio file that Moran preserved and increased for the rest of his life. On being asked years later how he proceeded on a sketching trip, he declared that he "never carried an easel or any oil colors. These were left at home in the studio. All he [Moran's third person again] encumbered himself with was a good-sized portfolio for his paper and sketches, while for coloring [if any were needed] he used water color. The rest of his equipment was the same as any other tourist's."[34] Some of his sketches he, apparently, never found occasion to use; others, sometimes in combination with one another, suggested many different pictures, often years apart—oil paintings, water colors, or designs on wood for engraved illustrations. The sketches that he had made during the past two summers would, for instance, inspire not only engravings in various magazines but also illustrations for books like *The Pennsylvania Railroad,* which, in 1875, described the railway's various scenic routes.

In the summer of 1866 the Morans embarked on a trip much more significant than his customary outings. They had moved to better quarters, first at 838 Race Street, then at 1812 Wood Street, and Moran felt confidence in the future. But there was one disconcert-

[33] *Ibid.*
[34] Scrapbook, p. 46 (clipping dated June 9, 1900), Moran Collection, East Hampton Free Library.

ing gap in his artistic background: he had never gone to the Continent or studied the masterpieces in the European galleries. So in June he and Mollie took their meager savings, gathered up his best canvases and the baby, and sailed for Europe "to study the works of the old masters."[35] They stopped in England so that Mollie might see the Turners, while Moran did additional sketching after the master. Then they moved on to Paris, taking a small studio at 50 rue de l'Ouest, not far from the Luxembourg Gardens.

There Moran and Mollie continued to work, between their visits to the Louvre and the Luxembourg Palace, or their rambles about the Gardens or through the city streets. It was a carefree time for them, but Moran worked hard to perfect his grasp of principles underpinning the works they studied there, especially the "ideal beauties" of Claude Lorrain. They kept their studio for nine months but at times interrupted their concentration with excursions to the countryside, "making sketches in quaint towns and villages, along country roads and mountains passes, by lake and river, woodland, seashore and meadow."[36] Nine hours out of Paris, down the valley of the Seine, brought them to Dieppe, a city that glittered in the rain, where the clatter of wooden shoes could be heard on the stone paving, and where they sketched a quaint street filled with carriages and horses and people under umbrellas—it was as picturesque as Hastings. October found the couple in Fontainebleau, which was congenial enough to prompt them to return after the New Year to sketch in the forest there. Moran's sympathy for the artists of the area was limited at best. He condoned their devotion to nature, but not its result, saying: "Corot, Rousseau, Diaz, and Daubigny are all men of one idea. Diaz, for example, paints forever the forests of Fontainebleau. He is a perpetual copyist of himself. Now, we don't care to live on one dish all our lives. No artist is great who has made a reputation on one idea—and Corot's idea was a very indefinite one at that." His condemnation of the entire Barbizon school sounded not unlike Baudelaire's demurs at the work of Rousseau. "Indeed," Moran said, "French art, in my opinion, scarcely rises to the dignity

[35] Note, Envelope 54, *ibid.*
[36] Draft for sketch of Mrs. Moran, Envelope 62, *ibid.*

Cliffs of Green River, Utah [*sic*], 1872.
Water color, $6\frac{3}{16}$x$11\frac{11}{16}$ inches.

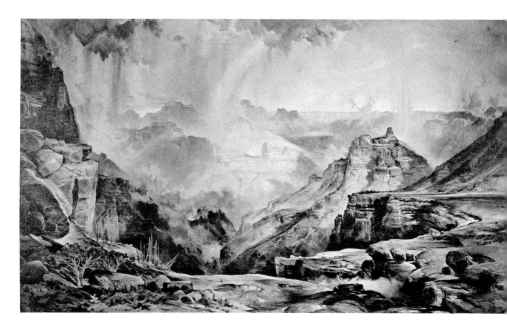

The Chasm of the Colorado, 1873.
Charcoal on canvas, 84x144 inches.
Basic design of the oil now hanging in the Museum, U.S. Department
of the Interior.

Photograph Courtesy Gilcrease Institute, Tulsa

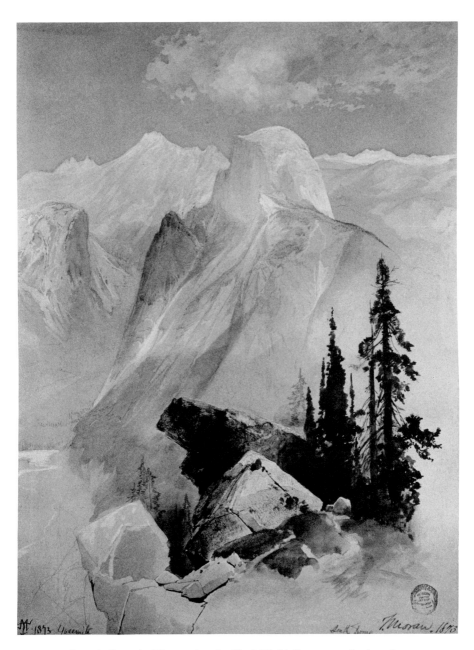

South Dome, Yosemite (called Half Dome today), 1873.
Water color, 14½ x 10⅜ inches.

The Cooper Union Museum, New York

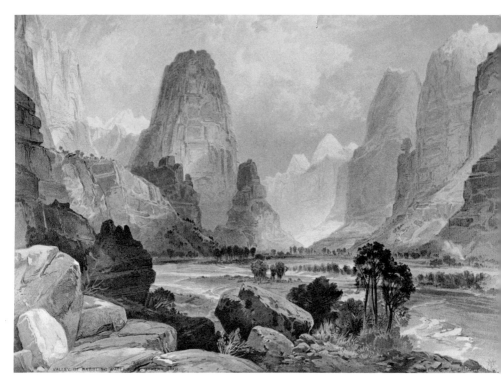

Valley of Babbling Waters, Southern Utah (i.e, Zion Canyon), 1874.
Chromolithograph from Moran's original water color, 10x14 inches.

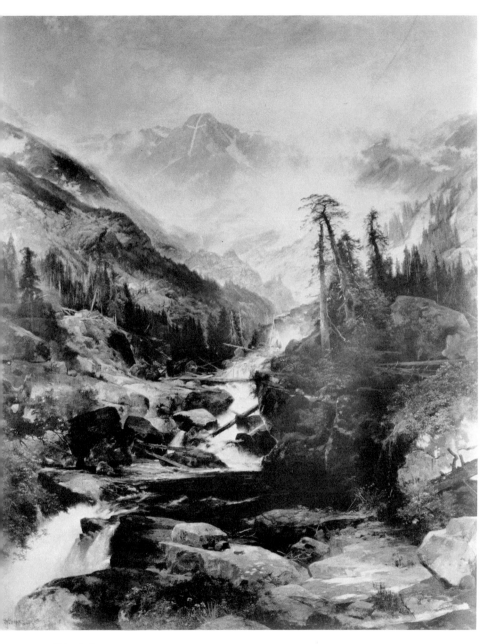

The Mountain of the Holy Cross, 1875. Oil, 82¾ x 64¾ inches.

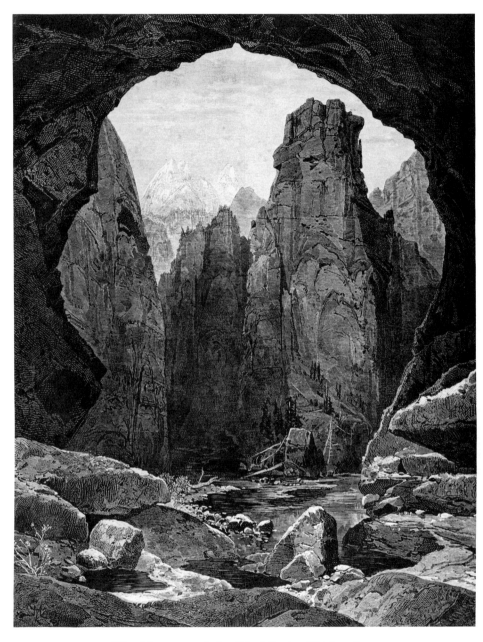

The Narrows of the Rio Virgin, Utah, 1875.
Wood engraving, 10⅜ x 7⅞ inches.

Gilcrease Institute, Tulsa

Ponce de León in Florida, 1512, 1877. Oil, 64x116 inches.

Mrs. Jay Paris, Ponca City, Oklahoma

The Empty Cradle, 1878. Etching, 7¾ x 5¾ inches.

of landscape—a swamp and a tree constitute its sum total. It is more limited in range than the landscapes of any other country."[37]

The Morans enjoyed a visit, though, at Corot's studio one afternoon in Paris. They talked with the aged artist through an interpreter, Corot knowing no English and they no French. Everyone called him "Papa Corot," and he struck Moran as "a bright, wideawake, cheerful fellow"[38] in spite of his years, "always smiling and full of jokes."[39] Moran later recalled that Corot was then painting, at the incredible rate of three a day, "those gray pictures that you see in every American auction."

"When I was painting good pictures," Corot said, "nobody would have them" (there was a time when his friends were afraid he might give them a canvas and they would have to buy a frame), "but now that my eyes are poor I can't see to paint enough."[40]

Alas for Moran that he was studying then and had no money to spare: "I could at that time have bought anything that had Corot's name on it for $50 or $100."[41] But he benefited from "Papa" in other ways; perhaps the most apparent effect of his Paris stay was the subtle gray tonality that would sometimes show henceforth in his work. Yet he would later claim to have no great respect for Corot's painting. "I have but a small opinion," he was to say in 1879, "of his large 'Orphée,' recently in the Cottier Collection. The work is bad in drawing—it is not drawing at all—and certainly it cannot be called color. It has some tone, to be sure, just as black-and-white may have tone; but there is in it no quality that demanded a canvas of that size. It is a small conception of the subject expended on a very large surface. A picture ten inches by twelve would have given all that this picture contains probably better than a larger one."[42] Size alone, although Moran himself was later accused of elephantiasis, did not much impress him.

His particular aversion within the Barbizon school was Millet,

[37] Quoted in Sheldon, *American Painters*, 126–27.
[38] *Brooklyn Daily Eagle*, August 18, 1889.
[39] Note, Envelope 54, Moran Collection, East Hampton Free Library.
[40] *Brooklyn Daily Eagle*, August 18, 1889.
[41] *Ibid.*
[42] Quoted, Sheldon, *American Painters*, 126–27.

then so much admired by the advance guard. Moran thought Millet's pictures "coarse and vulgar," in fact, "repulsive." He shows us only the ignorant and debased peasant; he suggests nothing noble or high, nothing that is not degraded. His peasants are very little above animals; they do not look capable of education, or of being other than what he has made them. In fact, I think he libels the French peasantry."[43]

Concerning certain Salon painters Moran's judgment was more favorable, though not without reservations. He found Bouguereau "a little sentimental," but otherwise acceptable. He admired the "mechanical skill" of Meissonier but thought his art was of a "lower type" than Gérôme's, as "a pastoral poem is lower than an epic." Of all the French academicians, he seemed to prefer Gérôme, for the "conception of his subject and for his extreme refinement and beauty of drawing."[44] But obviously Moran was not by temperament attuned to most of French art, and he never felt that he had gained greatly by his stay in Paris.

In February, 1867, he sailed with Mollie and the baby from Marseilles to the more inviting land of Italy, the spiritual home of Lorrain and Poussin. On arriving, Moran made drawings of boats and fortifications at Civitavecchia. In Rome he copied pictures at the Doria Gallery, where he found the warmer Italian art more agreeable than the French. He met and talked shop with F. O. C. Darley, the American illustrator, whose work he admired. He drew picturesque oaks and pines at the Villa Borghese, just outside the gates of Rome. He sketched the Baths of Caracalla, the ruined Palace of the Caesars, the Ponte San Bartolomeo, the tomb of St. Helena; and for views of the ancient Claudian aqueduct he tramped the Campagna with its plain bordered by green hills and studded with the mute remains of Roman monuments, trees scattered over it in little clusters. On March 6 he drew a picture of Rome from the perspective of the aqueduct.

Soon he took Mollie south to Naples, where he copied Lorrain in the Museo Borbonico, and where the two of them fell in love with Baiae. Later in March they moved northward through Florence,

[43] Ibid., 127. [44] Ibid., 126.

Bologna, and Milan, where Moran copied Salvator Rosa in the Brera Gallery; then they sketched along Lake Como, and his painting of a scene there would eventually come to the Metropolitan Museum. But the countryside of Italy, like that of France, failed somehow to satisfy Moran, and his *View of Lake Como* was not one of his better works. His daughter later wrote that "he cared little for the Continent; only Venice really held him—and as he would always say, 'Venice is only a dream.' "[45] But Venice lay nearly two decades in the future: the Morans did not see it now, with its mellowed buildings and its golden light shimmering over canals and blue lagoon.

At last in April they wound through St. Gotthard Pass over the Alps. There were frequent glimpses of high waterfalls or of convents or chapels, sometimes perched on steep crags. Moran must have been moved, for to him mountains were a passion, as they had been to Byron's Harold. Yet there was something disappointing here as well, something that did not meet his expectations. Perhaps too many tourists had already extravagated on the sublimities of the peaks; Moran could never pay them the same respect he later developed for ranges in the American West. "I looked at the Alps," he once said, "but they are nothing compared to the majestic grandeur of our Rockies."[46] They are too "decent and well behaved," with lines too "conventional and proper, as though built according to prearranged and well-proportioned designs." Their symmetry made them too predictable. "You know from seeing one part what to expect in another."[47] He missed that rough and sudden variation or irregularity that had long been enshrined as the picturesque.

One of Moran's few Alpine scenes, a Turneresque oil called *Children of the Mountain* (one version of the theme went later on the market as *Swiss Alps*), had been completed one year before. On returning to Paris he had the pleasure of seeing it hang in the Salon of the Universal Exposition of that year, along with his *Autumn on*

[45] Ruth Moran, "Thomas Moran, N.A.," B5(b), Moran Papers, Gilcrease Institute.

[46] *New York Evening World*, June 12, 1911.

[47] Scrapbook, p. 46 (clipping dated June 9, 1900), Moran Collection, East Hampton Free Library.

the Conemaugh. The seventy-five American paintings occupied one end of the British gallery, most of them hanging on the walls of the Avenue d'Afrique which divided the British gallery from the Italian. The passage was usually crowded, and the lower tiers of pictures were often obscured, but the honor of his work hanging there could only have pleased Moran. Henry Tuckerman described the Alpine "children" as "not of human birth; but the cataract, the storm-cloud, the rainbow, and the mist,"[48] and declared the scene Moran's best work thus far; yet before Moran could again be tempted to use the Alps as his theme, except for the study of an Alpine peak he never finished, he would feel the decisive impact of the Yellowstone and the Rocky Mountains.

On returning to Philadelphia Moran and Mollie settled again on Wood Street, resuming the life they had interrupted there, their evenings filled with work as well as their days but interspersed with happy gatherings of their friends and family. Soon a new baby was born, a daughter whom they named Mary Scott. Moran continued to paint at intervals, amidst his bread-and-butter chores. He had learned a great deal in Europe, but unlike most American artists in Paris, he had not been deeply influenced by the new French modes. He remained, in his own phrase, "essentially an American painter." It was said that he vowed to "paint as an American on an American basis."[49]

Meanwhile he reverted to the historical vein in the most ambitious canvas since his return from Europe, though, in fact, his theme for *The Last Arrow* may well have been more legend than an actuality of history. The scene for this canvas, thus far his largest (over four feet by six and one-half feet), lay in the Adirondacks in upper New York State. The Mohawk Chief Kendago, having suffered defeat in a surprise attack from a band of French led by Count Frontenac, had sent his wife and child by a secret route to a cave in the mountains. (To make the melodrama more complete, the young squaw was really the Count's adopted daughter, who had been

[48] *Book of Artists: American Artist Life*, 569.
[49] Quoted in James Thomas Flexner, *That Wilder Image: The Painting of America's Native School of Painting from Thomas Cole to Winslow Homer*, 300.

captured by Mohawks some years before.) With a few followers, Kendago had diverted the pursuit, planning to join his squaw by another trail. Three of his arrows had struck down enemies. Then he saw among the French pursuers a Dutch trader who had lived for years with the Indians and who had betrayed their village into the Count's hands, who knew, besides, the whereabouts of the secret retreat. Filled with rage and hatred, Kendago reserved his last arrow for the trader's heart. A wound in his right hand affected his aim; the arrow struck the cuirass of the Count, but glancing off, it pierced the trader's breast. Thus in outline ran the tale served to the public on a broadside at the picture's exhibition.[50] Moran had dramatized the moment when the chief drew his bowstring for the last time.

Yet on comparing the painting with the gallery note the observant viewer must have had reservations about details. Moran's Kendago has no warrior followers, at least none to be seen, nor does his wife lie hidden with her baby in some secret cave. Indeed she huddles at his feet in plain view. It was evident, then, that Moran had not illustrated the version of the story the gallery note had detailed. He seems rather to have followed the lead of *Last Arrow* prepared by the pioneer wood engraver J. A. Adams for the *New York Mirror* in 1837. The engraving had later appeared in the *Family Magazine*, where Moran could have seen it during his boyhood.[51] Yet whatever its inspiration, *The Last Arrow* was of a type of picture popular in that day, and its scene allied Moran with the Hudson River school, at least temporarily. It was typical of only a phase of his work, however—an aspect that diminished over the years. Thorough-going landscape painter that he was, he never felt at ease while painting beings of any sort, whether man or beast, and most of his pictures, as Tuckerman observed, "do not admit . . . the human figure."[52]

Often now a strain of fantasy imbued his work, as though he

[50] Exhibition note, Envelope 175, Moran Collection, East Hampton Free Library.

[51] W. J. Linton (*The History of Wood-Engraving in America*, 13–14) describes the woodblock thus: "the subject is the pursuit of an Indian by some settlers,—the Indian on a rock in the foreground aiming his last arrows at his enemies; a woman with a child in her arms is at his feet." In 1860 Moran made a glass cliché etching on the same theme.

[52] *Book of the Artists*, 569.

transferred dreams to canvas. In *Dream-Land*, painted in 1869, a smoking, conical mountain, veiled in mist and edged with dark volcanic foothills down which cascades glittered; a lake with shores overgrown by tropical verdure, including festooned palms; the reclining figure of a woman, too small almost to notice, like the tiny heron in the water—all struck the spectator as strangely familiar, like some vista seen long ago and only half-remembered. It was a landscape idealized far beyond Moran's custom, and it therefore lost his usual robustness. That same year he also painted *The Spirit of the Indian*, which showed Hiawatha's arrival at the home of Megissogwan, the Manito of Wampum and a mighty magician. The hero had forced his birch canoe through a mass of fiery serpents, the dread Kenabeek, whom he killed with his "bow of ash-wood," and now having reached stagnant "black pitch-water," he

Leaped through tangled flags and rushes
And upon the beach beyond them

landed dry-shod. Snakes crawled on the rocks before him, and on the upland in the background loomed the gigantic form of the Manito, dimmed by mist. So, with ash bow ready, the hero met the great magician in the prelude to

the greatest battle
That the sun had ever looked on,
That the war-birds ever witnessed.

Moran painted the scene in subdued colors, with frequent tones of silvery gray, but a modern critic has found in it "warmth and feeling as well as something of the old romantic conception harking back to Cole."[53] Certainly the picture involved less allegory than such critics would suggest, unless the term can be stretched to fit *The Song of Hiawatha*. Moran's preoccupation with the poem continued for years, especially through the middle seventies. His pleasure never lessened in its idyllic tapestries of nature, above all in the wild scenes he had himself beheld along the south shore of Lake Superior.

[53] Frederick A. Sweet, *The Hudson River School and the Early American Landscape Tradition*, 108.

His response was especially sympathetic to Longfellow's sunsets, with their purple clouds and blazing glories.

In 1875 he painted *Fiercely the Red Sun Descending* to portray the outset of Hiawatha's journey when the path of the lowering sun glowed like a "fiery war trail."[54] At the same time, and far into the next year, he concerned himself with a series of Hiawatha illustrations—some twenty or more wash drawings—which his brother Peter undertook to reproduce as steel etchings. Although somehow never completed, the series was planned as a subscription project, and Moran's subscription list read like the rolls of an exclusive club. There was General Grant, for instance, and John Hay, Senator Edmunds, Collis P. Huntington, General Sherman, Mark Twain, and even Longfellow himself, to name a few. When the *Aldine* ran a picture from the series—*Kwasind, the Strong Man*—the editor remarked: "Moran has caught the spirit of the original—the wild and primitive feeling in which the old Indian traditions originated. His characteristic excellences—power and imagination—are represented as well as they can be without color, in which he excels. For what he is, he has no master in America."[55]

Meanwhile he had turned his attention, with exceptional success, to lithography, an art that had served chiefly for commercial purposes in America. He had first tried the process as early as 1860, "when lithography for artists was not a live issue in this country," making a small marine print after Eugene Isabey. Others followed, including romantic views of the town of Baiae and the Bay of Naples. And then in 1869 a Philadelphia printer named McGuigan issued a portfolio of his work under the title of *Studies and Pictures*, which according to Frank Weitenkampf, "expressed his love of bold scenic effects, towering mountains, forest giants, vistas of wild stern nature."[56] Print No. 1 of the series was Moran's lithographic masterwork, a

[54] Newton Arvin, Longfellow's latest biographer, informs his readers (in *Longfellow: His Life and Works.* Boston, Atlantic, Little Brown, 1963, p. 172n.) that "a sunset by Thomas Moran, the romantic landscape painter, was used as an illustration for *Hiawatha* in some editions of Longfellow's poems." It was based on *Fiercely the Red Sun Descending.*

[55] *Aldine,* Vol. V, No. 6 (June, 1872), 109.

[56] *American Graphic Art,* 168.

somber wood-and-mountain scene called *Solitude,* set near Lake Superior. Weitenkampf pronounced it "perhaps the first example of pure painter-lithography . . . a picturesque and finished performance."[57] Its storm-battered pines and cedars tower against a cloud-filled sky, while at their feet a boulder-lashed stream races from a tarn whose dark surface mirrors a rock mountain in the background —all combined into an impression of elemental power. Another effective print was titled *In the Forest, Wissahickon.* But Moran's own favorite was *The South Shore of Lake Superior,* which he produced in 1869. Unfortunately an accident ruined the stone before more than a dozen impressions could be taken, so that it was largely lost to the public. Moran had thus demonstrated brilliant capabilities as a lithographer, but as his enthusiasm for the medium cooled, he abandoned the process, seldom if ever to practice it again.

[57] *How to Appreciate Prints,* 236.

IV _Yellowstone_

✛✲✛☙✛✲✛☙✛✲✛☙✛✲✛☙✛✲✛☙✛✲✛☙✛✲✛☙✛✲✛☙✛✲✛☙✛✲✛☙✛✲✛☙✛✲✛☙✛✲✛☙✛✲✛☙

Among the friends who frequented Moran's house on Wood Street was a young man of flashing dark eyes, and in build almost as slight as Moran himself. Richard Watson Gilder was a poet by vocation, an editor by necessity. He had grown up in Bordentown, not far from Philadelphia; he and Moran had been close friends from boyhood, and they had remained in touch with one another even after Gilder had moved to Newark, to be near the magazine world of New York City. Soon he became "office editor" of _Scribner's Monthly_, which began publication in November, 1870. The editors were determined to outdo the illustrations of _Harper's Magazine_, and so they ran fine wood engravings. One with Moran's initials was printed in the first issue. Moran also contributed designs at Gilder's invitation for a piece on Fairmount Park, and these appeared in the third issue. For the same number he illustrated a poem called "The Northern Lights," his sketch of a tall, spectral ice mass seeming to suggest the ice fields of Dante's Hell. His work pleased the editors, and in time he became a principal illustrator for _Scribner's_.

Much of the energy of the nation, six years after the Civil War had ended, was directed towards taming vast and dimly known expanses in the Western interior. The first ocean-to-ocean railroad had received its final link in 1869, and four vigorous government surveys were now in the field from spring to fall, mapping and geologizing what remained of terra incognita. Eastern readers were hungry

{57}

for information about the West, so articles by men who had gone there and seen the country for themselves became a staple in the magazines and newspapers. Whenever possible, editors tapped the experience of the various exploring parties, as when the *Atlantic Monthly* offered mountain sketches from the pen of Clarence King, leader of the Fortieth Parallel Exploration. From its start *Scribner's* had carried its share of frontier reportage, and now early in 1871 the editors had a manuscript by N. P. Langford on "The Wonders of the Yellowstone," which they planned to run in sections in the issues for May and June.

Langford had gone to Yellowstone the summer before in a party led by a General Washburn from Montana and "protected" by a small military escort from the Crows who were thumping their drums. With his manuscript he had sent a few sketches made by a soldier in the escort. They were too crude for direct use as illustrations, but Gilder suggested that Moran work them up into something more professional. By supplementing them with Langford's descriptions, Moran produced some "singular pictures," calling much upon his own imagination. They included "one of the Grand Canyon of the Yellowstone in which the chasm appears"—in the words of Wallace Stegner—"about four feet wide and four miles deep, and several of mud volcanoes in which the cones look as if they had been cut out of sheet metal with tin shears."[1] If they were not convincing by objective standards, who could tell at that early date? Yellowstone was still so little known, and sounded so fantastic, that incredulity was the common reaction. One reviewer blasted Langford as the champion liar of the Northwest, and readers reminded the editors that the *Scribner's* prospectus had promised a moral tone, which presumably ought to exclude plain lies.

The assignment fascinated Moran, and he wanted to see the wonderland for himself. But he had managed to save no money since his return from Europe, and his family was growing—his daughter Ruth Bedford had been born the year before. It chanced, however, that Langford planned to visit the Yellowstone again that summer, as a guest of Dr. Hayden's survey, and to supply *Scribner's* with another

[1] *Beyond the Hundredth Meridian: John Wesley Powell and the Second Opening of the West*, 178.

paper on the experience. Moran expected to illustrate it. Perhaps *Scribner's* could help him finance a trip to the West. He remarked later that it had not occurred to him to ask the magazine to pay his expenses outright. But he offered his cherished *Children of the Mountain* to one of the owners as a pledge for a loan. He also borrowed five hundred dollars from Jay Cooke, who was eager to have the Northwest publicized in the interest of the Northern Pacific Railroad.

On June 7 General A. B. Nettleson, of Cooke and Company, wrote Hayden of Moran's wish to join the Yellowstone expedition. "I have encouraged him," the General explained, "to believe that you will be glad to have him. . . . He, of course, expects to pay his own expenses, and simply wishes to take advantage of your cavalry escort for protection. You may also have six square feet in some tent which he can occupy nights."[2] As Hayden was a Philadelphia man, on good terms with Nettleson and Cooke, Moran felt sure of a welcome in camp, and so, with his family secured for the summer, he headed west, with sketching materials and a small carpetbag stuffed with clothing.

He rode the cars to Green River, where he made the first sketches of his journey, pictures of the bizarrely weathered bluffs that overlooked the river. The Union Pacific carried him to a point just north of Great Salt Lake, probably Corinne, where he caught a stagecoach for a journey of four days and nights "without stopping save for meals."[3] In his utter innocence of Western ways he asked why the stagecoach was so heavily armed.

"Road agents," came the terse reply.

All that the term suggested to him was the station agents along the way. Now why go gunning for them? He was surprised at the laugh his question produced. His education proceeded rapidly, however; soon he was wearing a Smith and Wesson revolver himself, and next year he consoled Dr. Hayden for having lost all his pocket money to a band of highway robbers.[4]

[2] General A. B. Nettleson to F. V. Hayden, June 7, 1871, Letters Received, Hayden Survey, R.G. 57, National Archives; Hans Huth, *Nature and the American*, 223n.

[3] Thomas Moran, Note (MS), A19, Moran Papers, Gilcrease Institute.

[4] Ruth Moran, Miscellaneous notes, Envelope 52, Moran Collection, East Hampton Free Library.

He joined Hayden's party just outside Virginia City, a boom town of board buildings and shanties of every description along the sides of Alder Gulch. The party had pitched its tents on the side of a hill, not far from the road, and Moran walked into camp. He found it deserted except for a slim young man with brown hair and a Southern drawl, who proved to be James Stevenson, Hayden's executive officer. He received Moran cordially, though he said little and looked at the small carpetbag with a twinkle in his eyes. When Hayden arrived in camp, Stevenson told him that Moran the artist had come with two Saratoga trunks.

"What!" the geologist exclaimed. "Send him to me; I'll fix him."

But when he saw Moran's bag, Hayden laughed.[5] Lean, bearded, with piercing eyes, the man whom the Indians had named "Who-picks-up-stones-running" was a surgeon by training. He was twelve years older than Moran, and his explorations in the mountain country had made him famous. He had begun his geological career at twenty-four with a trip for fossils into the Bad Lands of Dakota, and he had followed science ever since, except for his years of service as a surgeon in the Union Army. He had organized his present corps in 1867 and, since then, had surveyed vast areas in Nebraska, Wyoming, Colorado, and New Mexico. He had wanted to explore the headwaters of the Yellowstone ever since 1860 when the expedition of Captain W. F. Raynolds, on which he had served as geologist, had floundered in deep snow and been checked from reaching the geyser area by baffling ridges and the men were forced to satisfy themselves with merely "listening to marvellous tales of burning plains, immense lakes, and boiling springs."[6] Their guide, Jim Bridger, had told tall stories about the place. The Doctor's opportunity had at last come in the wake of the Washburn party's publicity, when Speaker James G. Blaine had guided an appropriation of $40,000 through Congress to send the corps to the Yellowstone. Hayden made Moran welcome, and they became good friends.

Moran was instantly ready for the great adventure. He tucked his

5 Ibid.

6 William F. Raynolds,, Report on the Exploration of the Yellowstone and the Country Drained by That River, 10.

thin frame into a red flannel shirt, rough trousers, and heavy boots and mounted a horse for the first time in his life. Soon the hard McClellan saddle became a torture, only a little relieved by the camp pillow he inserted between it and his "spare anatomy." But as the photographer Jackson remembered him, Moran "made a picturesque appearance when mounted. The jaunty tilt of his sombrero, long yellowish beard and portfolio under his arm marked the artistic type, with something of local color imparted by a rifle hung from the saddle horn."[7] Camping out could not have been easy for him, with his delicate, sensitive constitution. All his life he had a deep aversion to oils and fatty foods, of which he ate, habitually, almost none, but if enduring bacon and fried foods was the only way he could reach the Yellowstone, he was determined to endure them, and endure them he did. Soon he was even writing home, "You should see me bolt the bacon."[8] Jackson later recalled "his ready adaptation to the camp life of the expedition."[9] For all his companions might judge, Moran was a seasoned camper.

The wagons were loaded, and the party took the field, crossing the ridge to Madison River, then rolling through Gallatin Valley to Fort Ellis, not far from Bozeman. They camped at the post, where they filled out their provisions and were joined by a small escort of cavalry. They also discovered that during part of their movements they were to have the company of some army engineers charged with making a topographical survey of Yellowstone Basin. Before they left the fort, the officers there arranged a side trip, to a lake about twelve miles away. "Here, in addition to enjoying some remarkable scenery," Jackson wrote:

> . . . we had excellent fishing. After pitching camp . . . we soon had a long string of trout for supper.
>
> Moran, an expert fisherman and also a past master in *al fresco* cooking, promised us a better dish than the frying pan afforded. Scraping aside the coals and ashes of the camp fire, he dug a hole in

[7] ". . . With Moran in the Yellowstone," *Appalachia,* Vol. XXI, No. 82 (December, 1936), 152.

[8] *Ibid.;* also Jackson, *Time Exposure,* 200.

[9] To Ruth Moran, September 17, 1936, Ruth Moran correspondence, No. 88, Moran Collection, East Hampton Free Library.

the hot earth and in it placed the fish, previously cleaned and wrapped in wet brown paper; then covering them with earth and hot coals, he allowed them to remain until cooked. It was not an attractive mess as it came from the extemporized oven, but when the charred paper was removed, we had as dainty a bit of steaming white flesh as the most exacting taste could wish for.[10]

Thus Moran on one occasion escaped the product of the frying pan.

After a rest most of the party returned to Fort Ellis, but Moran and Jackson, with his assistant, decided to remain at the lake overnight. They rose before daybreak next morning. Moran scouted out scenes for Jackson to photograph, and the picture taker secured thirteen negatives that day. Photography in the field was then a complicated business. It required a pack-mule load of apparatus and material, as well as the help of an assistant or two. Plates had to be prepared in an improvised "dark room" and developed immediately after they were exposed in the camera. "Moran was particularly interested in this part of the survey's business," Jackson wrote, "and was always one of the little party that lingered behind or wandered far afield to portray the picturesque or remarkable along the way."[11] By midafternoon they were ready to return to Fort Ellis, Moran jotting in his diary: "I do not expect to see any finer general view of the Rocky Mountains."[12]

Hayden chose to make his base camp at Boteler's Ranch, some thirty miles east of the fort, beside the Yellowstone River. The expedition reached the ranch in two days, and there the camp men shifted gear and supplies from wagons to pack mules in preparation for the rough country ahead. Then the party was off for the enchanted land, pushing south along a narrow trail close to the tree-fringed river, where marks of dragging lodge poles spoke of Indians close at hand. Moran and Jackson, along with four others of the corps, forged ahead, reaching Middle Canyon on the afternoon of July 19. There Moran sketched and Jackson photographed, and all "did

[10] *Pioneer Photographer*, 104–105.

[11] ". . . With Moran in the Yellowstone," *Appalachia*, Vol. XXI, No. 82 (December, 1936), 154.

[12] Diary, July–August, 1871 (typescript), A1, Moran Papers, Gilcrease Institute.

some tall fishing"[13] next morning, for there seemed to be no limit to the trout in the clear, green water. Then they rode on to the Devil's Slide, on Cinnabar Mountain, where they camped for the night. The main party overtook them there the next day and moved on while they were sketching and taking pictures. Moran and his companions rejoined the corps at Mammoth Hot Springs, however, a few miles up the Gardiner River, a tributary of the Yellowstone.

"From the river," wrote Hayden, "our path led up the steep sides of the hill for about one mile, when we came suddenly and unexpectedly in full view of the springs. This wonder alone, our whole company agreed, surpassed all the descriptions which had been given by former travelers. Indeed, the Langford party saw nothing of this. Before us arose a high white mountain, looking precisely like a frozen cascade . . . formed by the calcareous sediment of the hot springs."[14] Camp was pitched on a grassy terrace near the foremost group of springs. Delighting in the "chaste beauty" of the place, Moran sketched for three days and helped Jackson with his photography, while Hayden's men conducted their scientific studies. Each day's work ended with a soothing bath, the temperature depending on which pool a bather chose.

Then on the twenty-fourth the expedition broke camp. The next pictorial treat came at Tower Creek, where Moran and Jackson worked for two days to capture "magnificent" views of the stream plunging into the gorge, a descent of more than one hundred and thirty feet, between vast and somber columns of stone. Moran marveled at the pinnacles above the falls. They had figured in Langford's articles, and he had made some bizarre designs of them for *Scribner's Monthly*. But the actuality, he found, was even more bizarre, "certainly the most weird and impressive scene in the park," he later wrote on the back of a water color.[15] For Jackson the place created the "biggest photographic problem of the year,"[16] since his develop-

[13] *Ibid.*

[14] "The Wonders of the West—II: More About the Yellowstone," *Scribner's Monthly*, Vol. III, No. 4 (February, 1872), 389.

[15] *Kennedy Quarterly*, Vol. III, No. 2 (October, 1862), 74.

[16] *Time Exposure*, 199.

ing equipment was too heavy to bring within proper distance of his camera near the falls.

They resumed their march on the twenty-seventh. At noon they stood on the top of Mt. Washburn, then toiled down the south side, through dense stands of evergreens, alternating with meadowlands and clumps of aspens. They passed fields of sulphur, dazzling yellow in the sun, and there were soda springs and mud pots filling the air with ugly smells. At last they reached the Great Canyon, at a point not far from the Lower Falls, and they set up camp on Cascade Creek near where it flowed into the river. The main party moved on the next morning, bound for Yellowstone Lake, but Moran and Jackson passed four days in the vicinity of the falls. "Moran's enthusiasm," Jackson wrote, "was greater here than anywhere else."[17]

Moran studied the view from many vantage points, sometimes from the rim, sometimes from the depths of the canyon. He sketched the Lower Falls and the great sweep of the gorge into which the water plunged and swirled. But he was almost equally moved by the grandeur of the Upper Falls, whose water hurled itself with snow-white violence from the cliff, its arch and bounce inspiring one of his best water colors. He also sketched the gloomy cleft of the Devil's Den, watered by Cascade Creek, but always his enthusiasm returned to the Lower Falls and the awesome chasm below it. Here the foaming torrent had carved a gorge more than one thousand feet deep and twice as wide, from rock that glared white and yellow in the sun. Where volcanic gas and waters had left their inevitable stains there smoldered a range of hues fantastically expanded, from the palest of lemon yellow to the mellowed reds of old bricks, or from pearl gray to the deepest jet. Color was the scene's most striking feature, at once both brilliant and utterly delicate. Only an artist with the most sensitive color sense could do the panorama justice, Hayden declared, and then: "Thomas Moran, who is justly celebrated for his exquisite taste as a colorist, exclaimed with a sort of regretful enthusiasm, that these beautiful tints were beyond the

[17] "With Moran in the Yellowstone," *Appalachia*, Vol. XXI, No. 82 (December, 1936), 155.

reach of human art."[18] Not that Moran would not try his hardest to catch their special nuances. He sat long at a spot known later as Artist Point and studied the spectacle, memorizing even its slightest details.

"Since that time," Moran later wrote, "I have wandered over a good part of the Territories and have seen much of the varied scenery of the Far West, but that of the Yellowstone retains its hold upon my imagination with a vividness as of yesterday. . . . The impression then made upon me by the stupendous & remarkable manifestations of nature's forces will remain with me as long as memory lasts."[19] As Jackson observed, the Great Falls and the Grand Canyon of the Yellowstone made the pictorial climax of their summer.

They broke camp at Cascade Creek on the last day of July and moved up the river to meet the main body of the corps. The river was smooth and calm above the falls, and after a two-day march through its picturesque valley, past many a hot spring and coughing mud pot, they came to Hayden's encampment on the shore of Yellowstone Lake. The next morning the camp men packed the mules, and the expedition moved toward the "thumb" of the lake. Moran and Jackson followed, intent on their work, and they were lost for several hours that evening in a dense forest and on a mountainside covered with fallen trees, and they got their bearings only in time to reach camp by midnight.

One of Hayden's objectives was to explore the lake, chart its shore lines, and sound its bottom. For this purpose a collapsible boat had been packed from Fort Ellis; for several days it had received hard use, and the greater part of the lake survey was now finished. On August 4 Moran and others were authorized to go by boat to some springs that spouted at a point farther around the lake, and the following day the main camp was transferred to that place. On the sixth Moran and Jackson set out in search of Shoshone Lake, which lay to the west, but they were stopped by thick forests of evergreens and gave up the quest at two in the afternoon, since they were too low

[18] *Preliminary Report* [for 1871] *of the United States Geological Survey of Montana and Adjacent Territories,* 84.
[19] Note (MS), A19, Moran Papers, Gilcrease Institute.

in rations to venture farther. Game was scarce, probably in retreat among the higher mountains to escape from the flies of midsummer; the hunters returned empty handed evening after evening. "4 Biscuits a day for the last 5 days," Moran jotted in his notebook.[20] Such was the state of their larder on the seventh of August when Lieutenant G. C. Doane, who had commanded the escort for General Washburn's party, arrived from Fort Ellis. He brought an order recalling the military guard, and, tired of biscuits and assured that he had seen most of the wonders of Yellowstone, Moran decided to return with the soldiers.

One more marvel awaited him, however—the geysers of Firehole Basin, to which Lieutenant Doane agreed to show the way (Jackson would go that distance too). A day of travel brought the party to Firehole River, where they camped. The next morning Moran and Jackson went to the geysers, first to those in the place known later as Upper Geyser Basin, then to those in the Lower Basin, where Moran sketched the Castle Geyser in eruption.

His portfolio bulged with sketches—studies characterized by "extreme delicacy."[21] The *Nation* described them as "rapid, racy, powerful, romantic."[22] His stubbornly retentive memory was even more richly stocked; so he was content to return with Lieutenant Doane to the fringes of civilization. Presumably, he caught the stagecoach at Virginia City and traveled to the railroad by the route he had come. Hayden, meanwhile, retrieved his wagons at Boteler Ranch and prepared for several weeks more in the field, to survey an ample swath between Fort Hall on Snake River and Evanston on the Union Pacific Railroad.

Moran himself hurried home to give more final form to the sketches that filled his portfolio and the images that crowded his mind. "Every artist of genius experiences during his life a great spiritual upheaval," thought his daughter, who also believed that such a revelation had come to her father in the Yellowstone. "To him it was all grandeur, beauty, color and light—nothing of man at all,

[20] Diary, A1, *ibid*.
[21] *New York Times*, May 14, 1873, p. 12.
[22] Vol. XV, No. 375 (September 5, 1872), 158.

but nature, virgin, unspoiled and lovely. In the Yellowstone country he [had] found fairy-like color and form that his dreams could not rival."[23]

He worked intensively for month after month on his Yellowstone materials. He interrupted himself only long enough to remove his studio to Newark, where he took a house at 61 Sherman Street, in order to be near the New York magazines and his friend Gilder, as well as Alexander W. Drake, art editor for *Scribner's*. Newark itself had little to attract the Morans. As a local editor wrote, the city had nothing "outside its gigantic industries and its general thrift. In things aesthetic we are comparatively destitute. To the stranger in the city we can point out a black forest of smoking chimneys, and give such other convincing proof of manufacturing enterprise as to make it clear to him why Newark is called the Manchester of America. But when he has beheld these his sightseeing is over."[24] From the esthetic point of view it was the last place his friends might expect Moran to select, yet his move there scarcely broke his stride; he set up his studio in the parlor and fell to work with entire absorption. "His vitality was great," wrote his daughter, "and his concentration on any goal of art enormous and complete."[25]

First there were the designs to illustrate the Yellowstone campaign for *Scribner's*. "Mr. Moran has come with his sketches," Gilder informed Dr. Hayden on the eleventh of September, "and we are at sea for some literary accompaniment!"[26] As Langford, from whom the editors had expected a text, had failed to accompany the expedition, they turned to Hayden for help, and in spite of his involvements he obliged them with a rambling article that had its moments of vividness. For it engravings were made from Moran's drawings of such features as the hot springs and bathing pools on Gardiner River, the ruins of extinct geysers and caldrons (including

[23] "1837—Thomas Moran—1926" (typescript dated East Hampton, L.I., November 17, 1934, and signed "Ruth M. Bedford"), B8, Moran Papers, Gilcrease Institute.

[24] *Newark Courier*, May 1, 1874.

[25] To William H. Jackson, (typescript), n.d., B26, Moran Papers, Gilcrease Institute.

[26] Letters Received (1871), Hayden Survey, R.G. 57, National Archives.

a dead cone called the Liberty Cap), the Lower Falls and the Grand Canyon, the Devil's Den, Yellowstone River and Yellowstone Lake, the Great Blue Spring and the Great Geyser of Firehole Basin. He began a water-color series of such features for Jay Cooke, some of them no doubt to settle his debt to the financier. He made some large drawings of Yellowstone Canyon for *Harper's Weekly*, and was engaged to do five or six similar drawings for the *Aldine*. The *Scribner's* designs were to reappear in Hayden's official report. But the most spectacular use of Moran's Yellowstone work was in the series of chromolithographs that Louis Prang published in 1876 in an oversized portfolio volume called *The Yellowstone Park, and the Mountain Regions of Portions of Idaho, Nevada, Colorado and Utah*. The series comprised fifteen of the twenty-four scenes Moran had supplied. Dr. Hayden wrote the text; the edition was limited to a thousand copies, after which the stones were destroyed; and each volume sold for sixty dollars. Henry P. Rossiter has recently characterized these chromolithographs as "one of the finest series in the medium to be published in America."[27]

Meanwhile, several months after his summer journey, Moran began the large picture of the Yellowstone that he had for so long dreamed of painting. The large size that he adopted (7 feet by 12 feet) was not typical of his work, but he was responding to a development in the art market. American millionaires were buying enormous canvases for the walls of their palaces along Fifth Avenue, and a tendency toward the gigantesque now marked a culmination, on the one hand, of the Hudson River school and a rise, on the other, of what might be called the Rocky Mountain school; the works of Church representing the first, the works of Bierstadt the second, notably his *Indian Encampment*. Moran's picture brought friends to his house at intervals to note its progress. As he was not seclusive, it did not bother him when people, at least in moderate numbers, watched him work.

"I knew the artist was going to paint a big picture," Gilder mused in "The Old Cabinet," his column for *Scribner's*, "but I didn't

[27] Boston Museum of Fine Arts, M. & M. *Karolik Collection of American Water Colors & Drawings, 1800–1875*, I, 31.

know how big it would be. . . . When I think of his carrying that immense canvas across his brain so long, I wonder that he didn't go through the door sidewise, and call people to look out when they came near." Gilder continued:

Watching the picture grow was like keeping one's eyes open during the successive ages of world creation—from darkness to the word Good. The outline was thrown on canvas in a single day. [No doubt in charcoal, if Moran followed his ordinary procedure.] Afterwards great streaks of, to me, meaningless color flashed hither and thither. I saw only hopeless chaos. Then the sky appeared; by and by, delicate indications of cloud, mist, mountain, rock, and tree crept down the canvas, slowly gathering body and tone; till at last the artist's full, glorious Idea shone perfect in every point.[28]

Moran finished the picture in two months. He had sought to make it true, but true to his own impressions; it was far from a literal transcript of the scene. Intricate as the composition was, it represented great simplifications and omissions of detail, and Turner had taught him how to blur and fuse and soften when necessary and how to bring out in sharp relief. Nor in the arranging of his composition did he hesitate to take liberties with the details of topography; topography in itself, he thought, was valueless in art. He explained:

Every form introduced into the picture is within view from a given point, but the relations of the separate parts to one another are not always preserved. For instance, the precipitous rocks on the right were really at my back when I stood at that point, yet in their present position they are strictly true to pictorial nature; and so correct is the whole representation that every member of the expedition with which I was connected declared, when he saw the painting, that he knew the exact spot which had been reproduced. My aim was to bring before the public the character of that region. The rocks in the foreground are so carefully drawn that a geologist could determine their precise nature.[29]

In fact, before taking the canvas from its easel, he requested

28 Vol. IV, No. 2 (June, 1872), 242.
29 Quoted in Sheldon, *American Painters*, 125–26.

Hayden to inspect it for the correctness of its geology, and the scientist found that he could approve. To honor him and his executive officer, James Stevenson, Moran included their portraits among the figures in the foreground, for which he secured the help of a "good portrait painter." "The picture is all that I ever expected to make of it," he wrote on the sixth of April, 1872, "and the indications are that it will make a sensation whenever it is exhibited."[30] The truth of his prediction has been shown already. Meanwhile he had sent his Yellowstone sketches down to Hayden in Washington to promote the park bill, with what success we have also seen, the bill becoming law on March 1, one month after Hayden's article ran in Scribner's with an insistent final query: "Why will not Congress at once pass a law setting [the Yellowstone] apart as a great public park for all time to come, as has been done with that far inferior wonder, the Yosemite Valley?"[31] Hayden would later arrogate to himself almost sole credit for the park idea. But when all was said in refutation of his claim, it remained clear that without his strenuous support the park bill probably would have been pigeon-holed. Another fact was evident: the sketches of Moran along with Jackson's photographs were Hayden's most powerful ammunition, in recognition of which the the Park Service would later call Moran "Father of the National Parks."[32]

While his sketches circulated in Washington, they impressed a wealthy British industrialist, William Blackmore, who had asked to accompany Hayden on his second exploration of the Yellowstone. When Moran came to Washington in connection with his Yellowstone canvas, Blackmore commissioned him to make for his Salisbury Museum a series of aquarelles like those he had in mind for Jay Cooke. These Moran finished late that year, when they were shown at Goupil's Gallery, arousing the Scribner's critic to call them

[30] To F. V. Hayden, Letters Received (1872), Hayden Survey, R.G. 57, National Archives.
[31] "The Wonders of the West—II: More about the Yellowstone," Scribner's Monthly, Vol. III, No. 4 (February, 1872), 396.
[32] U.S. National Park Service press release, December 22, 1936, B14, Moran Papers, Gilcrease Institute.

the "most brilliant and poetic pictures that have been done in America thus far."[33] In finding the Yellowstone, Moran had found himself as artist; and, as Hayden observed, his reputation was now made.[34]

[33] "Thomas Moran's Water-Color Drawings," *Scribner's Monthly*, Vol. V, No. 3 (January, 1873), 394.

[34] From this time on, Thomas Moran was regarded as the foremost artist of the "clan Moran," his reputation outstripping that of his brother Edward, who also removed to the New York area, eventually settling on Staten Island. The Moran family made a remarkable record in American art during the late nineteenth and the early twentieth century. A dozen members achieved such prominence that they were sometimes called the "Twelve Apostles" (*International Studio* [August, 1924], 362). Edward Moran was cited at his death in 1901 as the outstanding marine painter in America. His sons, Percy and Leon Moran, made art careers for themselves as young men, their accomplishment exceeding that of Thomas' son, Paul Nimmo Moran, whose death in 1907 brought his career to a premature end. Edward's second wife, Annette Parmentier Moran, became a competent painter under her husband's guidance, in much the same way that Mary Nimmo Moran developed through Thomas Moran's help. Peter Moran, who remained in Philadelphia, where he became president of the Philadelphia Society of Etchers, achieved pre-eminence in the field of animal painting; his first wife, Emily Kelley Moran, also etched and painted. John Moran established himself as a photographer; he accompanied a U.S. expedition to Darien and recorded the transit of Venice on a further expedition to Tasmania. He devoted himself to studies of horses in action and the development of stereoscopic pictures. He later turned to landscape painting, but in this endeavor failed to achieve acclaim equal to that of his brothers. Stephen J. Ferris, who married Thomas Moran's sister Elizabeth, gained recognition as a painter and etcher in Philadelphia, and his son, J. L. Gerome Ferris, also followed a successful art career in that city. In view of such various talent and accomplishment Alfred Trumble hailed the clan in 1877 as "the strongest artistic family on the Western continent" (*Representative Works of Contemporary American Artists*).

V *Canyon Country*

✦✳✤❂✤✳✤❂✤✳✤❂✤✳✤❂✤✳✤❂✤✳✤❂✤✳✤❂✤✳✤❂✤✳✤❂✤✳✤❂✤✳✤❂

Explorers had long been aware of the value of taking artists along on their expeditions, and as the artists benefited, the practice flourished. Sanford R. Gifford had gone with Hayden in 1870, for example, and now, in the spring of 1872, Bierstadt was preparing to spend a season with Clarence King in the High Sierra. Major Powell had seen Moran's sketches, he was impressed with *The Grand Canyon of the Yellowstone*, and he conceived that Moran's presence would be an asset to his field party as they ran the Colorado River that season, through the Grand Canyon of Arizona. So keen was he, in fact, to have Moran become his guest that he offered "great inducements,"[1] though what they were seems not to be of record, and he was disappointed when Moran declined his invitation. "I feel that I miss a glorious opportunity," Moran replied on June 24, "but my contracts for work must take precedence of my desire to accompany you."[2]

Hayden was also eager for Moran's company that summer, but the same press of work prevented the artist from either returning to the Yellowstone or visiting the Tetons, where Hayden would put a second group into the field. This party, under James Stevenson, later linked up with Hayden's main detachment in Firehole Basin.

[1] Thomas Moran to F. V. Hayden, November 24, 1872, Letters Received, Hayden Survey, R.G. 57, National Archives.

[2] To Major John Wesley Powell, Letters Received (1872), Powell Survey, National Archives Microcopy No. 156, roll 1, frame 98.

{72}

"It was a grand reunion," wrote Langford, who was there as the first superintendent of Yellowstone Park; a campfire burned brightly, and around it sat the men. "The Doctor . . . stated that . . . this was probably the last time the whole party would be together, and . . . he wished to propose the names of three persons as honorary members who, though not of it, had yet so far participated in it . . . as to have a strong claim to its recognition. The first name he proposed was that of Thomas Moran."[3] Next came William Blackmore's name, and last that of Langford himself.

News of his honorary membership in Hayden's survey pleased Moran, but later he received an even greater token of Hayden's esteem. Stevenson, convinced that he and Langford had reached the summit of the Grand Teton, had named the peak Mt. Hayden (a name that would fail to endure), on hearing which, Gilder suggested that the Doctor call another Teton Mt. Moran. The idea pleased Hayden, and he so named the most monumental peak in the group, the glacier-crowned giant that overhung Jackson Lake. And when Langford submitted his account "The Ascent of Mount Hayden," with a reference to the naming of the two peaks, Gilder was authorized to illustrate it with a woodblock (Moran prepared the design from a Jackson photograph), thus captioned: "Mount Hayden and Mount Moran from the West." "It was very friendly of you to name that Peak after me," Moran acknowledged, "and I shall be delighted to be so honored."[4] Then Hayden wavered; he considered it advisable to exchange its name with that of the less spectacular Mt. Leidy, not a great distance off. But he waited too late to make the exchange; the magazine had gone to press by the time he informed Gilder, who convinced him that everyone concerned would look foolish if he persisted in making the switch, and so the most massive of the Tetons would ever afterward be known as Mt. Moran (for this name stuck). In time, moreover, a bay, a canyon, and even a town in that vicinity would bear Moran's name.

Meanwhile, Moran completed his work commitments early

[3] "The Ascent of Mount Hayden," *Scribner's Monthly*, Vol. VI, No. 2 (June, 1873), 152.
[4] To Hayden, April 4, 1873, Letters Received, Hayden Survey, R.G. 57, National Archives.

enough to leave on August 24, 1872, for a hurried trip with Mollie to the Far West. Their itinerary was in part determined by an assignment he had undertaken for the Appleton Company, publishers of what was to be "the most important book of landscape that [had yet] appeared in this country, their *Picturesque America*," produced under the editorship ostensibly of William Cullen Bryant, but really of O. B. Bunce. It was published first in monthly parts, beginning in 1872, on imperial quarto-sized pages to give scope to the engravings; and those large pages, according to W. J. Linton, the British engraver, carried "the best landscapes engraved" in America.[5] Later the various parts would be gathered into two sumptuous volumes— "an epoch-making work," according to S. R. Koehler, and certainly one of the notable books of American illustration.[6] Bunce had already had Moran's drawing of the Upper Yellowstone Falls engraved on steel for its pages, and now he engaged Moran to draw scenes along the Union and Central Pacific railroads to accompany an article on that route—"The Plains and the Sierra," by E. L. Burlingame. For this assignment Moran would have the benefit of Jackson photographs, but this could not compare with the value of a trip among the scenes themselves, especially those beyond the Great Salt Lake.

The Morans transferred to the Union Pacific at the dusty town of Omaha. One express train a day rolled west from there, scheduled to leave at half-past eleven in the morning, but it was late as usual, although the time would be regained before they reached Cheyenne. The plains were unusually dry that year, stretching out like a gray-green sea. The railroad advertised an observation car, but the train had none, so they were obliged, presumably, to watch the sights through an ordinary window. There was no call upon Moran to furnish views other than what could be easily seen from the train or on short side trips, and his contributions were of the usual sights that adorned the guidebooks—Red Buttes on the Laramie Plains; the cliffs of Green River; views of Echo Canyon, including Monument Rock; and of Webber's Canyon, including Witches' Rocks,

5 *History of Wood-Engraving*, 37.

6 Sinclair Hamilton, *Early American Book Illustrations and Wood Engravers, 1670–1870*, 126.

Devil's Gate, and Devil's Slide. There were scenes also of the Bad Lands in Utah and of Great Salt Lake. The Morans left the train for a tour into the mountains east of Salt Lake Valley, the Wasatch and the Uinta, going, among other places, to Moore's Lake, the head of Bear River, at an elevation of eleven thousand feet. Ice and snow could still be found among the rocks at its margin, and the rocks were smooth and polished from the wear of an ancient glacier. Moran later sent the *Aldine* a large drawing of the scene.

The railroad skirted the north shore of Great Salt Lake, and the train dashed across the Salt Desert, no more water, no more greenery meeting the passengers' eyes until they reached the Humboldt Plains, under the lash of a summer thunderhead, a picturesque view of which Moran included among his sketches. There were views too of Palisade Canyon, Truckee River, Donner Lake, Lake Tahoe, and the crestline of the Sierra. The Morans apparently went as far as Oakland, whose majestic oaks Moran sketched in his final illustration for Burlingame's article. They headed then for Yosemite, where they stayed in one of the Valley hotels and sketched the well-known features of the place: El Capitan and the Sentinel, the Domes, and the various falls. In a sense Moran was familiar with it all, having drawn nearly a score of designs on wood for an article called "The Big Trees and Yosemite" in the January *Scribner's*; he had then worked from photographs, and now he was eager to form his own impressions of the wonders there. But grand as Yosemite was, it proved a disappointment; the soft, cool blues and grays of the granite walls did not appeal to him like the warm riot of color he had found at Yellowstone, and the lack of distant perspective did not seem conducive "to the witchery of atmospheric gradation"[7] in which he excelled. Except for the basic design of an etching of Half Dome that would appear in John Muir's *Picturesque California*, Moran's art gained little from this visit; his paintings of the valley and its imposing features came much later. Yet his name was now given to a promontory on the rim not far from Glacier Point. It may be that ailing health on Mollie's part affected his enjoyment of the place.

[7] Eliot Clark, "Studies by American Masters at Cooper Union," *Art in America*, Vol. XV, No. 4 (June, 1927), 185.

The trip was too taxing on her strength, and she would never travel to the Far West with him again.[8]

He was engaged on the Plains and Sierra drawings as late as February, 1873, interspersing them with other work, notably the water colors for Cooke and Blackmore and drawings on wood for *Scribner's*. He received from fifteen to sixty dollars a design as a usual fee, though now and then one hundred, depending on the size; and a good year now as a free-lance illustrator brought him an income of between four and five thousand dollars. At about this time he developed his distinctive monogram as a signature for his smaller works, especially his designs on wood: ₪ —a *T* superimposed upon an *M*, both with upturned serifs, the central angle of the *M* flush with the crossbar of the *T*, joining the trunk of which it formed a *Y*.[9] Thus, the combined initials of Thomas "Yellowstone" Moran (and as a consequence he was also known among his friends as "T. Y."). His work as an illustrator had kept him so busy that he had painted practically nothing in oil since his Yellowstone panorama.

"I shall be hard pressed," he wrote Hayden in January, "to get through with my work by the time of departure next summer";[10] for as it was then Hayden's plan to have Jackson photograph the Colorado River down as far as the Grand Canyon, Moran planned to join the expedition. As a result, he made commitments to supply various editors with a total of one hundred or more drawings of the Canyon. He had also begun to think of painting a large canvas of it as a companion piece to his Yellowstone view. Hence, when circumstances forced Hayden to change his plans, and Jackson was asked to prepare instead for a campaign among the high peaks of the Colorado Rockies, Moran faced embarrassment. It was fortunate for him that Major Powell's invitation still held. Almost at the last moment he switched his plans, secured a railroad pass to Utah, and made arrangements to join the Major at Salt Lake.

[8] According to Professor Fryxell, Moran revisited Yosemite with his wife in 1874, a conclusion I cannot sustain from my reading of the evidence.

[9] Owing to its symmetry, the device was well suited to wood engraving: it remained unchanged when the block was printed. There was no need to reverse it in the drawing.

[10] January 28, 1873, Letters Received, Hayden Survey, R.G. 57, National Archives.

He found it distasteful to leave Hayden in this manner, and his letter to the Doctor was apologetic: "I felt it obligatory," he explained, ". . . to accept the offer [of] Major Powell. . . . I hope you will not feel that I do not appreciate your great kindness & the invaluable opportunity of seeing the region of your present survey, but my business relations . . . and my intense desire to see the Grand Canyon force me to change my original plans."[11]

A ten-day fishing excursion in Maine ("a sort of newspaper and literary party," he explained[12]) delayed his departure till early July. His companion on the road was J. E. Colburn, a young staff writer for the *New York Times*, and they reached the Mormon capital on the eighth of July. Powell awaited them there, with his stump arm which had been shattered at the Battle of Shiloh and his reddish beard, which he preferred to call russet. His athletic body had begun to grow a little stout, but he was still brisk, boiling with energy. He was on excellent terms with the Mormons, and the following day he invited Moran to go with him to pay his respects to the Mormon hierarchy. "Powell and I went to Brigham Young's house," Moran wrote. "I was introduced to all the leading Mormons." There was Brigham himself, square-jawed, with sandy hair shot through with gray, and George A. Smith, the second man in power, also George Q. Cannon, editor of the Mormon paper and delegate to Congress, and Bishop Hooper, along with a number of other Mormon high priests. "They are very much like the rest of mankind," Moran concluded, "and all smart fellows."[13]

On the tenth the travelers boarded cars at the Utah Southern Railroad Depot, and the puffing little engine pulled them down to Lehi, then the end of the line. There they took a stage for Springville, some twenty miles farther south, where the Major in his capacity as special commissioner for the Indian Bureau found it necessary to interview some Ute Indians. Moran and his friends spent the night rolled in blankets in the dooryard of a local Mormon, and

11 June 28, 1873, *ibid.*
12 To F. V. Hayden, May 28, 1873, *ibid.* The trip seems to have resulted in his *Rangeley Stream* and some seascapes of the Maine coast.
13 Note dated July 9, 1873, A25, Moran Papers, Gilcrease Institute.

the next day "Wanero, a Ute sub-chief . . . came into town with a number of his band—a picturesque group—who were chiefly anxious to obtain tobacco and flour."[14] Major Powell, who had a knack with Indians (for one thing, he never traveled armed or with a military escort and took the trouble to learn their languages), gained all the facts he needed and sent the Utes away reassured and happy. Then the Major's party moved a few miles up Spanish Fork Canyon, where they made a two-night camp. Moran found the landscape spectacular, and while the Major geologized, he made several sketches. "The Wasatch hills to the east of Salt Lake Valley," he decided, "are among the grandest specimens of Nature's architecture."[15] He must have climbed the divide and gazed down into Springville Canyon, a scene which he later drew for the *Aldine*. "It is a grand and impressive sight," wrote the editor, "to look down into the abyss from a point fifteen hundred feet above the little stream at the bottom of the gorge." The canyon was deep and gloomy, and perpendicular strata had been "worn into numberless needle-like forms, giving it a . . . horrible aspect."[16]

On returning to Springville, the Major hired a Mormon driver with a wagon and a span of mules to take the party and its gear to Fillmore. The travelers would stop at night and sleep by the roadside, and they bought their meals at towns and ranches. They delayed one day on the journey to climb Mt. Nebo, which they thought was the highest peak in Utah (Hayden had not yet fixed that honor on Kings Peak). They parked their wagon at the base of the mountain at five in the afternoon; then with packs on their shoulders they climbed till dark, camping beside a small spring, where they made a fire and cooked their supper. At dawn they forged ahead and reached the crest by noon, the view magnificent. They could see the summits of the Colorado Rockies to the east, the White Mountains of Nevada to the west, Great Salt Lake to the north, and the rim of the Grand Canyon—almost—to the south. How that

[14] J. E. Colburn, *New York Times*, August 7, 1873, p. 2, col. 3.
[15] Scrapbook, p. 46 (clipping dated June 9, 1900), Moran Collection, East Hampton Free Library.
[16] "Utah Scenery," *Aldine*, Vol. VII, No. 1 (January, 1874), 15.

terrain, to the south, impressed Moran—"heaped up, massed up, and often in a profusion of irregularities, tempestuous combinations and stupendous effects that fairly daze the beholder, leaving him to wonder and admire by the hour."[17] The party made its way down the mountain and two days later arrived at Fillmore, where Moran and Colburn left Major Powell for a conference with Kanosh, an old and able chief, "who wanted his people to live like white men by cultivating the soil."[18]

From Fillmore, Moran and Colburn continued on horseback, a five-day journey, most of the way in company with a wagon taking freight to the Major's men at Kanab. Their route lay through Beaver and Cedar City. Some eight miles south of Kanarraville they turned into Kanarra Canyon, the entrance to a narrow pass through the mountains, where in a side canyon they saw a lofty red knob which they named Colburn's Butte, and which Moran later drew for the *Aldine*. It was also from this pass that they received their first view of that massive wall of sandstone, with its array of pinnacles gleaming red in the sun—that wall which Major Powell had named Vermilion Cliffs. The cliffs were carved with immense amphitheatres, they were buttressed with beetling spurs, embellished with turrets and towers; and near the Virgin River they flung off vast buttes. "And giant buttes they verily are," wrote Powell's assistant, Captain C. E. Dutton, "rearing their unassailable summits into the domain of clouds, rich with the aspiring forms of Gothic type, and flinging back in red and purple the intense sunlight poured over them. Could the imagination blanch those colors, it might compare them with vast icebergs."[19] The Indians called the place "Rock Rovers' Land." The cliffs fascinated Moran; he studied them and fixed their forms and colors in mind; not only would he draw them for the *Aldine*, they would also provide the subject of his spectacular oil, *The Valley of the Rio Virgin*.

The wayfarers reached the small Mormon town of Toquerville on the twenty-third of July, and taking a two-day rest from travel,

[17] *Ibid.*
[18] Colburn, *New York Times*, August 7, 1873, p. 2, col. 3.
[19] *Tertiary History of the Grand Canyon District*, 54.

Moran made sketches of the Virgin Valley and Vermilion Cliffs while Colburn prepared a long letter about their journey for the *Times*. Then they pushed on toward Kanab; eight more miles brought them to Sheep Troughs, where they found the Major's tall, aloof topographical aide, Professor A. H. Thompson. Powell had wired Thompson of their approach, and knowing their desires, he had directions ready for a side trip to a valley that proved to be the most interesting and beautiful region they had yet seen. They rode with one of Thompson's men to the small town of Grafton, where before them loomed the great West Temple of the Virgin, an awesome mountain of naked rock, sculptured and fluted by the elements and gleaming with iridescence under the burning sun. Skirting the Temple, they turned up the Virgin River and followed its course to the fork, took the left prong to the north, and rode into the canyon which the Indians called *Mu-koon-tu-weap*. They stopped at the house of a settler named Heep, where, according to Moran's notebook, "an infernal Indian boy upset a bee hive while we were at dinner."[20] Angry bees buzzed everywhere but did not discourage Moran from making a hurried sketch of the cabin.

The party continued up the canyon. Water often filled the channel from wall to towering wall, and then one had to wade upstream. There was no talus, no flood plain, no piles of boulders at the cliff foot, where bubbled frequent springs. The smooth faces of the walls rose vertically for one thousand feet or more, then veered back into shelving slopes, but as Moran and his friends progressed, the right cliff broke into new forms, even more impressive. "A row of towers half a mile high" was "quarried out of the palisade, and [stood] well advanced from its face."[21] Intent on the "most peculiar formations . . . toward the top," Moran decided that "for glory of scenery and stupendous scenic effects"[22] the place could hardly be surpassed. The

20 Pocket notebook, JNEM–4336, Moran Collection, Jefferson National Expansion Memorial, St. Louis, Missouri. This item gives details valuable for the reconstruction of Moran's itinerary.

21 Dutton, *Tertiary History*, 58.

22 Scrapbook, p. 46 ("Thomas Moran on Utah Scenery"), Moran Collection, East Hampton Free Library.

colors dazzled one—orange, vermilion, pink, and white. He agreed with Colburn that "in beauty of forms, in color, in variety, in everything but size" it excelled Yosemite and deserved to be as famous. In the course of one dozen miles stood "as many real domes, 3,000 feet and upward above the valley, dome-shaped from the very base, and beautifully banded with lines of color," also, "vast arches, cathedrals, columned temples, monuments and gates so perfect that the forms [were] recognizable without any aid from fancy."[23] When Moran later pictured *Mu-koon-tu-weap* for the *Aldine*, under the title "Valley of Babbling Waters," the editor remarked that nothing in nature could be conceived as "more truly blending the beautiful and awful."[24] No doubt it was the first pictorial record to reach the public of that wonderland the Mormons had named Little Zion, and which nearly five decades later became the heart of Zion National Park.

The Valley of Babbling Waters held the travelers absorbed for about two days. Then they made their way to Kanab, a Mormon settlement of log and adobe houses, only three years old but a thriving town already, with grapevines and apple, pear, and cherry trees that would soon be bearing fruit, and cool streams of water brought down in ditches from the mountains. Here Powell's field party had made its headquarters, and now Moran found Thompson at the base camp, a group of tents, well floored against the damp, where the professor and his party carried on their map work. There were so many rattlesnakes about the place that the survey men had dubbed themselves the Rattlesnake Brigade.

Moran and Colburn rested for two days and made preparations for future excursions. Then on August 1 Thompson and the photographer John K. Hillers took them out on the Rockville trail, back toward Little Zion. The party made a dry camp that evening, and the next day they followed the trail to the brink of *Pa-ru-nu-weap*, or Roaring Water Canyon, the east fork of the Virgin. "Below us," Major Powell wrote of the same scene, "stretching to the south, until the world is lost in blue haze, is a painted desert; not a desert plain,

[23] Colburn, *New York Times*, September 4, 1873, p. 2, col. 1.
[24] "Scenery of Southern Utah," *Aldine*, Vol. VII, No. 16 (April, 1875), 307.

but a desert of rocks, cut by deep gorges, and relieved by towering cliffs and pinnacled rocks—naked rocks, brilliant in the sunlight."[25] The little party made no attempt to descend the "difficult trail" into the canyon, as Powell had done the year before. They admired the view, Moran fixing details in mind for future work, then turned back, making camp at a spring in Cottonwood Wash. They reached the Kanab base on Sunday the third of August.

Excitement flared in camp when a rattlesnake bit an Indian boy from the Piute band which waited for Major Powell outside Kanab. The professor had no whisky, the best antivenom that he knew, but he secured a pint at a nearby ranch, and the boy was treated successfully. The assembled savages presented Hillers with an excellent chance to take pictures, and the next day was given over to that pleasant task. Hillers had a knack for portraiture, and nowhere was it put to better use than in his series of Indian shots. He enlisted aid from Moran, who posed the subjects in what he considered effective attitudes. Having confidence not only in Major Powell but in all his associates, the savages consented to take the positions Moran suggested—they were grouped, then scattered, some of them dressed, some undressed; it made no difference whether they were placed "in easy or to them constrained and ridiculous attitudes"; the results were superb studies, even if the posing did prove detectable. "The redskins," wrote the editor of the New York Graphic, ". . . exhibit delicate limbs, small hands and feet, and are finely sculptured in what the French call attachments—that is, the ankles and wrists. Some of the old men . . . with wrinkled visages, scraggy beards, and horned caps made of antelope heads look like melodramatic sorcerors. . . . The young matrons and maids . . . are primitive goddesses."[26] The plate Hillers called The Empty Cradle—Moran would later use this theme for one of his etchings—showed "a dusky bereft mother" watching over the relic of her dead child. For another plate Moran and Colburn posed with a young boy in deerskins with a feathered headdress and a bow and arrows, whereupon the boy's father offered to sell the youngster to Moran. "Mr. Moran was tempted. He liked

25 Wallace Stegner (ed.), The Exploration of the Colorado River, 114.
26 August 10, 1874.

the boy."[27] In fact he had come to like the red man in general and found that he held much the same views as Major Powell, "that the abuse and villainy of the white man has been the cause of all the trouble between them and that the treachery of the Indian is not to be compared to the utterly unjustifiable treachery of the whites. The white man under similar conditions," he believed, "would have been more bloody than the Indians."[28]

On Tuesday the fifth Thompson placed Moran and Colburn in the care of Hillers for a journey south to the rim of the Grand Canyon. They loaded two mules, one with Hillers' photo equipment, the other with blankets and food for ten days—flour and yeast for bread, jerked beef, bacon, cheese, and dried peaches. Leaving Kanab at noon and riding their horses at an easy pace, they reached Pipe Spring, some twenty miles away, in time to camp for the night. There they left the wagon road, and next day they struck southwest across the desert, toward Mt. Trumbull, looming like a blue cloud in the distance. That noon they stopped at Wild Band Water Pocket, a round hole surrounded by low volcanic rock; it contained several barrels of muddy water, drainage from a recent shower. Wild mustangs could be seen grazing in the distance—no doubt the "wild band" for which the pocket had been named. Although many hours of sunlight still remained, the party could go no farther that day, for the nearest water pocket was another twenty-five miles away, and to miss it in the dark or to find it dry might mean their death in that bone-dry country. They spent the night at Wild Band, then the following day they forged on to the next pocket, where they were pleased to find water. Their way, a torrid *via mala*, led them to a point near the base of Mt. Trumbull, and there they came to *Unupits Pacavi*, or the Witches' Water Pocket. All about it jags of black lava thrust themselves from a ground of weathered cinders, and here and there struggled forlorn and stunted clumps of cedar and piñon pine. The water in the pocket twitched with tadpoles and mosquito wrigglers; it tasted bitter to the tongue and left a prickle in the

[27] Note on reverse of photograph, Moran Collection, East Hampton Free Library.
[28] "Thomas Moran, N.A." (unsigned MS), B29, Moran Papers, Gilcrease Institute.

throat. The only way to get it down and make it stay was to brew it into strong coffee. After supper Moran sketched his weird impression of their bivouac under the glow of a campfire, and in his picture of it for the *Aldine* he added a few Indians for a savage genre touch.

The next day the group moved down the dry gash of the *To-ro-weap*, which headed behind Mt. Trumbull; its walls increased in mass and proportion, and the valley itself grew broader as they proceeded, until it spread three miles from side to side. They rode for fifteen miles in furnace-like heat, till they came to a final pocket in the basaltic bed about one mile from the brink of the Grand Canyon. They made camp there for two days, though the water left the same prickling in the throat. They drank as little as possible; still, on the second day all were slightly ill.

Meanwhile, with lunch finished, they hurried to the verge. "The scenery here becomes colossal," Dutton was to write:

> Its magnitude is by no means its most impressive feature, but precision of the forms. The dominant idea ever before the mind is the architecture displayed in the profiles. It is hard to realize that this is the work of the blind forces of nature. We feel like mere insects crawling along the street of a city flanked with immense temples, or as Lemuel Gulliver might have felt in revisiting the capital of Brobdingnag, and finding it deserted.[29]

Moran and his friends could see the topmost part of the chasm's opposite wall, but not the chasm itself, until they were on the very rim; then "the gorge suddenly opened," Colburn wrote, "almost as if the very crust of the earth had been rent asunder. We stop and gaze in awe-stricken silence. . . . But still we do not yet comprehend, in the fullness of its power, the grand scene. . . . We go forward to the very edge, and creeping out on a projecting cliff look directly down upon the river raging in its rocky bed."[30] This was the river Moran would have run in a boat had he come with Powell the year before, but who could tell, from their eyrie-like perspective, that this narrow band was filled with killer waves and rapids; yet up

[29] *Tertiary History*, 86.
[30] *New York Times*, September 4, 1873, p. 2, col. 2.

from the depths welled a low roar, reverberating against the walls of the inner gorge.

During the two queasy days they spent at the foot of To-ro-weap, Hiller took pictures, while Moran sketched. "The general color of the canyon is a bright violet," Moran wrote on one of his pictures. "The upper surfaces gray intermixed with red going to a yellow in red at the bottom of the canyon. The near rocks of the foreground are a-glow with gray surfaces. . . ."[31] The grays were pearled and lustrous and sometimes gave way to a creamy tint in the frieze of cross-bedded sandstone. In the hour before sunset the effect was dazzling, weird, awesome; the scenes shifted constantly in the light of the lowering sun, one monumental pile after another striking into shade, while others, obscured from view till then, emerged for the moment into light. Such kaleidoscopic effects fascinated Moran, who sat in silence and absorbed them or made quick sketch notes on his drawing pad. "The drawings and water colors made at this period," wrote Eliot Clark, secretary of the National Academy, "show a remarkable sense of observation and a superb rendering of organic line."[32] But Moran feared that no palette was equal to the endless succession of tints and shades that he observed there.

And then early on their third day near the brink the trio repacked their mules and began to retrace their route. They found Major Powell awaiting them at Kanab, the Major having arrived two nights before with a government doctor from the Uinta Indian Agency. The following morning Powell conducted Moran to Three Lakes Canyon, some eight miles north of the settlement, its brook a willow-grown tributary of Kanab Creek. The canyon's main attraction was its cave lakes on which the sun never shone, as well as formations of sandstone, multicolored and carved by wind into strange, fantastic shapes.

Then came the climax of Moran's summer. On the fourteenth of August, mules were packed with provisions, and the Major led a

[31] Note on Moran's sketch TM-95, Moran Collection, Jefferson National Expansion Memorial.

[32] "Hudson River School of Painters," Scribner's Magazine, Vol. LXV, No. 4 (October, 1918), 511.

small party toward that huge pine-grown plateau they had seen from the side of Mt. Trumbull, the lofty Kaibab, whose name signified in Piute "Mountain-lying-down." By starting late in the afternoon they avoided the intense heat of the day on Kanab Desert. Dutton wrote of a journey along the same route:

> As the sun nears the horizon the desert scenery becomes exquisitely beautiful. The deep rich hues of the Permian, the intense red of the Vermilion cliffs, the lustrous white of the distant Jurassic headlands are greatly heightened in tone and seem self-luminous. But more than all, the flood of purple and blue which is in the very air, bathing not only the naked rock faces, but even the obscurely tinted fronts of the Kaibab and the pale brown of the desert surface, clothes the landscape with its greatest charm. It is seen in its climax only in the dying hour of daylight.[33]

Soon after sundown the air became cool; the party rode until midnight, over a road faint and hard to follow in the dark, then rested till dawn, after which they finished their march to the first water, Big Spring in Stewart Canyon, a distance of forty miles from Kanab.

From Big Spring they probably followed an Indian trail to a small spring near the southwest edge of the "Mountain-lying-down." If so, they passed through rich forests of pine and spruce, with intermingling clumps of aspen, a region altogether sylvan in marked contrast to the desert country to the west. On reaching the spring— *Parissa Wampitts* was its Indian name—they had come within a few miles of the spot which Major Powell considered "the greatest point of view in the Grand Canyon."[34] This was a small plateau detached from the principal mass of the Kaibab, and a feature to which the Major had given his own name. The intervening saddle dipped more than a thousand feet, and this the climbers had to cross, but the view which burst upon their gaze was worth their hardiest effort. The position of the plateau, a kind of vast butte around whose base the river angled, was such that it stood in line with a prolonged sweep of the gorge, in its grandest section. Thus as the party approached the southern brink they could look for miles up and down the canyon

[33] *Tertiary History*, 124–25.
[34] *Newark Daily Advertiser*, March 28, 1874.

—not directly across it, but for forty miles of its length in one direction, twenty miles in the other. Moran was convinced that he had achieved his goal; here was the scene that he would use for his large picture of the Colorado chasm. He selected his exact vantage point only after much deliberation.

"You look," Powell wrote of the view from Moran's chosen perch:

> . . . and see in the distance, about a dozen miles away, the Colorado itself. Beyond the Colorado you see the crags and peaks and angles formed by the side canyons on the edge of the great escarpment or plateau, and looking beyond in the dim distance, you see faintly outlined a group of volcanic mountains, of which San Francisco mountain is the culminating peak.
>
> In the immediate foreground you look down into a vast amphitheatre, dark and gloomy in the depths below, like an opening into a nadir hell. A little stream heading in this amphitheatre runs down through a deep, narrow gorge until it is lost behind castellated buttes, and its junction with the Colorado can not be seen. On the left there is a cliff [and] towering crags and pinnacles, buttressed below and resting on a huge mass of horizontal stratified formations, presenting a grand facade of storm-carved rocks. The Colorado itself, seen in the distance, though a great river, appears but a creek.[35]

A thunderhead was boiling up from the depths of the chasm, where the air had grown hot from sunshine streaming down on the naked rock. Suddenly blue-violet lightning flashed from crag to crag and ran in rivulets along the buttes, and deafening peals of thunder followed; then streamers of rain, like dark irregular draperies, burst across the gorge. "A thousand streams gathered on the surrounding plains, and dashed down into the depths of the canyon in waterfalls many times the height of Niagara."[36] Moran was quietly ecstatic as he watched; here was the wild, savage effect he needed to match the awesome sublimity of the chasm. He sketched, but even more important, fixed the scene unshakably in his memory.

[35] Scrapbook, p. 49 (unidentified clipping), Moran Collection, East Hampton Free Library.

[36] J. E. Colburn, "The Canyons of the Colorado," in *Picturesque America*, II, 509.

Major Powell had planned one other venture for his guests—a descent to the river through the sixty-mile-long Kanab Canyon which paralleled the Kaibab's western wall. The trip would have cost them several days of hard climbing, for there was no easy trail, and since commitments required that both Moran and the journalist friend return to Salt Lake City by early September, they had to forego the plan. But striking photographs which Hillers had taken of Kanab Canyon, as well as Glen and Marble canyons and the inner gorge of the Grand Canyon itself, were placed at Moran's disposal, so that he could include those remarkable places in the designs he would provide editors upon his return. The weeks he had spent with Powell's corps were at once almost as rewarding as his trip to the Yellowstone and in the long run were to bring his career even greater benefits.

On reaching Newark he began at once to satisfy his promises for landscape designs. "I am awfully pressed with drawings on wood," he informed Major Powell, "and have to work every night until one or two o'clock."[37] He made several large scenes for the *Aldine*, and that journal, noted for the finesse of its wood engravings, did ample justice to his work. Moran called the handling of three of his Utah sketches "the best pieces of engraving that have ever been made from my drawings. Springville Canyon is particularly fine."[38] The editor, his friend Richard Henry Stoddard, was inclined to agree. "Both the artist and the engraver have succeeded in catching the spirit of nature," he remarked of *A Storm in Utah*. He commended the picture for its depiction "of the rush of water, the solidity of the rocks, the feeling of wind and strife of elements." The quality of its engraving he cited as "the equal of a steel plate," and concluded: "nothing has ever been seen in the *Aldine* to surpass this."[39]

Moran also furnished illustrations for the brief article Colburn wrote about their trip for *Picturesque America*—all of them "strong scenes," based on photographs, of Glen and Marble canyons, the

[37] Letter dated December 16, 1873, Letters Received, Powell Survey, R.G. 57, National Archives (Microcopy No. 156, roll 2, frame 38).

[38] *Ibid.*

[39] "A Storm in Utah," *Aldine*, Vol. VII, No. 9 (September, 1874), 175.

walls of the Grand Canyon (which reminded some people of a Doré scene in hell), and a remarkable tower of red limestone in Kanab Canyon. These drawings merely marked the beginning of his use of the canyon country as a theme for woodblocks. Soon Major Powell sold *Scribner's* the account of his first conquest of the Green River, and Moran agreed to supply the illustrations, some directly to Powell, some to the magazine, and as a result, when the Major's official report appeared, its twenty-nine illustrations were mostly Moran's work, placing the book in artistic company with the lavishly illustrated reports of Clarence King.

Moran enjoyed reading the Major's book, as serialized in *Scribner's*. He found the descriptions "strong and vigorous," but he wrote Powell of one reservation:

> You do not once (if I recollect right) give your sensations even in the most dangerous passages, nor even hint at the terrible and sublime feelings that are stirred within one, as he feels himself in the jaws of the monstrous chasms. It seems to me that the expression of these impressions and thoughts tend to realize the descriptions to the reader & are almost as necessary as the descriptions themselves.[40]

Here Moran gave Powell perceptive literary criticism, relevant at least to the magazine appearance of the narrative. But when writing the account, the Major thought of it only as a scientific report, and as such it had no place for his personal feelings, however dramatic. As a scientific document, however, Moran might have censured it for still another reason—Powell's unexplained fusion of episodes from two passages down the river, all as a reconstruction of his earlier descent. The historical confusion he thus created was not to be unsnarled for nearly thirty years when, in A *Canyon Voyage*, his former assistant, Frank S. Dellenbaugh gave the second trip its proper perspective. In the meantime Moran himself would receive censure in certain quarters for having taken artistic license in his pictures of several scenes along the river.

In time his work for Powell led to his also illustrating Dutton's

[40] Letter dated December 19, 1874, Letters Received, Powell Survey, R.G. 57, National Archives (Microcopy No. 156, roll 2, frame 174).

Tertiary History of the Grand Canyon District. That assignment would mark an apt collaboration, for "what Moran loved to paint— the big, spectacular, colorful view—Dutton loved to describe. He took his stance like a painter"—Wallace Stegner's words—"and he composed like a painter, and his drift, like Moran's, was constantly away from the meticulous and toward the suggestive."[41] Moran contributed nine woodblocks to the book and helped to make it the "most beautiful book produced by any of the surveys."[42] His work for Dutton eventually came to a climax in *The Transept,* based on a sketch by William H. Holmes and published in the atlas to the *Tertiary History*—one of the best paintings of the Grand Canyon ever made, but that lay nearly a decade in the future.

Meanwhile, in October, 1873, Moran began the large picture of the chasm. Because he considered it a companion piece to the Yellowstone panorama, he chose the same size of canvas—seven feet by twelve feet. First, and only after much thought, he sketched the design in charcoal, then put the canvas aside to let the conception ripen in his mind. He knew that he had undertaken a task more problematical than his painting of the Yellowstone. When Powell paid him a visit on Thanksgiving Day, he had gone no further than the charcoal plan, but the Major's imagination was strong enough to grasp what it implied and to praise it. December at last found Moran tackling the canvas, owing perhaps to Powell's encouragement. On the sixteenth he wrote to the Major: "I have been pretty constantly at work on the Big Picture for the last two weeks & it has progressed wonderfully for the time & promises all that I could desire of it. I have got our storm in good."[43]

It was not so much a picture of the chasm itself as the whole country through which the chasm had cut its way. The distance it encompassed was immense—the atmosphere in the canyon country was so clear that it allowed the vision to range across an expanse of more than one hundred and twenty miles. If all to be seen there were included, only chaos could result. Moran had to be ruthless therefore in suppressing details. Even so, more remained than could

[41] *Beyond the Hundredth Meridian,* 165.
[42] *Ibid.,* 189. [43] Letter dated December 16, 1873.

be brought into a basic harmony or fused into a coherent unity. That he should have managed as well as he did was testimony to his maturing powers.

He chose to place the spectator on the highest ledge of the Powell Plateau, whose rock-strewn rim occupied the foreground of the picture. Beyond its verge opened a gulf choked with deep gray cloud, an abyss produced by Muav side canyon, across whose head the party had climbed to reach their vantage point on Powell Plateau: Moran revealed it spilling into the Grand Canyon, along which the eye swept through the middle distance, where the Colorado gleamed, here and there, like a silver snake, twisting through a maze of crags and walls and island-like buttes. In the left foreground he placed a high red cliff, carved with architectural forms, a part of the vast Kaibab abutment; to the right an intricate amphitheater, beyond which loomed a portion of a mighty butte. In foreground clefts he placed stunted pines and firs and cedars, mountain mahogany shrubs, Mexican bayonets in bloom, prickly pears, and barrel cactus, all calculated to give the compositon scale, in lieu of the human figure, which he could not introduce, as he had done in his Yellowstone panorama, except as something hardly larger than a fly. Beyond the opposite edge of the chasm the spectator could see across the vast plain out of which the Grand Canyon had been cut, his eye reaching the tops of far, shining mountains that seemed to swim on a faint blue haze. The storm which he had "got in good" hovered over the chasm, a great nimbus cloud dropping streaks of dark rain and hail, like a cataract from the sky. At one point a rainbow gleamed, and above it shone a blue sky, thinly laced with cirrus clouds.

Moran was still intent on keying up the picture late in April, his final stints of work interrupted by frequent visitors, many more than had watched his progress on the Yellowstone view. "The callers are all friends of the artist," Gilder wrote in the *Newark Register*, "and take a deep interest in his labors; but they would show much greater consideration for him if they would wait until the picture is finished before calling to see it."[44] The most annoying interrup-

[44] March 31, 1874.

tion came from the tax assessor, who, on seeing the picture on its easel, inquired the value and promptly hiked Moran's taxes by one hundred dollars. Perhaps the most welcome visitor was Major Powell, who was full of warm congratulations.

"It required a bold hand to wield the brush for such a subject," wrote the Major. "Mr. Moran has represented the depths and magnitudes and distances and forms and color and clouds with the greatest fidelity. But his picture not only tells the truth . . . it displays the beauty of the truth. The somber shadow in the foreground, the light in the distance, the great clouds that roll in the gulches, the cloudlets that hide in the chasms and creep along the face of the cliffs—all of these features, and many others, are so arranged as to give a most vivid and grand picture."[45]

On its completion, Moran displayed the painting in Newark's Upper Library Hall, and for two days local people crowded around it. Then he took it to New York City, where he showed it first in Leavitt's Art Rooms, then in the gallery of Knoedler and Company, successors to Goupil. In June he sent it to the Corcoran Gallery at Washington. Everywhere it attracted people like the Yellowstone canvas, perhaps even larger numbers, but their reactions were much more mixed.

The critics treated the work with great respect, but in nearly every instance they advanced some reservations. Moran had sought to encompass too much, some thought: "There is no use in trying to paint all out-of-doors."[46] Major Powell had intended a compliment when he said: "Altogether it is a most composite picture; a picture of many pictures."[47] Others, noting its composite character, thought that Moran had failed to impose sufficient unity upon the misbehaving scene. Moran was well aware that the scenery misbehaved; he had made no attempt to beautify it, to give it regularity; he had striven for a sublime effect, and his conception of the sublime, a most traditional one, presupposed elements to arouse the fears of

[45] Scrapbook, p. 50 (unidentified clipping), Moran Collection, East Hampton Free Library.
[46] Quoted in [Clarence Cook], "Art," *Atlantic Monthly*, Vol. XXXIV, No. 203 (September, 1874), 376.
[47] Scrapbook, p. 50, Moran Collection, East Hampton Free Library.

spectators. It surprised him, perhaps, when even the critic of *Scribner's*, otherwise his staunchest supporter, quailed at "an oppressive wildness that weighs down the senses. You perceive that this terror has invaded the sky," the notice ran. "Even the clouds do not float; they smite the iron peaks below with thunderous hand; they tear themselves over the sharp edges of the heaven-defying summits, and so pour out their burdens in showers of down-flying javelins. In spite of the showers, the sensitive spectators will be dismayed. This seems to be a glimpse of another planet."[48] In the *Atlantic Monthly* Clarence Cook, so hearty in his praise of the Yellowstone canvas, found the new picture "wanting almost entirely in the beauty that distinguished [the] earlier work."[49]

Perhaps the most common objection of all was the claim that Moran had failed to establish a proper scale, grounded in a sure and readily apprehended measurement (apparently his trees and shrubs failed of their purpose for many people), and so did not succeed in conveying the magnitude of his subject. "It rather gives us the belief that we are looking through a rocky mass of limited dimensions," wrote the critic of the *New York Times*.[50] Many could not believe the distances were as great, the canyon as deep, or the walls as high as they were said to be. Here was a difficulty that Moran had recognized and sought to cope with, a difficulty inherent in every scene he had depicted. Dutton was to recognize that fact when he wrote of the view from Powell Plateau: "The defect which usually mars all canyon scenery is here more pronounced. It is false perspective, the flattening of objects through want of gradations in tones and shades, and the obscurity of form and detail produced by the great distances and hazy atmosphere."[51]

Yet with all the adverse criticism, *The Chasm of the Colorado* was a triumph for Moran. Early in July Congress appropriated another ten thousand dollars for its purchase, and it eventually came to hang in the Senate Lobby with *The Grand Canyon of the Yellowstone.*

[48] "The Chasm of the Colorado," *Scribner's Monthly*, Vol. VIII, No. 3 (July, 1874), 373.
[49] Vol. XXXIV, No. 203 (September, 1874), 377.
[50] May 12, 1874, p. 8, col. 4.
[51] *Tertiary History*, 164.

Moran believed there were certain subjects a painter should not attempt. He could never agree, however, with those who placed the Grand Canyon of the Colorado in such a category. He regarded it rather as a sublime and exacting ideal, whose challenge an artist might strive to meet, and even to equal. In the future he would return to its inspiration again and again.

VI *Mountain of the Holy Cross*

⚜❋⚜❋⚜❋⚜❋⚜❋⚜❋⚜❋⚜❋⚜❋⚜❋⚜❋⚜❋⚜❋⚜❋⚜

Late in 1873 Appletons commissioned Moran to illustrate an
article on the Rocky Mountains for *Picturesque America,* and
once again, from Jackson photographs, he was obliged to sketch
places he had never seen. Ironically, the author, William H. Rideing
of the *New York Tribune,* had gone with that division of Hayden's
survey that Moran had planned to join; so the designs Moran made
early in 1874 must have given him a ghostly feeling of the might-
have-been. There were thirteen scenes of such places as the Garden
of the Gods, Long's Peak, Boulder Canyon, Monument Park, Pikes
Peak and Chicago Lake, then said to be one of the highest snow-
lakes in the country. A most unusual landmark, called the Mountain
of the Holy Cross, intrigued Moran more than any other feature in
the assignment and caused him keen regret that he had not accom-
panied Hayden's party.

The Mountain of the Holy Cross, said to have received its name
from Spanish priests long ago, had become a theme for legends,
fostered by its inaccessibility and by the freakish marking of its pre-
cipitous face; two enormous transverse gullies had trapped perpetual
snow in the form of a shining cross. The peak stood about one hun-
dred miles west of Denver at the head of the Sawatch Range. It was
rendered doubly elusive by its having been misplaced some thirty
miles on the various maps and by the circumstance that Notch
Mountain obscured its presence from the east. Few men had seen it.
None had climbed it till the summer of 1873, when one of Hayden's

parties had established a geodetic station on its crown. The approach had been so difficult that W. D. Whitney, a guest professor from Yale, had predicted that another ascent would be achieved "only after years, if at all."[1] Jackson had made a superb photograph from the vantage point of Notch Mountain, the cross of snow gleaming against the towering face. So stirred was Moran at the thought of it that he resolved to see the marvel for himself, whatever the difficulty, and paint a large picture of it, one to rival, if not excel, his panoramas of Yellowstone and the Colorado chasm. He was in touch with James Stevenson during the winter, and Stevenson agreed to conduct him there, come summer, subject to Dr. Hayden's approval. As Hayden knew the value of a spectacular picture for advertising his survey, he authorized a second expedition to the Holy Cross.

Moran reached the survey headquarters outside Denver early in August, long after the several parties had taken the field. Stevenson had remained behind at the base on Clear Creek to see that needs of the various operations were supplied. There was a delay of several days, owing to Stevenson's official responsibilities, but on Saturday, the eighth of August, the small expedition was ready to start, Moran finding himself in the company not only of "Jim" but also of J. S. Delano and L. W. Woods, of Washington, D.C., as well as a wagon driver and a Negro cook. They rode on horseback to the edge of the plain, reaching the town of Morrison at four in the afternoon. "It was rather an interesting place," Moran reported to Mollie, "though there was nothing I wanted to sketch. We spent the evening at the house of a man . . . whose daughter, a widow about 16 years old, played the piano & sang for us. The singing was the funniest thing I ever heard but she clawed the instrument pretty well."[2] Two nights later found the party in camp on the South Platte River; Moran thought the scenery beautiful, for they were well into the mountains now. Pikes Peak had loomed fifty miles or so to the south, a snowy cone; he made no effort to sketch it while they marched, "but I can remember it near enough," he assured Mollie. "I do not take

[1] Quoted in Fritiof Fryxell, "The Mount of the Holy Cross," *Trail and Timberline,* No. 183 (January, 1934), 5.
[2] Letter dated August 10, 1874 (typescript), A2, Moran Papers, Gilcrease Institute.

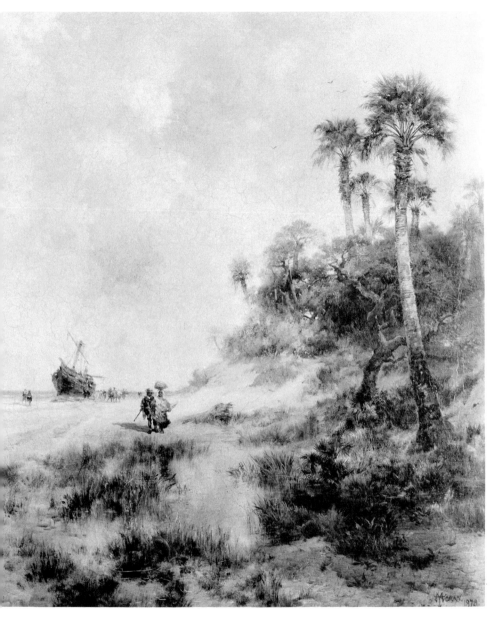

Fort George Island, Coast of Florida, 1878. Oil, 25⅝x21⅝ inches.

Hinman B. Hurlbut Collection,
The Cleveland Museum of Art

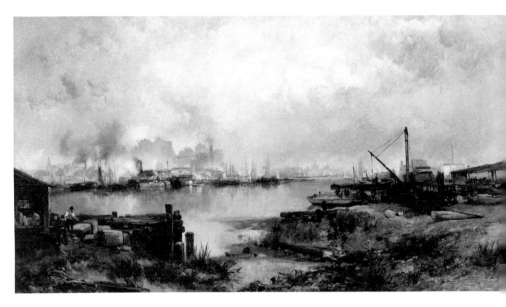

Lower Manhattan from Communipaw, 1880.
Oil, 25³⁄₁₆x45¼ inches.

Washington County Museum of Fine Arts,
Hagerstown, Maryland

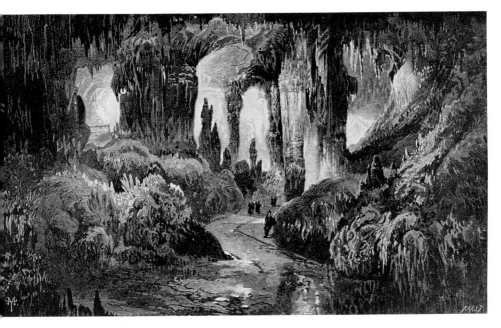

Luray Cave, 1881. Wood engraving, $4\frac{3}{16} \times 7\frac{3}{16}$ inches.

Gilcrease Institute, Tulsa

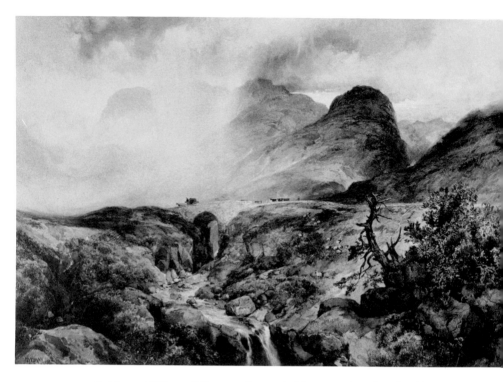

Bridge of Three Waters, Pass of Glencoe, Scotland, 1882.
Water color, 19½ x 29½ inches.

Gilcrease Institute, Tulsa

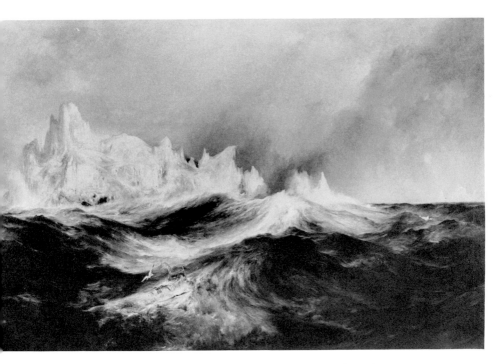

Spectres from the North, 1890. Oil, 74x118 inches.

Gilcrease Institute, Tulsa

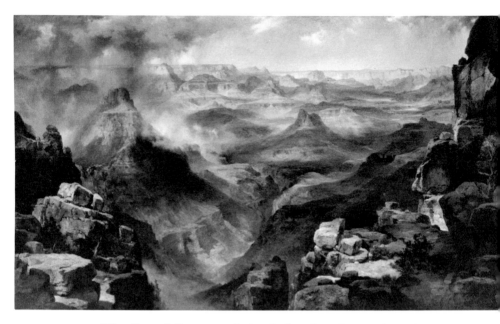

The Grand Canyon of the Colorado, 1892 and 1908.
Oil, 53x94 inches.

Graeme Lorimer, Paoli, Pennsylvania

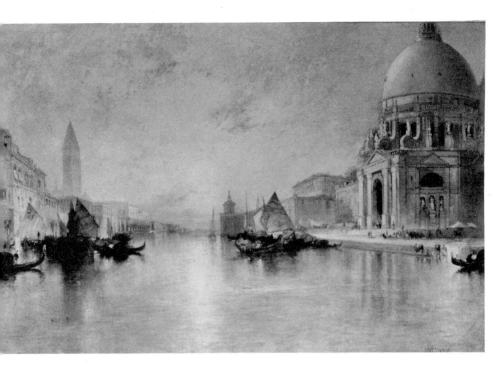

The Opal Venice, 1892. Oil, 18x26 inches.

George Cammann, New York

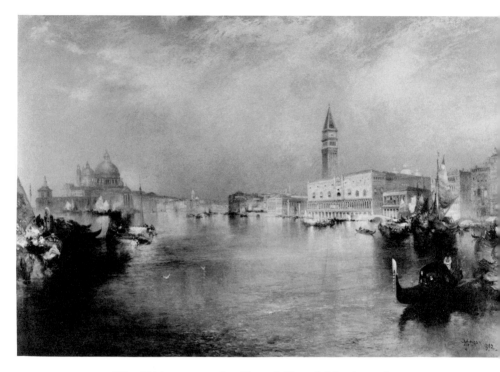

The Entrance to the Grand Canal, Venice, 1893.
Oil, 30x40 inches.

Mrs. W. W. Hoppin, New York

to the bacon very well." But like the rest of the party he was "in excellent health and spirits."[3] He especially enjoyed the company of Woods, who was full of anecdotes and stories.

Soon the party reached the South Park, a rolling plain covered with waving grass and surrounded by mountains. "The main range is now in full view," Moran wrote, "but the forms are very poor. Mt. Lincoln, 14,000 feet high, looks like a big sand hill." Their course took the travelers through Fairplay, "a regular out west mining town . . . made up mostly of drinking saloons," though they were able to get a tolerable dinner at a small hotel.[4] On Friday evening they camped near Buffalo Peaks, then crossed the Park Range at an elevation of 11,000 feet, the road "awfully steep." It descended alongside a tributary of the Arkansas River; Moran and Woods left their companions to fish the stream, "and we brought back a large lot of trout," Moran wrote.[5] Camp was pitched on a grassy plain near the river, in the midst of the Weston Ranch, where the cook bought milk and eggs. This was as far as common sense permitted the use of a wagon; the span of mules could be packed as far as their destination, but as the wagon driver now needed a mount, the party was obliged to wait at the ranch while Stevenson rode to the mining town of Oro to buy another horse.

On Monday the seventeenth Moran and his friends rode up the Arkansas and camped near the Great Divide, where the horses broke away and the whole company was hard pressed to round them up before nightfall. The next morning the cavalcade crossed the divide at Tennessee Pass and began to descend Eagle River. Rocks barred their path, there was much fallen timber, and it was necessary to climb and descend a number of high hills. "It was a hard day's ride," Moran concluded; but in spite of his weariness, he again left the party and fished with Woods in the roaring stream. "We brought in a fine lot of trout & we feasted on them. Our camp was beautifully situated in a grove of firs beside the river & we made a splendid

[3] Letter dated August 11, 1874 (typescript), A2, *ibid.*

[4] To Mary Nimmo Moran, August 13, 1874 (typescript), A2, *ibid.*

[5] To Mary Nimmo Moran, August 24, 1874 (typescript), A2, *ibid.* Fryxell includes this letter in "Thomas Moran's Journey to the Mount of the Holy Cross in 1874," *Trail and Timberline*, No. 203 (September, 1935), 103–105.

bed of fir boughs & slept well." They rode only five miles farther the following day then made camp in order to rest before beginning the final lap of their journey, "for here the real difficulties were to commence."[6] Moran and Woods went fishing again, and they also shot seven dusky grouse, a welcome addition to their camp fare.

On Thursday the travelers started up the ridge between their last bivouac and Cross Creek Canyon, and Moran decided that the route demanded the hardest climbing he had ever done: it was not only steep, the ground was also littered with burnt and fallen timber, three or four feet deep. Here the expedition of last year had turned back to recoup for a second attempt. It took perseverance to coax the horses through such tangles of logs, and the riders had to dismount and walk much of the way. The climb tired the whole party, but as Moran was so thin and wiry, he suffered from the altitude less than the others; high mountains apparently gave him a sense of well-being; he seemed to feel at home there: "As light on his feet as a mountain goat"—so one description of him ran—"he had no more conception of fear than if he were made of rubber, and the fall of a thousand feet was simply the question of how high he might rebound on striking the rocks below."[7] He felt a great exhilaration on reaching the ridge top and the view it commanded.

"Two thousand feet below us," he noted, "lay the valley with the Holy Cross Creek rushing through it & at the head of the valley the splendid peak of the Holy Cross, with the range continuing to the left of us. The descent into the valley was even steeper than the ascent had been but was freer from fallen timber. We got down . . . without accident, but Horror!!!! the way up the valley was worse than anything we had yet encountered."[8] There was a boggy meadow covered with high, coarse grass and filled with rotting logs, and out of it reared smooth and slippery rocks, or *roches moutonnés*. The party worked through the bog with heartbreaking effort; a horse slipped from one of the sheep rocks and punched "a hole in his belly." A fir bough struck Moran in the eye, and it gave him pain

[6] *Ibid.*
[7] Pangborn, *Picturesque B. and O.*, 20–21.
[8] To Mary Nimmo Moran, August 24, 1874.

for the rest of the day. Rain began to fall; the rocks and logs became more slick and treacherous. After three hours of gruelling toil, and a gain of only three miles, the climbers reached a pine-sheltered flat, where they made a fire and dried their clothes, cooked supper, and pitched their tent for the night.

The next day three of them—Moran, Woods, and Stevenson— tackled Notch Mountain, leaving Delano behind, too weary for further climbing. "We started at 8 o'clock," Moran wrote, ". . . the toughest trial of strength that I have ever experienced. . . . Woods was very weak & came on slowly, but I stood it all right."[9] By two-thirty they had reached an elevation of twelve thousand feet. They were still eight hundred feet below their goal, but as they now had a splendid view of the cross, they gave in to their weariness and went no further. The sky had cleared from yesterday's storm, and the mountain loomed before them in clear relief, its vertical face of granite dropping some three thousand feet from the summit to the amphitheater where a green lake nestled, the fountainhead of Cross Creek. And what a titantic cross!—the upright fissure reaching over eleven hundred feet, with each arm at least two hundred feet long, formed by a bench weathered into the granite. Moran called the view "one of the grandest he [had] ever seen"[10] but failed to record whether he sketched it from his perch on Notch Mountain. He wrote only that he and his friends rested for a half hour, then began their difficult descent, to reach camp three hours later. In the valley they passed a picturesque waterfall, which Moran promised to use in the foreground of his projected picture. Here was an example of his disregard for the literal facts of topography, for where the waterfall spilled over its ledge, the Mountain of the Holy Cross could not be seen. He later declared of the picture: "The idealization of the scene consists in the combination and arrangement of the various objects in it. At the same time, the combination is based upon the characteristics of the place. My purpose was to convey a true impression of the region," not its strict topography.[11]

[9] *Ibid.*
[10] *Rocky Mountain News,* September 1, 1874, p. 4, col. 2.
[11] Quoted in Sheldon, *American Painters,* 126.

That night the party lounged around a large campfire, and Stevenson said that in all of his mountain work he had never seen "worse travelling." All were still tired and worn next morning, even the horses, who had received little to eat except the coarse bog grass which held no nourishment. Nevertheless, the men at once packed up and began the return march. They retraced their way as far as Weston's Ranch, where a downpour caught them and they took shelter for a day, entertaining themselves with a pack of cards. Then they made a detour to the Twin Lakes, one of which Moran had drawn for *Picturesque America*. Their rocky basins lay near the Arkansas River, which emerged from a narrow gorge, and their icy waters drained into a stream that joined the river. Rideing suggested:

> Our illustration "does not exaggerate the chaste beauty of the upper lake, the smaller of the two. The contour of the surrounding hills is marvellously varied: here softly curving, and yonder soaring to an abrupt peak. In some things it transports us to the western Highlands of Scotland, and, as with their waters, its depths are swarming with the most delicately flavored, the most spirited and largest trout.[12]

Moran no doubt indulged in his favorite sport; then if his party followed their planned itinerary, they returned to Weston's, retraced their route to Fairplay, gave up their horses there, and took a stage to Canon City, whence the Rio Grande Railroad whisked them down to Denver, and the *Rocky Mountain News* heralded their return. Moran had a thin portfolio of drawings, much thinner than after either Yellowstone or the Grand Canyon trips. "I have not done much sketching," he admitted, for he had been too busy with other tasks, the trip too strenuous to leave him time or inclination for the sketch pad, but he added that he had "done a good deal of looking,"[13] all that was necessary to stock his tenacious memory. He left Denver for the East on the last day of August.

Moran began *The Mountain of the Holy Cross* soon after reaching Newark. The canvas, seven feet by five feet, was more than twice as large as his ordinary oil but less than half the size of his Yellow-

[12] "The Rocky Mountains," in *Picturesque America*, II, 498.
[13] To Mary Nimmo Moran, August 24, 1874.

stone and Grand Canyon panoramas. In one respect the design was hardly typical of his oils, especially his mountain landscapes; it was a vertical arrangement, and on the whole he preferred the wide, horizontal picture, as being more in harmony with the panoramic ideal. He would resort to the vertical scheme only on the rare occasions when, as now, the subject gave him little choice. As he had decided in the depths of the Rockies, he worked the cascades of Cross Creek into the foreground; the water lashed itself into a white foam against the gray and jagged rocks that choked its course; he scattered the banks with riven pines and firs and cedars, while from clefts closer to the observer grew mats of grass and wild flowers; a darkened bluff to the right was studded with cedars and arborvitae and a few storm-twisted pines. Moran took great pains with the delineation of the form and texture of the rocks; they were "realized to the farthest point I could carry them," he once remarked. "I elaborated them out of pure love of rocks. I have studied rocks carefully and I like to represent them."[14]

Here, then, he characteristically caught the foreground at close range, and in minute detail, in contrast to the distant center of interest. As the eye climbed the stream back into the middle distance, where the current swept around a cedar-strewn jut of debris, it marked the fallen timber scattered over the rocks. Such was the scene that he had found in Cross Creek Canyon, and in his composition he merged it with a view of the peak itself, as he remembered it from Notch Mountain. Mists, melting into light, obscured the lower reaches of the mountain, but the summit was clear, though softened with the subtle gradation of distance; and on its face gleamed the white cross, sloping slightly toward the picture-left, with its arms elevated just a trifle. Characteristically, Moran executed the peak in light, delicate tones, in contrast with the predominantly darker values of the middle distance and, especially, of the foreground.

He did not plan *The Mountain of the Holy Cross* as another picture for Congress but hoped apparently that it might hang in the Corcoran Gallery in Washington as a companion piece to Church's *Niagara* and Bierstadt's *Mount Corcoran*. When it was finished, he staged a reception at his house in Newark—he now lived at No. 9

14 Quoted, Sheldon, *American Painters*, 126.

THOMAS MORAN: ARTIST OF THE MOUNTAINS

Thomas Street—and "nearly all the prominent citizens of that place were present."[15] Then early in April, 1875, he moved it to the Broadway gallery of Schaus and Company, in New York City, and it was at once pronounced his masterpiece, superior in the opinion of most critics to either the Yellowstone or the Grand Canyon panorama. The *Aldine* was sure that Moran had now "made one of those exceptional professional leaps which bridge the chasm between reputation and immortality,"[16] and the critic of the *New York Times* was certain that *The Mountain of the Holy Cross* would "take rank as one of the finest examples of American landscape art."[17] Moran was pleased with its reception, and he wrote to Powell that it had "received the highest praise from the artists and the public with a fair share of newspaper laudation."[18] The picture remained at the Schaus gallery till late in May; then Moran sent it to the Corcoran in Washington, where to his disappointment it failed to find a permanent place. Later in the year he shipped it up to Boston, along with other western scenes that he had just completed, and it hung for several weeks in the gallery of Elliot and Company. There the poet Longfellow, who knew of Moran's concern with Hiawatha, may have seen it and recalled it later when he wrote the sonnet on "The Cross of Snow," which was published after his death:

> *There is a mountain in the distant West*
> *That, sun-defying, in its deep ravines,*
> *Displays a cross of snow upon its side.*

The Mountain of the Holy Cross was Moran's chief contribution to the Centennial Exposition at Philadelphia in 1876. Later it was shown at the Royal Academy in London, where Mrs. William A. Bell, of Manitou, Colorado, saw it and called it to the attention of her husband, an official of the Denver and Rio Grande Railroad.

[15] Scrapbook, p. 54 (clipping dated April 3, 1875), Moran Collection, East Hampton Free Library.

[16] "Moran's 'Mountain of the Holy Cross,'" *Aldine*, Vol. VII, No. 19 (July, 1875), 379.

[17] April 10, 1875, p. 3, col. 7.

[18] Letter dated May 10, 1875, Letters Received, Powell Survey, National Archives (Microcopy 156, roll 3, frames 208–209).

Dr. Bell subsequently bought it for five thousand dollars, and it hung for years at Briarhurst, his Colorado mansion, where it narrowly escaped destruction when the house burned. The canvas had to be cut from the frame, which had been securely fastened to the wall; later Moran himself repaired the damage for a fee of five hundred dollars. After Dr. Bell's death, the widow took the painting to her estate in Surrey, England. Later still, it was acquired by Huntington Hartford and now hangs in the Gallery of Modern Art in New York City.

Meanwhile, during the time of his preoccupation with the Mountain of the Holy Cross, Moran painted several other notable canvases. First among them was his *The Valley of the Rio Virgin*, which involved, essentially, the scene of his *Rock Rovers' Land*, engraved for the *Aldine*. The center of interest was the Vermilion Cliffs, the upper stratum almost white, the lower strata passing through yellow to vermilion, and from that to a striking purple for the sandstone that formed their base. Above the cliffs reared the tips of the Pine Valley Range, at the base of which stood the village of Toquerville, through which Moran had passed on his way to Kanab. At the extreme left he included the Santa Clara Range of southeast Nevada, toward which the Rio Virgin flowed through the middle of the picture. He revealed a band of Piutes riding down into the valley on their way to a talk with Major Powell, and over all he cast the delicate glow of early morning.

In 1875 he painted another picture on the same scale, *The Azure Cliffs of Green River*, likewise developed from a scene that the *Aldine* would engrave. A bluff of turreted rocks glowed red with sunrise; from it a ledge studded with cottonwood trees pushed out into the valley where the river rippled along the cliff base, a gleam of the sky caught in its greenish water. On Moran's sending the work to the Royal Academy, an American critic predicted that "aesthetic gentlemen who have no knowledge of American scenery" would open their eyes and say, "We never allowed anybody but Turner to use color in this manner."[19] Another scene painted the same year,

[19] Unidentified clipping, Envelope 179, Moran Collection, East Hampton Free Library.

Rock Towers of the Colorado (later renamed The Glory of the Cañon) half revealed the soaring forms of pinnacles that loomed through an opalescent haze. In the left middle distance the river emerged as a swirling rapid from the blue recesses of the canyon; it swept diagonally to the right, then abruptly reversing its course, it flowed off the lower left corner of the canvas, blue and placid except where it caught the gold of the sky. Dark trees crowned a low promontory in the foreground, its cap of rocks at one point shining with highlights of yellow, at others subdued in shadow. Not only did Moran develop a contrast between the dark values of the foreground and the light, airy opalescence at the center of interest; the picture also involved a favorite device of his for space projection—that is, an alternation of stretches of dark and lighter values. Moran considered the Rock Towers a highly successful picture and kept it in his possession for the rest of his life. It was a production of which Turner might have been justly pleased.

Even more Turneresque was Dream of the Orient, which Moran completed in 1876. It was vaguely suggestive of Venice, which he had, thus far, seen only in the works of other artists. A golden halo shone from the setting sun over the edge of a placid sea. There was a group of boats and barges with a towered city rising from the shoreline behind them, and in the mirror-like surface of the water shone all the color of the sails and the mosques and minarets—color that seemed magically diffused in the mist that filled the entire composition.

Moran, had thus on hand an effective group of pictures from which to choose his offerings for the Philadelphia Centennial. John Sartain, an old friend who was in charge of the art displays at Fairmount Park, accepted five of his canvases for exhibition along with a water color and six Hiawatha drawings. Fifteen rooms in Memorial Hall were devoted to American paintings, the walls cluttered with one thousand canvases. Some were by artists of the past, but most were by contemporaries; some were historical, some genre, and some portrait, but landscape easily predominated (about one-third of the entire show was of Hudson River vintage), and landscape painters received at least half the prizes. The judges awarded The Mountain

of the Holy Cross a gold medal with a diploma "for excellence in landscape painting."[20] The honor somewhat allayed the disappointment Moran felt when Congress refused him permission to show his Yellowstone and Grand Canyon panoramas at Memorial Hall. Although denied the spectacle of his most famous work, the public still responded warmly, if not with the most acute intelligence. One critic observed visitors returning again and again to Moran's glowing sunsets, "although they apprehended but dimly the ideas the artist intended to convey."[21]

Shortly after the Exposition had opened, a commission came to Moran from an unexpected quarter, the Women's Centennial Committee of Wisconsin. Mrs. J. G. Thorp, of Madison, approached him late in the spring with a sad story. The Committee of which she was a moving force had decided on the beauty of the Four Lakes region surrounding Madison as the theme for Wisconsin's fine arts contribution to the Fair. As she was related by marriage to Longfellow, she had succeeded in pursuading the gentle old poet to apostrophize the Four Lakes, the poem to be framed for exhibition, and he had taken the mythic approach:

> *Four limpid lakes—four Naiades*
> *Or sylvan deities are these,*
> * In flowing robes of azure dressed;*
> *Four lovely handmaids, that uphold*
> *Their shining mirrors, rimmed with gold,*
> * To the fair City in the West.*

In the second stanza "coursers of the sun" drank of their waters, and in the third the lakes were "serene and full of light," and the town was "arrayed in robes of white." Apparently Mrs. Thorp's instructions had not been clear when she ordered of a Colonel Fairman in Paris four landscapes to illustrate Longfellow's verses. The Colonel had taken "four Naiades or sylvan deities" at face value

[20] Diploma, A3, Moran Papers, Gilcrease Institute.
[21] John V. Sears, "Art in Philadelphia," *Aldine*, Vol. VIII, No. 9 (September, 1876), 283.

and had painted four allegorical figures to symbolize the lakes, a course which disappointed the intention of the committee.[22]

In spite of the short time remaining for the execution of the task, Moran agreed to go to Madison and see the lakes and paint two pictures—not four—to constitute Wisconsin's display in Memorial Hall. Mrs. Alexander Mitchell had agreed to pay for one picture outright; the other would be bought by public subscription. Mollie joined him for the trip, and they spent several days in Madison during July, in sketching while they drove about the countryside or sailed upon the lakes. The commission prevented Moran from going farther West for another season in the canyon country of Utah or Arizona.

Moran completed the first scene, *Sunrise on Lake Monona*, by the end of summer, and the second, *Sunset on Lake Mendota*, arrived at Memorial Hall sometime in October. Sartain pronounced both scenes "supremely good,"[23] and when the Centennial closed they were shipped to Madison. Mrs. Mitchell offered hers, the sunrise, to the University of Wisconsin, to hang in the new art gallery in Science Hall, provided that the subscription could be carried for the purchase of the other. A local writer declared in support of the project that the scene on Lake Monona was not just "a topographical drawing of each tree and house and hencoop. But should we ever wander to a foreign land and should our heart be yearning . . . for our home between the lakes . . . thus it would appear to us, as a vision of cloud forms, of vague gleams upon the waters, and cresting the green slopes in the center, the white dome of the Capitol, dreamy, dim, and distant."[24]

The same writer spoke of "glory that envelopes the scene" on Lake Mendota, and he observed:

The sun is setting in the centre of the picture. [It pierces] the storm cloud . . . and sends a track of red light across the water, while the

[22] Louise Phelps Kellogg, "Wisconsin at the Centennial," *Wisconsin Magazine of History*, Vol. X, No. 1 (September, 1926), 11–13.

[23] John Sartain to Mrs. A. C. Thorp, October 24, 1876; Scrapbook, p. 62 (clipping), Moran Collection, East Hampton Free Library.

[24] Unidentified clipping signed J. R. Sand and dated December 7, 1876, Envelope 179, Moran Collection, East Hampton Free Library.

sky above is ablaze with light and color; purple shadows are trans-
fixed by long rays . . . which touch the fragments of cloud with
gold. . . . Note the cool grey tones among the cumulous red masses
on the right, and still further to the right the bit of clear green sky
on the horizon, and the weird purple cloud forms there, just as
we used to watch in our childhood, and shape, by our imagination,
into dragons and giants, and again in their metamorphoses [we
thought] "very like a whale."[25]

Such was the scene that must be purchased by subscription. Ole
Bull, the violinist, gave a benefit concert, and the governor made
a generous contribution; the subscription carried, and the paintings
were hung in the new gallery as a nucleus for an art collection. Alas
for them, Science Hall caught fire on the evening of December 1,
1884; the local fire crew, thinking the alarm was a student prank,
halted their engine along the way, and the building burned to the
ground, with everything inside it. This loss and the narrow escape of
The Mountain of the Holy Cross impressed Moran acutely with the
danger from fire; and after his death, when Ruth Moran presented
an assortment of his sketches to the National Park Service, a con-
dition of the gift was that the works must be housed in fireproof
quarters.

[25] *Ibid.*

VII *Where the Bittersweet Orange Grows*

꧁꧂꧁꧂꧁꧂꧁꧂꧁꧂꧁꧂꧁꧂꧁꧂꧁꧂꧁꧂꧁꧂꧁꧂꧁

Moran's enthusiasm for the Far West had not reduced his exuberance in painting the Madison lakes. He now began thinking of semitropical scenes in the South. A few years before, he had assisted in the illustration of a series of papers published by Edward King in *Scribner's* and then collected in 1874 in a volume called *The Great South*. The task had involved redrawing on boxwood blocks many sketches by J. Wells Champney, who had accompanied King on his Southern tour. Among the scenes that Moran reworked were several in northern Florida, some along the St. Johns River, an area King described in such romantic terms that Moran conceived of it as a worthy subject. King depicted the river as "dark blue," though if the water were taken up in a glass it had the hue of diluted coffee. On the banks, Moran read, one found nature lush and teeming. "The very irregularity is delightful, the decay is charming, the solitude is picturesque. The bittersweet orange grows in wild profusion." The feeling that had impelled him to paint a Caribbean island at the start of his career stirred in him again. Then in February, 1877, the chance came for him and Mollie to go south in connection with an article that *Scribner's* planned to run on Fort George Island, at the mouth of the St. Johns River.

Washington's birthday found the two sketching at St. Augustine, famed as the oldest city in the country, though hardly more than a village on a sandbank surrounded on the land side by stunted pines

and a swamp. There was a venerable cathedral, but it was hardly the subject for a picture, shaped as it was like a nondescript barn. The city's ancient gate consisted of two coquina pylons, and there was an old fort that looked no different from a hundred other old forts scattered about the land. Moran's disappointment evidently precluded a single canvas of the city or its landmarks. Yet in one thing St. Augustine had seized his fancy—its association with the Spanish explorer Ponce de León. The city let no one forget that on a white level beach nearby the explorer first set foot on Florida earth. Perhaps Moran could already visualize the glitter of arms, the blaze of gold and scarlet, the cross flashing in the sunshine as the small party disembarked; but Ponce de León had not tarried where St. Augustine would rise, and Moran, when at last he came to paint the explorer and his party, would place them in a forest glade near the broad St. Johns, so silent and slow moving.

How soon Moran reached the river is not clear, but he found it more congenial than the city, a better subject to paint, with its banks lined with long-needled pines and live oak trees, many festooned with Spanish moss. Moran sketched the river with its floating water plants, the boats, the palm trees rearing from the lower growths upon its banks, brilliant with seventeen rapturous shades of green. The first of March found him at the river's mouth, sketching palms on Fort George Island, their lissome trunks swaying in the trade winds. No doubt he and Mollie had ridden the *Water Lily* on its daily trip to the island, a twenty-five-mile run down the river from Jacksonville. They seem to have ranged from one end of the island to the other—"some twelve hundred acres of low wooded plateau," as it was described in the article that Moran illustrated, "surrounded mostly by a band of salt meadow of varying width, beyond which, on the eastern and southern sides, three or four miles of fine beach stretch along the sea."[1] Miles of road had been cut through the woods in all directions, sometimes paved with oyster shells, and Moran drew several scenes for *Scribner's*—there was Palmetto Avenue lined with palms lifting their fans fifty or sixty feet into the air, "the boast of

[1] Julia E. Dodge, "An Island of the Sea," *Scribner's Monthly*, Vol. XIV, No. 5 (September, 1877), 653.

the island and unequaled upon the continent."[2] There was also Edgewood Avenue, skirting clumps of cypress and cedar mixed with palms and Spanish bayonet, while the block that Moran labeled *The Southern End of Fort George Island* showed a causeway through a marsh, with a moss-hung tree beside it. He sketched the bar between the shore and the sea, alive with gulls and pelicans; Point Isabel with its blue lagoon locked from the waves by a yellow strand; and the Ghost House, dating back from the time of Captain Kingsley, the island's sole ruler, who had brought in his own ships the blacks who worked the sugar cane. It was a large unfinished house of co-quina, and legend held that its construction had stopped with the violent death of its builder. Its roofless walls stood near the road; tall trees filled the enclosures, and every Negro on the island claimed he had seen the "hants" that walked there—sometimes "a woman all in white," sometimes "a great wolf wid eyes like fire."[3] Moran also sketched the slave quarters round a spring where a few black families still existed, former slaves who knew of nowhere else to go.

The week the Morans spent on Fort George Island led to few oil paintings by Moran; in fact three trips to Florida within a decade resulted in scarcely more than one dozen known paintings over a period of fifteen years. As a friend said, "The scenery of Florida did not especially appeal to him."[4] Yet among his Florida paintings were several excellent works, in some of which he took pride. Disappoint-ment with their reception may have dulled his interest in the South-ern scene.

He painted his *Ponce de León in Florida, 1512* almost at once after returning to Newark. It was a large canvas, over five feet by nine feet in dimensions, and he aimed to suggest a dramatic histor-ical event. Ponce de León and his followers stood in a grassy open space, holding a parley with a band of Indians. The figures held the center of interest, but they were dwarfed by surrounding semitropical verdure. In fact, Moran's real interest was in painting the forest that enclosed the glade with gigantic trees and riotous undercover. He

[2] *Ibid.*
[3] *Ibid.*
[4] G. H. Buek, MS, B22, Moran Papers, Gilcrease Institute.

made the picture radiant with rich greens and the gold of sienna, though the soaring treetops robbed the undergrowth of all direct light. A warm glow filled the open where the men stood, and overhead a patch of blue shone through the foliage. He had planned the picture to fill an empty panel to one side of the Speaker's desk in the House of Representatives, and with that objective he took it to Washington late in the year and displayed it in the Wright Building on G Street, where many people saw it in spite of dim and unsuitable light. On January 18, 1878, he requested permission of the proper joint committee of Congress to hang it in the panel for which it was designed.

His petition concluded:

So far as I am aware, with the single exception of *De Soto Discovering the Mississippi,* there has not been any picture . . . purchased for the Capitol that has any reference to the early history of the Southern States, and it seemed to me that a picture commemorative of the first attempt at settlement, and characteristic of the semitropical part of our country, would be a proper pendant to a picture already purchased representing a later and more northern discovery.[5]

Moran's request to hang the painting in the House seems to have been denied, and in April he arranged to show it in the Corcoran Gallery. After a week the curator was much discomfited by the vehemence of a certain Mr. Worthington of Georgetown, "an old resident of Florida" who claimed that Moran's trees were "utterly unlike the timber of that State." However mistaken, such objections may have influenced the joint committee on their visit to the gallery to inspect the work. The painting failed to impress a sufficient number of congressmen, and instead of it, as Moran jotted in his record book, Congress "foolishly [bought] Bierstadt's poor picture of the Discovery of California."[6]

[5] To the Hon. T. O. Howe, January 18, 1878 (printed leaflet), L–12, Moran Collection, East Hampton Free Library.

[6] Quoted from records of the Corcoran Gallery in Horace H. F. Jayne's "Moran and His 'Florida Landscape,'" *Pharos* (Summer, 1964) (on third unnumbered page of article); "Partial Memoranda concerning Pictures from Dec. 1, 1879," Moran Papers, Gilcrease Institute.

Later Moran offered *Ponce de León in Florida* to the Corcoran Gallery "for the nominal sum," it was said, "of one dollar," but for reasons of its own the gallery declined the windfall.[7] And then as if the picture were hexed, certain critics scorned it when it hung in the National Academy show of 1879. "Mr. Thomas Moran's largest contribution to the academy exhibition is a disappointing and unsatisfactory picture," one observer wrote. "There is fine work in it, and a sense of tropical splendor in its luxuriance of color that is interesting and highly decorative: but like many a gaudy flower . . . it is a thing of outer show and shallowness."[8] Its vegetation was simply "too much"; as for the human figures, they were small, stiff puppets.

The same critic thought another, more modest contribution to the Academy exhibition made a better impression: the subject of *After a Thaw—Communipaw Ferry* included wharves, shipping, locomotives, a sugar refinery, "and the gruesome atmosphere of mingled smoke and fog incident to the fragrant waterfront of Jersey City."[9] Such a scene and such an atmosphere were rare in Moran's work, but he brought out all the poetry he could find there. The sky was "full of the radiant mystery of diffused sunlight, soft, tender, and exquisitely delicate, and below it the wet marshes and stagnant pools of the inundated, noisome flats" gleamed with reflected warmth.[10] The picture was effective, in the direction much landscape painting was then about to take in America, that of a moody lyricism or the hard-bitten braggadocio about "the beautiful Dreck" of the modern industrial scene.

Conversely, *Ponce de León* seems to have come too late, expressive as it was of a development that had reached its apogee at the Centennial Fair. There its imposing size would have been a fault in itself, and the luxuriance of its natural setting, even in Moran's relatively broad and bold manner, might have won him a prize. But by now the tradition which the Centennial had supposedly consolidated was rapidly dissolving. In 1876, American taste underwent a sharp

[7] Unidentified clipping dated August 30, 1926, Envelope 179, Moran Collection, East Hampton Free Library.

[8] Scrapbook, p. 33 (unidentified clipping), *ibid.* [9] *Ibid.* [10] *Ibid.*

change. The Fair had given the American public its first comprehensive view of European art, including the latest tendencies; this coincided with the return of a whole generation of students who had worked in the studios of Holland, Munich, and Paris, where they were filled with the leaven of new ideas. They could see little of value in the work of their elders at home, especially those who dominated the National Academy. They were convinced that vital American art was just beginning with themselves. They were vocal, impatient, and insistent, and with their clamor, along with the growing prestige of the new art of Europe, fostered by dealers for their own reasons, the American art establishment underwent a swift change of attitudes.

Smarting from his recent setbacks, Moran saw the situation as the work of cliques. When, for example, he received no invitation to contribute to the Paris Exposition of 1878, he concluded that a clique hostile to his style dominated the jury of selection. Conservative friends sympathized with him and deplored the neglect he suffered. The *Aldine* regretted that the American commissioners had solicited neither *The Grand Canyon of the Yellowstone* nor *The Chasm of the Colorado* nor *The Mountain of the Holy Cross*, works it considered "truly representative of American landscapes."[11] But then the *Aldine's* opinion seemed a bit myopic to many people, as when its observer *Outremer* had wondered publicly, "What excuse can the painter offer for sending, and our judge and jury for accepting, under the head of Fine Arts, such nondescripts as those which bear Mr. [Winslow] Homer's name?"[12] It was a period of confusions, with the lines of opposition not always clearly drawn.

One subject of derision, however, consistently united the younger men—the National Academy of Design. They held it to be hidebound with vested interests. Certainly its dominant members depreciated most of the works of the newer artists, and the Academy tended to ban them from its exhibits. The discontent of the younger men came to a head in the spring of 1877, when they decided to found an organization of their own. This development occurred at the home of Gilder and his wife, Helena de Kay, who had settled in somewhat

11 "Thomas Moran," *Aldine*, Vol. IX, No. 8 (1879), 265.
12 *Ibid.*

Bohemian quarters on East 15th Street, a former stable which they had converted into a "garden studio," in line with Mrs. Gilder's interest in art. The studio was an attractive one, as she described it, "with great shelves for casts and books in the place of honor near the head of Dante by Giotto. Mr. Moran sent R. a hammock, and it hangs across one corner of the room with a beautiful leopard skin below it."[13] Here the Gilders held open house on Friday evenings during the winter months, and Moran and Mollie were often there among the guests, who included Walt Whitman (who was not always welcome at the homes of fellow literati, but who was prompt to acknowledge that "the Gilders took me in"[14]). Here came stage celebrities like Madame Mojeska, Joseph Jefferson (who had studied painting with Moran's brother Edward), and artists such as Stanford White, John La Farge, and Augustus Saint-Gaudens, to name a few. Here, too, the young malcontents met to organize themselves, with Gilder serving as secretary. Years later, Gilder wrote:

> Just then the old Academicians were carrying things with a pretty high hand, so I spoke to a few of the younger men of our American "renaissance" about starting a new organization. When I mentioned it to [Saint-Gaudens] he said that the time had not quite come. But one day . . . he rang the bell at the iron gate at 103 East Fifteenth Street. . . . I ran down to the gate and I tell you there was a high wind blowing! [Saint-Gaudens] was as mad as hops! He declared that they had just thrown out a piece of sculpture of his from the Academy exhibit, and he was ready to go into a new movement. I told him to come around that very evening. We sent, in addition, for Walter Shirlaw and Wyatt Eaton, and the Society of American Artists was that night founded by Walter Shirlaw, Augustus Saint-Gaudens, Wyatt Eaton, and Helena de Kay, your humble servant acting as secretary, though Wyatt Eaton was the nominal secretary.[15]

Shirlaw, who had roomed with Moran and Mollie at Newark upon his return from Europe, was chosen the first president, and it may have been at his bid that Moran became the fourteenth member of the Society, to find himself allied with men whose methods he often

13 Richard Watson Gilder, *Letters of* . . . (ed. by Rosamond Gilder), 62.
14 Quoted, *ibid.*
15 *Ibid.*, 81.

opposed. His *Fort George Island* was hung at the Society's first exhibit in the spring of 1878, but it was clear that, in point of style and technique, he was one of the more tradition-bound members of the group.

The practice of the *pleine aire* men, whether in France or at home, had never appealed to Moran, and allowing for certain rare exceptions, he still worked as he had begun, in the studio from memory, or from shorthand sketches made from nature. This was the conventional method in America, that followed by the Hudson River school and the men from Düsseldorf, and by such younger contemporaries as Sanford Gifford, Homer Martin, and George Inness. Ordinarily Moran would begin a canvas by sketching the composition in charcoal, a step he executed with meticulous care, never stopping until a finished black and white picture existed on the canvas; but once he had fixed his idea, he would wipe the charcoal out, "leaving only a few pencil lines to keep his composition in sight—usually that also changes completely two or three times before the picture is finished" —wrote his daughter—"the color alters things so, and he is easily disenchanted with an effect and paints it out with great strokes of white lead; then once again . . . he is at work to try for the effects he remembers so vividly."[16] He took care with his composition, selecting a solid framework to hold the picture together and constructing it on a firm basis of space arrangement. "His knowledge of form and constructive ability," according to Sadakichi Hartmann, "is quite remarkable, and his skill in composition reveals itself best in the black and white reproductions of his works."[17] Eugen Neuhaus also found Moran "a master of composition."[18]

"The palette he sets is simple," continued his daughter, "—the chromes, raw sienna, burnt sienna, yellow ochre, bright red, cobalt blue, rose madder, asphaltum, & zinc green; usually that is all."[19]

[16] Ruth Moran, Notes, A25, Moran Papers, Gilcrease Institute.
[17] *A History of American Art*, I, 74.
[18] *History and Ideals of Modern Art*, 85.
[19] Ruth B. Moran, Notes, A25, Moran Papers, Gilcrease Institute. The asphaltum has produced some unfortunate changes in certain of Moran's works. Mr. Albert Gallatin, who painted in the 1890's as a youthful student in the artist's studio, assures me that Moran was using it still at that time, especially in his glazes. The effect has

His colors were bright and vivid for the period, in their own way an anticipation of the hues of impressionism, or a harking back to the intensities of older romanticism. "We are apt nowadays to regard the love of primary colors as a trifle old-fashioned," said the *Critic*, "and it requires great excellence in other directions to make us forgive it in a painter of our native school. Mr. Moran's bursts of color are, however, so spontaneous and often so splendid, that we can seldom find fault with them. His Colorado and West Indian subjects show a chromatic audacity which would be successful with but few painters."[20]

It was Moran's custom to build his paintings up with successive layers—"only by repeated painting," he held, "can a man get the quality of nature."[21] There was much glazing with pure color over white, a process which gave his surfaces their remarkable luminosity. As with Inness, his pigments were at first a trifle thin, but he kept adding stronger touches, glazing the shadows to keep them clear and transparent and make them recede in effect, splashing opaque highlights on top of the glaze. He would thus build up a picture, key up one part, and then another, until it was all fused together as a satisfactory whole. A visitor at his studio once described this patient keying-up technique:

> I was told that when he was so engaged he would not stop to talk or eat. . . . He never took his eyes off the canvas. He would get far over to one side and almost across the room, studying the painting closely. Then he would hurry across the studio with his brush poised, make one little stroke and back away, looking neither to right or left, studying again from some other angle. Again he would dash forward, make not more than one or two strokes—then back away.[22]

He used his hands a great deal to supplement his brushwork, "especially the soft padded part of the thumb, wiping off just the right amount with this best of paint rags; and he allows his paint to run &

been that some of his paintings have darkened with age, with a certain amount of wrinkling and cracking.

[20] Vol. VIII, No. 113 (February 27, 1886), 108.
[21] Quoted, Ruth Moran, Notes A25, Moran Papers, Gilcrease Institute.
[22] A. Seely, Jr., Note, Envelope 144, Moran Collection, East Hampton Free Library.

creep at times on his canvas, getting suggestive and realistic effects in his foreground in this way."[23]

There was nothing casual about these methods. "It was fascinating," said the spectator. "If his cigar went out or burned down, he dropped it into the nearest ash tray and without looking groped for a fresh smoke. He was a picture of intensity and energy. I never saw such concentration."[24] He worked long and hard on every canvas, relinquishing none until he was satisfied with its finish. It was over this matter of finish, perhaps more than any other point of style, that he clashed with younger colleagues, whose work he felt was all too often raw and incomplete.

One of the painters with whom Moran disagreed about technique was William M. Chase, just back from Munich (he was later a valued friend, to whom Moran sat for his portrait). Chase served on the hanging committee for the Society of American Artists' exhibition in 1879, and because he opposed "worn-out, old-fashioned methods," a second painting that derived from Moran's Southern trip received a curt rebuff. It was *Bringing Home the Cattle, Coast of Florida,* which Moran had recently finished. He considered it one of his best works, moody and animated, though he was seldom really good with figures of any sort. It showed several cows driven over a rutted road, with a clump of palms in the right middle distance stirring in the wind of a coming storm, a wild beach extending across the background, the sky glowing with an ominous flush. In submitting it, Moran had felt it would attract attention. As the opening day approached, he learned that it had not been hung at all; he rushed to the Kurtz Gallery and demanded an explanation from Chase, who coolly replied that it did not reach the standard which the Society had set for itself—hardly an answer to mollify the enraged artist. "No Academy hanging committee," observed one onlooker, "was ever more soundly rated than the unfortunate body that did not hang up both of Mr. Moran's paintings."[25] Moran de-

[23] Ruth Moran, Notes, A25, Moran Papers, Gilcrease Institute.

[24] A. Seely, Jr., Note, Envelope 144, Moran Collection, East Hampton Free Library.

[25] Clipping identified only as from *Evening Express,* March 8, 1879, Envelope 179, *ibid.*

manded the return of his second picture, a forest scene called *Woodland Reflections*, then stalked from the hall with it under his arm. He at once submitted his resignation, nor would he ever rejoin the Society, and years passed before he again sent work to its exhibits.

A sidelight on the fracas came with a question raised about another entry in the show. "It would be curious," wrote one critic, "to hear upon what principles of art they could have rejected any picture coming from . . . Mr. Moran, and accepted such a desecration of art as is to be found in the large canvas of Mr. Eakins, of Philadelphia, that hangs immediately to the left of the visitor as he enters."[26] That "desecration of art" was the powerful *Gross Clinic*, one of the most provocative canvases of the period. Neither the controversy which it aroused nor the argument over *Bringing Home the Cattle* ended with events in New York. Public interest in the exhibition at the Kurtz Gallery moved the directors of the Pennsylvania Academy of the Fine Arts to invite the Society of American Artists to lend its entire show for the Academy's annual exhibition. The Society agreed, provided its pictures were shown as a unit, a proviso that forbad the very course the Academy now adopted. Not only did the directors invite Moran to send his rejected scene; the hanging committee assigned it to a "place of honor" amidst the pictures of the Society. In turn they rejected the *Gross Clinic*, the blood shown in the operation having made one of the jurors ill. This step, as Eakins himself predicted in a letter of protest, struck all the moving spirits in the Society of American Artists as "a direct insult." Chase led a committee into Philadelphia with an ultimatum that unless Moran's painting were removed and Eakins' hung in its stead, they would withdraw the Society's entire show. The startled officials at the Academy had no choice but to comply, at least in semblance. They shifted *Bringing Home the Cattle* from among the Society's works, but allowed it to remain a feature of the exhibition; then they virtually lost the *Gross Clinic* in the darkest part of the galleries.[27]

Such a course could not have impressed most people then as

26 Scrapbook, p. 33 (clipping), *ibid.*
27 Lloyd Goodrich, *Thomas Eakins: His Life and Work*, 54.

Quixotic or extreme. In 1879 Moran was better known than Eakins, and certainly more appreciated by the general art public. But already, at the height of his career, his younger contemporaries sought to relegate his work to the category of the outmoded and passé. They did not cause him to doubt his methods or to change them in the least to please *avant guard* critics; yet they had thus inaugurated a revaluation that would in time raise Eakins not merely above Moran in critical favor but to the very pinnacle of world acclaim.

VIII *The Tetons: Mountain Glory*

✦❅❀❀❀❀❀❀❀❀❀❀❀❀❀❀❀❀❀❀❀❀❀❀❀❀❀❀❀❀❀

Moran had become identified with three or four enormous oils depicting spectacular vistas; throughout his long career, however, he painted less than one dozen such gigantic pictures, in contrast with hundreds of smaller ones. Twenty inches by thirty inches became his favorite size of canvas, and as his body of work grew, it remained close to these dimensions, on the average. But not only were his pictures so often small in size, they were also low keyed in theme and mood—the opposite of grand. There was, of course, a practical reason for this: the grandiose had been defeated by the popularity of Barbizon or other French conventions. "I prefer to paint Western scenes," he later remarked, "but Eastern people don't appreciate the grand scenery of the Rockies. They are not familiar with its effects, and it is much easier to sell a picture of a Long Island swamp than the grandest picture of Colorado."[1] A Long Island swamp was more like Daubigny's swamp with a single tree; so Moran painted many a Long Island marsh or, in the 1870's, many a meadow in New Jersey.

Sometimes he painted Newark or Passaic meadows, Mollie often going with him on his walks for sketches, she confining her studies, as a rule, to the flat scenery of New Jersey, often so like the landscape of Holland. Sometimes they rode the Central Railway a few miles from the city; they would leave the cars at Feltville, where Moran sketched at least twice, and walk toward Scotch Plains, in

[1] *Rocky Mountain News*, June 18, 1892.

Union County, where he found "the beautiful calm and serene mid-summer pastoral scene" which he caught in the canvas called *The Watering Place*. The editor of the *Aldine* chose this poetic land-scape as a frontispiece for an early number in 1879 and wrote:

> [It] is filled with the poetry of a summer's afternoon; distant fields of ripening grain; black clouds gathering at the right, indicative of a coming shower; swallows circling high in the air, to catch a cooling puff of wind; the refreshing pool of water in the upland pasture, with reedy banks and smell of wild flowers, its waters checkered by the shade of forest trees; the cattle, content to rest and chew the cud, splashing their limbs in the water; the ripe and lush foliage of summer's meridian; each and all of these conspire to make a picture radiant with beauty, happily expressive of one of nature's most enjoyable moods.[2]

The Watering Place was characteristic of the subdued and tranquil feeling with which Moran used the New Jersey countryside.

A sense of peace radiated also from *The Bathers*, which he completed in the spring of 1879. The edge of a forest shaded a pool of water, at whose brink three women had disrobed, small, exquisite figures at the center of interest, yet too small (as Moran's figures often were) to constitute the chief attraction of the picture. In essence it was a landscape, a gentle and serene forest scene, typical of the simpler, sylvan aspects of his work, where the influence of Corot was often manifest. But satisfying as Moran found the scenery of New Jersey as a subject for his art, the urge to travel, to find themes in far places, constantly recurred. There is evidence he returned to the Southwest in the summer of 1878, possibly with his brother Peter; he showed widely a small painting of a Hopi pueblo entitled *Sunset over a Moqui Town*, which he completed in 1879, and according to the *Aldine*, he spent "a portion of the winter of 1878–9 . . . in Georgia."[3]

That summer Moran planned to take his son Paul and again travel to the Far West with Major Powell.[4] For several years now he had

2 "The Watering Place," *Aldine*, Vol. IX, No 8 (1879), 242.
3 *Ibid.*
4 Scrapbook, p. 40 (clipping), Moran Collection, East Hampton Free Library.

hoped to join the Major's corps for another season in the canyon lands of Utah or Arizona; thus he had kept in sporadic touch with Powell, for whom he retained a thriving regard. In the spring of 1876 he had written: "I am just finishing a pretty large picture of a side gulch in Grand Cañon, a great amphitheatre with waterfall that I think will please you. The subject is based on the illustration opposite page 64 of your report."[5]

Scribner's had captioned the engraving A Side Gulch of the Grand Cañon, but Moran should have known from Powell's account that the spectacular cleft opened back from the river actually miles above the Grand Canyon proper. True, in Picturesque America he had already developed the theme as Walls of the Grand Cañon, and the locale was not correctly identified until Powell's official report had appeared. There the woodblock "opposite page 64" was captioned Gypsum Canyon, in accord with the Major's account of how he and a small party had explored its narrows, its amphitheaters, and its rock basins filled with deep pools of clear, cold water, how they had admired a graceful rill that murmured down a precipice of sandstone, how with sickening effort they had succeeded in scaling the steep and often overhanging cliffs of yellow and brown rock, and how in the end they had named the canyon for the abundant deposits of gypsum they had discovered there. Moran had begun the painting as a kind of personal tribute to the Major and his corps. Employing his favorite device of successive bands of light and dark, he showed the immediate boulder-strewn foreground bathed in profound shadow, its brown surface suggestive of mysterious depths. Above it towered a ragged rock wall gloomed in shadow, its serried profile jutting out into the canyon, rimming the far margin of the basin and producing a dark contrast with the opposite walls, ablaze with yellows and orange in the sunlight. Against that bright wall the fragile waterfall seemed to waver in a breath of wind. As though it were their goal, the diminutive figures of three men—the Major and his companions—toiled through shadow up a steep porchlike ledge to the left; the painting thus became

5 Moran to Powell, May 29, 1876, Letters Received, Powell Survey, R.G. 57, National Archives (Microcopy No. 156, roll 4).

a memorial to Powell's conquest of the Colorado, indeed to one of the most heroic expeditions in the history of Western exploration. Moran allowed it to season for about two years, then retouched it to his satisfaction and dated it 1878. "I have now finished a large canyon picture," he wrote Powell in September of that year. ". . . I wish to present [it] to you in acknowledgment of the innumerable courtesies & favors you have done me in years past."[6] Whether he actually sent it down to the Major's headquarters in Washington is not clear, but whatever the case, Powell did not warm to it as to *The Valley of the Rio Virgin,* the canvas which showed the Paiutes riding for a "talk" with him at Kanab. This picture he requested in preference to the *Side Gulch,* and though Moran had already sold it, he retrieved it and shipped it down to Washington. And as in the case of *Rock Towers of the Colorado* (or *The Glory of the Cañon*), he retained the picture of Gypsum Canyon in his studio collection for the rest of his life.

Meanwhile Moran's plan to go west with Powell in the summer of 1879 came to nothing, perhaps because the Major was delayed too long by official duties. He had been involved all winter in the struggle to consolidate the Western surveys—a struggle that Moran followed as best he could from newspaper accounts; and now, besides setting up the new Bureau of American Ethnology, of which he had been named first director, the Major also lent his support to Clarence King in organizing the U.S. Geological Survey. His field party, transferred to King's organization, headed for the Grand Canyon country early in July, but Powell could not foresee himself released for travel until the end of summer. With a commission from the Union Pacific Railroad to fill, Moran could not delay so long, and the fifth of August found him with his brother Peter in the Donner Pass region of the Sierra Nevada. They visited camp sites of the ill-starred Donner party, where tree stumps twenty feet tall preserved a visual measure of the snow depths during the awful starvation winter of 1846-47. Among the sketches Moran made was one of the Murphy cabin, as seen from the camp of Lewis Keseberg, the most baleful of the survivors, suspected of having added murder to canni-

[6] Moran to Powell, September 19, 1878, *ibid.* (roll 8, frame 54).

balism. Soon the brothers moved south to Lake Tahoe, whose expanse of cobalt blue between pine and firwood ridges had been a joy to Moran seven years before. The two remained there several days, then retraced their way east, through the valley of the Humboldt, where at Elko a "Chinese wheel for raising water"[7] aroused his curiosity.

By August 13 the two were deep in the Wasatch Mountains of Utah, climbing through Little Cottonwood Canyon, "a beautiful illustration," he decided, "of the American picturesque."[8] On the fourteenth the pair stopped at the mountain town of Alta, where the infamous Emma Mine could be seen, its buildings in doleful ruins—the humbug exposed by Clarence King in 1873 after British investors had been fleeced of about two million pounds. Moran made sketches of the Toledo Mine. He also searched for scenes in American Fork Canyon. But a far more exciting prospect now awaited the two—the Teton Range, which Moran had wished for years to see.

One day in the third week of August, the two arrived at Fort Hall, after a stagecoach journey that duplicated part of Moran's trip to Hayden's camp in 1871. The fort—not to be confused with the old trading post of the same name—was an army post in a valley east of Snake River. Irrigation ditches made it a cool, green oasis in a parched land. The garrison there—Company A, of the 14th U.S. Infantry—was commanded by Captain Augustus H. Bainbridge, to whom Moran delivered a letter. "This," it read, "will introduce to the commanding officer at Fort Hall, Idaho Territory, Mr. Thomas Moran, a distinguished American artist for whom I bespeak such attentions and courtesies as he would extend to myself." It was written on a White House letterhead and was signed, "Sincerely R. B. Hayes."[9] How Moran had secured it is not clear, unless it had come at Major Powell's solicitation, for Powell had seen much of

[7] Notation on sketch (1879–82), Box 6, Moran drawings and sketches, Gilcrease Institute. Much of Moran's itinerary for 1879 is reconstructed from dates and notations on his sketches.

[8] Scrapbook, p. 46 (clipping dated June 9, 1900), Moran Collection, East Hampton Free Library.

[9] Letter dated March 31, 1879 (photostat), *ibid.*; published in Nolie Mumey, *The Teton Mountains*, 260.

the President that spring in his moves to found the U.S. Geological Survey.

The letter produced an instant response. Captain Bainbridge put himself on leave and arranged an expedition for the Tetons, a prospect not without some danger in view of the recent Bannock War. The party, swelled by an escort of twenty soldiers, left the post on the twenty-first, with two wagons filled with gear and provisions. They rolled twenty-seven miles along the hot, dusty stage road, mirages playing in the distance. Late in the afternoon they reached the abandoned town of Taylor's Bridge, where the river rushed "like Niagara Rapids"[10] through a cut of black basalt. Wind made their camp cold and dismal throughout the night, and it was still driving sand before it when morning came. A discharged soldier created a disturbance, but the party managed to break camp by seven o'clock. The sharp wind whipped up dust—"blinding us all the way," according to one of Moran's jottings. Visibility suffered not only from the blowing dust but also from the smoke of "fires all over the country," and yet not far beyond Taylor's Bridge Moran secured his "first sight of the great Teton some 70 miles away." It looked like a shark's tooth, just as Hayden had described it.

The party reached the south fork of the Snake in mid-afternoon. They found the current hard to ford, and it took them two hours to force the heavy wagons through the willows on the opposite bank, the mules heaving and straining, the soldiers yelling and cursing and beating the animals till the rim was reached. Then they went into camp, and the soldiers bathed and watered the stock. It was "amusing," Moran jotted, "to see the mules inquisitively surrounding the teamster who was handling the rations."

The next day the expedition followed a good wagon road. Blue

[10] Diary, August 21-[30, 1879], quoted in its entirety in Fritiof Fryxell, "Thomas Moran's Journey to the Tetons in 1879," Augustana Historical Society *Publications*, No. 2 (1932), 3-12. Fryxell's article was reprinted in the *Annals of Wyoming*, Vol. XV, No. 1 (January, 1943), 71-84. Moran's diary also appears in the Grand Teton National Park *Nature Notes*, Vol. III, No. 2 (1937). Except where otherwise noted, subsequent quotations in this chapter concerning Moran's Teton excursion come from his diary. The original is held by the Museum of Grand Teton National Park at Jenny Lake.

haze veiled the Salmon River Range to the north, and the tops of the Tetons in the east could be distinguished only dimly, owing to smoke. The lower reaches of the peaks were obscured by the Snake River Range, a squat line of mountains "pinkish yellow" in color "with delicate shadows of pale cobalt," merging into "exquisite blue" where they receded into the distance. At noon the train rested at Moody Creek, whose pools were full of trout, and that night they encamped on Teton River, where another windstorm seasoned their breakfast next morning with dust and grit.

"The Tetons [were] very well defined . . . before the sun rose," Moran observed, "but soon disappeared when the atmosphere lighted up." A local ranchman guided the expedition for fifteen miles through undulating grasslands to Canyon Creek, which rushed through a deep *couloir* with precipitous banks. On scouting for a mile or two along the brink the soldiers discovered a shallow draw, down which the company made their way to a flat covered with sage and grass. Here they unloaded the wagons and sent them back with several mules and half a dozen men to wait at the ranch for their guide. "We made our camp on the flat," Moran wrote, "caught a few mountain trout and ascended the canyon again to get a glimpse of the Tetons, but . . . only the top of Mount Moran [was] visible owing to the slope of the hills beyond the canyon."

The next morning dawned very cold; "ice had formed on the tin cups." By six-thirty the pack train began to move over terrain that grew increasingly difficult to travel. Each mile had its aspen-bordered gulch, two hundred feet or so deep, all nuisances to pass. Then the party crossed the divide into Teton Basin, the old Pierre's Hole of fur-trade history, and found to their relief a gentle grade down which they marched into the basin proper. "The Tetons have loomed grandly against the sky," Moran wrote, "and from this point [are] perhaps the finest pictorial range in the United States." On coming to a small stream, Captain Bainbridge decided to camp. As soon as the tents were pitched, hunters went out, to return with three mule deer, while Moran and Peter made sketches of the Teton Range, in defiance of the obscuring smoke.

The next morning the company rode through "smooth rolling

country" down to the bottom of the basin, where the Teton River flowed through thick brakes of willow trees, interwoven with masses of vines, with here and there a cottonwood gleaming yellow and green. Here somewhere in 1832 had occurred the skirmish between the mountain men and Blackfoot Indians, as described in *The Adventures of Captain Bonneville*. The valley varied in width from five to fifteen miles and extended from twenty to thirty miles along a northwest-southeast axis. It had a prairie look, with heavy bunch grass and blue camas flowers and strawberries growing in the wetter spots.

Moran's party forded the shallow river, then saw a tipi in the willows, with several horses grazing nearby. It was the encampment of "Beaver Dick" Leigh, who had guided Stevenson's party in 1872. Langford had found Leigh "quite a character," with "personal traits that would make him a fitting hero for a popular dime-novel."[11] He was an Englishman, who had trapped the Teton country for nearly thirty years, and in that time he had adopted Indian ways. He had an Indian squaw. Friendly and ready with directions, he pointed the way to their next camp ground and would have come with the party had they needed a guide. They pressed ahead for ten or twelve miles more, directly toward the canyon of the Teton River. At the canyon mouth they found a good camp spot near the stream, in the bottom of which grew stands of pine, and near whose bank occurred fine grazing for the animals. As sketching was scarcely feasible that afternoon, with smoke completely veiling the mountains, Moran spent his time in "working up" the drawings he had made the day before.

Early next morning, he and his brother, the Captain, and two soldiers started up the canyon, their way at first blocked by a curious bear, who retreated only after receiving a bullet through his foot. "We proceeded . . . about 6 miles and ascended to the top of a granite cliff about 500 feet to get a good view of the canyon that leads up to the right of the Tetons." The Tetons were themselves hidden from sight, but several other fine peaks loomed ahead, and Moran found the view magnificent. "We remained on the shelf for some three hours sketching and afterwards amused ourselves by

11 "The Ascent of Mount Hayden," *Scribner's Monthly*, Vol. VI, No. 2 (June, 1873), 134.

rolling great boulders over the precipice upon which we stood and watched their descent as they went bounding from rock to rock and crashing through the branches and dead timber." Then they climbed down into the valley, finding feasts of raspberries and black currants; there was plentiful sign of game, "elk and deer tracks . . . everywhere," and a large beaver dam spanned the canyon. "We returned to camp early in the afternoon; the [smoke from] fires in the surrounding mountains had become so dense as to almost obscure the peaks of the Tetons, and the sun went down in fiery redness. A strong and cold wind began to blow soon after, and during the night a violent thunderstorm continued until nearly daybreak [with] rain in the canyon and snow on the peaks."

Striking their dreary bivouac next morning, the men began their return march through gusts of wind and rain, but when they had left the canyon and come into the open plain, the sun burst through the clouds. They called at Beaver Dick's again and after a short parley continued on their journey, to be overtaken the next morning by the trapper, who showed them a shorter though hardly less arduous path to the ranch where the rest of the company waited. Captain Bainbridge now requested Beaver Dick to bring his father-in-law into custody, a hostile Bannock named Pam-Pigemena; this the trapper promised to do the following day, and "as we were at breakfast," Moran wrote, "[he] came into camp with the information that the father-in-law, and his mother-in-law also, would be [there] very soon." Actually the Indians overtook the party on its march that afternoon. "They had all their worldly goods with them, packed on three horses, consisting of beaver, otter, deer, bear and other skins. They were about 60 and 50 years of age and seemed entirely indifferent to their position as prisoners. We bought some otter skins from them, but a coveted gray bear skin the squaw would not part with, as she said Beaver Dick [had given] it to her." Having recrossed the south fork of the Snake, the train went into bivouac on Willow Creek, not far from Taylor's Bridge. It was a "poor camp with no grass for the animals," and thus Moran broke off his diary of the excursion. Presumably his party reached Fort Hall the next day, the thirty-first of August.

The Glory of the Canyon, 1875. Oil, 52x40 inches.

Gilcrease Institute, Tulsa

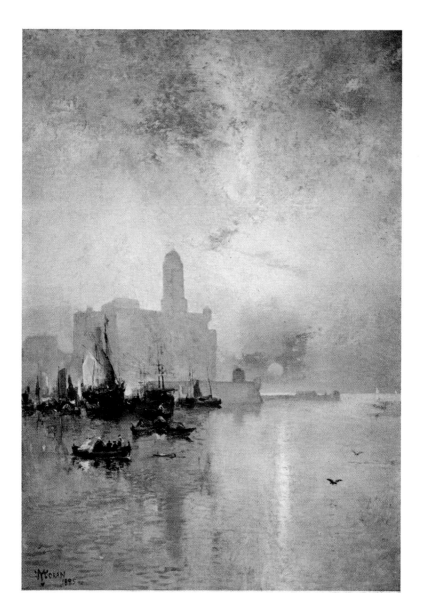

San Juan d'Ulloa [*sic*], *Vera Cruz*, 1885. Oil, 20x14 inches.

Gilcrease Institute, Tulsa

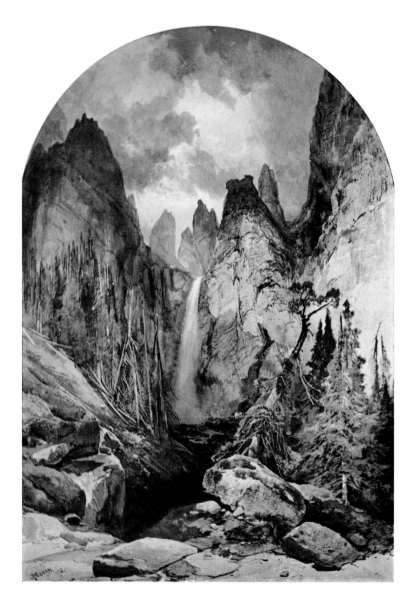

Tower Falls, 1872. Water color, 11x8 inches.

Gilcrease Institute, Tulsa

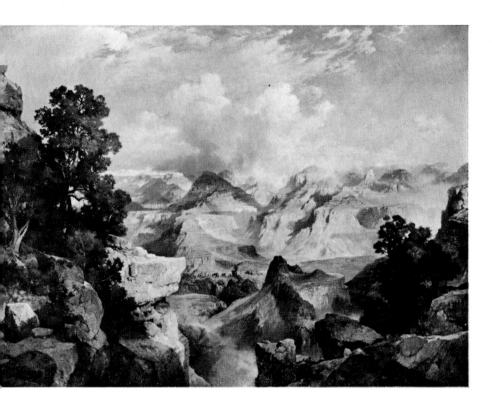

The Grand Canyon, 1913. Oil, 30x40 inches.

Gilcrease Institute, Tulsa

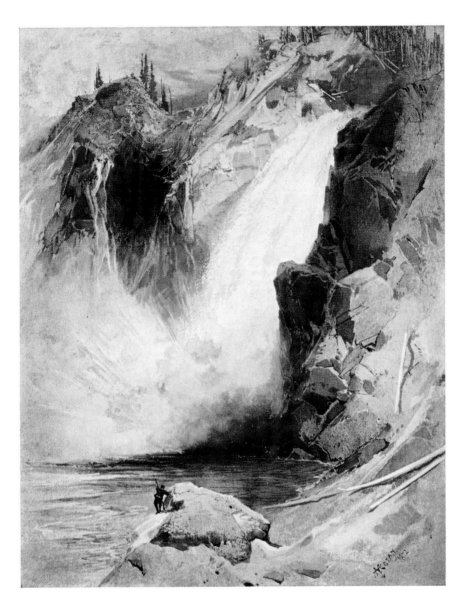

Upper Yellowstone Falls, 1872. Water color, 10x8 inches.

Gilcrease Institute, Tulsa

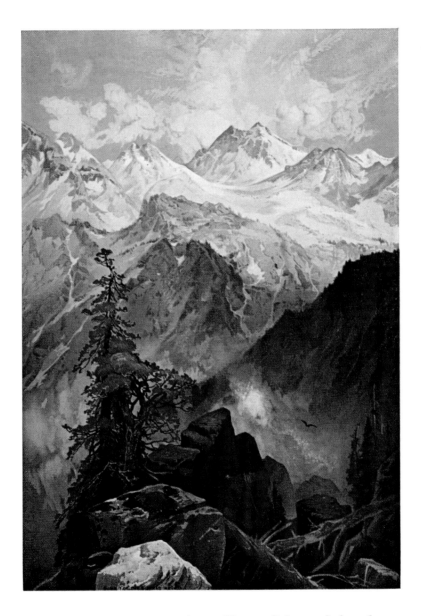

Summit of the Sierras [1875]. Chromolithograph based on Moran's water color, 14½ x 9⅞ inches.

Gilcrease Institute, Tulsa

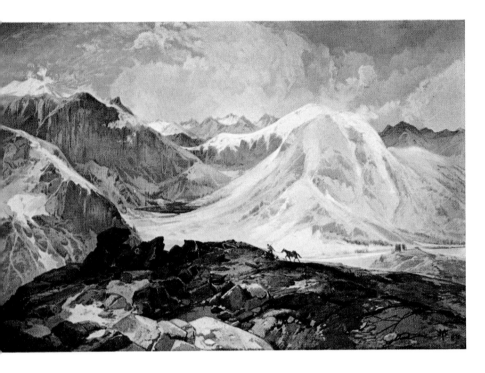

The Mosquito Trail, 1875. Chromolithograph based on Moran's water color, 10x14 inches.

Gilcrease Institute, Tulsa

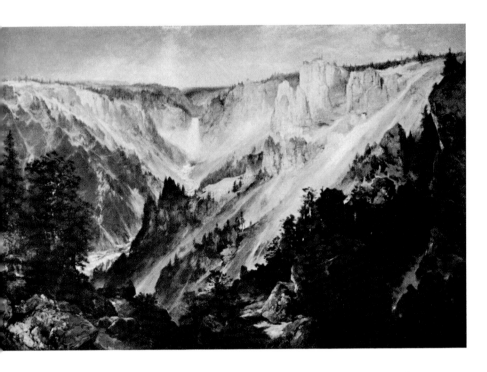

The Grand Canyon of the Yellowstone, 1893. Oil, 40x60 inches.

Gilcrease Institute, Tulsa

Moran would never come back to the Tetons, in spite of a long-held wish to do so; except at great distance he never saw them from the east, their most spectacular side; he never saw the image of the peak that bore his name reflected in the blue waters of Jackson Lake. In view of how poor he had found conditions for drawing during the summer of 1879, it was astonishing that he secured sufficient sketches, or impressions sharp enough, to provide for his several pictures of the range, some made over thirty years after his visit there. He painted *The Eternal Snows of Mount Moran, the Teton Range* as late as 1912, its cloudy sky reminiscent of the thunderstorm that had harassed his last hours in the Teton Basin. The snowy peak looms in the background, a slanting streak of cloud hiding its lower reaches, while a canyon with rocks and trees and a turbulent stream fills the foreground. Over portions of the scene play dapples of light as sunshine breaks through holes in the clouds.

Moran allowed the Teton views to work in his mind and waited to make the greatest use of them between 1897 and 1903. Yet less than two years after his appearance at Fort Hall, in the spring of 1881, he painted a small canvas with the Tetons silhouetted in the background, their base hidden by a low mauve mountain in the middle distance, its flanks splashed with delicate yellowish green. To the right along the course of a hidden river are dense stands of pines, beside which a camp has been placed, with tents and campfires, around which men have gathered to warm themselves and perhaps to recount the day's adventures. In front of a tent two figures stand and gaze at the rugged mountains, and a third sits with a sketch pad in his lap. A band of mules graze in the meadows to the left. Amid the grass and flowers in the corner below is the date with Moran's signature and a terse inscription: "To Mrs. Aug. H. Bainbridge, Fort Hall."[12] It was given as a recompense for her having been left alone while the Captain took the painter into the mountains. When Captain John G. Bourke, soldier and scholar, saw it hanging on her parlor wall, he jotted in his journal: ". . . a gem of drawing and color."[13]

[12] The painting now hangs in the Gilcrease Institute.
[13] "Bourke on the Southwest," ed. Lansing B. Bloom, *New Mexico Historical*

Yet for sheer majesty and power the theme must wait till 1897 when Moran at last came to paint *In the Teton Range, Idaho* (he never knew where the line ran which placed the peaks inside Wyoming). The picture was larger than average, though not an immense canvas (thirty inches by forty-five inches), but so great was the scene's impersonal power that when the Metropolitan Museum received it as a gift, its spokesman wrote:

> The snow-covered Teton range lies spread out in the sun and shadow . . . out of the human scale altogether, and man, in spite of his constant intrusion, has been powerless to disturb its vast serenity. Although he has had the audacity to scale these peaks, to fell these forests, and to fish these streams, he has made no noticeable impression upon them . . . ; if he is at work in this painting he is too minute to be seen.[14]

It was precisely this character of Western mountain scenery that had oppressed Oscar Wilde on his Western tour; he questioned the availability of high mountains to poetry and painting because, it seemed to him, man was not their master, and so he stated estheticism's current negation of a bedrock principle of romantic tradition. It made no difference that such a view knocked Milton in the head and ruled out of court half the mythological and religious art of all time. Not that Moran so reasoned; he was still imbued with what Ruskin had called "Mountain Glory," that feeling for mountains that had dawned with the romantic movement after "Mountain Gloom" had for centuries obscured the eyes of poets and artists to their splendor. He never doubted that high mountains afforded the landscape artist a splendid subject. As for the Tetons, he considered his paintings of their snowcapped heights among the most significant of all his works.

Review, Vol. X, No. 4 (October, 1935), 290. Bourke thought, apparently, that the painting was by Peter Moran, who had visited the Moqui Pueblos in his company.

[14] Louise Burroughs, "The Moses Tanenbaum Bequest," *Bulletin* of the Metropolitan Museum of Art, Vol. XXXIV, No. 6 (June, 1939), 138.

IX *Etching: East Hampton*

✦✣✦✣✦✣✦✣✦✣✦✣✦✣✦✣✦✣✦✣✦✣✦✣✦✣✦✣✦✣✦

As Moran laid plans for his Western tour in 1879, the question had arisen whether Mollie should accompany him, but in view of the drain on her health in 1872, she had decided to remain behind and visit Easton, Pennsylvania. Moran had then suggested that she pass the time by trying her hand at etching. The New York Etching Club had been founded two years before, and a great concern for this medium was flourishing among American artists, especially now that etchings had become attractive to collectors.

Moran's interest in the medium had been renewed after he had neglected it for almost twenty years. He had made his first plate as early as 1856, a small rather dry and formal study after a wood engraving by Birket Foster. Thomas Sartain had instructed him and Stephen J. Ferris, his brother-in-law, by giving a practical demonstration of the technique.[1] Moran had produced his second plate in 1860 and during the same year had experimented with the glass cliché process employed by Corot and Daubigny. By means of this technique, which involved etching through a film of collodion on a glass plate, then photographing the plate against a dark background, he had made a striking study on the theme of his painting called *The Haunted House*. Moran had thus been one of the earlier American artists to take up etching,[2] and as Frank Weitenkampf observed

[1] Frank Weitenkampf, *American Graphic Art*, 5.
[2] "The art had its native precursors in the very able work of Thomas Moran and James D. Smillie. . . ." Eliot Clark, *History of the National Academy of Design, 1825–1953*, 198.

of his initial efforts, "one hardly gets the feeling of experimentation. It seems a matter of intention carried out with easy sureness."[3] But with his time so crowded with other work he had put the process aside until sometime in 1878, early in what would retrospectively be termed the "etching craze." Much of the stimulus had doubtless come from his younger brother's example, especially Peter's steel etchings of the illustrations for *Hiawatha*. And so, as Ruth Moran later recalled:

> The old studio in Newark . . . had its floor strengthened and we got a press. Such excitement when the prints of the first plate were pulled [—a small one called A *Bazaar*, characterized by vigorous, almost Rembrandtesque biting, with a curious effect added by means of sandpapering]! I hung on to the great arms of the wheel to assist, as I thought, the very light weight of my father, about 104 pounds. All of the plates were successes from the start.[4]

Moran had etched some six or seven of them during the first year and about as many in 1879, most of them experimental with varying effects. He printed the proofs customarily in brown ink, though sometimes in black. There were several New Jersey scenes, including two of Newark Meadows and one of Passaic Meadows, all of which had the same delicacy that marked his work in water colors, and there was A *Study of Willow Trees* that S. R. Koehler singled out to publish in the *American Art Review*. Moran did two studies of picturesque bridges, and then from one of his sketches of 1873 he etched A *Piute Girl*, perhaps his finest drawing of the human body: the tones of the lissome figure were superbly rendered as the girl stood in native dress. There was also *The Empty Cradle*, from the Hillers photograph, and *The Head of Yellowstone River* from one of his water colors in 1872. But by far the most ambitious plate among these early efforts was a large reproduction (some sixteen by twenty-one inches) of *Conway Castle*, the oil painting by Turner that Moran had seen years ago in Philadelphia.

[3] "A Thomas Moran Centenary," *Bulletin* of the New York Public Library, Vol. XLI, No. 2 (February, 1937), 128. See also "American Etching Indebted to Moran," *New York Times*, September 19, 1926, Section IV, pp. 14-15.

[4] Clipping from *Santa Barbara Morning Press*, Nov. 29 [year?], Envelope 179, Moran Collection, East Hampton Free Library.

Early in 1878 he had rediscovered it in the possession of a farmer at Hammondton, New Jersey. As the farmer wished to sell it, Moran bought it for a modest sum, which he agreed to pay in installments, and brought it in triumph to his studio in Newark.[5] He cleaned away the smoke that begrimed its surface, and when its glowing color had come to life again, he proudly showed the work to friends and artists of his acquaintance. The presence of the picture in the metropolitan area created something of a stir in art circles and was noticed by the press, as there were almost no original Turners then to be seen in America. The painting was a fairly large one, double the size of the *Slave Ship*; the view it presented of the town and castle of Conway at the foot of a lofty mountain, under the arc of a rainbow and piles of cumulus clouds, was much admired, and it had at once impressed Moran as the subject for a reproductive etching. He worked at intervals for a year and a half on the large plate, and when it was finished to his satisfaction, he allowed the original painting and proofs of his etching to be taken by R. E. Moore of the American Art Gallery for exhibition in England.[6] There the painting aroused almost as much interest as it had in America, and would be the means of bringing Moran and Ruskin, Turner's greatest idolator, together a year later.

Meanwhile Moran made arrangements to publish the etching in an edition of three hundred prints. The *Century* magazine cited it as "the most successful reproductive etching yet attempted in America,"[7] Moran having succeeded in catching the magic play of light that Turner had registered in the original. It seemed to be just breaking out after the storm, to illuminate the whole middle of the scene, casting a glow over the castle and part of the mountain side. This work alone would have been sufficient to establish Moran as a master of the needle, but all his plates, one after another, were praised by the critics. They were admired for their "attractive touch," which, as Koehler wrote, had a "nervous vitality . . . which makes

[5] "An Original Turner Picture," *New York Daily Tribune*, December 10, 1878, p. 8, col. 2; *Art Journal* (New York), N.S., Vol. V (1879), 64.
[6] "Notes," *Art Journal* (New York), N.S., Vol. VII (1881), 224.
[7] Mrs. M. G. Van Rensselaer, "American Etchers," *Century*, Vol. XXV, No. 4 (February, 1883), 499.

every line an interesting subject of study."[8] Success sharpened Moran's interest in the medium, but he noticed that Mollie seemed drawn to it also as his work progressed, hence his suggestion that she try etching herself while he toured the West in 1879. He explained the use of the needle and coated six plates with wax for her to practice upon.

Reluctant to risk the plates he had prepared, Mollie decided to make her first attempt on the back of her copper calling-card plate, waxing it herself, then drawing from memory a small scene on the St. Johns River. Then taking in one hand a plate that Moran had waxed, and leading her daughter Ruth with the other (Ruth later recollected how excited her mother had seemed), she went outdoors and made a small sketch of a bridge across the Buskill. She bit both plates with acid and took impressions, and felt so encouraged at the results that she used up all the plates that had been prepared, always etching directly from nature. When Moran returned home and saw the results, he thought her style "so original that he hardly knew what to say."[9] It was certainly different from his own work, freer, rather slashing, and—so it would be suggested—more masculine than his own. Elizabeth Luther Cary would later remark that Mollie's "vigorous compositions, etched straight from nature," might lack "Moran's beautiful calm," might lack "his intelligence of soul," but certainly they communicated "her breezy interest in the scene before her."[10] Moran chose the four most successful plates and had Mollie submit impressions from them to the New York Etching Club, which he had joined. They were accepted for exhibition by unanimous vote, and as her signature "M. Nimmo" was not known, they were assumed to be the work of a man. The public registered such approval that "Mr. M. Nimmo" was elected a member in

[8] "The Works of American Etchers: Thomas Moran," *American Art Review,* Vol. I, Part 1, No. 4 (February, 1880), 151.

[9] Ruth Moran (?), Draft for a sketch on Mrs. Moran, Envelope 62, Moran Collection, East Hampton Free Library; see also Morris T. Everett, "The Etchings of Mary Nimmo Moran," *Brush and Pencil,* Vol. VIII, No. 1 (April, 1901), 3–16; Frances M. Benson, "The Moran Family," *Quarterly Illustrator,* Vol. I, No. 2 (April–June, 1893), 78ff.

[10] *New York Times,* December 11, 1927.

the club, no one suspecting "that the vigorous and bold lines were done by a woman's hand."[11]

Mollie had at last found her forte. Her painting had achieved sufficient strength and distinction to hang at exhibits of both the National Academy and the Society of American Artists, and as a result of her work in water colors and oils, she had become an excellent draftsman. Now with etching she had found a medium which gave her complete satisfaction; she was content to concentrate on it for the next twenty years, and with Moran's help and encouragement she became, for her time, the foremost woman etcher in America. She and Moran were able to develop, thus, an even closer artistic comradeship than ever. Moran took up the etcher's point with redoubled zeal, and in the summer of 1880 he turned with Mollie to what impressed them as an exquisite source of subjects for their plates—the town of East Hampton, Long Island, and the country roundabout.

They had first gone there in the summer of 1878, the season the Tile Club had made its excursion to eastern Long Island, a trip that gained fame when Hopkinson Smith wrote it up in a *Scribner's* article a few months later. Contrary to a common notion, Moran never belonged to the club, although he knew most of its members and was a close friend of several. But the Tile Club had, in effect, sent him and Mollie to East Hampton, for it was a jolly, one-eyed William Laffan—whose club name was Polyphemus—who had told them, "That's a wonderful place for a landscape painter—perfect."[12] That remark had enticed them there with the children, according to Ruth's recollection—first by "slow ferry to Long Island City," then "via the Long Island Railroad" as far as Bridgehampton. "Seven sandy, woodsy miles [had been covered] in a knife box stage—curtains down—smelling of leather and hay"; then they had turned a corner into the dusty ruts of a wide road and careened past Goose Pond—which was later known as Town Pond—and up to the front

[11] Ruth Moran (?), Draft, Envelope 62, Moran Collection, East Hampton Free Library.

[12] Ruth Moran, "Notes on the Tile Club," JG 104, Long Island Collection, East Hampton Free Library.

of Gardner's Hotel. They had tumbled out "into the arms of Mrs. Gardner," as Ruth wrote, "and were comforted by fried blue fish, hot bread and layer cake, and the sweet smell of fields, of growing things with the salt downy fog dripping from the . . . blackness that was East Hampton's night. No single ray of light [gleamed] in the dark little town as we had clip-clopped into it."[13]

The whole family had quickly fallen in love with the quaint village with its main street shaded by magnificent elms and poplar trees, and its quiet lanes where one might meet sauntering cattle or flocks of hissing, honking geese. It was so like a peaceful English village that it won Moran's heart and filled him with nostalgia. He remained loyal to it for the rest of his days. Two scenes he loved above all others, he once declared—the Grand Canyon of Arizona with its kaleidoscopic colors, always shifting, never the same from one glance unto the next, and the town of East Hampton with its heartwarming, antique, rural charm.

According to the Tile Club account:

> The town consisted of a single street, and the street was a lawn. An immense *tapis vert* of rich grass, green with June, and set with tapering poplar-trees, was bordered on either side of its broad expanse by ancestral cottages, shingled to the ground with mossy squares of old gray "shakes"—the primitive split shingles of antiquity. The sides of these ancient buildings, sweeping to the earth from their gabled eaves in the curves of old age, and tapestried with their faded lichens, were more tent-like than house-like. . . . Every other house . . . is more than two hundred years old. They last like granite,—weatherbeaten, torn to pieces, and indestructible.[14]

For the summer of 1880 Moran rented the home of a tiny bent old lady—aunt of Senator Roscoe Conkling—who took snuff, wore a red wig, liked to sing lively songs like "Hi, Betty Martin, Tiptoe Fine," and proudly bore the name of Aunt Phoebe Parsons Stratton Conklin Huntting. She put the Morans comfortably up in her seven-

[13] *Ibid.*

[14] [F. Hopkinson Smith], "The Tile Club at Play," *Scribner's Monthly*, Vol. XVII, No. 4 (February, 1879), 464.

teenth-century salt-box house on Main Street (the same house which decades later Percy Hammond, the drama critic, bought and moved to a new location).[15] Ruth Moran, recalling a mid-summer day at the old place which always smelled as of kindling drying, wrote:

> My father . . . is coating a small plate to get the beautiful mantle-piece and fireplace on to copper & Mother is wishing she could get away to Fithian's pear orchard next [door] to finish her own etching of the old homestead, but no, T. M. sits her down by the fireplace to get his drawing—and little Ruth Moran skips in the July dust while . . . E. L. Henry [whom Moran's enthusiasm had moved to visit the town] calls out to Swain Gifford and C. D. Weldon to come on over to Moran's & plan a Montauk trip. . . . Yes, here we were all busy . . . painting, etching, sketching.[16]

Walter Shirlaw was due to arrive at any moment—Shirlaw the great, tall craggy Scot who loved geese and who would find fierce flocks of them every morning meandering over the green to Goose Pond—how he would make them flap and fly! But as a devotee of the Munich school he would find East Hampton in summer much too green to paint, as William Chase had also discovered. Not so the many other painters who descended on the town in the wake of the Tile Club article. So many of them now arrived that they could be called an art colony. "East Hampton was a farming community," Ruth observed, "and while there was plenty of fishing, I think the old barns, the countless chickens and ducks, the cows and horses [in the] street . . . were what brought . . . the artists [and kept them] happy and painting." Large umbrellas were soon spotting the town, with men intently painting underneath, some with their canvases tacked to trees. At first the farmers' horses shied at such spectacles, but in time they were accepted as a normal part of the summer scene. "In the early days of the invasion," Ruth recalled, "everyone came to Aunt Phoebe's parlor to hear M. Nimmo Moran sing her Scotch songs, [while] E. L. Henry played the flute."[17] Much of the visitors' social life centered in the Tennis Club which the

[15] Jeanette E. Rattray, *East Hampton Literary Group* (no pagination).
[16] Ruth Moran, "Notes on the Tile Club."
[17] *Ibid.*

Moran's had helped to organize. The courts were laid out in the apple orchard next to Aunt Phoebe's, and once a week the ladies poured tea in a nearby barn, informally decorated with fishnets, cattails, and glowing sunflowers. So the summer sped happily by, though for Moran its success consisted chiefly in the opportunity it gave him to work.

Sketches from nature, made at intervals from June to September, filled his sketchbook—drawings made at the East Hampton beach, or among the adjacent dunes, or at Hook Pond where Egypt Lane ran near the water, or in one or another grove of bent, windwoven trees. The summer also yielded a rich lot of etchings for himself and Mollie, his own plates numbering at least ten, some of them etched straight from nature. He found in the sand dunes a challenging motif and used it twice, experimenting in one instance on a silver plate. He was "always an experimentalist and an inventor of ways and means in art," wrote Alfred Trumble,[18] and if his early work in etching had begun as a diversion from his painting and the designing of woodblocks, the medium steadily developed a fascination of its own. While the tedious slowness of wood engraving had palled on him, he found a great release in the speed and spontaneity one could achieve with the etcher's point: "The limitless possibilities of the needle and acid appealed to his nervous and progressive nature with a special charm. To complete one plate was but to master new methods and processes by which another might be better produced."[19] He could apply the needle with utmost delicacy, as in *The Rainbow*, a boat and harbor scene after a thundershower, where the sky, piled high with clouds, in front of which the rainbow gleamed, was limned with a gossamer-thin texture of hatching; or he could achieve a fluent vigor of line that carried all before it, as in *"The Resounding Sea,"* a study etched from nature of a huge comber breaking on East Hampton Beach (sometimes cited as *The Breaking Wave*), no doubt his greatest accomplishment during the summer of 1880 and one of his finest etchings.

One of Moran's plates showed Three Mile Harbor, a land-locked

18 "Thomas Moran, N.A.; Mary Nimmo Moran," gathered in Klackner, *Catalogue of Etched Works*, 5.
19 *Ibid.*

inlet from Gardiners Bay, a real harbor of refuge, whose picturesque scene later served him in a more important context. He also combined etching with some excellent fishing in Gifford's company at Montauk Point, where they caught immense sea bass among the submerged rocks. Their carriage had whisked them past many a scene that later appeared in Moran's work—the old village of Amagansett, as fragrant as fresh hay, overlooking the ocean across a stretch of dunes; a poorer hamlet known as Promised Land; the countryside beyond as bleak as the moors in *Wuthering Heights*; waving salt grass and more sand dunes, then wizened pines and dense woods of scrub oak. Then where the island was narrow lay the long, thicket-bound waste of Napeague Beach, alive with mosquitoes; and then at last Hither Wood. This was the course taken by the Tile Club, and, as their story went:

> Emerging from the enclosed region . . . our tourists came out upon a scene of freshness and uncontaminated splendor, such as they had no idea existed a hundred miles from New York. The woods roll gloriously over the hills, wild as those around the Scotch lakes; noble amphitheaters of tree-tufted mountains, raked by roaring winds, caught the changing light from a cloud-swept heaven; all was pure nature fresh from creation. The beach they skirted was wild and stern, with magnificent precipices. . . . And so . . . they finally made the extremity of Montauk Point, and the Fresnel lantern, against which the sea-birds and the giant dragonflies often dash out their little lives."[20]

The lighthouse with its mighty beam, peering through swirls of fog, had only one year before formed the theme of one of Moran's most dramatic etchings, one in which he had adroitly woven certain imperfections on the surface of the plate into the texture of the composition. Now he etched the rugged cliff of the Point itself, with its incredible debris of water-worn boulders, and under the title of *Montauk Ponds* he caught a view of the two "gem-like lakes" commonly known as Great and Fort ponds, set in the convex tableland of the cape.

[20] [Smith], "The Tile Club at Play," *Scribner's Monthly*, Vol. XVII, No. 4 (February, 1879), 474–75.

In addition to Long Island scenes Moran etched two plates that year of Tower Falls, one of them of fairly ample size, "with a simple and remarkably vigorous foreground, and the brilliancy of a sunburst mingling with the mist from the fall."[21] He also executed an Arizona scene, *The Coyote*, in a combination of mezzo tint and etching, with roulette work included, so effective in the opinion of S. R. Koehler that he reproduced it with all its rich tones in his book entitled *Etching*. The plate, Koehler observed, "shows the artist in his weird mood . . . and we would not be surprised at all, if, upon closer examination, we discover the poet hiding in fear behind one of the trees."[22] Moran was thus enlarging the range of his etched scenes and subjects to such an extent that Alfred Trumble could declare before the end of the decade that his themes:

[ran] the gamut . . . from placid pasture lands and somnolent old homesteads to the frowning splendor of pinnacled crags, the monstrous magnificence of towering mountain chains, and the tremendous swing and illimitable vastness of the sea. And on each subject that he sets his hand to, he also sets his seal. We recognize the symbol of his genius in the fluent lines of the boiling breakers, in the rugged escarpments of the beetling bluffs, and in the tufted masses of verdure which turn the forest arches into the aisles of a temple, and stand in guard upon the landscape like fortresses of nature.[23]

Moran made several other plates on East Hampton themes upon the family's return there in the summer of 1883, notably *An Apple Orchard*, a study etched straight from nature "of peculiarly distorted and picturesque forms of fruit trees warped by sea winds."[24] And there would be several Long Island scenes among the plates he was to do in 1886, one of his most productive years as an etcher, his work that season including probably his masterpiece in the medium, the rather large (eleven-inch-by-seventeen-inch) *Morning*,[25] with its "brilliant sunlight effect . . . from a point overlooking Hook Pond

[21] *Catalogue of Etched Works*, 11.
[22] *Etching*, 161.
[23] Trumble, "Thomas Moran, N.A.; Mary Nimmo Moran," 5.
[24] *Catalogue of Etched Works*, 12.
[25] Also cited as *Hook Pond, East Hampton*.

. . . with the Atlantic bounding the horizon."[26] It won a prize of six hundred dollars from the Rembrandt Club of Brooklyn as the best original etching on an American subject. His only serious rival for the prize was Mollie, the judges being evenly divided at first, though they finally decided in Moran's favor. "What a happy frame of mind the man must be in," exclaimed the *Critic*, "who knows that if he doesn't win a $600 prize his wife will!"[27] As an etcher, Moran became so enamored of East Hampton and its environs that eventually the subjects of from one-fourth to one-third of all his plates were drawn from eastern Long Island. In all he produced well over eighty plates, and during the "etching craze" they brought him recognition as a "painter-etcher" second only to that which he enjoyed as a painter in oils. "Mr. Moran likes complicated and difficult subjects," observed the *Critic*; [he] composes in the Turneresque manner, and is master of a technique equalled for range and subtlety by few living etchers."[28]

Moran and Mollie exhibited every year with the New York Etching Club, to whose executive committee Moran was elected in 1882, and frequently one of his prints, or one by Mollie, was chosen for reproduction in the club's spruce catalog. For several years the exhibitions were associated with those of the American Water Color Society, of which Moran was also a member, held in the miniature Ducal Palace of the National Academy on Fourth Avenue at 23rd Street. "The opening nights . . . were jolly affairs," according to Frank Weitenkampf; "at one of them the genial Joseph Keppler tried in vain to teach his colleagues the solemn drinking ceremony of the 'salamander.' "[29] While, in 1881, the Boston Museum of Fine Arts sponsored a notable exhibition of etched works, perhaps the most significant encouragement the art had yet received in America. Both Moran and Mollie contributed to the more than four hundred etchings by Americans displayed there along with an interesting selection of European work. Both received critical approval,

[26] *Catalogue of Etched Works*, 14.
[27] Vol. X, No. 164 (February 19, 1887), 92.
[28] "Etchings at Klackner's," *Critic*, Vol. XIV, No. 272 (March 16, 1889), 135.
[29] *Manhattan Kaleidoscope*, 124.

but Mollie's work, "bold and vigorous," was singled out for special notice. That same year James D. Smillie, on behalf of the New York Etching Club, invited them both to submit proofs for an American collection to be sent to the First Exhibition of the Painter-Etchers' Society of London, at the Hanover Gallery in New Bond Street. Smillie submitted 104 proofs by fifteen Americans, and both Moran and Mollie were among the twelve Americans selected as "original fellows," receiving accolades from the the Society's president, Seymour Haden, and diplomas signed by Queen Victoria. Mollie was the only woman among the sixty-five original fellows, selected from several nationalities.[30]

The joint exhibition of their proofs in March, 1889, at the gallery of Christian Klackner, dealer in etchings, on East 17th Street dramatized the extent of their achievement in the medium.[31] For this they compiled a catalogue of their "complete etched works," as of that date, Moran himself listing some seventy plates. Few "painter-etchers" of the time could point to as many of consistently high quality. In the anticipatory sketch, Trumble wrote:

> No artist in America—if, indeed, in the world—so completely unites the qualities of the artist and the etcher as Mr. Moran. The same hand which gives us, with the spirited touch of original inspiration, plates in which the delicate poetry, the robust picturesqueness and the superb animation of nature are interpreted by a master, gives us also etchings of the reproductive class, in which the sentiment and feeling of another artist are translated, with a fidelity at once rare in itself and remarkable in its revelations [Moran reproduced works not only of Turner, but also of John Linnell, Harry Chase, Rousseau, Daubigny, J. F. Kensett, A. F. Bunner, George Inness, Regnault, and Diaz, not to mention paintings of his own].[32] The

[30] James D. Smillie, to Thomas Moran, March 19, Envelope 59, Moran Collection, East Hampton Free Library; *New York Herald*, April 26, 1881; *Art Journal* (New York), Vol. VII (1881), 224.

[31] "Two American Etchers: The Work of Mr. and Mrs. Moran," *New York Daily Tribune*, March 11, 1889, p. 7, col. 1.

[32] In 1891 Moran climaxed his list of reproductive etchings by basing a large plate (20 inches by 30 inches) on his brother Edward's historical marine, *The White Squadron's Farewell Salute to the Body of Captain John Ericson, New York Bay, August 25, 1890*. "A superb etching by another great American artist," wrote Theo-

versatility of Mr. Moran is on a par with his technical ability and with his sensitiveness to all that is beautiful in art and nature.[33]

The "robust picturesqueness" of which Trumble spoke was a weakness in the eyes of many, especially after picturesqueness had lost status. Owing to the frequency of that quality Sadakichi Hartmann would consider Moran's proofs as slightly passé.[34] But by that time, in the last decade of the century, the "etching craze" had run its course, and most of the presses in the studios were merely gathering dust, with only a few dedicated artists hardy enough to persist despite public apathy. For most etchers, photogravure and improvements in the chromolithographic process had created such unprofitable competition that it brought the painter-etcher development to an emphatic halt. If Moran lived to see his and Mollie's etchings devalued, it was for the same reasons that left the entire etching movement, such a flourishing phenomenon in the 1880's, obscured in neglect from the end of the century on.

dore Sutro (*Thirteen Chapters of American History*, 96). Radke Lauckner & Co. purchased the plate for two thousand dollars.
[33] "Thomas Moran, N.A.; Mary Nimmo Moran," 5.
[34] *A History of American Art*, II, 138.

X *Railroad Artist*

᛭᙮᛭᙮᛭᙮᛭᙮᛭᙮᛭᙮᛭᙮᛭᙮᛭᙮᛭᙮᛭᙮᛭᙮᛭᙮᛭᙮᛭᙮᛭᙮᛭᙮᛭᙮᛭

In the latter part of 1880, Moran set up a studio in New York, but he left the family temporarily at the Thomas Street house in Newark. His new quarters were located in the Booth Theatre Building on the southeast corner of Sixth Avenue and 23rd Street, two blocks from the National Academy. This building, which Edwin Booth had conceived as a drama center for the city, was an ornate monument of Concord granite in the Renaissance style. Although Booth had gone bankrupt and lost control of the property, it still retained his name and was still regarded as a cultural center. Sarah Bernhardt had just been playing there when Moran moved in, and the place ranked with the Tenth Street Studio Building, the Y.M.C.A. Building, and the mullioned towers of New York University as a hive for working painters. For several years George Inness had kept a studio there.

Its pretentious exterior belied the simplicity of the rooms inside, and a visitor to Moran's studio was "surprised at the simple and unostentatious manner" in which he found the "great artist" living and working. Moran painted (he was then at work on a Green River scene to be sent to the Royal Academy) "in a room accessible to anybody from the hallway—no lackey to intercept—and surrounded by only such accessories as [were] required,"[1] a few chairs, presumably, and a table, easels, canvases, canvas stretchers, brushes, paints, and palettes. There was a couch as well, so that he could

[1] Clipping dated February 12, 1882, Envelope 179, Moran Collection, East Hampton Free Library.

stay in the city on occasions after a day's work. It was no cluttered museum room of draperies and bric-a-brac such as one found on visiting Chase's quarters in the Tenth Street Studio Building. Its bareness suggested that Moran had taken it only temporarily, though he remained there for nearly four years. His later studio rooms would have more of the "esthetic" appearance that one expected of a successful artist during the late nineteenth century.

The family remained in Newark till June, 1881. Then they, too, came to Manhattan, Moran having taken a house for them at 166 West 55th Street, a few blocks from the corner of Central Park and even nearer Hell's Kitchen, a section of town later described as "one of the most dangerous areas on the American continent."[2] Conditions on 55th Street were still primitive in spots; poor families rather like those who squatted in the park had holed up in ramshackle huts there, and Mollie had a chance to etch the disreputable but picturesque "shanties on the rocks in our street" before they were pulled down. She worked up the subject in a rather large plate which she called *The Cliff Dwellers of New York*, and Moran rightly speculated that it would have "an historic value in time to come."[3]

Meanwhile Moran received a commission from the engravers Schell and Hogan for one dozen drawings of Niagara Falls, and its surroundings, and so the family went there for the rest of June. They seem to have walked all about the falls and through the cool forest depths of Goat Island, and to the great Whirlpool. Moran made a number of drawings to meet his commitments. He sketched the profile of Goat Island from "under the American Falls";[4] June 13 found him drawing the river from the Doric shaft of Brock's Monument, and on the twenty-ninth he sketched the superb, wild rapids below the lower suspension bridge where the river narrowed to a gorge. Such experiences would lead to at least four paintings—one a view of Whirlpool Rapids—a work of surging power, with its roil of blue-green water and eddies that lashed the surface into white foam, and

[2] Federal Writers' Project, *New York City Guide*, 155.

[3] Letter to S. R. Koehler, July 7, 1881, L-6, Moran Collection, East Hampton Free Library. Mrs. Moran's etching was published in *Harper's Weekly*.

[4] Sketch 1881-13, Box 8, Moran drawings and sketches, Gilcrease Institute. Remarks on Moran's Niagara excursion derive largely from his sketches with their dates and notations.

white mists seething up to obscure the almost vertical wall of the opposite shore, though not the green pines of the immediate right. "A rain storm is sweeping through the ravine," wrote a spectator, "and veils of rain, blown in the direction that the water is running, augment the apparent motion of the current."[5] Another painting, *The Rapids above Niagara* delineated a fan-shaped wave that came crashing over a vast flat rock, at a point considered by William M. Hunt as the epitome of Niagara. Moran also made a reproductive etching that caught much of the power of the original picture; in another, *Niagara—from the Canadian Side*, he caught the falls from an out-of-the-ordinary angle above them, for a fresh effect. In this plate he may have reproduced his *Looking over Niagara Falls*, described as "the Great Cataract seen from a thoroughly original point of view."[6] Years later he painted *Under the American Falls at Niagara*, which he gave to a friend in East Hampton. The question might be asked: Why did Moran not make greater use of such a spectacle? Did he feel that Church had said all that could be said about the scene? Or was he overwhelmed in the presence of such power? Did he feel, as Captain Marryat had felt, that it was "impossible for either the eye or mind to comprehend the whole mass of falling water"? You might *feel* its vastness, the Captain had suggested in his American diary. "Still the majesty of the whole is far too great for the mind to compass—too stupendous for its limited powers of reception." Did Moran feel the same? Not much can be said for certain except that *Whirlpool Rapids, Niagara* was a painting of great power, and that Moran's etching of the upper rapids was one of his finest, a superb picture of water in motion, instinct with elemental force.

Moran did not return home for long. An even fatter commission now came from the Baltimore and Ohio Railroad, to supply its publicity department with "upward of seventy" illustrations for a book describing the railroad's scenic routes.[7] To provide material the com-

[5] *Brooklyn Daily Eagle*, May 17, 1885.

[6] Ortgies & Co., *Catalogue of the Oils and Water Colors of Thomas Moran, N.A.*, Item No. 11.

[7] Pangborn, *Picturesque B. and O.*, 10.

pany offered Moran and the writer—J. G. Pangborn—a "grand tour" during the month of August. They met in Jersey City on a torrid afternoon toward the end of July—four of them in all, for the party included a minor official of the railroad (who could be useful in making arrangements along the way) and John Karst, the wood engraver called Apple Jack in Pangborn's narrative.[8] The third vice-president of the line had lent his private car—No. 217—for the comfort of the four, and it was attached to the seven o'clock train ready to roll from the Jersey City depot. A Negro steward met the tourists at the door of the car. He assigned Moran—whom Pangborn habitually called Yellowstone—to a palatial stateroom. To Pangborn, who called himself the Fairy because of his enormous girth, went the other stateroom, while the others occupied two sumptuous lounges in the main saloon of the car.

They were whisked down to Baltimore, where they awoke next morning, finding their car detached from the train, which had rolled on toward Chicago. Moran asked to visit Locust Point, the marine terminus of the B. & O. inside the main harbor, and so the management placed a tugboat at their command, and they cruised down the waterfront. When they were ready to leave Baltimore, they found car No. 217 attached to an engine, awaiting them in Camden Station. This special train, so amusingly brief, bore them through the city of Washington, and when the Capitol dome had faded from sight, the train plunged through a screen of heavy, green timber, and then "the clear sparkling bosom of the Potomac" opened to view. Pangborn noticed that "the artistic eye of Yellowstone glistened through the tears as his cultivated nature responded to the scene."[9] At Frederick Junction the riverbanks were heavily wooded, the growth reflected in the smooth water, and Moran's enthusiasm was so great he could not go on until he had put the scene on paper. The rest of the party stayed too, for many black bass drowsed in the shady pools.

The four decided to leave the car that night for beds at an inn

[8] Karst engraved most of the woodblocks for Pangborn's volume.

[9] Pangborn, *Picturesque B. and O.*, 86. This account of Moran's excursion on the B. & O. draws freely on Pangborn's volume, the source of subsequent quotations concerning the tour.

beside a canal which paralleled the river. It was a picturesque old place, with low ceilings, long sloping eaves, and a moss-covered roof. Next morning the tourists piled into a boat which an old gray horse pulled up the canal about three miles. Dispensing with the horse, they hauled the boat over the canal bank into the river and began to fish. The bass were numerous and the holes plentiful. From a large rock in the water they could see Harpers Ferry, seven miles upstream, "and Yellowstone could hardly be induced to leave it and go down the river." He drew, while the others fished, and thus they spent two days in that vicinity.

Returning to their car, the four continued toward Harpers Ferry, the last three miles through "mountain fastnesses, precipitous piles of granite rising up to a tremendous height and dwarfing the train." Ben, the B. & O. man, had telegraphed for a team to meet them at the depot, and after their arrival, a hack drove them up a steep road into the higher parts of town. "Yellowstone, as usual, grew pensive, insisting . . . that the street alone was worthy of a week's journey." Harpers Ferry summoned memories of the war, and Pangborn and the B. & O. man, having both served as soldiers, retraced the movements of the armies. While they talked, Moran looked for scenes to draw; he "commenced sketch after sketch," Pangborn observed, "tearing them to pieces one after the other as new inspirations seized him; and finally he . . . sought a place where he could be alone, and remained there until dark."

From Harpers Ferry the train took them through Charles Town, where John Brown had been hanged, and then they sped on to Winchester, Virginia. There a large hack met the tourists, and the Negro driver let them know that such a conveyance was called "a Virginia fix." The drive to Rock Enon Springs, their destination, was over sixteen miles of the roughest sort of upland road, so they decided to go as mountaineers. They took off their coats, vests, and neckties and dressed "in wide brimmed hats, flannel shirts and top boots." The result was a frigid reception at the hotel. In front of it several small boys jeered at them and were mollified only when Ben, the B. & O. man, explained that they were the advance agents of Barnum's circus. The host looked grim until they handed him their

cards; then his face broke into a smile. A bath was ordered at once, and when they came from the bathhouse, they looked so transformed that a Negro woman stared at them in bewilderment, then exclaimed: " 'Fore de Lawd you was a hard-lookin' lot when you went in, but you is gemmen now." Even the boys who had jeered at them failed to recognize them thus transformed and roamed about for the rest of the day in search of "them circus men."

The charm of Rock Enon Springs, in its small valley surrounded by mountains, could not hold the four long. Soon they were bowling along in the fix towards Capon—"up hill and down . . . [the hours] enlivened by the sallies of Ben and the quick repartee of Apple Jack, together with reminiscences of European trips by Yellowstone." The driver sang old plantation songs, with the passengers sometimes taking up the choruses. The hack rolled into Capon as the sun set, gleaming on the lake beside which the road ended. Cramped from the journey, the four stretched their legs before supper. "Like a schoolboy Yellowstone climbed boulders, jumped from crag to crag, and was soon upon the top of Eagle Rock," with a view of the Blue Ridge to the east, the Alleghenies to the west, and in between, a long look down the valley of the Shenandoah. They were up at daybreak the next morning, and after a swim in the lake, were off in the fix for Mount Jackson, seventy-four miles from Harpers Ferry. They then took a side trip to Orkney and back, new scenes of beauty revealed at almost every turn of the road. The Negro driver had become so attached to his passengers that he begged to continue with them for the rest of the tour, for no other pay than just his "grub," and there were tears in his eyes when they left him at Mount Jackson, where their train was waiting.

They rode their car to Staunton, where their enthusiastic letters had encouraged Mollie and Mrs. Pangborn to meet them and share the excitement of their travels. Pangborn, who met Mollie for the first time, described her as "trim of figure, graceful in action and repose; apt, clear-headed, and quick as a flash in repartee, [with a] voice [that] was a charm none could withstand." He was impressed with her reputation as an artist, yet noted that, "sensible and practical" as she was, she had not escaped being infected by the current

"esthetic craze." The special train took the enlarged party to Mill-boro Station, where it was sidetracked, and preparations were made for a ride in a "mountain wagon" over the Blue Ridge. A powerful team pulled the wagon, and away they rolled. At their first stop, Rock-bridge Alum, they had a musical evening, "with Mrs. Yellowstone at the piano, the Fairy's wife at the guitar, and Apple Jack at the fiddle, with Ben, Yellowstone, and the Fairy to join the chorus."

The six were up and away early the next morning, their route taking them over Mount Jackson. Soon they came to Falling Springs, which Moran thought one of the most beautiful waterfalls he had ever seen, "less majestic . . . than the mighty Niagara" but "incomparably more fascinating." It reminded him of a celebrated falls he had seen in Europe, though Pangborn failed to record which. "Nothing could be more beautiful than . . . that serrated, moss-covered wall where the water fell in gossamer-like veils." All about were dense growths of "radiant, changeable green," and at one time in the shifting spray the party saw five distinct rainbows. They lingered longer than they intended, while Moran sketched, and it was after dark when they reached their car at Covington. While they slept that night the engine pulled them to Allegheny Station.

They now made side jaunts to several valley resorts, all within one day's journey of Harpers Ferry, where they at last arrived. Then the train rolled on to Shenandoah Junction and down to Luray Cave, sixty-six miles south. The six strolled for hours in that weird place, more spectacular than Mammoth Cave, though not as large, and while they ate lunch on the shore of Broddus Lake, the cavern resounded with echoes of their voices. Moran made several sketches of the bizarre formations they saw there.[10]

On their return to Shenandoah Junction, Mollie and Mrs. Pangborn found it necessary to go home to their children. Again the car became a rolling bachelor's castle, as the four men continued the tour. The train was now switched to the Pittsburgh division of the railroad so they could run through the Youghiogheny and Mononga-

[10] Sketches No. 1881–4, 1881–6, 1881–14, 1881–17 (Luray Cave), Box 8, Moran drawings and sketches, Gilcrease Institute. For this trip, as for others, Moran's field sketches, with their dates and notations, greatly assist in fixing the itinerary.

hela valleys. They spent the night at Ohio Pyle, and the next morning went on foot to Cucumber Falls, high up in the hills. It was a hard climb. On the way Moran sketched a rustic bridge over a creek which "danced its way to the Youghiogheny, and just above this the old tannery long since passed into decay. . . ."

> From this spot the hard, stony roadway led directly up to the summit, and from here the route down to the falls was such that persons of weak nerves would hardly dare attempt it. . . . Hand in hand, the quartet scrambled over fallen trees and projecting crags to the bottom; and once there, the query was . . . how in the world to get back again. But such trifling considerations soon faded in the presence of the falling water.

They did get back, somehow, and that night their train took them to where Indian Creek emptied into the Youghiogheny. The moon shone bright through broken clouds, and Moran sketched the mouth of Indian Creek by moonlight. Then they rode on through the moonshine to Pittsburgh and the next morning started at once for Chicago.

The result of all their scurry was the publication in 1882 of Pangborn's *Picturesque B. and O.*, followed by a de luxe edition the next year. The text was indifferently written, but as the Preface announced: "The fact that Thomas Moran had furnished upward of seventy drawings for any new work would at once establish its character in the first art circles." In a pictorial sense, the *Picturesque B. and O.* was a commendable guidebook, and Moran, apparently, was never ashamed of his connection with it, nor of his belonging to that professional category denigrated as "railroad artist." A painter had to make a living, and it was becoming harder to do so in America solely by painting pictures. Some painters were turning to teaching for their bread and butter—Chase, for example; others to writing, like Kenyon Cox. La Farge had begun to make stained glass. Moran merely persisted at what he knew best—illustration. When asked once if he were afraid of commercialism, he answered, in effect, No; the artist had to provide for his family. The thing for him to do was to accept the limitations and restrictions that the commercial imposed, and then within them do the best he could.

As long as an artist was sincere and did his best, commercialism was "no hindrance to his art. . . . The real artist will express himself anyway."[11] Moran refused to pervert his painting to make it sell better, and when obliged to continue with illustration to make money, he insisted on high standards and delivered only the best work he could do at the time.

Meanwhile, with "Apple Jack" Karst, he rode on to Denver, where on September 4 the *Rocky Mountain News* noticed his presence and reported that he would sketch for several days in the mountains. He was now committed to provide illustrations for the *Colorado Tourist*, a monthly sponsored by railroad interests and printed at the *News* office.[12] Moran planned a tour of the mountains with William H. Jackson, now a proprietor of a photographic studio in Denver, to sketch and photograph scenes together as they had done ten years before. In addition to Karst, their party included Ernest Ingersoll, an ebullient journalist who had attached himself to a Hayden field group in 1874, with the result that his *Knocking Round the Rockies*, published first as magazine articles, was now about to appear as a book, with illustrations by Moran. Ingersoll had reached Denver with a commission from *Harper's Magazine* for an eyewitness report of the San Juan mining region, now booming. Moran agreed to illustrate the article, and so with mutual objectives, the combined party set about arranging an excursion that was complicated no little by the presence of Ingersoll's wife. It required but an hour's discussion in the office of the general passenger agent of the Denver and Rio Grande to charter "a train"—nothing so elegant as the private coaches the B. & O. had made available, merely two boxcars and a parlor coach that also served the men as a sleeper.

The journey provided Ingersoll with the opening chapters of *The Crest of the Continent*, his popular travel book that would appear in 1885, including illustrations by Moran. It was not in a class with the de luxe edition of *Picturesque B. and O.* for elegance of pro-

11 Interview, *Pasadena Star-News*, March 11, 1916, p. 6.

12 *Rocky Mountain News*, May 29, 1881, p. 5, col. 1. Editor of the magazine was Robert Strahorn, publicist for the Union Pacific, but the Denver & Rio Grande commissioned the drawings that Moran produced, according to Notebook, 1877–82 (G), Moran Papers, Gilcrease Institute.

duction, but Ingersoll contrived a readable narrative, however stuffed with guidebook chaff. He was less explicit than Pangborn in identifying his fellow-tourists, saying only that "at least two of the gentlemen you would recognize at once, were I to give you their names. The Artist is famed on both sides of the Atlantic for the masterly productions of his brush. He is a wide traveler and an enthusiast over mountain scenery. The Photographer is likewise a genius, and literally a compendium of scientific knowledge and exploration." He mentioned further that Jackson had been "connected for many years with the Geological Surveys of this region."[13] As for Karst, who had brought along the violin he had played in his role of Apple Jack in Pangborn's account, Ingersoll labeled him merely as the Musician, though he was scheduled to engrave most of the woodblocks that would adorn the book.

The party found their rolling quarters comfortable enough, though supplies had been tumbled into the cars in some confusion. They were soon streaking over the plain beyond Denver, their parlor coach bringing up the rear, giving them "the advantage of a lookout behind." One of the boxcars served as a kitchen and commissary, the other as a joint dining room and study, with one end curtained off as a sleeping nook for Ingersoll's wife.

The railroad led up the valley of Plum Creek, and the train made a first stop somewhere on the Divide, not far from a hillside weathered into a series of fantastic Gothic ruins. The shattered towers and arches "enchanted" Moran, according to Ingersoll's account, "and the Photographer insisted on taking out his camera and getting at work." That evening they pulled into Colorado Springs, where the cars were switched on to a side track. Time was too short for a thorough exploration of the neighborhood; hasty drives took them to various points for unusual views: Glen Eyrie, Queens Canyon, the Devil's Punch Bowl, Blair Athol, Monument Park, and the two

13 *The Crest of the Continent*, 26. This account of Moran's tour through Colorado and northern New Mexico rests heavily on Ingersoll's narrative, the source of subsequent quotations except where otherwise noted. A number of Moran's sketches confirm the itinerary as Ingersoll recorded it. Jackson devoted only one sentence to the trip in *Time Exposure* (p. 258), a statement to the effect that he was employed by the Denver and Rio Grande Railroad.

Cheyenne canyons. They also visited Manitou, billed as the Saratoga of the Rockies, passing Briarhurst on the way, the many-gabled mansion of Dr. W. A. Bell, who had purchased *The Mountain of the Holy Cross*. Before moving on, they also looked at the Garden of the Gods and the Cave of the Winds, and as Ingersoll observed, Moran's "deft pencil" was never "weary in so much loveliness." All regretted leaving such beauty behind, and in their reporter's words: "Our train bore a pensive party down the Valley of the Fontaine, as it headed for Pueblo. The Musician drew a plaintive air from his violin."

Pueblo they found in a state of boom, the second business center of Colorado. There they attached their cars to a southbound express, which pulled them as far as Veta Pass, their resting place for the night, and at Jackson's request they climbed Veta Mountain the following day, all, that is, except Karst, who took another view of the ways of mountain goats. It was not an easy ascent, burdened as they were with Jackson's photographic equipment, but they gained a view worth all their trouble and were amused to find a prospect hole and a miner's pick and shovel on the very summit, reminders that some of "the best silver mines in Colorado are on the very tops of such bald peaks as this." Later that day the train made a quick descent down the western side of the Pass through an unbroken forest of pine and cedar. On reaching the plain of San Luis Park, the rails ran as straight as any surveyor's line; then past Alamosa, their course began winding toward the purple rim beyond which lay the Río Grande Valley. The next stop was at Barranca, on the summit of the divide, and there while Karst went hunting for small game, Moran and Jackson clambered to the tops of some high and distant buttes. "From their summits they could distinguish Fernandez de Taos," Ingersoll wrote. "They could see more grand peaks than they could count on their fingers and toes; and told us about the road to Ojo Caliente, the Warm Springs of New Mexico, famous for almost three centuries." The springs were only twelve miles away, but to get there was a problem, with no stagecoach running there as yet. They hired a Mexican on a burro to carry a message to the proprietor, and they learned the following morning that transportation,

an ordinary farm wagon, had arrived for them in the middle of the night. It jolted them over a rough road through clusters of pale trees and past grotesque buttes, and then for ten miles over the sandy, cactus-studded top of a mesa. They passed flocks of sheep and goats and came to a straggling pueblo, whose inhabitants seemed "almost in barbarism." Some of their adobe houses "had wooden gratings in place of windows; and the doors, made with auger and axe, had been rudely carved in an attempt at decoration. . . . Behind the best houses often would lie an unfenced bit of old orchard, grown almost wild." The wagon skirled to a halt at a hotel that could accommodate fifty guests, and the meal that awaited them began with Baltimore oysters. The real reward of the trip, however, was the forlorn adobe church, "one of the oldest in the new world," ugly enough to seem superlatively picturesque.

On returning to Barranca, Moran and his friends hooked their cars to another express and sped down into the valley of the Río Grande, by way of Comanche Canyon. A cloudburst had left a wake of destruction in the valley, and at one point they came upon a Penitente church, whose wall had been caved in by the flood. Crawling through the breach, they examined a dozen or more heavy crosses, the smallest of which was over ten feet long, with a crossbeam more than six inches in diameter. As Ingersoll could hardly lift the heaviest cross from the ground, it amazed them to think of how the penance-doers could shoulder them at Easter time and drag them for great distances under a rain of flagellation. The party then proceeded to the pueblo of San Juan, set on a puma-covered mesa above the gold of cottonwoods where the Chama joined the Río Grande. Here, too, the church with its carved furniture and plastered walls attracted Moran's eye, and later that year he made an etching of it, with shrouded Indians lounging before its façade, as relaxed and unconcerned as the natives seemed in every pueblo of the valley. "We were never weary of wandering about these Indian towns," Ingersoll wrote, "and watching the people at their work and sunny-tempered play." The Pueblo of Taos, which they reached from Embudo, climaxed their week in New Mexico, its mud houses glowing yellow in the sunshine and flung seemingly like heaps of stones against its

mountain backdrop. During the next year it would serve Moran as a subject, along with Laguna and San Juan. His oil painting of the latter town would be "skied" at the National Academy, where the hanging committee "hung [it] over a door out of the way."[14]

Yet however cool its reception, that canvas marked further pioneer work on Moran's part. With his brother Peter he, thus, introduced to the American public a province that later became the hunting grounds of whole colonies of artists.

Meanwhile, Moran returned with his friends to Colorado for a tour of the silver mines in the San Juan Mountains. Their route wound through Los Pinos Valley and into Toltec Gorge, a place of wild grandeur that would provide themes for several canvases to come. At Phantom Curve, Moran sketched the pinnacles whose shadows moved like ghosts across a white bluff beyond; at the Chama River the travelers paused to fish for trout; at Amargo they studied a horde of Jicarilla Apaches, assembled for a government issue of beef. Three of the Indians begged for rides, and were permitted to stand on the rear platform, but crawling with lice as they were, they were forbidden to come inside the car. At last the train reached Silverton, in the heart of "Silver San Juan," and there Moran made sketches while Ingersoll gathered data for the article *Harper's* had commissioned.

They could have spent but a few days at most in the San Juan region, but that was enough to infect them with silver fever. Moran later became the owner of a one-third interest in the Thomas Moran Lode, located in Georgia Gulch, in the Red Mountain Mining District of San Juan County, a venture that seems to have brought him nothing.[15] Meanwhile, the band parted company. Moran moved on to Utah over the Denver and Rio Grande line, and the third week in September found him sketching in the Wasatch Mountains, at such places as Martha Lake.[16] "I go to the Yellowstone," he had

[14] "Partial Memoranda concerning pictures from Dec. 1st, 1879 [through 1882]" (G), Moran Papers, Gilcrease Institute.

[15] Location certificate, with covering unsigned letter dated October 10, 1883 (C8), *ibid.*

[16] Sketches 1881, Nos. 3 and 5, Box 8, Moran drawings and sketches, Gilcrease Institute.

written Koehler on July 7,[17] but it was impossible for him to have reached that goal in the time at hand. Late September found him at Green River on his way home.

On reaching his studio Moran fell to work on the designs for *Picturesque B. and O.* The pictures constituted the largest number that he had ever contributed to a single volume, even a greater number than had appeared with his device in *The Great South* of Edward King. The commission thus came as capstone to his career as an illustrator, in the course of which he had made drawings for many volumes besides those already mentioned. A number were elegant gift books, of the type that flourished during the period, their pictures contributing to the newly acquired reputation of America as having the best illustrations in the world. Often Moran was but one of a number of artists offering designs for a particular volume; at other times he was the sole illustrator, and among the works that carried his pictures were *Songs of Nature,* selected and edited by John W. Palmer; James Richardson's *Wonders of the Yellowstone;* A *Century After: Picturesque Glimpses of Philadelphia,* edited by Edward Strahan; *The Poetical Works of Henry Wadsworth Longfellow,* in addition to the poet's *Excelsior,* his *Skeleton in Armor,* and his *Hanging of the Crane;* Hawthorne's *Scarlet Letter;* Benjamin F. Taylor's *Songs of Yesterday;* A *Popular History of the United States,* by William Cullen Bryant and Snyder Howard Gay; Noah Brooks' *The Boy Emigrants;* an anthology called *Golden Songs of Great Poets;* another called *Laurel Leaves;* Whittier's *Mabel Martin;* J. G. Holland's *Mistress of the Manse;* Bayard Taylor's *The National Ode;* John Russell Young's *Around the World with General Grant;* Henry T. Williams' *The Pacific Tourist;* and Eugene J. Hall's *Lyrics of Homeland.* The last volume appeared about the time of Moran's B. & O. excursion, and from this time on he would illustrate fewer books, but for two later volumes he would feel more than ordinary enthusiasm, books of verse by Lloyd Mifflin, an old friend, and Henry N. Dodge.

[17] L–6, Moran Collection, East Hampton Free Library.

XI *A British Summer*

⚜✶⚜✶⚜✶⚜✶⚜✶⚜✶⚜✶⚜✶⚜✶⚜✶⚜✶⚜✶⚜✶⚜✶⚜✶⚜✶⚜✶⚜✶⚜✶⚜

Estheticism flourished in the 1880's; beauty enjoyed a social vogue. Oscar Wilde, who had arrived in America with nothing to declare but his genius, had gone West to preach the gospel, and had admonished the miners, presumably for esthetic reasons, to retain their high boots and their blouses and their broad-brimmed sombreros when, with gold and silver in their jeans, they returned to civilization. He had politely condemned "the stolid ugliness of the horse-hair sofa" and "stoves decorated with funeral urns in cast iron"; he had begged Americans to adopt a greater and more seemly variety of jugware and to place some importance on color in their houses; he had praised the Peacock Room and the room in blue and yellow decorated by the American whom Ruskin had charged with flinging paint in the public's face.[1] Americans paid their money, and listened; "art," decidedly, was on the town.

Along with estheticism came another development, more provincial by nature: a resurgence of the colonial attitude. Americans looked toward ancient homelands—the Europe Henry James called the Great Good Place. Moreover, droves of them began to indulge their nostalgia; there began a great American Exodus. Every spring and summer thousands of Americans sailed to Europe to visit the places from where their forebears had come, to genuflect before the monuments of the Old World and rifle it of its symbols of culture, its paintings, objects of virtu, and bric-a-brac.

[1] Arthur Ransome, *Oscar Wilde*, 72.

Mollie Moran not only cultivated the current esthetic manner, she and Moran decided to join the great hegira. Sometimes in May, 1882, they sailed for England, with an assortment of their paintings and etchings. The voyage was pleasant, the weather mild, though icebergs were reported drifting south as far as the shipping lanes.

After docking at Liverpool, the Morans went to Bolton, where they received the hospitality of friends, the Tillotson family, connected with the Bolton *Journal*.[2] Moran made arrangements for an exhibition in the Bromley Art Gallery, in Bradshawgate. To enthusiastic notices in the local paper, he hung twenty-two oils, including his *Ponce de León in Florida, A Dream of the Orient, The Pueblo of Walpi, The Valley of the Rio Virgin, [Mist in] Kanab Canyon, The Azure Cliffs of Green River, Sunset on Long Island Sound,* and *The Bathers.* The display also included one hundred water-color drawings and his series of Hiawatha illustrations.[3] Because of Moran's connection with Bolton and his support from the press, the exhibition was a success, drawing curious crowds, and later the art dealer named Moran as an object-lesson to Bolton citizens in a campaign for better schools. According to the local paper, "Mr. Bromley told the story of . . . a poor Bolton handloom weaver who emigrated with his children to a country where they could go to school and receive a free education, and have a chance of finding some business to their taste when they grew up. One of the sons . . . developed into Thomas Moran the artist, whose paintings he had lately had on exhibition."[4] Moran seems to have enjoyed being "a local boy makes good" hero.

He and Mollie went on to Scotland, to the small weaving town of Strathaven, Mollie's birthplace, in Lanarkshire. On June 1 they were both sketching the ruins of the old castle of Avondale, where the Duchess of Hamilton, so tradition said, had found shelter during

[2] Fred L. Tillotson, of the *Bolton Evening News*, to Helen Comstock, ed. *Connoisseur*, January 12, 1937, in Ruth Moran correspondence, No. 89, Moran Collection, East Hampton Free Library.

[3] Note, Envelope 55, *ibid.* This source contains an extensive excerpt from a column on the exhibition in the *Bolton Evening News* (no date preserved). See also "Exhibition of Paintings in Bolton," *Manchester Guardian*, June 9, 1882.

[4] Scrapbook, p. 35 (unidentified clipping), Moran Collection, East Hampton Free Library.

Cromwell's invasion. The ruins stood on a rocky hill beside a small beck that purled into the Avon about one mile below, on its way to the Clyde, a view that prompted both to etch plates of the castle on the spot. Mollie was especially moved by the view down the vale of Avon, the banks of the river bold and craggy, and here and there studded with some of the largest oaks in Scotland. She found it a stirring homecoming, but they were soon making a journey across the Highlands.[5]

They stopped on what seemed the worst road in Scotland to sketch the Pass of Glencoe. It was wild and forbidding defile, virtually un-inhabited, with only a few primitive dwellings, all without chimneys, the smoke drifting gloomily out the doorways. Iron-gray volcanic mountains rose on either side, while tough grass and springy bog-land choked the bottom of the glen. Here was the place that Ma-caulay called the "Valley of the Shadow." The Morans were aware of its history—the murder of thirty-nine MacDonalds in the massa-cre of 1692.[6] A cold wind blew through the tall grass, a fit obbligato to the murmur of icy water in the Cona, brown with peat. At one place a stone bridge across the stream provided Moran with a sketch that led to several etchings and at least one oil painting. The *Bridge of Three Waters, Pass of Glencoe* struck the *Critic* as "painted with the love and spirit of a Highlander, and one might fancy that the artist had worked to the sound of bagpipes."[7] Nevertheless Moran destroyed the canvas for some unknown reason,[8] though the scene survives in his etchings and in the dramatic water color that even-tually joined the Gilcrease Collection.

The Highland tour ended with a cruise to the Hebrides. The Morans stopped at the island of Iona, long ago a center of Celtic Christianity. Tradition called it the cemetery of ancient Scottish

[5] Sketches for 1882 (Box 9, Moran drawings and sketches, Gilcrease Institute) provide numerous details to indicate the movements of the Morans in England and Scotland.

[6] Ortgies & Co., *Catalogue of Oils and Water Colors* (sale: February 24, 1886), Note for item No. 36 (*Bridge of the Three Waters, Pass of Glencoe, Scotland*).

[7] "Art Notes," *Critic*, Vol. VIII, No. 113 (February 27, 1886), 108.

[8] A photograph of the painting is preserved in the photographic file of Moran's works in the Gilcrease Institute.

kings. They found it full of romantic ruins; yet it evidently led to nothing among Moran's works. Next they went to Staffa with its celebrated Fingal's Cave. Moran studied the wondrous opening in the rock, lined with lofty basaltic columns, broken and variously grouped, overhung by a roof of the same fragmented rock; and as a consequence in 1885 he painted *Fingal's Cave*. In general, however, the scenery of Scotland failed to impress him, and he made sparing use of Scottish themes.

On going to London Moran rented a walkup flat at 45 Margaret Street, Cavendish Square, where the family settled for a three-month stay: Moran arranged for a London exhibition of his work, and it turned out to be an even greater success than the Bolton affair. Indeed, before his visit in the capital ended, the Bolton paper could inform its readers that "his success in London has been of the most unqualified character. The whole of his paintings and sketches have found customers at good prices, and the few remaining works in the hands of Mr. Bromley . . . will be removed to the metropolis."[9] In fact, Moran rode down to Bolton again to oversee their shipment.

One explanation for the London triumph was the approval his works received from Ruskin, still the foremost critic of the day, regardless of his mad spells and his loss of face from the contest with Whistler. For calming the old Prophet's nerves Moran had just the right opinion of Whistler's work, which he disliked for its lack of finish and other "eccentricities"; he considered Whistler much overrated, too lazy to "work after the first inspiration was gone."[10] There were other more positive reasons for Ruskin's sympathy, however; Moran and he had much the same attitude toward mountains, which the author of *Modern Painters* had connected with a love of liberty; he had written with delight about seeing "our painters traversing the wildest places of the globe in order to obtain subjects with craggy foregrounds and purple distances." He was convinced that the leading masters reserved "their highest powers to paint alpine peaks or Italian promontories."[11] He might have added the Rocky Mountains

[9] Unidentified clipping (probably from a Bolton newspaper), Envelope 179, Moran Collection, East Hampton Free Library.
[10] Interview, *Pasadena Star-News*, March 11, 1916, p. 6, col 3.
[11] Vol. III, Chapter XVI, 263.

had he seen Moran's work in time; indeed Ruskin considered Moran the ideal type of artist. Both believed of course in the necessity of finish.

On seeing Moran's etching after Turner's *Conway Castle*, Ruskin was eager to inspect the original painting. "Your etching," he wrote, "is very powerful and interesting: and the picture must be good, be it Turner or not. I will call in Margaret St. to-day about ¼ past four in case you are then able to show it to me."[12] He came, as he promised, a fantastic bowed figure, who looked very old now, with white hair and beard. He had some trouble in climbing the stairs that led to Moran's lodgings. He burst into the flat, and when he had caught his breath, he kissed young Ruth and put his name in the daughter Mary's autograph album, and almost at once, according to Ruth's remembrance, he fell in love with Mollie "and offered her, after half an hour of looking at her etchings and at her, his home in the English Lakes for the summer."[13] The rest of the family was, of course, included in the invitation. Then Ruth nearly put out one of his turquoise-colored eyes with the cork of a ginger pop bottle, which she thought, in her "American youthfulness, would refresh him. Fortunately, it went into the paper wall of the English jerry-built house that poor old Ruskin was trying to cure England of building."[14]

Ruskin disliked etchings as a medium, just as he disliked Americans as a people—or so he had once informed Longfellow. But the old man was apparently full of exceptions where his prejudices were concerned. His dislike of Americans had not prevented him from making Charles Eliot Norton his confidant or, a little later, from pouring "lyric toffee" over the head of Clarence King, who had come to Europe in green velvet knee pants, cut like Oscar Wilde's. Ruskin's dislike of etching did not prevent him from calling Mollie's work "grand," and when he looked at Moran's, he paused solemnly over *The Breaking Wave* (also called *The Resounding Sea*) and a short purple passage rolled from his lips: "the finest drawing of water in

[12] John Ruskin to Thomas Moran, n.d., Ruth Moran correspondence, No. 89, Moran Collection, East Hampton Free Library.

[13] Ruth Moran, Clipping from *Santa Barbara Morning Press*, November 29 [year?], Envelope 179, *ibid*.

[14] *Ibid*.

motion that has come out of America!"[15] He bought the etching on the spot for his museum at Sheffield. He also purchased several other etchings, both of Moran's and Mollie's, and ordered a portfolio of the Prang chromolithographs of Yellowstone and other Western scenes. When Moran showed him a sketch of the Bad Lands of Utah, he exclaimed naïvely:

"What a horrible place to live in!"

"Oh, we don't live there," Moran answered with a straight face. "Our country is so vast that we keep such places for scenic purposes only."[16]

At another time, when Moran showed him a sketch of the Grand Canyon, Ruskin was sure that it was Turner's work (though he could not place the location), and Moran found it difficult to convince him otherwise. "He . . . could not let an adverse opinion slip by unnoticed," Moran later reminisced, "and as I was of the same nature, we had some fine arguments. He was a sentimentalist of a high order; . . . this was apt to cloud his reasoning faculties and make him an unsafe guide for young artists."[17] As a matter of fact, Moran discounted some of Ruskin's criticism of his own work, as when the old man found his style a bit too broad and begged him to give up "flare and splash" and make closer renditions of nature.[18] All

[15] *Ibid.*; also, Note or revision, Envelope 54, in the East Hampton collection; Alfred Trumble, "Thomas Moran, N.A.; Mary Nimmo Moran," 3; Ruth Moran, in the Emigrant Industrial Savings Bank, New York, Calendar Brochure for 1937. This statement by Ruskin has been frequently quoted, indicating the pride Moran took in it; although the language varies in the several quotations, the gist remains always the same.

[16] Buek, "Thomas Moran," *American Magazine*, Vol. LXXV, No. 3 (January, 1913), 32.

[17] Quoted in Ladegast, "Thomas Moran, N.A.," *Truth*, Vol. XIX, No. 9 (September, 1900), 212.

[18] Ruskin to Moran, Feb. 15, 1883, Typescript C7, Moran Papers, Gilcrease Institute. Ruskin to Moran, n.d. (1882?). Cf. Ruskin to Moran, December 27, 1882: "—and I *do* wish with all my whole heart you would give up—for a whole all that flaring and glaring and splashing and roaring triumph—and *paint*, not etch—some quiet things like that little tree landscape absolutely from nature" (Typescript, C6, *ibid*. Also cf.: "—And please *do* mind what I said, about a severer and simpler sincerity of study" (Typescript C6[b], *ibid.*). I assume that Ruskin desired Moran to return to a style and manner more comparable to that of the early Pre-Raphaelites, with their meticulous attention to the minutiae of nature, the style Moran had employed

things considered, however, Ruskin held Moran's work in such high esteem that he asked his new friend to stay in England, promising to make his fortune for him there. Moran replied that America was the only place for him, that he could be happy nowhere else. The friendship continued in spite of Moran's rebuff, and after returning to America, he received several letters from the old man. A poignant touch of big-brotherly concern occurred in one when, after Christmas greetings, Ruskin cautioned Moran against working so hard, lest his health break down.[19] But Moran was a negligent letter writer and failed to answer, whereupon Ruskin also ceased to write.

Meanwhile, the Morans enjoyed three months of the "Londonizing process." They renewed their acquaintance with the collections of the National Gallery, the South Kensington Museum, and the Grosvenor, now so fashionable, Comyns Carr having made it a veritable cave of Alladin. They met many artists and exchanged proofs with etchers of note, including Seymour Haden, Whistler's brother-in-law and the leading etcher of London. Haden invited them to his Mayfair home.[20] They also attended a session of Parliament, a friend securing passes for them,[21] and sometime during the summer they sketched in Hampshire, along the Stour, where Moran presumably etched his plate entitled *An English River*.

With Turner's *Conway Castle* in his possession, he found the pull of Wales strong, and in early September he took the family there for a two-week tour. They spent most of their time at Conway, an old walled town, and among Moran's studies was one he made from the same hillside as the Turner painting. Mollie etched two plates of the castle, which, if not the grandest, was at least the most graceful ruin that they would see in Wales. They left the town on September 14 and rode up the valley of the Conway until they came

with fine effect in *Summer on the Susquehanna at Catawissa*, painted in 1862; if so, except in a few Long Island views, he ignored Ruskin's advice.

[19] *Ibid.* (December 27, 1882); *Fifty Years of the Maidstone Club*, 135–36.

[20] Seymour Haden to T. Moran, n.d. [1882], C3, Moran Papers, Gilcrease Institute; Percy Thomas to Moran, n.d., C60, *ibid.*; Alfred Slocombe to Moran, September 14, 1882, C5, *ibid.*

[21] John T. Thomasson to Moran, July 24, 1882, C2, *ibid.*

to the tributary Lledr. They stopped at Dolwyddelan Town, with its weathered castle, where Llewellan the Great was born. Then they traveled on toward Tremadoc Bay, with Snowdon rising on their right. At last they reached Criccieth Castle, facing the Bay; probably then they doubled back to Portmadoc, a center of slate quarries, sketching wherever they went. The road they took toward Harlech ran through oak forests mingled with birch and sycamore, with glimpses of Snowden ever in the background. The mountain still loomed on the north horizon when they came to Harlech, their resting place for the night. From their hotel window Moran sketched the battered castle on its cliff above a plain where the surf rolled, and in another drawing he included the bold profile of Snowdon in the distance. He also caught suggestions of the old village that straggled below the ruins on a terrace above the plain. The family then rode on, along the shore of Cardigan Bay, until they reached the last grand scene of their tour, Cardigan Castle.[22]

They must have embarked for home without delay, for by September 26 Moran was at work again at East Hampton, Long Island, where he bought Dr. Edward Osbourn's sheep pasture overlooking Goose Pond and matured plans for building a summer studio there. In noting his tour the press remarked: "He will paint this winter exclusively pictures from his summer studies in England, Scotland and Wales, and will also etch some of the scenes."[23] He made a number of etchings, especially of Welsh views, and in addition to his ill-starred canvas on the Pass at Glencoe, his oil painting during the months of fall and early winter included such works as A *Lancashire Village, Twilight*; *Welsh Mountains, near Conway*; *Windsor Castle*; and *On the Stour in Hampshire, England*. His paintings on British themes would, over a long period, reach an ample number, many of them deriving from later travel in the British Isles. Meanwhile, in January, 1883, he interrupted work for a quick, though richly stimu- lating jaunt through Mexico.

[22] The itinerary of the Morans' tour of Wales is reconstructed from dates and notations on sketches in Box 9, Moran drawings and sketches, Gilcrease Institute.

[23] Scrapbook, p. 31 (unidentified clipping, probably from a New York newspaper), Moran Collection, East Hampton Free Library. This item proved helpful in crystal- lizing the pattern of Moran's summer in the British Isles.

XII *Old Mexico*

❧✳❧✿❧✳❧✿❧✳❧✿❧✳❧✿❧✳❧✿❧✳❧✿❧✳❧✿❧✳❧✿❧✳❧✿❧✳❧✿❧✳❧✿❧✳❧✿❧✳❧✿❧✳❧✿❧✳❧✿❧✿

M oran's attention had turned to Mexico before his actual journey here. In 1881 he had painted a colorful oil, prob-ably from his Florida studies, but so Spanish American in atmosphere that it came to be known as *Old Mexico*.[1] Whatever its derivation, it suggested the possibilities of that land as a source of subjects. His interest was sharpened, perhaps, by a *Harper's* assignment to do a woodblock design of the Great Cut near Mexico City, the Tajo de Nochistongo; or maybe it came from reading the story by his friend, Mary Hallock Foote, of her Mexican sojourn. Whatever the stimulus, Moran was ready to visit the country early in 1883 with Arthur Renshaw, an English traveler.

They sailed from New York about the twenty-fifth of January. Soon their ship was steaming past Cape Hatteras, and on the twenty-ninth Moran made a water-color sketch of Double Headed Shot Keys off the Bahamas. They arrived at Havana the following day; the ship slipped past the Morro Castle with its ancient guns of green-stained bronze and came to anchor in a harbor partly ringed with palms and a town of low-roofed, yellow buildings. They seem to have stayed there several days; Moran's last sketch of Havana—

[1] The titles of many paintings by Moran have changed over the years, sometimes resulting in names that differ widely from the true subjects of the pictures they designate. In more than one instance a Mexican harbor scene has acquired a Venetian label, although the error is evident to anyone acquainted with either Venice or Vera Cruz. The need for a comprehensive catalogue of Moran's work is obvious, to clarify confusions in titles that have developed.

labeled "Cabaño"—was dated February 2. His next drawing, in water colors, caught a flaming sunset over the Gulf of Mexico.[2] No "norther" like the storm he would soon depict in *A Norther in the Gulf of Mexico* beset them as they steamed into the harbor of Vera Cruz, the city rising like an undersized Venice on the flat shore. Moran thought the one-half mile of compact buildings with blackened old rococo domes and brown-red church towers was "the most picturesque city on the Western continent,"[3] and he made a drawing of the skyline, with the snow peak of Orizaba in the distance. He also made sketches of the old castle of San Juan de Ulúa, with its quaint battlements, whitewashed in part though stained with weather, and set on a low-lying reef, fringed with aged palms. He later described one of the drawings as "made on the spot in 1883. I think it a good & characteristic specimen."[4]

He explored the town with Renshaw, riding the yellow cars pulled by mules along *calles* paved with rough stones, each with its open sewer that was daily doused with disinfectant. Flocks of vultures perched on the edges of buildings, the recognized scavengers of the place. It was not always easy for Moran and Renshaw to make their way, since neither knew Spanish.[5] But they satisfied their curiosity about the city, after visits to the cathedral and the market place and a walk through the sand dunes beyond the edge of town. At midnight they caught the train for Mexico City.

After speeding across a sandy plain and then through tropical marshes, the train began to climb through a countryside richly wooded, with trees draped in thick lianas, as they might have seen

[2] Sketches made in January, February, and March, 1883, have contributed numerous details to the reconstruction of Moran's Mexican journey. The artist valued these studies, some of them gems of color; he refused to part with most of them, and thus many came into the possession of Thomas Gilcrease as part (Boxes 10 and 11) of Moran's studio collection of sketches. In 1917, however, the artist had included a few Mexican studies in the gift he made to the Museum for the Arts of Decoration at Cooper Union. They have supplemented the Mexican sketches at the Gilcrease as sources of data for this chapter.

[3] Ortgies & Co., *Catalogue of Oils and Water Colors*, Note to item No. 34.

[4] Letter to G. H. Buek, September 20, 1896, C10, Moran Papers, Gilcrease Institute.

[5] "Thomas Moran, N.A." (Unsigned draft), B29, *ibid.*; Ruth Moran, Miscellaneous notes, Envelope 52, Moran Collection, East Hampton Free Library.

had they traveled in daylight. About dawn they reached the town of Córdoba, which Moran sketched, while Indian women supplied the passengers with corn tortillas and fruit—bananas, pineapples, and oranges. Full day had come by the time they reached the station of Fortín and began to wind along the gorge of the Metlac River. Horseshoe curves followed, and a series of trestles and tunnels, while the river gleamed below when not obscured by shadow. Soon they arrived at Orizaba, where it was customary for passengers to stay a day or so to acclimate themselves to the altitude. They remained about three days. On the fifth Moran drew the peak of Orizaba, a perfect sugar loaf in form, and on the sixth the waterfall at Atoyac. Early on the morning of the seventh they continued their journey, reaching the lofty town of Esperanza later in the day. There Moran drew both the pueblo and the peak behind it, then considered the highest mountain on the continent. That night after hours of riding across the dry and dusty plateau they came to the city of Mexico, lying beside the lakes in its spacious valley.

Moran sketched one of the city's canals, where he and Renshaw may have gone the next morning to see the Indians come with vegetables, fruit, and flowers banked upon their canoes. The travelers also saw Chapultepec upon its volcanic bluff and walked no doubt in the Bosque, under cypress trees that were bearded with moss and older than Montezuma. Moran made sketches not only of the palace, rather the worse for revolutions, but also of the view from its terrace, which looked down over the treetops toward the capital. It was a panorama centered on the city and backed with distant hills, beyond which towered Popocatepetl and Ixtacchuatl, gleaming under shawls of snow.

How Moran and Renshaw continued their journey is not clear. At that date they could have gone farther by rail, or they could have taken a stagecoach—*diligence general,* as it was called in Mexico. Most likely they secured in the city that mule-drawn conveyance by which they accomplished most of their itinerary. If so, they would have left by the same route as Mrs. Foote two years before—"the ancient *camino real,* built soon after the conquest, and apparently

never mended since."[6] And they would have found it as rough as she. It struck west, crossed the valley to Tucabaya, and later climbed through wilder country; it led the travelers across mountain passes, thick with pine and fir, and brought them into the valley of Toluca. Near the foot of a great volcano they came to a town of the same name, which had seemed to Mrs. Foote like a city in a medieval romance—"mellow in color, with dark cypresses, white bell-towers, and tiled domes against the background of dreamlike mountains."[7] Moran made a sketch of the tall volcano—Nevado de Toluca—up whose side a forest climbed almost to snowline—and as they resumed their journey, they could see the peak for hours rearing up behind them.

One and one-half day's ride from Mexico City brought them down into the lower *templado* zone, and after crossing a hot plain they passed through a half-ruined gate and found themselves in Maravatio, a town that had looked to Mrs. Foote "as if it had never been young."[8] Its aged, picturesque decay must have pleased Moran; he found it just the place in which to linger for a while. He made several drawings there, of the plaza, of the pink-and-yellow-walled cathedral with people kneeling before it in Sunday dress, of the washing place where women thronged on wash day. He also walked the trails that fanned across the plain outside of town; one of his drawings showed the fields upon the plain, another the adjacent mountains.

On the thirteenth he drew a peon with a loaded burro and labeled the picture "At San José beyond Maravatio," an indication that his respite from the road had come to an end. The travelers' destination was now Morelia, capital of Michoacán. They rode south to Angangueo, where they stopped at the Trojes silver mine to see its works. The fires of its reverberatory furnaces lit the village at night like a scene from Dante's *Inferno* and gave off hot and poisonous fumes; the people there had a worn, unhealthy look. Moran sketched the works and also a great ravine nearby, where the rocks were sown with pines and oaks and cedars, toughened by adversity.

[6] Mary Hallock Foote, "A Diligence Journey in Mexico," *Century*, Vol. XXIII, No. 1 (November, 1881), 2.

[7] *Ibid.*, 5. [8] *Ibid.*, 11.

Soon Moran and Renshaw were under way again. On the seventeenth they passed the eighteen-mile-long Lake Cuitzeo, whose placid surface teemed with birds—egrets, ducks, and blue herons; birds standing, swimming, diving, and settling in swarms. And then they came to Morelia, one of the cleanest, best-built cities in all Mexico. They probably stayed there for a day or two; if so, they awoke in the morning to "a confused jangle of innumerable church bells, deep and near, far and faint, mingled with the alert sounds of drum taps and bugle calls," for as Mrs. Foote explained, "in this way Morelia wakes every morning, the church bells calling her to prayer, and the cavalry bugles appealing briskly to her military sentiment."[9] For an artist in search of the picturesque it was a satisfying place, with its white domes and towers—"old white, with a great deal of color in it"[10]—its cypress trees of olive green, its lofty aqueduct, and the purple sweep of mountains in the distance.

On leaving Morelia the highway led northeast. The twenty-third found the two at Acámbaro just inside Guanajuato, arranging for a change of mules. A hard road led them to Celaya with its great domed church, where they arrived late the following day. "Leaving Celaya for San Miguel," Moran jotted in a notebook, "the road runs through a fine tract of flat country. . . . A few miles out we pass a large Hacienda surrounded by cultivated fields, the barley in many of them fully headed."[11] During the day they stopped at the village of San Juan Abajo, with its colorful market place and plaza, and early that evening they reached San Miguel de Allende, set on a mountain slope overlooking the valley of the Laja. The sky had begun to fill with clouds, though winter in Mexico was called the dry season, and that night a storm broke.

"Monday, Feb. 26th," Moran's notes continued, "We left San Miguel in a drizzling rain, which continued all day."[12] To make matters worse one of their drivers had gotten drunk and gave them

9 *Ibid.* (December, 1881), 321.
10 *Ibid.*
11 Diary of Mexican trip, February–March, 1883 (fragment, MS), A7, Moran Papers, Gilcrease Institute. This item is supplemented by a MS itinerary (also fragmentary), Envelope 52, Moran Collection, East Hampton Free Library.
12 Diary.

trouble. The road was good, however, until it grew miry from the rain. "[We] passed through the little town of Santuario situated in a beautiful valley. Everywhere the fields were ploughed & a large part of the country seemed to be in a state of cultivation."[13] Soon they came to a miserable looking village, and at an inn there several natives, full of pulque, relieved their anti-American feelings by cursing at them and making hostile gestures as they passed. "About 3 o'clock we arrived at Dolores [Hidalgo], wet and chilled to the bone."[14] The town itself was "poor & uninteresting," though famous as the cradle of Mexican independence, but they found its hotel clean and comfortable, and since the weather continued rainy and cold, they decided to spend a second night there. The mules they had acquired in Acámbaro were exhausted from the mud. But engineers of the railroad then being built were camped outside of town, and as they kept numerous mules for their operations, Moran and Renshaw went to their camp and arranged another exchange.

"After leaving Dolores," Moran wrote, "we ascended to a very large plateau, fully cultivated, extending miles in every direction."[15] It was the property of a single owner, whose princely hacienda they soon passed. They enjoyed ten miles of excellent road, then descending from the tableland, they struck through the Gap of Chirimoya, where Moran made sketches of "magnificent mountains." They spent the night at San Bartolo in a hut crawling with fleas, as a consequence of which they made an extra early start next morning. They took breakfast at Jaral del Berrio, a large hacienda with three or four churches. It was a "queer town," Moran recorded, but their breakfast there was excellent. Later that day they passed near the village of San Francisco, and evening brought them to the thriving city of San Luis Potosí.[16]

A great rolling plain, strewn with cactus, stretched for league after league beyond Potosí, and through it their road, which struck due north, offered a gradual descent; thus they made good progress,

[13] *Ibid.*
[14] *Ibid.*
[15] *Ibid.*
[16] *Ibid.*

though it was sometimes "cold and drizzly."[17] By March 7 they had gone as far as Catorce, so named for a band of fourteen desperadoes who once maintained a stronghold there and held the surrounding country in tribute. Three days later they rolled into Saltillo, near the battleground of Buena Vista, and Moran sketched the Fort of the Americans there. They pushed forward at once to Monterrey, and Moran studied the city from the roof of their hotel. He made a drawing also of the "old palace of the Bishops," a shattered ruin on a hill outside of town, the scene of fierce fighting during the Mexican War. And thus ended his journey through the land of Cortés. The travelers' next stop was Laredo, which, though more Mexican than Gringo in appearance, stood on the eastern bank of the Río Grande.

Moran had grown to like the color and atmosphere of old Mexico, and in later years he would make other visits there and paint scores of pictures on Mexican themes. The first result of the tour in 1883 seems to have been his *Castle San Juan d'Ulloa* [sic], completed shortly after his return. Turner's radiant canvases must have swept back through his memory. As one spectator observed: "He filled the sky above the castle with light-suffused clouds. . . . dipped the powerful walls in a warm and gentle effulgence . . . [and] led the minor craft of the harbor over a gleaming sea to the clustered sailboats at the shoreline."[18] The vessels were of ancient model; Moran chose to paint the scene the way he imagined it must have looked during the Spanish regime. The picture glowed with a triumphant luminism, and the same year he turned it into a vibrant etching. Later he also used the scene in a water color. Other themes which occupied him in 1883, as he reported to the collector Thomas B. Clarke, included "Maravatio, Celaya at Twilight, [and] Havana."[19] The Tower of Cortés became the subject of both a water color and an etching, and subsequent oils resulting from the tour included *The Plaza, San Juan Abajo, Mexico; Market Days in San Juan Abajo; Morning at Vera Cruz; A Mexican Hacienda, Lake Cuitzeo;*

[17] *Ibid.*

[18] *New York Times,* September 19, 1926, Section IV, p. 15.

[19] Moran to Thomas B. Clarke, October 1, 1883 (microfilm: Negative D–5, frames 204–205, Archives of American Art).

Moonrise on the Gulf of Mexico; The Pool (at Maravatío); *Near Maravatio;* and *The City of Mexico.* Koehler found in his Spanish American pictures "a delightful sense of gladness which it is difficult to define in words. The lightness and soft brilliancy of their color, and the feeling of unbounded space they convey . . . are suggestive of the pure atmosphere of a fresh morning."[20]

[20] In New York Etching Club, *Twenty Original Etchings,* 32.

XIII *The Studio, East Hampton*

✣✣✣✣✣✣✣✣✣✣✣✣✣✣✣✣✣✣✣✣✣✣✣✣✣✣✣✣✣

Ruth Moran wrote that between trips her father "settled down at his studio to a feverish program of work." This he did on coming back from Mexico in the spring of 1883. "Clients," she added, "drove him wild with their continual bickering over prices. Starting interviews with a firm point, he generally ended by taking whatever they offered—to end the ordeal,"[1] for he ached to get back to his work. He painted now for several weeks at his Booth Building studio. Then sometime late in the spring he relinquished the studio as well as the house on 55th Street, and the family went for another season to East Hampton, where they rented the old Mulford place, beside a gnarled apple orchard, at the corner of Main Street and Buell Lane.

Between tramps about the countryside, along the beach, and around Hook and Georgica ponds, Moran applied himself as intently as ever to his etching and painting. "I have been very hard at work all summer," he wrote Thomas B. Clarke, "& have painted some very good pictures; two in particular which I wish you could have seen before anybody else . . . : one I call 'The Glory of Spring,' an East Hampton apple orchard in full bloom against a deep blue sky. The other I call 'Cloud & Sunshine.' "[2] Clarke, who bought neither but, instead, a view of Vera Cruz Harbor and a small pas-

[1] Quoted in "Moran Pictures Draw Crowds to Government Gallery," *Newsweek*, Vol. VIII, No. 7 (August 15, 1936), 21.
[2] Letter dated October 1, 1883 (microfilm: Negative D–5, frames 204–205), Archives of American Art.

toral called *East Hampton*, was a most unusual patron of art. While most rich collectors in America were snapping up the products of the French salon, he sought the work of native painters, buying directly from them and urging his wealthy friends to do likewise. He had already secured from friends at least two orders for works by Moran and had himself bought a small oil, *Enquiring the Way*, which Moran had painted in 1879. "I have heard of you all summer," Moran declared in October, "& the steps you are taking to advance the interest of American art You deserve & I believe you have the gratitude of the artists for your patriotic efforts in their interest."[3] Indeed, when Clarke came to sell his collection in 1899, the auction would seem a landmark in the history of American art, an event that imparted to native painting the sort of luster that Americans understood best—that generated by the liberal checkbook.

Meanwhile Moran produced other paintings in the summer of '83, including the small *Landscape with Cattle* that Thomas Gilcrease would eventually buy. A Long Island scene, it depicted dunes along the skyline to the right, with a streak of ocean along the horizon in the center. White sails glinted in the distance, mere bright specks, and light-yellow sand hills ranged to the left behind a low clump of trees. Moran gave his attention with Ruskinesque intensity to the marshy ground that began in the middle distance and spread down to the lower corner, with reeds and water lilies delineated in delicate detail. Five head of cattle grazed at the water's edge. Overhead the sky glowed a soft blue, with a few wisps of cloud. Here was no bold "flaring and glaring."[4] The small landscape was a complete antithesis of a Moran spectacular. No doubt it would have pleased Ruskin; its style, moreover, was typical of much of Moran's work that summer, his Mexican scenes included. "I shall have a good showing," he wrote, "when I get back to town which will be about Nov. 1st. I have no studio or house yet, but hope to find them while I am in town on the Hanging Committee at the Academy."[5]

[3] *Ibid.*
[4] Ruskin to Moran, December 27, 1882 (typescript), C6, Moran Papers, Gilcrease Institute.
[5] Moran to Thomas B. Clarke, October 1, 1883, Archives of American Art.

He rented a flat in Greenwich Village, on West Tenth Street, in a curiously shaped block bounded further by Sixth Avenue, West Eleventh Street, and Greenwich Avenue. The block later won notoriety as the home of such sturdy bohemians as Theodore Dreiser, John Reed, Dudley Digges, John Masefield, E. E. Cummings, George Cram Cook, and Susan Glaspell, with Eugene O'Neill a frequent visitor. Opposite the Morans' house rose the high Gothic walls of the Jefferson Market Police Court, with its array of turrets and traceried windows. From Moran's doorstep, sometime in early 1884, a friend saw the moon peeping from behind the clock tower, creating a picturesque pattern of light and shadow.

"Why don't you put that scene into a picture?" he asked Moran.

"Because I've already done so. I put an angel over the tower, and made a Christmas card of it."[6]

They both laughed. Such a combination resulting in a Christmas card struck them as funny. But in Moran's design Greenwich Village had the look of a sleeping medieval city, to which the angel brought joyful news. He had submitted the drawing to a contest sponsored by Louis Prang, who claimed to have published the first American Christmas card nine years before, and it took third prize. But when the entries were shown at the Noyes and Blakeslee Gallery, one critic thought a different ordering of the prizes would have reflected the quality of the winners more correctly. In his opinion Moran's design was "the most striking."[7] The exhibit attracted much attention; so many people attended that it was hard at times to get near the pictures.

In 1884 Moran concerned himself largely with painting East Hampton and Long Island scenes, and in the late spring he again took his family to East Hampton, the town which now became their permanent summer home. From plans he had himself drawn, he began building "The Studio," a gray-shingled, two-storied, hip-roofed house, on the sheep lot he had acquired from Dr. Osbourn. He hired a local builder to take charge of construction. The main

[6] Scrapbook, p. 31 (unidentified clipping), Moran Collection, East Hampton Free Library.

[7] Ibid.; New York World-Telegram, December 18, 1953.

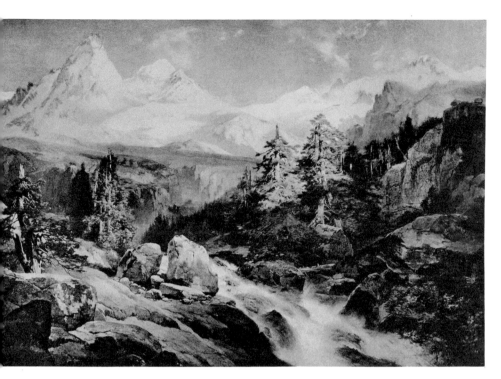

In the Teton Range, 1899. Engraving from an oil, 20x30 inches.

U.S. National Park Service

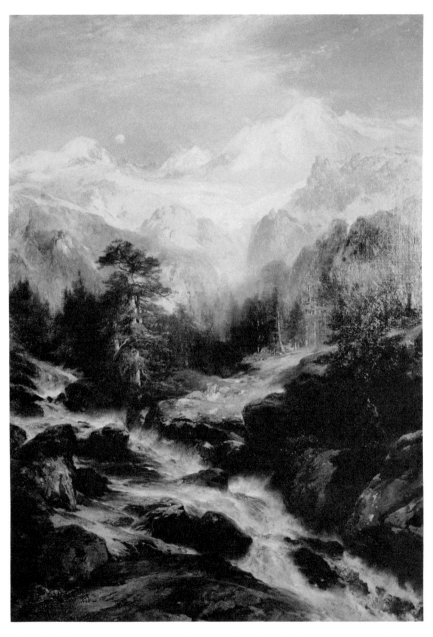

In the Teton Range (sometimes called *Rocky Mountains*), 1899.
Oil, 42x30 inches.

IBM Gallery of Arts and Sciences, New York

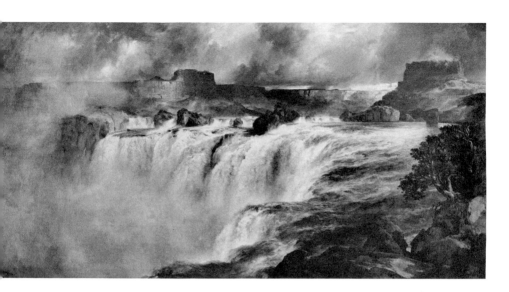

Shoshone Falls of Snake River, Idaho, 1900. Oil, 71x132 inches.

Gilcrease Institute, Tulsa

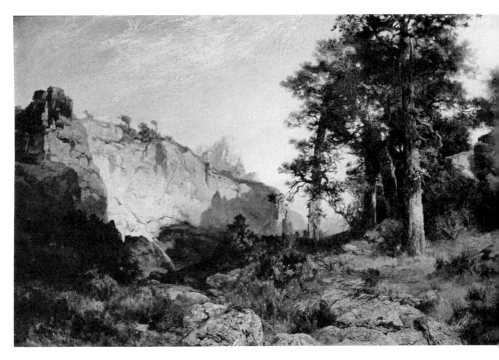

Coconino Pines and Cliff, Arizona (sometimes called
Red Rock, Arizona), 1902. Oil, 20x30 inches.

Albert Gallatin, New York

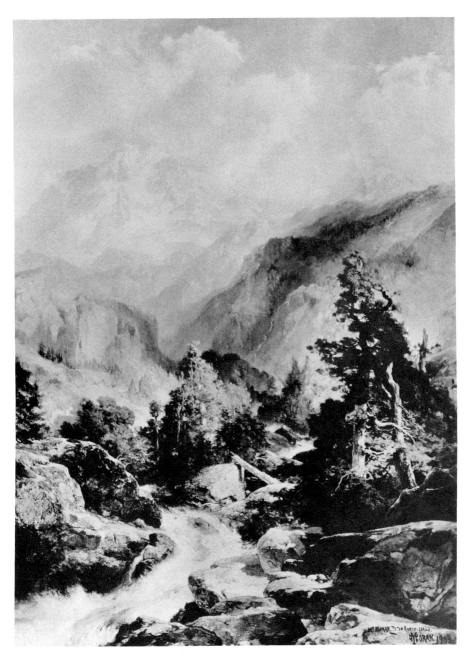

Mount Moran, Teton Range, Idaho [*sic*], 1903. Oil, 40x30 inches.

U.S. National Park Service

Autumn, Near Peconic Bay, Long Island, 1904. Oil, 20x30 inches.

Hirschl & Adler Galleries, Inc.

Ácoma, 1904. Oil, 23x36½ inches.

Gilcrease Institute, Tulsa

Cockington Lane, Torquay, England, 1910. Oil, 30x40 inches.

By permission, The Thos. D. Murphy Co.

room, designed as a combined parlor and studio, measured forty feet by twenty-five feet, and "with no supports," it was "a difficult job" to build.[8] But when the house was finished, it was recognized as one of the most commodious in town. It was said that only one other house then had a room larger than Moran's studio.

The front door opened directly into the studio from a columned porch that would in time be draped with vines. At one end perched a balcony—or gallery—reached by a flight of stairs, and under the balcony was a dining room, shut off from the studio by Oriental rugs that hung between long-seasoned mahogany pillars which Moran had bought from a razed mansion. Several windows had come from a similar source, as well as the front door, of heavy green glass and leaded panes, bearing the number 938, the address of a demolished house on Broadway. In one of the walls Moran had even embedded the porthole from a derelict ship. There was a large fireplace, and its old colonial mantle would, in time, be decorated by small heads painted by various artists—Stephen J. Ferris, Percy Moran (a son of Edward), Walter Shirlaw, and Moran's son Paul. A small pentagonal tower room, extensively glassed, opened off the balcony, and there one could always drench himself in sunlight whenever the sun shone, regardless of the hour. The stairway continued up to the second floor, divided into bedrooms.[9]

As the house stood back from the road, behind screens of trees and hedges, there was no annoyance from traffic or the dust which horses and carriages turned up. Moran was proud of the old elms that lined the street, interspersed with silver poplars, a fact that caused a day of excitement years later when the large building known subsequently as the Sea Spray was being moved to its new location on the beach. The movers brought it along Main Street, and several elm branches had to be sawed away to allow it to pass. As the movers brought their huge charge in front of the house next door to the studio, they found the street was narrow at that point, and a group of silver poplars stood in their way. Moran, ordinarily the mildest

[8] *Maidstone Club*, 24.

[9] Ruth Moran, "The Studio" (MS), Envelope 71, Moran Collection, East Hampton Free Library; *Newsweek*, Vol. VIII, No. 7 (August 15, 1936), 21.

sort of man, rose in wrath at sight of their saws and axes, and though he weighed at least one hundred pounds less than the foreman of the crew, he stated flatly that no more trees would now be maimed. To back his argument he produced his Smith and Wesson six-gun. If they cut another branch, he swore he would shoot. "To make sure that the trees were safe," according to one report, "Mr. Moran spent the entire day on a camp stool in the street until the house and danger had passed."[10] Nothing serious was to happen to the trees until the 1938 hurricane. Meanwhile they gave the studio a pleasant sense of privacy.

As soon as the shingles weathered and vines crept up the walls, the house assumed what Ruth Moran called "a mellowed charm."[11] Along its broad lawn stood rows of hollyhocks, chrysanthemums, and other flowers which Mollie planted every spring, for she was a tireless gardener. And here, unless upon their travels, the family was glad to spend six months or so of every year, arriving early in May and returning to the city in late October, or early November; and in time, after their successsive returns, the studio became as cluttered with esthetic objects as the usual Victorian bric-a-brac shop. "You stand in delightful wonder as you look about you," wrote one visitor:

> Across that dark, wood-carven gallery above are thrown the gorgeous vestments, now dulled, now diamonded in the shadows and the sunshine of the studio, of prelates of Brittainy, ecclesiastical fragments from Hungary, fragrant moth-eaten robes from old Rome, dimmed now but most divine with the sacred smell of incense. Suspended from the "gallery" swing bulbous bronze delights, deep hued, lustrous as the eyes of a Sultan's favorite, or the jewelled splendors of her sandalled feet. Here are rugs from Persia and Afghanistan; but, more wonderful than all of them, a chef d'oeuvre of the Oriental weavers' art, [is] an Egyptian rug with scarabs and a lotus flower woven into its texture.[12]

This paean was hardly more extravagant than the actual furnish-

[10] *Maidstone Club*, 49.

[11] "The Studio"; William H. Simpson, "Thomas Moran—the Man," *Fine Arts Journal*, Vol. XX, No. 1 (January, 1909), 23.

[12] Lucy Cleveland, "In Thomas Moran's Studio" (clipping), Envelope 179, Moran Collection, East Hampton Free Library.

ings of the studio—such a contrast to the comparative austerity of Moran's work rooms in New York City. In its exotic contents the East Hampton studio rivaled Chase's bizarrely accoutered quarters at the Tenth Street Studio Building in Greenwich Village.

As there were only two houses in town with rooms large enough for dancing, the Morans' big room became "a social center for the young people, who nearly danced it down."[13] Music often filled the room, Mollie's plaintive Scotch songs, Moran's three-finger fiddle playing, or Paul's more studied performances on the violin, guitar, or mandolin. Mollie held a weekly "day," and she gave parties for her son and daughters, some of them fancy-dress affairs, others less formal. At a party in 1891, according to report, "Evening dress prevailed, although half a dozen came in flannels from a yachting party and sustained the East Hampton custom of go-as-you-please dressing. The grounds were arranged with rugs and chairs and the trees hung with Chinese lanterns."[14] Moran had a green bathhouse built and carted down to the beach every June, when the ocean was finally warm enough for swimming, and back again in October when the water grew too cold; and the family spent much time on the beach, where Moran liked to walk and watch the roll of the surf, seeing fleeting pictures, thrusting his cane into the sand until its tip assumed a permanent bend. As time went on, the family had many "crabbag parties" and suppers around a fire at Georgica Pond, whose seaward shore was literally alive with large blue crabs.[15] At their parties and outings they often had the company of Leon and Percy Moran, whose father Edward had built a summer home at Greenport on the north edge of the island.[16]

There was tennis still at the Tennis Club behind Aunt Phoebe's, with the barn for its clubhouse.[17] Out of that carefree organization

[13] *Maidstone Club*, 24.

[14] Quoted, *ibid.*, 159.

[15] Ruth Moran, "Notes on the Tile Club," JG 104, Long Island Collection, East Hampton Free Library.

[16] Lizzie W. Champney, "The Summer Haunts of American Artists," *Century*, Vol. XXX, No. 6 (October, 1885), 852.

[17] Jeannette Edwards Rattray, *East Hampton History, Including Genealogies*, 150–51.

grew the prestigious Maidstone Club, of which it was later remarked: "East Hampton Society falls into two distinct groups: those who belong to the Maidstone, and all the rest."[18] Moran, who was an enthusiastic clubman in the city, belonging to the Century, the Lotos, and the Salmagundi, of which he was for a while the president, helped incorporate the Maidstone in 1891. He assisted in drawing up its constitution and by-laws, and at the first business meeting he was chosen for the board of directors and elected vice-president. He declined to serve, though he gave a painting to hang in the new clubhouse, which later, alas, burned down.[19]

Summer living at East Hampton had its idyllic side, but heralded as a "new Barbizon," the town and countryside had greatest charm for Moran as an inexhaustible subject for his work. The leisured loafing enjoyed by so many summer visitors was a luxury his urgent temperament made impossible; he continued painting until November, and when not at his easel, he roamed the countryside, cane in hand, and became familiar with rural haunts for miles around, breathing with deep content the southerly winds so sweet with the scent of honeysuckle and wild roses, which seemed to abound everywhere. Sunset was a favorite hour for his walks, and the light effects were worth his trouble; for several years after 1883, when the explosion of Krakatoa in the South Pacific had spewed volcanic dust into the stratosphere, sunsets flamed the world over with a glory unexcelled in modern times. Those who later claimed that Moran's Long Island sunsets were exaggerated in their radiant glow had merely forgotten the spendors that had daily burst upon the world in the middle 1880's.

Places like Sassafras Hill, Appaquogue, Three Mile Harbor, Five Mile River, and Fresh Ponds (to mention but a few) drew him with their gifts of quiet scenes; time and again he sketched at Amagansett, with its dunes and its wide rolling stretches of sand and beach grass, where the blossoms of wild plum and shadbush tossed like mists in the spring, and the red leaves of woodbine and the shining

18 William K. Zinsser, "Far Out on Long Island," *Horizon*, Vol. V (May, 1963), 9.
19 *Maidstone Club*, 16, 37.

green of deerfeed made variegated carpets in the autumn.[20] And when the winds of fall began to quicken and the surf ran high, he would drape his thin, wiry figure in a cape coat, put on his beaver cap, and venture out into the wind in search of wilder subjects for his pictures. On one such hunt a wreck on the rocks at the tip of Long Island gave him the motive for *The Cliffs of Montauk.*[21] The tempest had passed, as Moran pictured the scene, but the sky still glowered, and the fallen tide strained toward the mossy boulders that littered the shore. High on the wrack lay the melancholy hulk, scarred and battered, where the sea had heaved it up. The picture left no doubt of the fury of the storm, and the effect so pleased Moran that he also made an etching on the theme.

In the fall of 1884 he produced his spacious *Storm on the Beach at East Hampton* (sometimes called *Blowing a Gale, East Hampton Beach*), panoramic in effect with a width twice its height (thirty inches by sixty inches). Under a lowering sky he depicted a heavy surf breaking against a sandy shore to the left; over the white manes of the combers the masts of a ship were silhouetted against the skyline, just to the right of center. The effect of fierce wind pervaded the entire scene, driving the waves, dashing the white spray, and the ship itself seemed in imminent danger of running ashore, while near the skyline on the beach stood a diminutive line of people, their eyes turned seaward, as if they were gripped with a heartsick sense of the ship's peril. Considering the way Moran could paint the sea in such a work, a critic of the *New York Times* wondered why he did anything else when there was such a dearth of skilled marine painters.[22] *Storm on the Beach* was a canvas to which Moran returned in subsequent years, retouching and repainting, a practice he followed on a number of his works, so compulsive was his artistic conscience, but when at last completed to his satisfaction, this grim seascape

[20] Several books are rich in detail about East Hampton and environs; notably, Rattray, *East Hampton History*; Samuel Seabury, *Historical Sketch of East Hampton, Long Island*; Jacqueline Overton, *Long Island's Story.*

[21] Dr. Charles A. Huguenin, "Thomas Moran, Painter, Etcher," *Long Island Forum*, Vol. XVII, No. 12 (December, 1954), 223.

[22] "Pictures by Thomas Moran, N.A.," *New York Times*, February 22, 1886, p. 4, col. 7.

had few more powerful rivals among his works. Less ominous in its import, yet full of the atmosphere of gathering storm, was *East Hampton, Long Island,* which Moran painted also in 1884 and later sold to F. W. Woolworth. It showed nimbus clouds boiling up over a green countryside, set with houses and windmills. Rays of sunlight had struck through the clouds, playing across a foreground rise where the nearest windmill stood. One sensed how ready the clouds were to crack with lighting, then erupt into sheets of rain; one could almost smell the impending downpour.

Moran had painted another notable canvas, *Three Mile Harbor,* which pictured a tan beach sloping down to blue water, with light green grass and darker trees in the background. Gray clouds covered the sky, except for splashes of blue. There was serenity in the scene, accented by the peaceful bearing of the figures (with a touch of red in their dress) who stood amid tangles of driftwood near the water's edges. Moran had sent the painting to an annual exhibition at the National Academy of Design, where it created a favorable impression. He enjoyed high standing among the academicians, many of whom sympathized with his withdrawal from the Society of American Artists. On May 12, 1881, he had received word of his election as an Associate the day before, the act contingent upon his supplying a painting of himself for the Academy's collections.[23] When sometime during the following year he presented a portrait done by Hamilton Hamilton, his election as Associate was confirmed. Now in 1884 he was named as a full Academician, and as his diploma painting he offered *Three Mile Harbor.*[24] In a retrospective exhibition, held fifty-eight years later in honor of the Academy's occupation of a new Fifth Avenue home, Royal Cortissoz found that Moran's canvas left "a very rich impression"; he thought it "one of

[23] Addison Richards, Corresponding Secretary, N.A., to Thomas Moran, May 21, 1881, A6, Moran Papers, Gilcrease Institute.

[24] Clark, *History of National Academy,* 121. Concerning membership in the Academy at the time of Moran's election, Clark states (p. 102) that "as recorded in 1883 [it] consisted of 92 Academicians and 83 Associates, the number in each class being limited to 100. The candidates nominated were chosen only from the current annual exhibition. . . . A two-thirds vote of the Academicians, providing a quorum was present, was required for election."

the best things in the show."[25] For several years now Moran had revealed himself as a master of poetic mood, and though his fame persisted for the grand spectaculars, to which he would still return on a few occasions, the greater bulk of his work strove less for grandeur and sublimity and ran to smaller canvases, in a quieter, more poetic mood; the generality of his work seemed typified by *Three Mile Harbor*, as poetic as anything by Daubigny.

Often Moran's Long Island landscapes suggest an affinity with the Barbizon school. Now and then a touch of Corot seems evident in his trees, lacy and feathery, with flecks of sky glinting through the foliage. Sometimes, too, the general tonality reminds one of Corot, as the *Critic* detected when noting "in some of his Long Island subjects . . . that beauty of subdued color and gray tone which is distinctly modern."[26] More often a touch of Rousseau may be detected, especially in the autumn-tinted oaks which so often border a reedy pond. The quiet pastoral scenes of Long Island encouraged Moran also to emulate the Dutch, especially Ruysdael, from whom, perhaps, he derived a characteristic device of securing depth; that is, by means of contrasting sweeps of sunshine and shadow that alternate from his foregrounds into the distance. This device Moran used skillfully, though unobtrusively, in *A Windy Hilltop—Amagansett*, and it was perhaps a factor in prompting M. L. D'Otrange Mastai, American editor of the *Connoisseur*, to find in the picture a "flagrant allegiance to the European tradition"[27]—a judgment admittedly not affected by a windmill in the distance, though wind-

[25] *New York Herald-Tribune*, January 12, 1942, Section VI, p. 8. See also "The Heritage of the National Academy," *Art News*, Vol. XL, No. 19 (January 15-31, 1942), 13-16.

[26] Vol. VIII, No. 113 (February 27, 1886), 108. Moran's mastery of the salient characteristics of Corot's style has a certain verification in an anecdote told by Mr. Albert Gallatin. His mother once remarked in the artist's presence: "I so like Corot's paintings; I wish I had one."

"I'll paint you one," Moran said, and he did. He listed it as "A Corot" in his records. Today it belongs to Mr. Gallatin, who once showed it to a prominent art dealer of New York City. The dealer claimed he could not have told it from a real Corot.

[27] "Landscapists of the South Fork: I," *Connoisseur*, Vol. CLIII, No. 618 (August, 1963), 282.

mills often impart to Moran's Long Island scenes a slightly Netherlandish atmosphere.

Other Long Island canvases which Moran painted during the 1880's included *A Misty Morning, Appaquogue; Path to the Village, Amagansett; The Edge of Georgica Pond; Gleaning from the Wreck, Montauk; The Oaks, Long Island; Five Mile River; Summer Squall; A Stormy Day;* and *Sunset, Long Island*. In the 1890's, *A Cloudy Day near the Coast; Watering Place, Amagansett; Moonrise on the Beach at East Hampton; Near Southampton; A Windy Hilltop—Gardiner's Bay*—but the catalogue could run on and on. Moran never tired of pouring his feelings for eastern Long Island into the scores of canvases that pictured its varied scenery. He devoted a greater number of paintings to the region than to any other single place except, strangely enough, Venice and its environs. The wonder is that, in doing so, he repeated himself as little as he did.

XIV *An American in Venice*

✦※↯◈↯※↯◈↯※↯◈↯※↯◈↯※↯◈↯※↯◈↯※↯◈↯※↯◈↯※↯◈↯※↯◈↯※↯◈↯※↯◈↯※↯◈

O n the seventeenth of May, 1885, the *Brooklyn Daily Eagle* noted that Thomas Moran was again ready to go to East Hampton for the summer. The paper mentioned his recent concern with marine painting and his aim to indicate in such paintings "the force and vastness of the ocean. Billows bursting in angry clouds of foam and spray on rocks and beaches; lonely stretches of mid-sea, and lowering sunsets burning on the distant horizon; these are aspects of the ocean he delights in."

That same year he also produced a marine of a different sort—*The Castle of San Juan D'Ulloa* [*sic*], *Vera Cruz Harbor*—in the golden style of Turner. Its antecedent, in tone and feeling, was his *A Dream of the Orient* of a decade before. It was a sunset scene, the clouds ablaze with yellow light, with glints of russet here and there, against which rose the paling silhouette of the fortress, with antique sailboats hovering in the water to the left. Whether or not a direct reminiscence of Turner, its atmosphere was so like that of a Venetian sunset by that master colorist that in time it would become miscaptioned as *Venetian Seaport*. Perhaps it reflected Moran's increasing desire to see Venice, so much a part of America's "Dream of Arcadia."

Not only was Venice the goal of ordinary Americans abroad, it had a magnetic attraction for American artists. In the 1870's Frank Duveneck had etched there. In 1880 Whistler had lounged in Florian's Cafe and sketched the lesser canals, the baroque gardens, the

{185}

courtyards, the doorways, and the golden tops of spires and towers rather than the usual monuments. Chase, too, had passed almost a year there, while copying Giorgione at the Giovannelli Palace and painting his *Venetian Fish Market*, so full of life and vigor. William Gedney Bunce had followed Turner's track there and had grown so fond of the city's color that he would paint it for the rest of his days. By the mid-1880's Venice had become a kind of artistic Mecca, where every morning the white umbrellas of artists rose like mushrooms on the canals. As the Morans had missed the city on their former Italian journey, they now resolved to go there and soak themselves in its glowing atmosphere.

Long Island scenes dominated the season's work at East Hampton, and Moran included several of them in the sixty-four pictures he assembled for an auction to pay for the coming trip. The sale opened on February 24, 1886, at the Broadway gallery of Ortgies and Company, which had prepared a catalogue illustrated with several of his etchings. Besides Long Island scenes, the collection included *Ponce de León in Florida* and a painting as old as 1859, "*Childe Roland to the Dark Tower Came*"; there were also marines, Western landscapes, and studies of Niagara. "Mr. Moran has probably untold pictures besides these that he exhibits now," one newspaper said. "They are not by any means the inventory of his studio, or the result of a cleaning up. On the contrary they constitute the most impressive exhibition that any of our artists has yet made for a like purpose, all serious and well considered works."[1] Thomas E. Kirby of the American Art Association wielded the gavel.

"The sale went off pretty well," Moran reported to a friend.[2] Nevertheless he must have been disappointed. Well attended though the event was, the entire collection realized a total of only $10,321. All too often the pictures went at a sacrifice. The *Ponce de León* brought two thousand dollars, a fraction of what Moran had expected when he painted it, and a fraction of what it would bring at subsequent sales. Some of the smaller pieces went for less than

[1] Unidentified clipping, Envelope 179, Moran Collection, East Hampton Free Library.
[2] Letter to S. R. Koehler, March 1, 1886, L–8, *ibid.*

one hundred dollars each.[3] Yet disappointing as the results were, Moran could now afford the expense of a family voyage. "I sail tomorrow in the *Fulda* for Bremen," he wrote on the thirteenth of April.[4]

The North German Lloyd liner cleared port on schedule and, with fair weather for sailing, reached Southampton on the twenty-third, then steamed on to its home berth. The Morans lingered in neither Germany nor Switzerland, and early May found them in Venice, housed at the Grand Hotel overlooking the Grand Canal, not far from the Molo.

Few sketches have survived from the sojourn; Moran left little record of it other than in his Venetian paintings, but they indicate that he memorized the scene "like a poem."[5] On May 7 he made a drawing at San Michele, beside the Campo Santo with its cypress trees and rose-colored walls, fronting the more squalid side of the city. His drawings of the Venetian skyline, centered on the Campanile of St. Mark and the Ducal Palace, with the domes of Santa Maria della Salute rising boldly to the left, he seems to have made from outlooks on the Giudecca and San Giorgio Maggiore, or from a gondola in the water.

The sun-drenched atmosphere was at its best during the season of his visit. The streets, the squares, the gardens, and the buildings gleamed with light from both the sky and the water of the canals; the city seemed bathed in radiance. The wonder spread to the surrounding lagoon, and Moran found, as William Dean Howells before him, that its "water forever trembles and changes, as with the restless hues of opal."[6] To judge from subsequent paintings he was fascinated with the vista where the Grand Canal and the Canal of the Giudecca came together in the lagoon. The lagoon it was in actuality, though the stretch of water between the Molo and San Giorgio bore the name of Canale di San Marco. It was the most

[3] *New York Times*, February 25, 1886, p. 5, col. 2. The sales catalogue, Item No. 85 in the Moran Collection, East Hampton Free Library, has a sales price recorded for each picture sold.

[4] Letter to S. R. Koehler, April 13, 1886, L–10, *ibid.*

[5] Ruth Moran's phrase for the way her father registered a view.

[6] *Venetian Life*, I, 219.

restless thoroughfare in Venice, full of boats, especially black-hulled gondolas that skimmed the water like swallows, and that prospect Moran suggested, more than any other, when he said: "Venice is an inexhaustible mine of pictorial treasures for the artist and of dreamy remembrance to those who have been fortunate enough to visit it."[7] His favorite hour was sunset, when the sun left a crimson trail across the water and a deep flush played over the city. The buildings soaked up the light and glowed like gems, and then he would exclaim, according to his daughter, "Venice is a dream!"[8] The city's beauty, however, did not divert the Morans from making trips to other points—Murano, Burano, and Torcello, to the north, or Chioggia at the south end of the lagoon.

And then if they adhered to their original plans, they returned to East Hampton late in June. The atmosphere, the luminous color of Venice had so appealed to Moran's "poetic temperament" (to use his own phrase)[9] that he set about at once to place his impressions on canvas. The result was a radiant picture he called *The Gate of Venice*; he chose that name because the view, as he explained, "embraces the entrance to the main artery of the city, the Grand Canal, in reality the *Gate* to this 'City of the Sea.' "[10] The hour depicted was late afternoon. A sinking sun hung above the Dogana, next to Santa Maria della Salute, and it made the cloud-dappled sky a glory of color. Opalescent mist shimmered over the water, an effect that suggested "a piece of rich Venetian glass,"[11] and through it the surfaces of the canals reflected the hues of the sky. Even the white sails that dotted the far horizon seemed to gleam, and through a long perspective the Grand Canal dissolved in a subtle gradation of atmosphere. Moran thus achieved a remarkable play of light, and when

[7] Letter to Christian Klackner, May, 1888, *"The Gate of Venice" Etched by Thomas Moran, N.A.* (Pamphlet—copy on file with Moran's etching in the Print Room, New York Public Library).

[8] Ruth Moran, "Thomas Moran, N.A.," B5(b), Moran Papers, Gilcrease Institute.

[9] Autobiographical sketch (MS), A18, *ibid.*

[10] Letter to Klackner, May, 1888.

[11] "Art," *Public Opinion*, Vol. II, No. 42 (January 29, 1887), 342.

the picture was shown at the National Academy, in the spring of 1887, its luminous effects were much admired.

No sooner had he finished the painting than he began a large etching based upon it, one whose proportions (eighteen inches by thirty-one and seven-eighths inches) exceeded those of even his plate etched from Turner's *Conway Castle*. He worked at it intermittently, and it took him most of two years to finish the task, but the results repaid his effort. Koehler found it as luminous as the original painting and especially approved of the vigorous way in which Moran had "treated the boats and crews down to the detail of the dress of the boatmen and the peculiarities of the cargoes."[12] The plate was not so much a copy as an interpretation, and possibly, as someone suggested, "more of an achievement than the painting from which it derives."[13] It was Moran's most elaborate etching, and he regarded it as his best. He also made a smaller plate from the same composition, one in which it was necessary to eliminate many of the intricate details; consequently the plate lost much of the interest, as well as the shining quality, that made the larger work Moran's etching masterpiece.

For several years he showed at least one Venetian painting at every National Academy exhibition, although his prolific outpouring of scenes from Venice did not begin till he made a second visit to the "City of the Sea." Meanwhile he continued to paint Long Island landscapes with an occasional Western view; he made several etchings every year and many designs for illustrations. In 1886 he helped organize the New York Art Guild, an association of artists for the protection of pictures at fairs and industrial exhibitions, and became its first president.[14] In 1887 he made another trip to Florida, in Mollie's company, revisiting Fort George Island and the slow and somnolent St. Johns River.[15] That year he took a winter house at 107 West 11th Street and opened a studio at 216 East 9th Street, a tem-

[12] Quoted in *New York Times*, September 19, 1926, Section IV, p. 15.
[13] *Ibid.*
[14] *Los Angeles Times*, September 6, 1926; Scrapbook, p. 31 (clipping: "New York Art Guild"), Moran Collection, East Hampton Free Library.
[15] Note, Envelope 55, *ibid.*; Fritiof Fryxell (ed.), *Thomas Moran: Explorer in Search of Beauty*, 46.

porary arrangement until he found "a small sky parlor" at 37 West 22nd Street,[16] where he maintained his winter studio for the next dozen years. Meanwhile, in 1889, came the joint exhibition of his and Mollie's etchings at Christian Klackner's Gallery, and the next spring the Morans were ready to renew their impressions of Venice.

They sailed in April, 1890, aboard a liner bound for Antwerp; a heavy ground swell ran, but the weather was good, and it held for the voyage. On the twenty-eighth, when they were several days out to sea, a report spread through the ship that an iceberg was floating near the vessel's path. Passengers came on deck to see it, an awesome novelty. Moran jotted its jagged configuration into a pocket note-book—a polished white dome and four sharp towers like the spires of some fantastic cathedral. Smaller pieces of ice floated in the deep-blue water about it. As the ground swell heaved into its fissured side, clouds of spray shot into the air three hundred feet, higher than the topmost pinnacle. The body of the berg was as green as bottle glass, with iridescent highlights and shadows that looked green gray. A cave yawning in its side was a deep green blue, but where sunlight struck its spires the ice turned to burnished silver. Streams of melt-water poured down its sides into the blue waves below. Three days later the ship passed another vast berg in the distance, and again Moran sketched pictorial notes.[17]

The frigid grandeur so impressed him that on coming back to East Hampton he turned at once to that subject. And so was born his large, six-by-ten-foot picture, *Spectres from the North*, which showed two mountains of ice, awash in a heavy sea, with spray lashing high into the air, under a lowering sky. The effect was of utter, in-human desolation, and when the picture hung at the National Academy in the spring of 1891, it chilled many a spectator, though its critical reception was excellent. "It is cold," admitted the *Times*

[16] Interview by Charles Thomas Logan (clipping), Envelope 179, Moran Collection, East Hampton Free Library.

[17] Pencil sketches of icebergs, April 28 and May 1, 1890 (with unidentified clipping "Green Icebergs Dead Ahead," concerning a similar encounter), Moran Papers, Gilcrease Institute; Ruth Moran to Horace M. Albright, director, National Park Service, undated [1929], Ruth Moran correspondence, No. 39, Moran Collection, East Hampton Free Library; Note, Envelope 55, *ibid.*

critic, "but coldness suits the subject."[18] Moran placed a price of ten thousand dollars on the picture. Because of its size, only a museum or a public building seemed appropriate for its hanging, but no museum responded to Moran's price, and though the picture hung on loan for years at the Smithsonian and became in time one of Moran's best-known productions, it remained unsold during his lifetime. It was not until after Ruth Moran's death in 1948 that Thomas Gilcrease bought it from the Moran estate; it now hangs in the galleries of the Gilcrease Institute at Tulsa, a spectacle of stark and elemental sublimity.

Meanwhile the liner steamed into Antwerp. By the ninth of May the Morans had made their way to Cologne; the seventeenth found them in Verona; then they moved on to Venice, where they settled again at the Grand Hotel and hired a gondola, an especially ornate model carved to the taste of a Medici, from an aged gondolier with the un-Italian name of Hitz.[19] Not much of a record remains of their comings-and-goings, but on the twentieth of May they were propelled to the low and sandy stretches of the Lido, beyond which moved the white sails of ships at sea, and looking south, Moran sketched a neighboring island with its array of colorful boats. The several sketches of the Venetian skyline that survive, dated from the eighteenth to the thirty-first, reveal his predilection for the views he had already placed on canvas, the panorama seen from various points on a wavering arc that centered roughly on the Campanile; he might move forward or back a little, or to the left or right, but there was seldom any radical change in his perspective. On the twenty-third, however, he was sketching at Murano, from where he drew Burano and its surrounding islands set in the blue lagoon. The twenty-ninth found him actually in Burano, a picturesque fishing village, and to judge from later works he must have also gone to Torcello and seen its peasant huts, its ruins and flourishing vinyards.[20]

His ancient gondola, nearly forty feet long, proved a success. Not

[18] *New York Times*, April 6, 1891, p. 5, col. 5; see also *ibid.*, January 17, 1891, p. 4, col. 6; and *East Hampton Star*, September 13, 1890.

[19] John McClain, "Man About Manhattan," *New York Sun*, September 9, 1945.

[20] Venetian sketches, 1890, Box 12, Moran drawings and sketches, Gilcrease Institute.

many like it remained on the lagoon. Elaborate carving decorated its black hull, and it sat as sleek as a swan in the water. Neptunian figures of brass graced the gunwales, and there was a brass lamp with red, green, and blue lights. Heavy black cloth covered the top of the felsa and, with its black silk tufts, gave it a rather funereal look, but the felsa could be removed and replaced by an awning of nearly the same shape. A lateen sail could also be raised, with stripes of brown and blue. "It was so beautiful and graceful," Moran wrote, "& so ancient and fine in its carvings, brasses and fittings that we fell in love with it, and decided to have it sent to our Long Island house."[21]

The elderly owner seemed disposed to part with it, since the care of its over-elaborate fittings had become a burden. Moran paid him 750 lira and became the owner of a fine Venetian antique. After it was packed for shipment the hotel manager remarked that the boat had once belonged to Robert Browning, who had sold it to Hitz when leaving on a trip to England. Whether or not Moran believed the tale he did not say, but "I love to think," he mused, "that Browning may have conceived his dramatic poem 'In a Gondola,' while being lazily propelled . . . through the close side-lagoons of the ancient city."[22]

The antique came to America on the same ship that brought the Morans home; it was strung from lifeboat davits, and went from New York to Sag Harbor in the same manner. A special wagon then bore it over country roads to East Hampton. Goose Pond, in front of the studio, proved too shallow to float it, so Moran decided to launch it on Hook Pond. A friend who owned some land there had a small canal dug to provide the boat a shelter when it was not in use. Moran developed no knack as a gondolier, but on the assumption that the canoe was the nearest thing to a gondola in America, he hired a Montauk Indian named George Fowler to be his boatsman. On September 13, 1890, the *East Hampton Star* reported the maiden cruise of "that novel craft" on Hook Pond.

[21] Letter to R. R. Ricketts, July 4, 1909, Moran Collection, East Hampton Free Library.
[22] *Ibid.*; Ruth Moran to "Mr. de Forest," March 20, 1922, Moran Collection, East Hampton Free Library.

"We used it a great deal when my children were younger, and at home," Moran wrote.[23] When it began to leak, he had it rebottomed by an expert boatwright from Sag Harbor, and he had its iron "horse-head" plated with nickel. Later he removed it from the pond and placed its dismantled hull under a shed in the garden of the studio, where it was shielded from bad weather, while the felsa and carved chairs were kept in the large room where he worked. He featured the boat in his Venetian paintings; then years after his death it joined the collections of the Mariners Museum at Newport News, Virginia.[24]

Moran's second visit to Venice fixed the city as a subject for his work, and it became the outstanding exception to his preference for American themes. Not all American subjects sold well; indeed the Western landscapes that Moran preferred to paint often moved slowly. In Venice he had found not only a subject which appealed to him, especially to his love of light and color, but also one which sold well, owing to America's love affair with Europe; moreover, it continued to do so, even through the end-of-century hard times when many artists failed to make a living. Moran now settled down to painting a few Venetian scenes each year, many of which he showed at the National Academy.

Turner, he frankly admitted, was his guide and inspiration—Turner but not Ruskin. Like Turner, he seemed indifferent to many of the monuments on which Ruskin had lavished so many words. Only a few of the best known, seldom shown close up, ever appeared in his pictures; he was devoted, rather, to the evanescent, opalescent play of light and color, especially in the water before the city, and in the sky above. Thus gorgeous effects of sunlight filled his Venetian scenes. To secure the necessary luminosity required no basic change in his technique; he had long followed Turner's lead in applying pure colors thinly and in glazes over a canvas first smeared with zinc white. Regardless of how he heightened the color key, he usually remained more faithful to the original hues of Venice than his master—as Elizabeth Luther Cary probably recognized when

[23] Letter to R. R. Ricketts, July 4, 1909, *ibid.*; *Maidstone Club*, 18.
[24] Rattray, *East Hampton History*, 151.

she admitted "a distinct personal preference for Moran's color, which seems to have colder and more stimulating depths than Turner's."[25]

Also, Moran's details were often more realistic than Turner's, his execution less reckless, less breathlessly hurried. Turner distorted his buildings, often heightened them outrageously; on occasion he made the Campanile look like a skyscraper. Moran was more meticulous with his proportions, and "Venice," his daughter once wrote, "is always a trial when it comes to the palaces. He *will* have them correct."[26] Ordinarily his boats, with their colored sails, were well drawn, but he showed less skill than Turner in his figures. There was, moreover, much less variety and imagination in his choice of scenes.

Over the years Moran devoted a scattering of canvases to the Campo Santo, Murano, Burano, Torcello, and Chioggia, but mostly, as in his sketches, he contented himself with depicting the vista he had called the Gate of Venice, with Santa Maria della Salute and the Dogana to the left, then the entrance to the Grand Canal, the Campanile and the Doge's Palace, with the domes of St. Mark's peeping over its roof, and at last more or less of the Riva to the right. He adjusted his foreground in every picture; the boats changed, they moved around, he introduced figures or deleted them. Also, he varied his perspective; sometimes he revealed his vista from the Public Gardens, sometimes from a hypothetical boat in the water, sometimes from San Giorgio, sometimes from the Giudecca. The hours of the day would also change, though sunset was a favorite time, and the color effects, the sky and atmosphere were different in every picture. No two canvasses were ever just alike; yet all too often the basic composition was much the same. Too often the domes of St. Mark's would barely peep over the top of the Ducal Palace. The general effect, in short, was that of an artist repeating himself.

But Moran took the Venetian theme seriously. However stereotyped or derivative his handling, he spared no effort to keep his painting of Venice at a high level of competence, and as Elizabeth

[25] *New York Times*, July 1, 1928, Section VIII, p. 8, col. 1.
[26] Ruth Moran, Miscellaneous notes, A25, Moran Papers, Gilcrease Institute.

Luther Cary concluded, "Seldom has a follower . . . come so near the pace of his captain or managed to infuse so much of his own into work based upon another's."[27] Sometimes Moran's pictures of Venice outstripped his other work in popularity. Brown and Bigelow, the calendar company, reproduced twenty-two million full-color copies of a Venetian sunset that he painted in 1898, somewhat of a record,[28] and so, encouraged with popular favor, Moran concerned himself with Venice, to some extent, for the rest of his life. A *Gala Day in Venice*, his most spectacular view of the city, painted in 1895 and '96, and measuring four feet by six feet, hung on loan at museums first in Syracuse and then in Toledo and eventually was sold to Samuel C. Scotten, the Chicago collector, for $10,000. The last canvas that Moran showed at the National Academy, in 1922, when he was eighty-five years old, was a dreamy impression of the city as it appeared across the lagoon.

[27] *New York Times*, July 1, 1928.
[28] "Sunsets," undated clipping from *Life*, Moran Papers, Gilcrease Institute.

XV *The Nineteenth Century Ends*

✦✳✦✦✦✦✦✳✦✦✦✦✦✳✦✦✦✳✦✦✦✦✦✳✦✦✦✳✦✦✦✦✦✳✦✦✦✦✦✳✦✦✦✦✦

At the time Moran began his career the painter's craft flourished in America. Then, with reasonable luck, industry, and talent, an artist could expect his craft to provide at least a marginal living for himself and his family. Changes came, however, with technological developments; photography and various mechanical means of reproduction competed with painting in the market place, and with time they gained in the struggle. Where the ordinary customer had once turned to portrait artists for likenesses of himself and his family, and used the original works of landscape painters to adorn the walls of his house, he now preferred camera portraits and chromolithographs of "old masters." A few well-to-do collectors were still buying original paintings in 1890; but notwithstanding T. B. Clarke's example as a patron of American art, their taste ran mostly to European works, and when financial panic struck in 1893, even these demands shriveled to a point of little consequence. As the century closed, few American artists could make a living by the exclusive practice of their craft; talent and dedication signified little when no one bought a painter's work.

The economic depression had its effect on Moran's affairs. His records show that several times he traded pictures for food, whisky, clothes, rent, and a doctor's service. Such exchanges hardly prove that he was in actual want, but they do suggest that he felt the financial pinch in some degree. There were often remarkable differences between his asking prices and the amounts for which his pictures

sold. On one occasion he received $450 for a canvas he had priced at $2,000. Another canvas listed at $1,000 went for $175. But he persisted with his painting—found it possible to continue as a full-time artist—when many other well-known painters had to turn to other work to keep themselves from want. As a matter of fact, Moran painted and sold an extraordinary number of pictures during the end-of-the-century frosts.

All through that period he maintained his winter studio on West 22nd Street. The room was well-suited for painting, with a skylight that admitted northern light at all hours of the day. There was an elevator in which he rode up to the room at eight or nine o'clock in the morning, with a small cigar in his mouth. He would fall to work at once; he could not bear to waste an hour. Sometimes he would sit before his easel in "a fiddleback Mayflower chair";[1] more often he worked standing. New pictures continued to come from his studio, but his meticulous urge for perfection kept many back in a growing assortment of works that he regarded as still unfinished. "I never send out a signed canvas," he once said, "that does not stand for my best work at the time."[2] He was not as prone as Inness to change his compositions when they displeased him; yet at times his revisions were extensive. On rare occasions he might destroy a troublesome canvas, but the ordinary failure could be painted over, and usually was, sometimes into something highly successful.[3] Months might go by before he got back to a "seasoning" picture, or even years, the most extreme delay occurring in the case of *Columbus Approaching San Salvador*, first painted in 1860. This work Moran did not retouch until 1912.

It was not unusual, then, for him to revert in 1891 to his *Mist in Kanab Canyon*, which dated back to 1880. The scene was similar to the Kanab Canyon woodblock he had designed for *Picturesque America* from a Hillers photograph, the salient feature a lone red limestone tower hemmed by soaring walls. Moran not only re-

[1] Interview by Charles Thomas Logan (clipping), Envelope 179, Moran Collection, East Hampton Free Library.

[2] Simpson, "Thomas Moran—the Man," *Fine Arts Journal*, Vol. XX, No. 1 (January, 1909), 21.

[3] *Ibid.*, 20.

painted it in '91, to heighten the atmosphere, he retouched it again sometime the following year, and dated it 1892. Pleased at last with its effect, he sent it down to Major Powell,[4] in Washington, where it was later hung in the National Museum. His return to the Kanab Canyon theme marked a reintensification of his interest in the Far West, a predilection that in after years did most to keep his name alive.

Moran planned a three-month sketching tour for the late spring and early summer of 1892, a trip that would take him to Arizona, New Mexico, Colorado, and Wyoming and allow him to review scenes that had been important to his career. The Santa Fe Railroad had begun to use scenic art to advertise its routes, and having launched a program of bringing artists to the Southwest to paint the spectacular landscape there, the director of publicity offered transportation to the Grand Canyon for both Moran and Paul, who had now settled down to a career in art after having wavered for some time between the conflicting pulls of art and music. In return for the trip Moran agreed to assign to the Santa Fe the copyright on a single canvas, to be reproduced for publication, and as it developed, the picture in question which Moran painted before the end of summer turned out to be one of the most spectacular of his career, a panorama of the Grand Canyon, as viewed from the south "near the junction of the Colorado Chiquito."[5]

He and Paul had left the train at Flagstaff, had climbed aboard a stagecoach, which had hauled them around the base of San Francisco Mountain, through cool and towering stands of pine. As they traveled northward, the pines had changed to cedar and juniper; they had crossed a corner of the Painted Desert; then after a day of jouncing progress, their stage had stopped near the edge of the abyss, and Moran again beheld the sight that had filled him with amazement nineteen years before. Once more the Grand Canyon, viewed this time from the south, held him fascinated with its multitudinous changes of effect.

Later work suggests that he visited Cataract Canyon, home of the gentle Havasupai. On May 27 he sketched in Hance's Canyon, on

[4] Notebook, 1888–95 (G), p. 51, Moran Papers, Gilcrease Institute.
[5] *Ibid.*, 67.

the old trail that suffered irreparable damage from a storm a few years later. On the twenty-ninth he caught the view from Morans Point, which Captain Bourke had named for his brother Peter when they were there together in 1881.[6] On the thirtieth he drew the Canyon from the perspective of Berry's Camp at Grand View Point. But the panorama that pleased him most was the sweep of the chasm as he beheld it from Comanche Point. There one could gaze out over the river winding through the inner gorge; there one could distinguish Vishnu Temple and Newberry Terrace and the purple wall of the Kaibab Plateau; and there Moran found a view exactly suited to the large picture he planned to paint on his return home.[7]

Meanwhile another arrangement helped to shape his itinerary for the summer. Plans were taking effect for the World's Columbian Exposition to be held in Chicago the following year, and Moran received an invitation from Elwood Mead, state engineer of Wyoming, to join an expedition through mountainous regions of the state for the purpose of gathering exhibition materials.[8] Mead hoped that some impressive theme for a painting might be discovered, something new and startling to form part of Wyoming's offerings at the fair. The idea of seeing Yellowstone Park again had great appeal; Moran accepted the invitation, and as William H. Jackson was to be guest photographer,[9] he planned to join his old friend at Denver on his return from the canyon country of Arizona.

Exactly when Paul left the tour is not clear. The record shows that Moran himself returned to Flagstaff on the first of June, in the company of W. A. Bissell, a Santa Fe traffic manager. In town he met the exuberant Charles F. Lummis, editor and writer from Los Angeles, who became his admiring friend.[10] He sketched the cones

[6] Will C. Barnes, *Arizona Place Names*, 288.

[7] Numerous sketches in the collections of the Gilcrease Institute, Cooper Union, U.S. National Park Service, and the Smithsonian Institution provide details for the reconstruction of Moran's travels in 1892.

[8] "The Artist and Photographer Visit Devils Tower" (photostat of broadside), B37, Moran Papers, Gilcrease Institute.

[9] American Guide Series, *Wyoming*, 159.

[10] C. F. Lummis to Ruth Moran, June 2, 1922, Envelope 82, Moran Collection, East Hampton Free Library.

of San Francisco Mountain, then moved on, through places in New Mexico where he had sketched before: the cliffs near Gallup, Laguna, the Hacienda San Juan (all subjects for future paintings), then north into Colorado, moving leisurely and making drawings as he went. He arrived in Denver during the second week of June, stopped at the St. James Hotel, from whose window he painted Mt. Rosalie in water colors; then, while waiting for Jackson to arrange his business for a leave, he made drawings of the smelters on the outskirts of town and took a side trip into the Front Range of the Rockies.[11]

On June 13 Moran and Jackson spent a day in Cheyenne, where Mead was making arrangements for the expedition. One week later the party was ready to move, eight men in all including a cook, a packer, and Jackson's young assistant.[12] They left Cheyenne on a Burlington train which took them as far as Gillette, a typical railroad construction town, already in rapid decline. There Moran and Jackson separated from the main party for a quick excursion to Devils Tower.

They hired a team with a light wagon and set out at six the following morning, expecting to buy food at ranches along the way. "We carried nothing," Moran wrote, "but Jackson's photographic apparatus, my sketching outfit, and our blankets."[13] Their team proved a sorry bargain; the horses had a "tired and a startling indifference to the whip." But since no others could be purchased at Gillette, there was little point in turning back. At noon they forded the Belle Fourche River but found what they had anticipated as the "101" Ranch—the first of their planned stops—was a deserted homestead. Farther on, they met a herder, who told them the "101" lay over the next hill. That hill became no fewer than five, all rises of about one thousand feet, hard going for their broken-down team, and a hot, hungry ride for themselves. An Eastern corporation owned

[11] *Rocky Mountain News*, June 18, 1892; Notebook, 1888–95 (G), p. 75.

[12] *Cheyenne Daily Leader*, June 14, 1892, p. 3, col. 3; and June 19, 1892, p. 3, col. 5.

[13] "A Journey to the Devil's Tower in Wyoming," *Century*, Vol. XLVII, No. 3 (January, 1894), 450–55. The present account of the Devils Tower trip derives from Moran's own narrative, and all direct quotations concerning this adventure come from his accounts unless otherwise specified.

the ranch, and it was run by a superintendent. They found him at the ranchhouse, a glum sorehead who glared at them coldly when they asked to buy a meal for themselves and feed for the horses. He did not keep a roadhouse, he grumbled, and had no horse feed, but there was plenty of grass outside. "He did not offer to give us any directions," Moran added, but one of the hands pointed out the way to the next ranch, across the Belle Fourche. They forded the river and found the log house of a dour and bilious sodbuster. They received no food there either, only directions which, when followed, brought them to a road that led apparently to Devils Tower. They passed several more cabins, all deserted. Their hunger grew acute. The road forked in successive branches, and having no notion of which prong to follow, they chose in each case the deepest set of ruts. They crossed a low divide and caught a glimpse of the Tower through a break in the mountains. Then a thunderhead began to boil up in the west.

A dazzling brightness edged the nimbus, like "a fringe of stationary lightning." The wind rose to a gale, the cloud raced across the sky, and they knew the storm would break at any moment. "We were about to stop and arrange our affairs with that in view," Moran wrote, "when the cattle that had been grazing on the hillsides came tearing into the valley in a perfect stampede, making for the shelter of pine-groves on the other side of a deep *arroyo*. . . . A ghostly grayness began to obscure the previously dark-plum-colored hills to the west." The darkness grew till Moran could see hardly more than a few yards ahead; the horses refused to move a step farther. Then a "fusillade of ice-balls . . . struck . . . with a force as if coming from a sling."

Under the blows the horses tried to turn their rumps to the storm, and their struggles nearly upset the wagon. How long, Moran wondered, could such punishment be endured? He felt himself shake in the wind as if from ague. "Our hands," he wrote, "were beginning to show purple lumps where they had been struck, and our heads were aching, and sore, and lumpy, from the pelting ice-balls." Then the hail turned to downpours of rain, and trouble began in earnest. The water softened the gumbo underfoot. It clung like tar to the

wagon wheels and to the horses' hooves. Moran and Jackson tried walking to relieve the team but found that the clay weighed their feet down like lead. They had to stop time and again to clear the wagon wheels. Night came on, and they lost the road, hidden by a four-inch slush of hailstones. "We could not make camp where we were," Moran noted, "in water and soft gumbo," but they finally spied a possible camp site—a clump of pines on a low hill, across a creek that blocked their way. It took them two hours to get the jaded team and wagon across the watercourse and up to the crown of the hill, where they found an old camp, whose pine-bough beds were dry underneath and furnished them makings for a fire.

They recrossed the creek next morning and searched for the road, but it was lost, and so were they. To retrace their tracks seemed the only sensible course—to find the Belle Fourche again and follow it to the Tower. They reached the river that afternoon and soon saw smoke, then a ranch house, where they found themselves at last made welcome. "We were grateful indeed to get something to eat," Moran wrote, "as we had had no food for thirty-eight hours." The rancher then set them on a sure road to their destination, and they reached it the following noon.

The Tower rose about two thousand feet above the river, a huge, blunted tusk of columnar rock known as phonolite. To Moran it seemed "a grand and imposing sight . . . one of the remarkable features of this country," the core, he thought, but not correctly, of a great volcano. He sketched it during the rest of the day, while Jackson made spectacular photographs.[14]

The hardships of the Tower trip seemed a good theme for a magazine account, and on their return to Gillette, Moran jotted down notes and sent them home to Mollie.[15] He wrote the piece during the summer of 1893, when coaxed by Gilder,[16] and the *Century* ran it the following January, with four of his drawings. On his later reading it over his "literary capacity" struck him as "nil," and he re-

14 Moran to his wife, from Curry Comb Ranch, n.d. (photostat), Moran Collec-lection, East Hampton Free Library.

15 Moran to his wife, June 29, 1892 (photostat), *ibid.*

16 Moran to R. W. Gilder, March 26 [1893]; June 18, 1893, *Century* Collection, MSS Division, New York Public Library.

solved never to write again for publication.[17] However, his vivid impressions led to his painting several forceful pictures of the Tower in later years.

Meanwhile, Moran and Jackson caught the mail stage for a ride of more than one hundred miles to Sheridan. The main party waited there with a pack train ready to strike into the dark and heavily wooded Big Horn Mountains.[18] The exact itinerary seems not to be of record, but July 3 found Moran sketching on upper Goose Creek, whose water ran out of defiles in the range and meandered through brakes of willow and cottonwood on its way to Tongue River. At first their route seems to have taken a southerly direction, for Moran's next surviving sketch was of Clouds Peak, the highest summit in the range. The party must have then turned north, skirting the edge of the range, until they came to the North Fork of Tongue River, where Moran sketched on July 7. He drew Tongue River Cliffs, where the stream had worn a gorge with almost vertical walls two thousand feet deep in the solid rock. His later painting of the Little Bighorn River suggests that the company moved as far north as the Little Bighorn Canyon, before crossing the massive barrier of the range, in accordance with their published aims. "The expedition proposes to . . . go through the heretofore impenetrable mountain fastnesses that have so long defied approach," the *Cheyenne Daily Leader* had announced. "The trip is chiefly made for the purpose of photographing the wild and rugged scenery in Wyoming's own Rocky range where snow perpetual glistens and only wild beasts roam."[19] Another week found the party west of the Bighorn Basin, facing the blue wall of the Absaroka Mountains, from a point south of Clarks Fork of Yellowstone River, and on the sixteenth Moran sketched a "Peak on Sunshine Fork." The range was thick with spruce and pine and fir, through which they climbed, crossing the divide, to camp the next day on Soda Butte Creek, a branch of the East Fork of the Yellowstone River. They now fol-

[17] Moran to Mr. Nicholson, January 29, 1901, C13, Moran Papers, Gilcrease Institute.

[18] Moran to his wife, June 29, 1892.

[19] June 19, 1892, p. 3, col. 5.

lowed a road built by a mining company, and on the eighteenth Moran made a sketch of Index Peak, near the eastern boundary of the park.

The next day brought the party to the falls on the East Fork of Gardiner River, whereupon they advanced more slowly, reaching Mammoth Hot Springs on the twenty-first, a place of civilization now with a good hotel. Moran made sketches of the springs and terraces, and Jackson snapped his camera. Two days later they followed the roadway south across a pass called the Golden Gate, which Moran sketched; then, it seems, they spent several days at the various geyser basins. They also visited Yellowstone Lake, and on the thirty-first a large loop brought them to the river gorge, as awesome as ever. Moran made several drawings there, one from a spot that Hayden had called Morans Point, a name that would fail to survive.[20] The tour ended three days later at the raw town of Cinnabar, spurhead of the Northern Pacific Railroad. Moran started for home at once, by way of the Bad Lands of South Dakota, his portfolio bulging with a rich haul of studies. "Made some 25 sketches in oil and water color," he recorded in his work log, without a word about his many pencil drawings.[21]

Soon after reaching East Hampton Moran began his new panorama of the Grand Canyon. He adopted a five-by-eight-foot canvas, but excited by the subject, he painted rapidly and finished the work by the end of August.[22] Rim rocks filled the foreground to left and right, with a few gnarled shrubs growing in crevices. A draw opened through the center foreground, permitting a view into the inner gorge, where the river lay revealed. The glance, in rising, ran for miles up canyon, or across a maze of buttes or terraces to the dark

[20] Horace M. Albright, director of the National Park Service, to Ruth Moran, March 26, 1930, Envelope 208, Moran Collection, East Hampton Free Library. "There is no record of it [Morans Point] that can be found in the Yellowstone library nor do any of the old timers remember it."

[21] Notebook, 1888–95 (G), p. 75. Some seventy sketches dated from the 1892 excursions are preserved in the collections at Cooper Union, the Smithsonian Institution, the East Hampton Free Library, the Gilcrease Institute, Yellowstone Park, and the Jefferson National Expansion Memorial. This number does not include undated sketches that may have been made during that prolific summer.

[22] Ibid., 67.

north wall. In the middle distance, beyond the inner gorge, loomed the pyramid of Vishnu's Temple, and through the labyrinth drifted veils of softly tinted mists. Moran had grown bolder, had heightened his palette since painting the large picture of the chasm in 1874. He knew that the glowing hues of the region were, in the ultimate test, too much for the human hand to match; he felt that his latest attempt to capture them was more successful than his first ambitious try; yet the Grand Canyon remained a perpetual challenge. Its chromatics obsessed him, as though, in the words of Wolfgang Born, "whirlpools of colored fire haunted his imagination, and . . . he tried to find a realization for his fantasies in the purple rocks, in the azure haze of gorges, and in the fiery sunsets of the Colorado scene."[23] He returned to the chasm of the Colorado time and again in the coming years.

Although Moran did not send the new Grand Canyon scene to the Chicago Fair as he had planned, it reached a wide public. The Santa Fe Railroad commissioned G. H. Buek of the American Lithographic Company to reproduce it in full color, provided Moran approved the result. "Knowing Moran had done excellent lithographing himself," Buek later wrote, "I naturally approached him with considerable hesitation. No man could have received a younger man, as I was, with greater cordiality than he received me."[24] Evidently the lithograph was faithful to the original, for the railroad distributed large numbers of prints about the country.

In June and July of 1908 Moran repainted the canvas at the canyon as a guest of the Santa Fe, and on seeing it there, Charles F. Lummis defied anyone to "try to better it."[25] It had hung for years at the headquarters of the Geological Survey in Washington, and now it remained at El Tovar, Fred Harvey's hotel on the canyon rim, until George Horace Lorimer of the *Saturday Evening Post* decided to buy it in 1919. "I am planning to hang the picture in our building," he wrote Moran from Philadelphia, "where . . . my

[23] *American Landscape Painting*, 109.
[24] "Thomas Moran, N.A., the Grand Old Man of American Art," *Mentor*, Vol. XII, No. 7 (August, 1924), 29.
[25] "The Artists' Paradise: II," *Out West*, Vol. XXIX, No. 2 (September, 1908), 191.

pleasure in it may be shared by as many people as possible." He had always admired the painting, Lorimer added, and wanted to have it where he could see it "at least once a day."[26] For years his attitude toward the Grand Canyon had verged on the religious, and it was said that he judged others by their reaction to it. Moran's painting now became a substitute for the canyon itself, as Lorimer's touchstone for gauging the people who came to the Curtis Building. "I can tell 'em by the picture," he claimed. Anyone who admired the scene must be at heart all right; the editor's guard went up, however, if anyone passed it by or spoke of it with disparagement.[27] The picture remained with his family after his death, and now Graeme Lorimer, his son, calls it "my prized possession and the feature of my house in Paoli."[28]

Meanwhile September, 1892, found Moran at work on his new panorama of the Yellowstone. His tour of the park had convinced him that only another picture of the gorge and the Lower Falls would produce the sublime effects that he desired. The canvas was so large—eight feet by fourteen feet—that he could not bring it through the doors of his East Hampton studio; so he used a nearby carpenter shop, where he painted steadily for the next two months.[29] Again he heightened his palette, with a forenoon effect, and again felt that he had fallen short of the glowing reality. The perspective was similar to that he had adopted in 1872, but to suggest the proper scale he relied only on the trees and shrubs there, without figures of any sort. The result was a vibrant play of color, which he sent to

[26] Lorimer to Moran, April 21, 1919, C19, Moran Papers, Gilcrease Institute.

[27] John Tebell, George Horace Lorimer and the Saturday Evening Post, 254.

[28] Graeme Lorimer to the author, September 18, 1964.

[29] Chicago Evening Post, "Art World," September 11, 1928; New York Herald, December 1, 1892, p. 6, col. 6. This panorama is generally held to be Moran's largest canvas. In the following year, however, he accepted a commission from Frederic Gallatin to help with an even larger picture—7.5 feet by 17.5 feet—for the billiard room of the Gallatin mansion. It was called Nuremberg. Exactly how much Moran contributed to it is not clear. He claimed to have painted only the background, but his pupil, Albert Gallatin, has said that Moran's share in the work amounted to considerably more than that. Gallatin, then only a boy of fourteen, helped with the painting and amused Moran by catching his likeness for a statue of St. Thomas in the picture. At present Nuremburg is said to be somewhere in California.

the Chicago Fair the following year, along with *Spectres from the North*. Years later he revealed his conviction that it was one of the two best pictures he ever painted, and William H. Holmes of the National Museum ranked it "as America's greatest landscape."[30] Yet neither it nor *Spectres* received an award, it falling to Mollie's etchings to bring the family its only official accolade from the fair. In November a wealthy benefactor thought of buying the Yellowstone view for the Art Institute of Chicago but withdrew the offer after consulting local experts. Moran repainted the picture in 1901 and later lent it to the National Museum, where it received favored treatment. It was hanging there still at his death. In 1928 George D. Pratt purchased it from the Moran estate, and the museum welcomed it as a gift to its permanent collection.[31]

Moran devoted the spring and summer of 1893 almost exclusively to further Yellowstone works. He painted not only impressions of the Lower Falls and the Grand Canyon but also views of Jupiter and Minerva springs, Emerald Pool, Mammoth Hot Springs, the Upper Falls, the Great Blue Spring, "Mabs Grotto," Fountain Geyser, and the Golden Gate. That year he sent paintings of the gorge to both the spring and the fall exhibitions of the National Academy, and in the spring exhibition of 1894 he showed his *Golden Gate*. The picture pleased Frederic Remington, but the pass had impressed him even more. He called it "one of those marvelous vistas of mountain scenery utterly beyond the pen or brush of any man. Paint cannot touch it, and words are wasted. . . . Mr. Thomas Moran made a famous stagger at this pass in his painting; and great as is the painting, when I contemplate the pass itself I marvel at the courage of the man who dared the deed."[32] Moran was always aware of how short of the real vision his best work fell, but the realization did not discourage his concentration on the grander effects of nature.

[30] *Ibid.*; Smithsonian Institution, press release dated February 7, 1917, D3, Moran Papers, Gilcrease Institute.
[31] "Mr. Pratt Presents Moran's Masterpiece to the National Gallery," *Art Digest*, Vol. II, No. 20 (September, 1928), 1.
[32] "Policing the Yellowstone," *Harper's Weekly*, Vol. XXXIX, No. 1986 (January 12, 1895), 35. Reprinted in Frederic Remington, *Pony Tracks*.

These, at times, Moran liked to manipulate in fanciful scenes, often illustrating themes from literary romance, and the *Critic* found him "at his best" on such occasions, "when his imagination is moved . . . by something weird or wonderful in his subject."[33] The hard times of the 1890's seemed to stimulate the vein of fantasy in his work. He represented scenes from the *Odyssey*—in 1892 *The Lotus Eaters* and later *Ulysses and the Sirens*. Also in 1892 he painted a small scene from *Lalla Rookh*—entitled *Yellow Sunrise*—which he gave as a wedding present to his nephew Percy Moran. Two years later he turned to fairy tale and painted *Bluebeard's Castle*. During the same period he produced a colorful series suggested by the *Arabian Nights*, favorite reading of his. The earliest canvas in the series seems to have been *Sunrise*, painted in 1892, but two years later he finished a similar picture which he simply called *Arabian Nights Fantasy*. In the interval appeared *The City of Queen Marjáneh*; *Sinbad and the Roc*, a glowing water color; *The Story of the Third Sheikh*; *The Mountain of Lodestone*; and others with less distinctive titles. Later, in 1919, Moran reverted to further themes from Scheherazade, with *Sinbad Wrecked*; *The Valley*, suggestive of the Valley of Diamonds; and *The Fisherman and the Genii*. These imaginative reconstructions combined qualities of form and color which Moran had perfected in his Venetian and Grand Canyon paintings. Spectacular mountains and canyons appeared, along with lakes and streams or the surf, and there were exotic ships and buildings, often limned in smoldering color, the hour usually sunset or early morning. *The Story of the Third Sheikh* showed a Bedouin hero in a red burnoose standing over a girl who had swooned on a sandy shore. Near them pools of blue water had seeped through bars from the bay to the left, where boats with lateen sails were riding. At the foot of the mountain to the right stood a strange hill town resplendent with spires and towers. In this canvas, as in others from the *Arabian Nights*, the figures suggested exotic story, but the background seemed of more importance to the painter, and into it went the greater share of his painstaking labor.

Obviously Moran enjoyed painting such scenes from the imagin-

[33] "Pictures by Mr. Moran," *Critic*, Vol. XXX, No. 783 (February 20, 1897), 132.

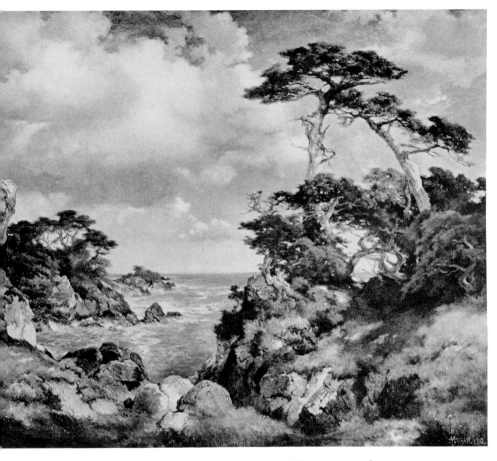

Cypress Point, Monterey, 1912. Oil, 25x30 inches.

By permission, The Thos. D. Murphy Co.

Fiesta at Cuernavaca, 1913. Oil, 25x30 inches.

Gilcrease Institute, Tulsa

The Owls, 1917. Oil, 36x30 inches.

East Hampton Free Library

California Landscape: Autumn, 1919. Oil, 25x30 inches.

Sinbad Wrecked (sometimes called *The Cavern, California Coast*),
1919. Oil, 14x20 inches.

By permission, Diamond National Corp.

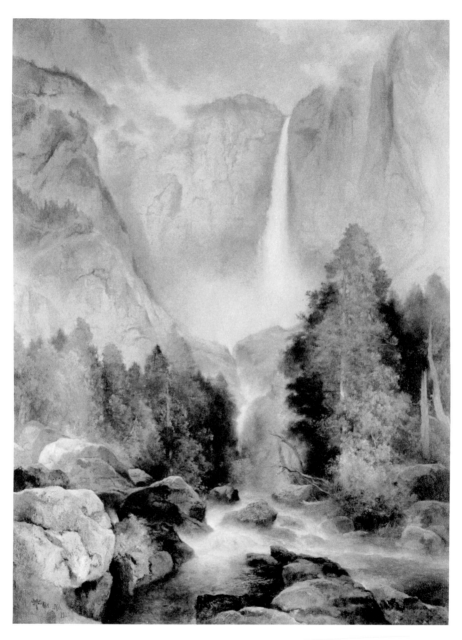

Yosemite Falls, 1922. Oil, 40x30 inches.

Autumn, Long Island, undated. Oil, 30x35 inches.

Philbrook Art Center, Tulsa

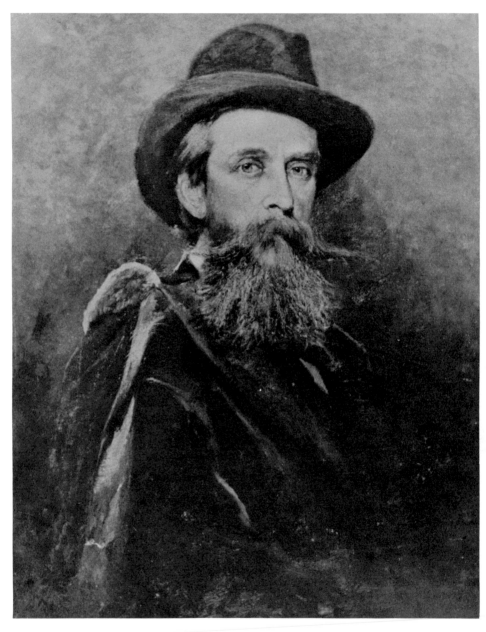

Thomas Moran, ca. 1882, by Hamilton Hamilton. This is the portrait submitted by Moran to the National Academy of Design on his being chosen National Academician.

ation. In a similar manner he later produced *Castles in Spain*, a fantastic arrangement of Grand Canyon effects under a brilliant moon, and later still, *Dream City*, which was perhaps an outgrowth, a fantasy rearrangement, of *The City of Queen Marjáneh*, though Ruth Moran thought a hazy view of the Channel Islands off the Santa Barbara coast may have suggested it. The Dream City, like the Queen's City, climbed the side of a mountain, which soared into veils of softly tinted mist, a sea of somnolent blue lapping its base.

Another more realistic exercise of the imagination resulted in *Solitude*, the wilderness scene which Moran exhibited at the National Academy in 1897. He labeled it a Rocky Mountain vista, but it was really an imaginative reconstruction of his early lithograph of the same title, which had depicted a forlorn view in the Lake Superior country.[34] Moran seems to have first produced the "Rocky Mountain" arrangement in the 1870's, and George W. Sheldon carried a wood engraving of it in *American Painters* in 1879. The painting finished some twenty years later, impressed Moran as one of the best he had ever made, as he assured his friend Holmes.[35] To some degree the picture illustrated a process on which he depended more and more as time slipped by. He did less sketching from nature in later years, perhaps because he did less traveling into regions strange and new to him; as a consequence he often based new work on old, changing and recombining effects and allowing suggestion to prompt new compositions. How natural and easy it was for him to do so was demonstrated by a pastime in which he indulged during his later years: this was making what he termed "metamorphoses."

After glancing through his evening newspaper, he would let his attention settle on some picture there. It did not matter in particular what it represented—a ship, a train wreck, a public building, or some social belle or matron. He would study the picture in a detached, dreamy way, until the basic configuration suggested a new possibility. Sometimes it would help to turn the design on its side or upside down; sometimes he would spread the paper on the floor

[34] [Caption], *Mentor*, Vol. XII, No. 7 (August, 1924), 35.
[35] Undated draft of letter to William H. Holmes [1916], C18, Moran Papers, Gilcrease Institute.

and slowly walk around it, letting association work its magic. Once the new image took form in his mind, he would set to work with pencil and eraser and reshape the picture accordingly, filling it in here, erasing there, until the original scheme was transformed into a new and different composition. Sometimes Moran used India ink and Chinese white to heighten the effect. Thus, a society dowager might become a mountain range; a train wreck an Indian pueblo; a speed launch a castle on a hill; a Chinese tong leader a spreading chestnut tree; a young girl in lace dress an alpine torrent with a bridge. Often he would retain the caption, to add a droll or incongruous touch. He devoted many an evening to such pleasant diversion and once remarked that he had found some good compositions in newspapers.[36]

The imagistic process here involved was quite like that in another artistic amusement he had practiced on occasion, perhaps as early as 1870: the making of blot drawings. Where Moran had found the idea is not clear; he may have seen the blot drawings of Alexander Cozens in the South Kensington Museum, or possibly he had taken his cue directly from Turner, who had studied the water colors of Cozens and sometimes amused himself with blots. Perhaps Moran knew the story of how Turner had given paints to some children and asked them to dabble on his paper, how, when the dabbling had gone far enough, he had called out, "Stop!" and then taking up the paper, had finished the landscape forms suggested by the accidental splatters.[37] However that may be, Moran seems to have practiced the method by making casual blots of sepia or India ink (or both) on paper and taking them as basis for a composition to be completed with brush or pen. The results were often provocative, with effects that projected him, without his realizing it, into the mid-twentieth century. The blot drawings often strike the observer as more like abstract expressionism than Moran's usual work. No evidence suggests that he considered them anything more than relax-

[36] Ruth Moran, Note, A25, *ibid.*; Note, Envelope 56, Moran Collection, East Hampton Free Library; Fryxell, *Thomas Moran*, 29–31. A number of these curious productions are preserved in the collections at the Gilcrease Institute and the East Hampton Free Library, mostly at the latter.

[37] Hamerton, *Life of Turner*, 191–92.

ing exercise. He seemed to like them, however, and matted several for exhibition, perhaps at the comprehensive showing of his work in Denver during the Christmas season of 1892.[38]

The newly organized Denver Art League had requested Moran to lend it a collection of his paintings, prints, and sketches, such as would trace his development as an artist over the past thirty years. He sent two hundred and sixty-one items. When placed on display, they made an impressive exhibition, the largest yet assembled of his work, and he took pride in it when he visited Denver at the end of the year.[39] His next important one-man show occurred during the late winter of 1897 at the Kraushaar Galleries in New York City, a display which involved, according to the *Critic*, "a fair share of the artist's most interesting work."[40] But now considered old guard, Moran was no longer news in the art world, and the exhibition went nearly unnoticed by the press.

Meanwhile rebellion had broken out in Cuba, launching a chain of circumstances that would change Moran's life and make his studio a lonely place for him. In time the United States became involved in the Cuban troubles; the revolution turned into the Spanish-American War, a brief conflict but vastly untidy. When the fighting was over and the troops began to come home, Camp Wykoff on the wind-swept hills of Montauk received thousands of fever-ridden soldiers, shipped from the tropics to recuperate there or die. Actually only 263 of them died, but the typhoid fever they had brought to Montauk spread to other places on Long Island, including East Hampton. At the studio, Ruth fell ill in the summer of 1899; and while nursing her, Mollie so drained her own strength that when she herself came down with fever she had little reserve to fight it. She died on the twenty-fifth of September, leaving Moran stunned. Episcopalian services were held for her on the following Tuesday at

[38] Blot drawings occur in the collections at the Gilcrease Institute and the Cooper Union.

[39] *Rocky Mountain News*, December 18, 1892; clipping from *Denver Evening Post* (December, 1892), Envelope 179, Moran Collection, East Hampton Free Library; Benson, "The Moran Family," *Quarterly Illustrator*, Vol. I, No. 2 (April–June, 1893), 78.

[40] "Pictures by Mr. Moran," *Critic*, Vol. XXX, No. 783 (February 20, 1897), 132.

St. Luke's Chapel, within sight of the studio, and she was interred in the old South End Burying Ground beside Goose Pond, "opposite the old windmill that ha[d] so often been a feature in her paintings and etchings."[41]

Moran's sense of loss was overwhelming. His relationship with Mollie had always been warm and close and strong. His career as an artist had been a chief concern of hers; she had watched his work grow and had done all she could to smooth his way. She had always been his most helpful critic. She had been a canny manager, moreover, and had taken charge of many practical matters in order to leave Moran freer for his work. The bereavement plunged him into a numbed depression of spirit, from which he sought relief in travel.[42]

It appears that he first went to Italy. Then in the spring of 1900, with Ruth now his constant companion, he headed West. The two stayed for a while in Colorado, and Moran sketched at Glen Eyrie. They also went to New Mexico, and after a visit at Laguna, took a dirt road south to the pueblo of Ácoma on its rock mesa, nearly four hundred feet tall. From a distance the rock looked like a palace or a fortress, but on coming nearer, they could see the town on the very summit, a tier of low adobe houses silhouetted against the sky. The walls of the mesa rose sheer all around, except in one place, and there a trail ascended, first on slopes of sand, then by means of toe holds cut in the rock. In the distance to the left beetled the vast cliff of Kat-zí-mo, or the Enchanted Mesa, its top virtually inaccessible. Moran sketched its imposing form, but it was Ácoma that really aroused his enthusiasm. In it he had discovered a subject for several future canvases.

June found him with Ruth in Salt Lake City on their way to southern Idaho.[43] Moran had drawn the Great Shoshone Falls of the Snake River for the *Aldine,* and he had made a water color of the scene for Louis Prang, both effective pieces, but Jackson's photographs had been his guide. Now he wished to see the falls in person,

41 Obituary, *East Hampton Star,* September 29, 1899; Ruth Moran (?), Note, Envelope 59, Moran Collection, East Hampton Free Library.

42 Ruth Moran (?), Note, Envelope 55, *ibid.*

43 Clipping, *Salt Lake Daily Tribune,* June 1900, Envelope 179, *ibid.*

for he had plans for a large picture. He found that Clarence King had not exaggerated in the passage Hayden had abridged in the text for Prang:

> . . . a monotony of pale blue sky; olive and gray stretches of desert, extending afar off to the horizon, as level as the sea; a circling wall of jetty lava, the sharp edges of which are here and there battlemented in huge fortress-like masses; a smooth broad river, the beryl-green waters of which, here and there reflecting the intense solemnity of the cliffs, flow quietly into the middle of the scene, there plunge into a labyrinth of rocks, tumble over a precipice two hundred feet high, and then, after having been broken up into a dazzling sheet of foam, move westward in still, deep current, to disappear behind a black promontory. . . .[44]

The dark bluffs were beyond comparison, Moran thought, with the dull, uninteresting plainness of the background at Niagara. He deemed the Shoshone "the grandest waterfall he ha[d] ever seen,"[45] and as he remarked to Ruth, "Not since his first sight of the Yellowstone and the Grand Canyon had he been so stirred and thrilled. . . . There were no houses or people to spoil the grandeur of the mighty torrent . . . and it was beyond words magnificent."[46]

Moran made sketches in pencil and water color, and on returning to New York, after a visit to Blue Lakes, Idaho, he set about painting his six-by-eleven-foot canvas of the falls. The picture progressed well, and as Ruth later wrote, "[He] considered it one of his most important works."[47] He depicted the falls almost head on, from a vantage point on the south brink, and there was tremendous verve in the rush and plunge of the water, remarkable strength and solidity in the rampart-like rocks. Except for the foaming cataract itself, the tone of the picture was dark, in keeping with the black lavas of the actual scene, and the sky was filled with appropriate gray and lower-

[44] *The Yellowstone National Park and the Mountain Regions of Portions of Idaho, Nevada, Colorado and Utah,* 43.

[45] *Santa Barbara Morning Press,* December 4, 1921.

[46] Quoted by the director of the National Park Service to the governor of Idaho, February 10, 1930, Ruth Moran correspondence, No. 54, Moran Collection, East Hampton Free Library.

[47] *Ibid.*

ing clouds. Moran showed the painting in the National Academy's annual exhibition in 1901, and on seeing it there a wealthy collector offered to purchase it at Moran's list price, provided he would repaint the glooming sky. The sky was right in Moran's opinion; he refused to change it and lost the sale.[48]

In reviewing the exhibition Charles A. Caffin declared that *The Shoshone Falls of Snake River, Idaho* was:

> a brave and earnest effort to portray a grand phase of nature. The canvas is very large, but the painter has not relied upon size to suggest bigness, having resolutely attacked the big elements of his subject—the rock formation, like giant ramparts and bastions, and the plunge of the mass of water. On these there is an infinity of patient labor expended, which leaves, however, no sense of niggling detail. The composition counts fairly as a whole, and possesses an impressiveness which cannot be reasonably ignored. That our preference may not be for the grand and panoramic in nature is beside the question. Wisely or unwisely the artist has attempted their portrayal, and from his point of view with remarkable success.[49]

William H. Jackson soon wrote that "such pictures as 'Shoshone Falls' will live many a long year after the eccentricities of the faddists have been . . . forgotten."[50] As for Moran himself, he had found the proper anodyne for his sense of loss—concentration on his work. From 1901 to 1905 may well have been his most prolific period.

[48] Buek, "Thomas Moran, N.A., the Grand Old Man of American Art," *Mentor*, Vol. XII, No. 7 (August, 1924), 33.

[49] "The Seventy-Sixth Annual Exhibition of the National Academy of Design," *Harper's Weekly*, Vol. XLV, No 2300 (January 19, 1901), 74.

[50] William H. Jackson to Moran, January 19, 1901, Envelope 81, Moran Collection, East Hampton Free Library.

XVI *Spokesman*

In his later years, Moran's silver hair and his patriarchal beard lent dignity to his slight figure, which seemed ageless, as straight and erect as a soldier's. He would walk briskly to his New York studio, dressed in a plain gray business suit, not always well pressed, with a black felt hat on his head and a small cigar in his mouth, his gray-blue eyes alert. Morning after morning he would appear thus at the studio, only a little later than before; nine o'clock was the usual hour now; and to do his customary stint of painting he remained till twilight. He napped more often now in the afternoon, but at an age when most men thought of retirement he worked with little slackening of vigor.[1] He signed a contract with Moulton and Ricketts, art dealers in Chicago, and he sent them canvases regularly,[2] though scarcely as many as he painted, for some must always be kept to "season."

Long Island and Venetian views as well as Western landscapes alternated with scenes from the *Arabian Nights* and other imaginary subjects. But with each new year of the twentieth century, the ratio of Western pictures grew—especially pictures of the Southwest, with a liberal admixture of Mexican themes. In summer, Moran continued to travel, reducing the time he spent at the studio at East Hampton. Its associations were poignantly sad, and made him feel

[1] Simpson, "Thomas Moran—the Man," *Fine Arts Journal*, Vol. XX, No. 1 (January, 1909), 20.
[2] Ruth Moran to M. A. Newhouse, June 2, 1924, Ruth Moran correspondence, No. 14, Moran Collection, East Hampton Free Library.

lonely. During much of his time there, he had only the company of Ruth, who had given up an uncertain career as a public reader of Shakespeare and was trying to take the managerial role of her mother. Moran's son Paul had struck out for himself as an artist, and his daughter Mary had married Wirt de Vivier Tassin and was busy making her own home.

In May, 1901, the Santa Fe Railroad sponsored another trip to the Grand Canyon, and Moran accepted an invitation to join the party. The railroad had undergone reorganization under Edward P. Ripley, who had created an advertising department in 1895, installing William H. Simpson as its chief, "a poet who loved pictures."[3] Simpson had extended the policy of advertising the road with paintings on Southwestern themes and made it his practice to haul the artists West to paint. It was he who had arranged the May excursion, or as he phrased the matter:

> I was in charge, for the Santa Fe, of a party of New York artists, who, with ladies, were touring the Grand Canyon region. The gentlemen were George Inness, Jr., George H. McCord, Thomas Moran, and G. H. Buek. . . . We stayed about three weeks. We rode horseback and muleback, went down and up steep trails, and took long excursions through the pines of Coconino.[4]

Moran's affection for the spectacle revived with all its old intensity. "Its forests of cedar and pine interspersed with aspens and dwarfish oak," he wrote, "are weird in the extreme; its tremendous architecture fills one with wonder and admiration, and its color, forms and atmosphere are so ravishingly beautiful that, however well traveled one may be, a new world is opened to him when he gazes into the Grand Canyon of Arizona."[5] Moran renewed his acquaintanceship with the colorful men who had bound their lives to the canyon country—William Bass, "Pete" Berry, and John Hance. For at least a part of the time the party stayed at Hance's log cabin

[3] Erna Fergusson, *New Mexico: A Pageant of Three Peoples*, 368; Merle Armitage, *Operations Santa Fé: Atchison, Topeka & Santa Fé Railway System*, 111; James L. Marshall, *Santa Fé: The Railroad That Built an Empire*, 287–88.

[4] Simpson, "Thomas Moran—the Man," *Fine Arts Journal*, Vol. XX, No. 1 (January, 1909), 24.

[5] "American Art and American Scenery," in C. A. Higgins, *The Grand Canyon of Arizona*, 87.

near the rim, and from there with mules and burros they descended into the gorge or trailed from point to point along the rim. "In a word," wrote Simpson, "we had a glorious outing."

The publicist found it interesting to observe how the canyon affected the various members of the party. The strongest appeal seemed always to the emotions. "Mr. Moran has the emotional side of his nature well under control," he concluded.

> When others hurried from place to place, lest some new view escape their attention, he sat on a convenient rock near the brink and gazed silently into space, watching the shadows come and go and absorbing the subtle transformations caused by the always changing sunlight. . . . But I could see that his enjoyment was as intense as anybody else's. . . . He sketched scarcely at all, contenting himself with pencil memoranda of a few rock forms, and making no color notes whatsoever. He depended upon keen powers of observation and a well-trained memory for the rich tones which perhaps a year later were to reappear on canvas, true to nature and likewise true to the interpretive touch of genius.

As the artists were kindred spirits, they had happy moments together, but there were also moments of disagreement. What afforded Simpson the greatest pleasure, the publicist declared, was:

> a daylight ride along the rim, when, having exhausted their vocabulary of adjectives with reference to the titan of chasms, [the painters] turned to art. These men, trained in different schools and in many respects as wide apart as the poles, were curiously at one in trying to define that indefinable thing called quality in art. Where they differed it was so courteously done, you hardly felt the disagreement.

On another occasion, after dining with Moran and a younger painter —W. R. Leigh, a tireless devotee of Western life and scenery, especially in the country of the Navahos—Simpson would deplore that Moran's conversation had not been recorded by a stenographer, in particular his "urgent appeal for a more native art, independent of European fads."[6] The publicist saw that Moran's present remarks

6 Simpson, "Thomas Moran—the Man," *Fine Arts Journal*, Vol. XX, No. 1 (January, 1909), 24–25.

were not lost; he persuaded him to write them down in a brief state-
ment which the railroad published the next year in a booklet called
The Grand Canyon of Arizona. Later Gustave Buek confirmed these
paragraphs as the gist of what Moran had said upon the canyon rim
that day:

> It has often occurred to me as a curious and anomalous fact that
> American artists are prone to seek the subjects for their art in for-
> eign lands to the almost entire exclusion of their own. This dis-
> position is, perhaps, attributable to a prevailing idea that to reach
> and see the pictorial wealth of the far Southwest involves much
> time, hardship, expense, and above all, dangers that do not really
> exist; for it is easier in every way to visit this land of color, sun-
> shine and magnificent scenery than to go to Europe, and much more
> comfortable traveling.
>
> Another idea alleged by many artists why our own great country
> has been neglected is that the grand in nature is not paintable; that
> is, not suited to pictorial representation. This idea is, I think, due
> to the influence of foreign teaching, especially of the French school,
> where most of our American art students receive their training.
> This school of painting, in landscape, has never aimed at anything
> beyond what might be called the pastoral; that is, a quiet poplar-
> lined riverside, or a bit of swampy ground reflecting a few trees
> under the gray and colorless skies of their country. This pastoral
> landscape seems to have satisfied the ambition of their best painters;
> and perhaps it could not be otherwise, as men will paint best that
> which they know best and are in sympathy with.
>
> That there is a nationalism in art needs no proof. It is bred from
> knowledge of and sympathy with their surroundings, and no for-
> eigner can imbue himself with the spirit of a country not his own.
> Therefore he should paint his own land. The English have painted
> England as nobody but an Englishman could. The same can be said
> of the French, the Dutch, the Spanish, and so on. Our countrymen
> seem to ignore this fact. They go abroad to study, and return laden
> with foreign ideas, and unthinkingly settle down to imitating as
> near as they can the subject, style, and methods of their masters,
> instead of seeking their subjects and inspiration in their own land,
> and applying their technical skill in the production of work na-
> tional in character; they seem to devote themselves to imitations

of foreign masters; and many even find it necessary to make occasional trips abroad to lay in a fresh stock of ideas for imitation. Before America can pretend to a position in the world of art it will have to prove it through a characteristic nationality in its art; and American artists can only do this by painting in their own country; making use of all the technical skill and knowledge they have acquired in the schools of Europe, and the study of the art of the past. There is no phase of landscape in which we are not richer, more varied and interesting than any [other] country in the world.[7]

Simpson remembered that when combating what he considered artistic heresies, Moran's eyes glowed "with a new fire and his voice [rang] with its old-time challenge and fervor."[8] Moran confessed that the present visit to the Grand Canyon convinced him more than ever that the future of American art lay in American artists' being true to their own country.

The excursion came to an end late in May, and Moran traveled home by relaxed stages. Perhaps it was on this occasion that he rode the cars with "Pete" Berry, dressed "in his best black cutaway, which when unbuttoned . . . disclosed a cartridge belt bristling with guns. He was on his way to Williams to find a photographer who had slandered him. The photographer was a bit unwise, for Pete already had killed a man who had shot [Pete's] brother."[9] Moran visited Laguna again, that always fascinating Indian pueblo; he may have dropped briefly below the Mexican border; he sketched the Spanish Peaks near La Junta, Colorado, and spent several days in the vicinity of Manitou Springs. As a result of the trip, wrote Simpson, "several [of his] paintings found their way into next winter's Eastern exhibitions—not altogether impressionistic, not strikingly realistic—but all American in treatment—strong, dignified, intuitively true to fact and yet full of the imaginative quality."[10] As to their peculiar effect

[7] "American Art and American Scenery," in Higgins, Grand Canyon, 86.

[8] "Thomas Moran—the Man," Fine Arts Journal, Vol. XX, No. 1 (January, 1909), 21.

[9] Nina Spalding Stevens, "Pilgrimage to the Artist's Paradise," Fine Arts Journal, Vol. XXIV, No. 2 (February, 1911), 112.

[10] Simpson, "Thomas Moran—the Man," Fine Arts Journal, Vol. XX, No. 1 (January, 1909), 25.

of imagination, John Sloan later said of Moran's Southwestern paintings that had the trees been more distorted, they would have seemed surrealistic. With pauses for Long Island pastorals, a Green River scene or two, a sunset in Venice, or a view of icebergs in the mid-Atlantic, he now devoted his energies to canvases which bore such titles as *Pueblo; Laguna—Sunset; La Rita, New Mexico; On the Berry Trail, Grand Canyon of Arizona;* and *Toltec Gorge, Colorado.* Moran declared:

> My chief desire is to call the attention of American landscape painters to the unlimited field for the exercise of their talents to be found in this enchanting Southwestern country; a country flooded with color and picturesqueness, offering everything to inspire the artist, and stimulate him to the production of works of lasting interest and value. The Grand Canyon of Arizona, and all the country surrounding it, offers a new and comparatively untrodden field for pictorial interpretation, and only awaits the men of original thoughts and ideas to prove to their countrymen that we possess a land of beauty and grandeur with which no other can compare.[11]

The pull of the Southwest prevailed the following summer, and Moran again spent time in Colorado and New Mexico (sketches survive of Glen Eyrie, Acomita, and a Navaho church near Wingate). The record of his movements is scant, but the summer also found him deep in Mexico. No doubt he rode the railway down to Mexico City; later work suggests that the trip also took him to Teoloyucan, a town of brick kilns set against a line of purple mountains; it certainly took him to Cuernavaca, for which he formed a strong affection, drawing on its semitropical environs for several of his pictures. He must have ranged the countryside, remarking many a view, through flower-tipped foliage, of walls and casas overgrown with bougainvillaea. He spent some time at the Borda Gardens, with their sparkling fountains and still pools, their ancient arcades, pergolas, arbors, and grassy terraces. He found the charm of Mexico so hard to resist that he went back the following spring, passing through Albuquerque on the seventeenth of April, 1903. May 4 found him buying antique wooden Virgins in a Mexico City curio shop. And

[11] "American Art and American Scenery," *Grand Canyon,* 87.

that year he painted such canvases as *Ruins of an Old Church—Cuernavaca* and *At the Well*, the latter interesting for the shawled figures, probably the largest that Moran ever introduced into a picture, though not really well done.

Soon, too, he would be painting such mementoes of the Southwest as *Ácoma*; *The Petrified Forest*; *Bright Angel Trail*; and *The Grand Canyon (Hance Trail)*. He had reached a high point in his art, with every canvas, it would seem, characterized by a consistently high degree of excellence. His success stemmed not only from his technical mastery, nor from his remarkable memory of particular scenes, but also from his vast general knowledge of natural effects, which he had accumulated over the years. His friend Buek recorded two remarks by Moran's artist companions during the 1901 excursion to the Grand Canyon. While gazing across the abyss one morning, the air being remarkably clear, one had said: "I've never fully appreciated Tom Moran's work until I took this trip." The other added: "How I could paint this, if I only had Moran's knowledge." In Buek's opinion these artists did make effective pictures of the canyon, but he had to admit that "the paintings of both suffered some for the lack of 'Moran's knowledge.' "[12] Moran had convinced himself when still a young man of the need for learning the gamut of nature's forms and effects; he was still impressed with the artist's need for knowledge, and said as much, in an interview that appeared in *Brush and Pencil*:

> In art, as in any [other] profession, knowledge is power. Twist this into any form you may, but it remains the truth, the foundation stone of all true art. It will always be the same, and this will always show itself in the pictures of the artist, no matter how humble or how pretentious. Just how far the artist will go with his knowledge is left to him. He must typify his own personality. This covers all—taste, opinions, everything. The man must exhibit himself in his pictures. This is the theory of art, and also of judgment. It is the same with the art critic, or any of the professions, the law, music, finance. . . . Knowledge in art cannot be excluded. Knowl-

[12] "Thomas Moran, N.A., the Grand Old Man of American Art," B22, Moran Papers, Gilcrease Institute. This anecdote was virtually sacrificed when the article was edited for publication in the *Mentor*.

edge in art is the power behind the handwork. Eyesight is nothing unless backed by brains. In condensed form, this is my theory of art.

He went on to declare that when painting the Grand Canyon of Arizona "and its wonderful color schemes," he had to "be full of [his] subject"[13]—he had to have knowledge.

He regretted that there was not more individuality, more originality, among American artists. There was too much imitation, too little independence. He tipped his hat, however, to the partisans of the "old Hudson River School"—"these were purely American," he said, "and they were an honor to our land." He suggested that Church was the greatest landscape painter that America had yet produced; who, like the Hudson River group in general, had not been hypnotized "by Schools of other nationalities." "Today it is not so," he continued.

> Our men go abroad and return with foreign ideas and apply the teaching of foreign masters to the American material—where [it is] American material. I want to voice myself as being opposed to the foreign subject in paintings when we have every phase of landscape and subject here at home. America is richer in material than any [other] country in the world. . . . We have, however, no distinct school of art in America.

Moran had now launched upon his favorite topic.

He believed that no more *Niagaras* or *Hearts of the Andes* had appeared in the United States because pictures of that caliber required such "unending toil." "Nothing else would have produced such tremendously successful canvases." He deplored the European orientation that led the young American painter to produce such quick, slovenly work as was then the rule; that led him "to slop over his canvas" under the notion, evidently, that spontaneity was the supreme quality. Such works, Moran declared, "lack the true art principle and the true standard of measurement as judged by the past"—in his opinion the only dependable criterion.

He urged the American artist to be more independent.

[13] "Knowledge a Prime Requisite in Art," *Brush and Pencil*, Vol. XII, No. 1 (April, 1903), 14.

What I ask is, to see a man's brains as evidenced in his work. I want to know what his opinions are. He is the arbiter of his own pictures and of nature. Zola's definition of art exactly fills my demands when he said that "art is nature seen through a temperament." The old idea that art is best defined as "painting nature as it looks, and not as it is," will not satisfy me. An artist's business is to produce for the spectator of his picture the impression produced by nature on himself.[14]

In that respect Moran agreed with George Inness, who had once said: "The purpose of the painter is simply to reproduce in other minds the impression which a scene has made upon him. A work of art does not appeal to the intellect. It does not appeal to the moral sense. Its aim is not to instruct, not to edify, but to awaken an emotion."[15] On another occasion Moran had expressed his opinion that true art was grounded in emotion.

Moran believed, further, that technique alone was of little consequence; it was more important that an artist have something worth saying, a significant theme. "Technical skill is only a means to an end, in itself valueless, the real value in a picture being the application of skill to a worthy subject." Moreover, he consistently opposed the technique known as impressionism: he thought the name a misnomer. What went by the label could not be true impressionism, because it was "false to nature, and I boldly say that it is not the way the artist sees it." He cited himself as the *true* impressionist, although he did not belong to the accepted school. That school, he declared, was "false to the very thing it pretends to imitate, and is therefore a mere pretension, and not real art."[16] The old guard's battle against impressionism, which Moran continued to fight, had long been lost, but he refused to admit the defeat.

He ended on a note that equated hard work with inspiration in the formation of artistic genius—a tact that seemed natural in one who worked as hard as Moran. In that respect, the position he held was quite Carlylean. He signed the interview: too bad he did not

14 *Ibid.*, 15.
15 Quoted in Homer Saint Gaudens, *The American Artist and His Times*, 126–27.
16 "Knowledge a Prime Requisite in Art," *Brush and Pencil*, Vol. XII, No. 1 (April, 1903), 16.

work it over and turn the phrases better. He might then have served the old guard as a more convincing spokesman.

About another matter he felt deeply, and he spoke out; and in this instance his opinion was favored no doubt by every artist in the land. The meager collection of art held by the Smithsonian Institution was inadequate, he felt, as a national collection for a country as important as the United States; so he made a plea for a new National Art Gallery. The interview appeared likewise in *Brush and Pencil*:

> I believe in a National Art Gallery with all my heart. It is a most desirable thing for the country. We cannot get along without it in the future as in the past. After all, in the civilization and enlightenment of a nation, art is the final test. This is how we judge all nations for all ages. We do not care so much for the material triumphs of a people as long as we can know their art. This has been the governing principle of the world since history began. We go on discovering things about nations, but we judge them finally by the art that remains rather than by anything else. The art of Greece immortalized that country. . . . So with the Aztecs and ancient Egyptians, both examples of the truth of my statement. They were centuries being understood, but were finally best known by and through their art.[17]

Moran castigated the United States government as the only government "with any pretensions" that had failed to foster art in any official or extensive way. He then cited the examples of France, England, Italy, Germany, Spain, and Russia in lending aid for the development and perpetuation of their national arts. "Of these nations," he stated, "France easily leads the world in the lavish spending of money from the public treasury for sustaining art. She has acted as a protectorate over art for centuries, and today leads the world in taste." He also singled out Germany and Italy for special praise. He could think of nothing better to establish the United States "among the nations of the earth" than an official policy to preserve the nation's art, and he ventured that if any President

[17] "Plea for a National Art Gallery," *Brush and Pencil*, Vol. XII, No. 3 (June, 1903), 172.

should institute a national art gallery he would deserve to be canonized. Never mind if the influence of such a gallery were not immediately felt. Its effect would come in time, "and the longer we delay it the further off we are from the fulfillment of our proper destiny, and from those ideal paths of civilized enlightenment we all so much desire."[18] Moran thought New York City the proper location for such an institution. But he would nearly live to see the ideal realized in Washington, where a splendid National Gallery of Art was erected through the largesse of Andrew Mellon.

Meanwhile Moran continued his steady, intensive work, relieved by periodic travel. Just as he was no longer an innovator but one who returned to themes he had worked before, he ceased to be exploratory in his travels: he now returned to places he had visited before, for instance to the Grand Canyon in May and June of 1904. That same summer he and Ruth rode horseback through Yosemite. He sketched the Valley, North and South domes, Sentinel and Cathedral rocks, and the various falls, and his aroused enthusiasm led in time to several canvases: *Bridal Veil Falls*; *Yosemite Valley from Glacier Point*; *Cascade Falls*; and *At the Back of South Dome—Vernal Falls*.

Many Eastern eyes found his palette still hard to believe when during the winter of 1904–1905 the Century Club showed several of his paintings of the Grand Canyon, Yosemite, Yellowstone, and the Petrified Forest. The *Critic* admitted that men who had seen the West called his color "faithful"; still, "the work seems more the result of an exceptional imagination than the copying of fact. The purple distance, deep blue-gray valleys, and white peaks possess the width and depth of a romance that we hear unbelieving. Yet Mr. Moran must possess an excellent grasp of the subject," the journal granted, "for by skillful rendering of detail and shadows he has given a metallic definiteness to the values that produce an effect of wonderfully clear air and great distance."[19] He still employed brilliant colors, but his management of them, his blending, had grown more subtle, as in the effects he achieved in his presentation of the

[18] *Ibid.*, 172–74.
[19] Vol. XLVI, No. 1 (January, 1905), 10.

rock of Ácoma, where he tempered rich browns with blendings of yellow on the one hand and violet and magenta on the other. Especially subtle were the harmonies of pastel tones in his *Petrified Forest* of 1904, now hanging at Ohio State University. A simple composition, with a few petrified logs revealed against a background of desert and distant mountains, the scene depended for interest largely on its color. Moran was still as much preoccupied with color as he had been when poring over the works of Turner at the National Gallery in London.

The incredible range of hues at the Grand Canyon explained his obsession with the chasm. He visited there again in the spring of 1905: It may have been then he met John Muir, when the two graybeards posed for a picture together on the rim;[20] the record during these years grows sparse indeed. The following spring Moran announced plans for another Western trip. Instead, however, he made a voyage to England and retraced his old route through Wales, stopping for several days at Conway. In 1907 Paul, his son, died in Los Angeles, and the body was brought back to East Hampton for burial in the family plot. During that year and in 1908 Moran sketched again in Colorado, New Mexico, and Arizona, and while repainting his large Grand Canyon canvas of 1892, at El Tovar Hotel at the head of Bright Angel Trail, he again met Charles F. Lummis, who had dubbed him Santo Tomás. Lummis wished he might "have seen Turner set down upon a certain brink . . . at a certain time—but with half-inch cables on him to keep him from falling into the gulf from sheer delight. Only a few weeks ago . . ." he added, "I had the joy again of sitting there with 'Old Tom' Moran, who has come nearer to doing the impossible than any other meddler with paints and canvas in the Southwest. No one knows better than he the hopelessness of painting God's masterpiece; but no one [else] has made [such a splendid] transcript for our comprehension."[21]

Moran returned West the following year, sketching at Green River cliffs, and in June, 1910, he paid another visit to England and

20 Photograph of Muir and Moran, *Arizona Highways*, Vol. XXXIII, No. 5 (May, 1957), 29.
21 "The Artists' Paradise," *Out West*, Vol. XXIX, No. 2 (September, 1908), 108.

sketched in such diverse localities as Cornwall and Devonshire, Warwickshire, and Scotland. The spell of the sea had come on him again during the voyage, and from time to time he painted more marines, a type of picture at which he excelled and which enjoyed sustained prestige with patrons. Seascapes of this period included *Icebergs in the Atlantic; Sunrise in Mid-Ocean; Sunset at Sea; Mid-Atlantic; Moonlight in Mid-Ocean;* and *Moonlight and Icebergs, Mid-Atlantic.* England had her effect, too, and Moran devoted several pictures to British themes, notwithstanding his plea in favor of American subjects. The trip to Cornwall in 1906 had resulted in *Tintagel* (or *King Arthur's Castle,* as the picture was called when reproduced); *Sunset near Lands End, Cornwall, England;* and *The Receding Wave.* Canvases for 1910 included *Tantallon Castle, North Berwick, Scotland; Cockington Lane, Torquay, England;* and another *Conway Castle.*

Not long after his return from the British Isles Moran was off again to the Grand Canyon with Ruth and a party of fellow artists: Elliott Daingerfield, Frederick Ballard Williams, De Witt Parshall, and Edward Potthast, all with their wives. Buek and Simpson had joined the excursion, too, and there was Mrs. Nina Stevens of the Toledo Art Gallery. In Chicago the company dined with R. R. Ricketts, the art dealer, then left for Arizona in a private car furnished by the Santa Fe Railroad. At Williams the coach was detached from the coastbound train and shunted to the canyon over a newly-built spur. The party arrived at El Tovar not long before sundown, and a carriage drove them to Hopi Point for its superb view across the canyon. "The road lay through the forest," wrote Mrs. Stevens; "between the deep green of the pines, the sky along the horizon was as red as pigeon-blood ruby; it was as though the sun shone through a stained glass window." Those who had come for the first time were led to the rim with closed eyes, to catch the impact of the panorama at one swift glance. "Slowly the color faded from the sky and the distant towers and domes changed from pink to blue, leaving the pinnacles alone crested with light as though illumined from within."[22]

[22] "Pilgrimage to the Artist's Paradise," *Fine Arts Journal,* Vol. XXIV, No. 2 (February, 1911), 108.

The party was up at dawn the next morning, the artists making color notes before breakfast. Ten rewarding days followed; storms filled the abyss to the brim with clouds. The artists painted with enthusiasm; even Moran felt impelled to record the canyon in mist. One sun-bright day the party drove through Coconino Forest to Grand View Point, where they stayed at the ranch of "Pete" Berry; on another day they rode mules down the Bright Angel Trail. "The guides were watchful," wrote Mrs. Stevens, "the mules sure of foot, and the plateau was reached without mishap. For two hours the way lay along the side of a creamy cliff and someone cried with wonder, 'Oh! how strange, the canyon is all yellow and white!' But five hundred feet below the rim, the Canyon began to be all red, in an infinite variety of shades and hues, and, looking up, the vast golden rocks became but as the foam upon the crest of the sea."[23] Sagebrush covered the whole plateau, except at a small Indian garden where roses and chrysanthemums blossomed under trees of flaming green. There the party met John Hance, who had left his log cabin on the rim at the first snow fall and pitched his tent at the garden below. Moran and his artist friends remained upon the plateau to sketch, while the rest of the company descended to the river that roared in the bottom of the inner gorge.

The pictures that came from that excursion, along with a few by other painters, were shown in several museums about the country, owing to the interest of the Santa Fe, and they met with an enthusiastic response. The artists decided then to organize themselves into the Society of the Men Who Paint the West, and they staged annual exhibitions for several years. Among those who joined the original five were Ernest L. Blumenschein, E. Irving Couse, Ben Foster, Albert L. Groll, William Ritschel, Carl Rungius, Gardner Symons, and William Wendt, all members of the National Academy. Their work fanned interest in Western scenery; so Moran could feel that he had largely succeeded in his aim of selling the Southwest to more American artists.[24] Meanwhile the Santa Fe had lithographed an-

[23] *Ibid.*, 113.
[24] "Exhibition of Paintings by the Society of Men Who Paint the Far West at the Albright Gallery," *Academy Notes*, Vol. XI, No 2 (April, 1916), 62–63.

other of his Grand Canyon scenes; prints in gilt frames were sent to thousands of clubs, hotels, stations, schools, colleges, and universities throughout the country, and as a result Moran found himself more than ever linked in the public mind with the great chasm of Arizona.[25] He was pre-eminently the Man Who Painted the American West.

[25] Armitage, *Operations Santa Fé*, 118; Marshall, *Santa Fé*, 287–88.

XVII *Dean of American Painters*

᠅᠅᠅᠅᠅᠅᠅᠅᠅᠅᠅᠅᠅᠅᠅᠅᠅᠅᠅᠅᠅᠅᠅᠅᠅᠅᠅᠅᠅᠅᠅᠅

Calling Moran "one of the stalwarts," Eliot Clark observed that he "prospered in old age as the classic painter of the romantic West";[1] also in his last years, the press began to call him the dean of American painters. "I am working as hard as ever," he told reporters on his return from Europe in the spring of 1911, "and I feel as strong as I ever did." He admitted though, when pressed, that he no longer clambered from peak to peak as he had done fifty years before; still, "I feel pretty young."[2] In 1913, when he was seventy-six years old, his friend G. H. Buek agreed that "his eye [was] as bright, his hand as steady, his mind as alert and his enthusiasm as youthful as belong to men half his age."[3] However patriarchal his beard or white his hair, Moran remained young in spirit, and his lean and lithe figure bore age well.

The years had scarcely curtailed his rate of production. He "continued to practice his art with an astounding regularity," wrote Forbes Watson, who occupied adjoining rooms on 22nd Street. (Moran had changed his winter studio, but had not moved from 22nd Street.) His canvas was squared off, according to Watson, who described a method Moran employed sometimes to copy a sketch. "Using small brushes, he would finish one square of the canvas inch by inch before moving over to another square, and the peaks

[1] *History of National Academy*, 172.
[2] *New York Evening World*, June 12, 1911.
[3] "Thomas Moran," *American Magazine*, Vol. LXXV, No. 3 (January, 1913), 30.

of sunlit mountains would appear finished on one part of the canvas before the other parts of it had been touched." It seemed to Watson that, seated thus before his easel and puffing on his black cigar, Moran was "living in a dream. However, the dream was practical; there was a regular demand for his paintings, and even as an old man, his monetary rewards were comparatively handsome."[4] Predictable though his themes might be, his skill in presenting them seemed only to grow. His style reached its peak of refinement during the teens of the century, and such was the call for his work that skilled forgers, first in Brooklyn, later in San Francisco, began faking pictures in styles not entirely foreign to his own and foisting them on gullible purchasers. As a safeguard against such frauds Moran began to impress his thumbprint on his paintings in addition to his signature.[5] An indication of his popularity was the number of full-scale color reproductions that were made of his paintings.[6] A large public liked his work, no matter how fashions in art might leave him behind, with younger painters calling his style outmoded and critics minimizing his accomplishment.

Moran worried little about such judgments. He was sure that his methods were right and that his work would last. His attitude verged, indeed, on complacency, with unfortunate results for those interested in his life story. He saw no need for saving biographical materials. There were his pictures, he would say; they would last, they would keep his name alive; there was no need for any biography, and as a result of his attitude, there was virtually none written.[7] His complacency was even worse in the face of new developments in art, which he frequently dismissed as crazes.

"I have no patience with any of the modern fads in painting," he liked to say. "Most of them have been deliberate frauds, attempts

[4] *New York World*, December 18, 1926 ("Art News").

[5] Record copies of Moran's fingerprints and handprints are preserved in the Moran Papers, Gilcrease Institute.

[6] The East Hampton Free Library holds over one hundred large color reproductions of works by Moran, a collection regarded as far from complete.

[7] Ruth Moran to George Derby of the James T. White Co., March 16, 1932, C43, Moran Papers, Gilcrease Institute. "It is, and has been, difficult to get data on pictures, etc., because Mr. Moran himself was not enough interested."

in the hands of unprincipled men to fool people who never think for themselves." Cubism, the latest European craze, had now replaced impressionism as his anathema, and he rejected it for the same reason he had rejected impressionism—that it was "false to nature." He condemned the movement as "a striving to express the intellectual in forms of art," an impossible thing to do, in his opinion. "Art, whether painting or music," he insisted, "is an expression of the emotions."[8]

He never tired of tilting at the "new faddists," as he had always tilted at Whistler. Van Wyck Brooks would long remember him as he appeared at Carmel, California, where he had come to paint along with everybody else, the "new abstractionists" included, or so it seemed to the young critic, and Moran "still talked about Whistler and the pot of paint he had flung in the face of the public as if he were a bad boy who lived just around the corner." Whistler, then the impressionists, and now the cubists—they were all to be railed at, like bad boys who had renounced "honest painting." "For Moran," as Brooks would remember, "defended the 'honest painting' that Ruskin had praised him for, representing leaves on a tree as a naturalist sees them, and he spoke of the Grand Canyon as he had known it and painted it when the old geologist Agassiz was living. Honest painting meant for him painting this in such a way that one knew the sandstone from the limestone and the limestone from the shale."

As the *avant garde* left him farther behind, and critical reaction set against him, it became customary to denigrate the leaves on his trees, as Brooks had done, as leaves painted the way "a naturalist sees them."[9] Also, the younger men patronized his work as lacking in the proper "broad effects," and he would exclaim in retaliation, "I hardly know what they mean. Nature is not broad; nothing could be more exquisitely detailed than nature, and why they should try to represent it with a 'broad' smear of paint is something I cannot understand." He could understand no better the scorn hurled at his foliage; he had never sought to delineate individual leaves. As he would

[8] Interview by Gussie Packard Dubois, *Pasadena Star-News*, March 11, 1916, p. 6, cols. 1–2.
[9] *Scenes and Portraits*, 197.

say, "The painter who tries to represent nature by painting every leaf on a tree, also fails, for that is merely photography and not art. The artist must know what to select and what to leave out, and paint his trees not leaf by leaf, nor yet with a splash of green, but in such a way that the leaves appear to be there."[10] Moran had learned the principle of selection early in his career and had followed it faithfully, and though his paintings often admitted a great variety of elements, he generally succeeded in harmonizing them one with another and bringing them into overall unity, so that the observer was seldom distracted by irrelevant details. All too often the stereotyped reasons for condemning the Hudson River school were thoughtlessly urged against his work, and he was right in rejecting most of such criticism. Yet even when legitimate questions were raised about his art, they had little if any effect upon his course. He was adamantly set in his mould; he continued to paint as he had always painted, only better according to his own canons, with a more sure control.

The most marked change in his routine were the frequent visits he now made to California, after long stays at the Grand Canyon. "I do not care to brave the Eastern cold," he said, "and I like the West, its wide spaces, its strength."[11] In the winter of 1916 he took a Pasadena bungalow as a temporary studio, with the pine and spruce-clad summits of Mount Lowe and Mount Wilson looming through his north window. There he painted till late in April, while a dozen of his canvases hung in the lobby of the Green Hotel.[12] Then he and Ruth returned to Manhattan for one month, after which they spent the summer at East Hampton. They would follow a similar routine for the next few years, varied by occasional sketching trips, especially to the Grand Canyon, where Moran painted a number of pictures at El Tovar Hotel.

Here he stayed with Ruth early in 1917, after making a gift to the Museum of Cooper Union—"a series of sketches," according to the minutes of the Cooper Union Council, "selected personally by

[10] *Pasadena Star*, February 4, 1916.

[11] *Pasadena Star-News*, March 11, 1916, p. 6.

[12] "The Pictures Exhibited at the Green, 1916," Envelope 204, Moran Collection, East Hampton Free Library.

the dean of American painters . . . from his own life work, intended to express it fully for the benefit of our students and such others as care to familiarize themselves with the methods of perhaps the only American painter eulogized by John Ruskin."[13] At the same time four of Moran's paintings hung in a loan exhibition which Stephen Tyng Mather, director of the National Park Service, had arranged at the National Museum as a side attraction to the National Parks Conference which met in Washington from the second of January to the sixth. "I want to tell you that our exhibit of Parks pictures is a great success," wrote William H. Holmes, while Moran still lingered at the Grand Canyon. "Your paintings are on the east wall of our large hall. . . . The light is perfect and your picture [of the Yellowstone] shows to enormous advantage. I wish that the fates might decide that it remain there forever. The exhibit is to be broken up early in March";[14] Moran consented then to let the huge Yellowstone panorama remain hanging in the museum till someone should buy it. Soon he and Ruth went to California till the latter part of April, then returned to New York by way of El Tovar. It was on one of these brief interludes in the city that Moran's old love for mountain heights reasserted itself in a curious way; according to the reminiscences of a friend: ". . . one day, when his daughter Ruth and he were staying at a New York hotel, she found him missing. She looked out the window, and there he was perched on the coping six stories above the street studying the skyline. And he was over 80 years old at the time."[15]

During his last years he sought the sun persistently in the American West. In Santa Barbara he found a winter refuge that pleased him even more than Pasadena; for one thing, an art colony had begun to develop there, with such painters as Howard Russell Butler (who would soon do Moran's portrait), Fernand Lungren, Carl Oscar Borg, Lockwood de Forest, and De Witt Parshall, to name a

13 Cooper Union, *Annual Meetings of the Council* . . . , April Meeting, 1917.

14 Holmes to Moran, January 17, 1917, D3, Moran Papers, Gilcrease Institute; Smithsonian Institution, News release dated February 7, 1917 ("Natural Park Paintings Displayed at National Museum"), D3, *ibid.*; Robert Shankland, *Steve Mather of the National Parks*, 108–109.

15 "Pupil Recalls Thomas Moran," *New York Sun*, December 28, 1926.

few. Moran took a modest bungalow on Anacapa Street not far from the old Santa Barbara Mission, and in one of its small rooms he set up a studio, filling it with sketches and etchings brought from East Hampton and hanging his panorama of the Shoshone Falls against one side of the room. Through the window he could look out at "the dreamy beauty of the Channel Islands."[16] In the opposite direction could be seen the granite backdrop of the Santa Ynez Mountains, rounded by winds and rain, not unlike the Scottish hills, taking on hues of heliotrope in the afternoon light, over which were blent the olive shade of live-oak trees and sycamores, in tapestry-like arrangements. He found many pleasing scenes there, and he began to put them on canvas. "The California landscape," he said, "draws more compactly than the Eastern landscape. The eucalyptus trees and the oak trees form masses that are simple compared to the more straggly trees back there";[17] and so to the Yosemite scenes and the Monterey seascapes of his California series he added wooded canyon views from the Santa Ynez Mountains or wooded glens in or about Santa Barbara, where live oaks and eucalyptus trees abounded. Of unusual charm was the *California Landscape*, which he painted in 1919, an autumn wood interior, with oaks and sycamores in a smolder of dull gold framing a still pond; or *La Primavera*, painted the following year, inspired by the Santa Barbara Fiesta, a part of whose setting it depicted. "The colors in it are the soft tints of April," observed one spectator. "The handling of the oak tree is particularly pleasing, but what one remembers longest is the poignant warmth of the violet blue shadows behind the eucalyptus trees and in the mountain canyons in the distance. It is the shade that the Channel Islands sometimes don, just before a rain."[18]

Clearly, the West dominated the last fifteen years of Moran's career, and there were only occasional reversions now to scenes of imagination, or memories of Britain or Mexico. It was during this period, in 1919, that he painted the imaginative *Dream City*, so like

[16] Harriet Sisson Gillespie, "Thomas Moran, Dean of Our Painters," *International Studio*, Vol. LXXIX, No. 327 (August, 1924), 365.

[17] Unidentified clipping (December, 1921), Envelope 179, Moran Collection, East Hampton Free Library.

[18] Unidentified clipping ("La Primavera"), *ibid.*

in feeling to a number of his Arabian Nights vagaries. Two years before, he had painted a fanciful twilight scene which he called *The Owls*, after two small birds silhouetted on a bare limb against the eerie blue of the sky. The picture was rich in Gothic atmosphere. Leaning trees, festooned with creeper, formed a picturesque arcade above the birds, and above a bush-choked gulley lower down, mysterious and indistinct in the darkened foreground. Behind the trees glimmered the arches of a ruined bridge, which cut the picture across the middle, yet gave it great solidity of feeling; and in the right background rose a weathered circular tower, against whose wall played ghostly light and shadows. A masterly work, the picture showed that Moran at eighty years of age had lost none of his uncanny touch and skill.

Almost equally deft was *The Stronghold*, which he painted three years later, a wild, stormy scene on a British motif. It showed a lonely castle on the farther shore of a lake or inlet from the sea, with somber, cloud-wracked mountains in the background and a wind-blown pine to the left on the darkened foreground shore—a picture with some of the feeling of Turner's Kilchurn ruins at the foot of Ben Cruachan. About the same time Moran also produced *Allingham Castle, England* and a rousing marine entitled *Mid-Ocean, Moonlight*. As for Mexico, he had painted several reminiscences of Cuernavaca during his later years; they included *The Borda Gardens, Mexico; The Bathing Pool, Cuernavaca*; and most important of all, *A Mexican Fiesta*, which Moran regarded as the best of his Mexican works. In it the Barbizon influence, especially that of Corot, had reasserted itself; the silvery-green trees rising lacy and decorative against the blue of the sky seemed as characteristic of Corot as they did of Moran. Cuernavaca, shown through the trees, hugged a hillside in the distance; a grassy meadow filled the foreground, the dancing space of a group of tiny figures. An air of gladness saturated the picture, in harmony with the cool greens, a truly festive effect. But on such themes as those above Moran now painted only a few works compared with the canvases he devoted to Western subjects.

He repeated motifs that had brought him earlier success: several new pictures dealt with Green River and its cliffs and buttes, and

Moran escaped duplicating himself only by showing the scenes under different conditions, in different moods. No two Green River pictures were ever exactly alike, however similar their basic composition. The same could be said of a few new Yellowstone paintings. Moran also repainted, in other moods, the Devils Tower and Index Peak. As for Southwestern subjects, he reverted on occasion to the pueblos of Laguna and Ácoma, achieving some admirable color arrangements. Especially effective was *Pueblo of Ácoma, New Mexico*, which he produced in 1913 with all the skill of his maturest style. It showed the great rock, with the pueblo on top clearly visible against a cloudy sky. Late afternoon sunlight bathed the leftward portion of the butte, bringing out its rich brown tones, while the other end reposed in blue and violet shadow. The low land in front shone with vibrant yellows. Scrub trees and jumbled rocks darkened the right foreground, while in the center and to the left exotic horsemen rode toward the mesa, where a hidden passage led to the town above. Similar glowing tones enlivened another Southwest picture, *The Cliffs Near Gallup, New Mexico*, which Moran painted on a wooden table top, likewise in 1913. The next year he produced *Zion Valley, Utah*, forty-one years after his visit to the spot, an interesting feat of visual memory. Other oils of the Southwest included *Lair of the Mountain Lion*, a colorful upright canvas, and *The Pioneers*, which showed a horseback party crossing a mountain pass in Arizona, with a rich sunset flush suffusing the scene.

The subject to which Moran returned most frequently, however, was the Grand Canyon. Its effects were inexhaustible, and often as he had painted it in the past, he felt no danger of repeating himself. One of his most satisfying impressions of it was a canvas of 1913 entitled simply *Grand Canyon*. The view extended across the chasm from a spot near Yavapai Point, toward Bright Angel Canyon and the distant Kaibab, over which gray clouds had drifted. The morning sun caught butte and canyon sides in rosy light, and violet shadows were cast in fantastic shapes. Stunted pines and rim rocks at both lower corners of the picture effectively framed the canyon vista, while through the center foreground the gaze slipped into drifts of gray-blue mist below. How well Moran had succeeded in fusing a multi-

tude of eroded forms into a satisfactory whole, and fifty years later the picture would remain one of the most popular of his works at the Gilcrease Museum.

"I am greatly pleased . . . to know that your father is still in good shape and hard at work," wrote William H. Holmes to Mary Tassin, Moran's elder daughter, on November 12, 1919. "He is a marvel, and I . . . consider him the greatest landscape painter the world has ever known."[19] Holmes' praise came, ironically, at a time when Moran's powers had begun to wane, and his production to slacken. He paid his last visit to the Grand Canyon in May, 1920, sketching at Desert View and recording the scene in one of his last Grand Canyon pictures. Moreover, the quality of reverie so remarkable in *Dream City* began to grow in his work. The phantasmic air especially characterized *Oak Trees and Eucalyptus*, which he began in 1921 and changed in some manner the following year and therefore signed twice, with each date in a lower corner. The picture lacks the sharp focus customary in Moran's work; it seems flat in places, deficient in space projection, its trees hardly more than smoky blurs. The picture makes the observer feel that it was painted in a curiously reduced state of consciousness, perhaps a waking dream. No doubt the changing style can be explained as the result merely of dimming eyesight and the blunting of Moran's memory, heretofore so prodigious, for the effects of nature. Langorous imprecision characterized his final view of Venice and *The Yosemite Falls*, which he painted in 1922 after a final visit to the park, and the quality is pronounced in the *California Landscape* of 1924, one of the last works he ever completed, along with a seascape that might depict the coast of California or Long Island.

In 1922 Moran summered for the last time in East Hampton. As the chill of autumn came, he authorized Ruth to close their old home there, in favor of their staying the year around in Santa Barbara. He decided to send *Spectres from the North* to the National Museum as a long-time loan; he also shipped *The Shoshone Falls* on the same terms as soon as he returned to California, and it pleased him to hear from Holmes that the paintings were shown

[19] In Envelope 74, *ibid.*

in the north lobby of the Museum "facing the entrance where every-body sees them."[20]

During the winter influenza forced Moran to bed, and owing to his age his recovery was slow. He was still feeble when, early in March, Stephen Mather and Ford Harvey, son of the restaurateur, paid him a visit to invite him on a trip to Bryce Canyon, soon to be made a National Park. The idea piqued Moran's interest, as he had not gone there during his visit to Zion Canyon in 1873; but as Ruth Moran wrote: "It will not be possible for Father to do such a thing in this life." In fact, he collapsed once more with influenza shortly after Mather's visit, but it was a mild recurrence so that he was soon up again. "Father is gaining every day," Ruth wrote on March 11. "But we have to keep a nurse to watch him. . . . I wonder if he will [ever] paint again. He has all the interest, and goes in and looks over the three canvases he started before he was taken ill."[21]

By the twenty-ninth Moran had recovered strength enough for a short trip to Los Olivos, where he sketched for the last time in the open air, and soon he was working for a few hours a day at the easel. He managed to finish a few paintings and to start others, and during the following March he was elected the "only honorary member" of the Painters of the West, an organization of some fifteen artists with headquarters at the Biltmore Salon in Los Angeles. The honor, as Moran read in the letter of announcement, came "in appreciation of your services to Western art, and . . . in recognition of the great work that you have done and are still doing."[22] The name of his friend Carl Oscar Borg led the membership roster, and the letter pleased Moran as much almost as the birthday greetings Fernand Lungren had sent him the year before on behalf of all the artists of Santa Barbara:

> *Thou Stripling of the Brush,*
> *We Greybeards of the Craft*
> *Salute thee.*[23]

[20] Holmes to Ruth Moran, July 13, 1923, Envelope 74, *ibid.*
[21] To G. H. Buek, March 11, 1923, C24, Moran Papers, Gilcrease Institute.
[22] Arthur M. Hazard to Moran, March 17, 1924, A16, *ibid.*
[23] Ruth Moran to G. H. Buek, March 11, 1923.

By December, 1924, Moran had grown so weak that he took permanently to bed, or to a wheelchair that allowed him to sun himself on the front porch when the days were warm, and in which he met the friends and painters who called to see him. He was still confined to his bed on June 29, 1925, when the Santa Barbara earthquake struck. It shook him up somewhat and cracked the plaster on the walls and ceiling of his room, and as a safeguard lest the shocks should resume, Ruth improvised a tent for him beneath the pepper trees outside, where he reminded Earl Stendahl, an art dealer from Los Angeles, "of an old Arab patriarch . . . reclining in his tent in the wilds of the desert."[24] A mere frail ghost of a man, he lingered for another year.

The end came on August 25, 1926, in Moran's ninetieth year. "He died looking at the cracks of the ceiling," wrote his daughter, "making Venice out of their patterns, just as, all his life, he had lingered at marble panels and stained wood, seeing pictures in the lines."[25] An Episcopal service was read for him at the Holland Funeral Chapel on the morning of the twenty-seventh.[26] Then his daughters took his body home to East Hampton for burial beside Paul and Mollie in the cemetery beside Town Pond.[27] Trees leaned stark and bare over the mounds and marble stones, but swans had replaced the geese on the waters of the pond.

Years passed, and no book on Moran's life or work appeared. Nina Spalding Stevens of the Toledo Museum had planned such a volume, but the work had come to nothing, owing perhaps to Moran's

[24] *Los Angeles Times*, August 16, 1925.

[25] Ruth Moran, "Further Notes," *Yosemite Nature Notes*, Vol. XV, No. 8 (August, 1936), 64.

[26] The development of Moran's religious views is not clear from available evidence. That he was still nominally a Catholic during the 1880's is suggested by a list of his organizations for that period, which includes the Catholic Club of New York City. His personal feelings might best be described as those of a "natural religion," in which nature served as the intermediary between him and the Deity. No doubt the writer who proposed to make much of his "Wordsworthian devotion to nature" was on the right track. Moran's daughter Ruth testified that, like a blithe pagan, he seemed to have no sense of sin, at least in the years she knew him best. It is thought that his later affiliation with the Episcopal church may have come about as a compromise with Protestant sentiments held by his Scotch-born wife.

[27] *Santa Barbara Morning Press*, August 26 and 28, 1926.

indifference.[28] "There are the pictures," he would say when pressed for recollections, but as American art continued its headlong flight from landscape, once its dominant subject, Moran's pictures seemed of less concern to the shapers of art opinion. In 1927 the museum at Yellowstone acquired a series of water colors from the expedition of 1871, thus turning a temporary spotlight on Moran's career, and George D. Pratt's subsequent purchase of the enormous Yellowstone canvas for a permanent place in the National Collection of Fine Arts brought Moran's name again into the news. Two years later Ruth presented to the new Grand Teton National Park a series of drawings and water colors of the Teton Mountains. In 1931 she had the pleasure of seeing Childe Hassam dedicate the Thomas Moran Gallery in the new Guild Hall at East Hampton. Yet within a year she felt it necessary to appeal to William Macbeth, the New York dealer, for guidance on how an aging, weary woman like herself might safeguard her father's reputation and insure his works against neglect.[29]

Encouraged apparently that the course she had adopted was correct, Ruth segregated a splendid lot of drawings and sketches from Moran's studio files and gave them in 1935 to the National Park Service, along with engravings, assorted memorabilia, and two unfinished oils. Select items from the gift were soon displayed at the

[28] Notes and fragmentary MS for this project are to be found in the Moran collections at both the Gilcrease Institute and the East Hampton Free Library. In *A Man & a Dream: The Book of George W. Stevens* (p. 180) Mrs. Stevens speaks of a week's visit Ruth and Thomas Moran made to Toledo, perhaps in connection with the projected book. It would seem, too, that Edith Singleton attempted a life of Moran, and a number of the notes preserved in the East Hampton Collection were apparently made for her benefit.

[29] Ruth Moran to William Macbeth, November 16, 1932 (copy supplied by Garnett McCoy, archivist, from the original in the Archives of American Art, Detroit, Michigan): "I am very much puzzled by the treatment accorded my father, Thomas Moran's, art work by the powers that be. I am most anxious to know why he is excluded from all American Art exhibitions [and] Museums . . . etc. after so long a life of recognition in the World generally. If my father's work is to be preserved for the future, it is for me to do it. Art is handled so differently now. I am an old woman and have not a great deal of energy. What I have, I believe so far has been wasted, as I am so much in the dark. I want light—if I can help matters by effort, I wish to do so, as my whole life has been given to my father & his work. . . ."

Yosemite Museum, receiving national notice. In 1937 Ruth also arranged loan exhibitions in East Hampton, New York City, Los Angeles, Santa Barbara, and Washington, D.C., to celebrate the centennial of her father's birth; and the response from critics made it clear that his work was still remembered, and highly valued.

The faithful daughter died in 1948, after which the Thomas Moran Biographical Collection was transferred from the studio to the East Hampton Free Library, across the street from Guild Hall. Ten years later the library helped to satisfy the need for a life of the painter by publishing *Thomas Moran: Explorer in Search of Beauty*, a volume of memoirs edited by Fritiof Fryxell. It left no doubt that Moran's reputation had survived a generation of dogmatic criticism which had assumed that only abstract or interior art could be valid for our time and that a preoccupation with natural scenery signified only arrested development in a painter. "Today," writes Clarence P. Hornung, "Moran's work is rare and in great demand."[30] Dealer after dealer ruefully admits his inability to locate sufficient pieces by Moran to satisfy the wants of a discerning clientele. Thirty-eight years after the artist's death the prestige of his work with gallery owner and collector coincides with the achievement of a more judicious perspective on nineteenth-century American art. No longer does one find it fashionable to dismiss the leaders of the Hudson River school as parochial, quaint embarrassments. At the same time, Thomas Moran's place, however modest it may be, seems firmly established in the pantheon of American masters.

30 Jay Monaghan (ed.), *The Book of the American West*, 579.

APPENDIX

꙳꙳꙳꙳꙳꙳꙳꙳꙳꙳꙳꙳꙳꙳꙳꙳꙳꙳꙳꙳꙳꙳꙳꙳꙳꙳꙳꙳

IN LIEU OF A CATALOG
OF THE WORKS OF THOMAS MORAN

Lack of space rules out including the checklist of Thomas Moran's works compiled in connection with the artist's biography. Such information was secured from many sources—the records of Moran and his daughter Ruth, exhibition catalogs, sales catalogs, dealers' records, miscellaneous picture lists and inventories, clipping files, and correspondence with collectors, art dealers, and curators of various galleries and museums. In spite of duplications, the most fruitful sources after Moran's own records were the labeled photograph files of his pictures at the Gilcrease Institute in Tulsa, the East Hampton Free Library on Long Island, and the Frick Art Reference Library in New York City. There is also a commendable contribution toward a catalog of Moran's works in James B. Wilson's unpublished dissertation, "The Significance of Thomas Moran" (Ohio State University, 1955).

I. OIL PAINTINGS

Gustave Buek, an intimate of the artist for thirty years, asked Moran toward the close of his career how many canvases he had painted. After pondering the question Moran replied: "Not more than twelve hundred, possibly less."[1] Certainly by the end of his life the number had mounted to more than twelve hundred. My check-

[1] G. H. Buek, MS (B22), Moran Papers, Gilcrease Institute.

{243}

list, obviously incomplete, includes the titles of more than one thousand oil paintings, ranging from panels less than 5 inches by 8 inches to a single canvas 7.5 feet by 17 feet. Moran's oil painting seems, so far as the record goes, to have begun with *The First Ship, San Salvador*,[2] painted in 1855 when he was eighteen years old, and continued till 1924. Illness then brought his work to a halt, and at least three paintings, then begun, remained unfinished at his death.

During the seven-decade span of Moran's career the statistics cited by his friend allow for an average of seventeen canvases a year; the compilation made for this biography specifically accounts for an average of fourteen. Either figure makes Moran a prolific painter. For 1903, one of his most productive years, titles for nearly forty oils are available, a figure all the more remarkable since the year was not unique. Yet as it has been remarked, Moran's work is now rare and in demand. Most of it has long since found its way into private collections, where it remains inaccessible to the public, making it difficult to secure a proper view of its entire range. I have been able to locate about two hundred of Moran's oils, some seventy of them in museums and other public institutions, the rest in the hands of private collectors, except for a number now available on the art market. No doubt individual dealers know of the whereabouts of many others, but they do not like to reveal the names of their clients.

The most extensive collection is found at the Gilcrease Institute. It numbers thirty-four canvases, of which several were chosen as illustrations for this volume. The two largest paintings at the Gilcrease, *Spectres from the North* (1890) and *The Shoshone Falls of Snake River, Idaho* (1900) hung for years as loans in the National Collection of Fine Arts at the Smithsonian Institution. There along with Moran's second largest canvas, the Yellowstone panorama named above, they were seen by thousands of people every month, and they helped to fix the popular notion, shared by certain art historians, that Moran "painted by the acre" and in general suffered from "an acute case of elephantiasis." This misconception

[2] Collection of Dr. William S. Serri, Camden, N.J.

was further fixed by the two spectaculars that hung for decades in the Capitol, Moran's first *Grand Canyon of the Yellowstone* (1872) and *The Chasm of the Colorado* (1873–74), both measuring 7 feet by 12 feet. In 1950 they were transferred to the Interior Building, where they hung for a time in the conference room of the Secretary. Now the public sees them in the Museum of the Department of the Interior. Two other paintings, at the National Museum, should have helped temper Moran's notoriety as an exponent of the gigantesque—the modest *Cliffs of the Upper Colorado, Wyoming Territory* (1882) and *Mist in Kanab Canyon, Utah* [sic], first painted in 1880 but retouched and dated in 1892. These conform more nearly to the normal dimensions of the artist's work.

The city of Tulsa is well provided with Morans. The collection at the Gilcrease Institute is supplemented by six canvases at the Philbrook Art Center: *Autumn*, an undated Long Island scene; *Grand Canyon* (1907); *Mid-Atlantic* (1911); *The Slave Hunt*, also called *Slaves Escaping through the Swamp* (1862?); *The Spirit of the Indian* (1869); and *The Splendor of Venice* (1888). Probably the only other public gallery with an almost comparable number of oils by Moran is the Heckscher Museum in Huntington, L.I., with five paintings; *Autumn Foliage* (1864), *Bluebeard's Castle* (1915), *Grand Canyon of the Colorado* (1911), *A Hopi Village in Arizona* (1916), and *Venice* (1915). Other Morans may be seen on Long Island. Mrs. Lorenzo E. Woodhouse presented *The Owls* (1917) to the East Hampton Free Library, where it now hangs only a few hundred yards from where Moran painted it. Across the boulevard, in Guild Hall, which houses the Thomas Moran Gallery, one may see not only the portrait of the artist by Howard Russell Butler but also one of Moran's glowing sunsets, *Tower Creek* (1917). The Parrish Art Museum, in Southampton, L.I., owns *Watering Place, East Hampton*.

Other oils by Moran at public galleries in New York include *Seascape* (1906), at the Brooklyn Museum; and *The Teton Range* (1897); as well as *View of Lake Como* (1867), at the Metropolitan Museum. Ruth Moran used to claim that at the Metropolitan "a

cabal" worked against her father's reputation,[3] no doubt an exaggeration. Yet the museum staff has never seemed overly interested in displaying Moran's art. Nothing by him was hung in its exhibition of Hudson River paintings a few years ago, nor in its current showing of three centuries of American art. I had to go to the cellar to see Moran's work at the Metropolitan. How different the attitude at the Gallery of Modern Art, where *The Mountain of the Holy Cross* (1875) hangs in a prominent place and is a popular attraction. The smaller but still spectacular Teton scene, now called *Rocky Mountains* (1899),[4] owned by the IBM Gallery of Arts and Sciences, is frequently shown too. It was recently sent on a nation-wide tour.

Other Morans in New York City include the Century Club's round panel *E Pluribus Unum*, which the artist conceived for a Twelfth Night Revel of the club in 1890. The National Academy of Design holds his diploma painting, *Three Mile Harbor* (1884); and *The Three Tetons* (1895) has long hung at the Paramount Theatre in Times Square.

In upstate New York, *Bringing Home the Cattle, Coast of Florida* (1879) has been for eighty-five years at the Albright-Knox Gallery in Buffalo; the Andrew Dickson White Art Gallery at Cornell University owns a Western view; while recently, in Corning, the Rockwell Gallery of Western Art acquired *Clouds in the Canyon* (1915), a Grand Canyon scene. Even nearer to Manhattan, though beyond the state line, *The Wilds of Lake Superior* (1864) or *Western Landscape*, as now retitled, may be seen at the Museum of American Art, New Britain, Conn.; *Sunset Venice* (1902) at the Newark Museum; and *Scene on Snake River* at the Montclair Art Museum in New Jersey.

Museums elsewhere holding oils by Moran include the Washington County Museum of Art, Hagarstown, Md., with *Lower Manhattan from Communipaw, N.J.* (1880); the Pennsylvania Academy of the Fine Arts in Philadelphia, with *Venice* (1887); the High Museum of Atlanta, with *Fingal's Cave, the Isle of Staffa, Scotland*

[3] Ruth Moran to George Derby of the Henry T. White Co., March 16, 1932, C43, Moran Papers, Gilcrease Institute.
[4] Moran's title: *In the Teton Range, Idaho* [sic].

(1885); the Georgia Museum of Art, at Athens, with *Arizona Adobe Village*, an undated wood panel; the Museum of Fine Arts at St. Petersburg, Fla., with a Florida landscape; the Berkshire Museum in Pittsfield, Mass., with *The Last Arrow* (1867); the Cleveland Museum of Art, with *Inquiring the Way* (or *The Dell*) and *Fort George Island, Coast of Florida*, both dated 1878; the Davenport Municipal Art Gallery in Iowa, with *Welcoming the Return of the Boat*; the William Rockhill Nelson Gallery in Kansas City, Mo., with *View of the Grand Canyon* (1912); and the Jefferson National Expansion Memorial in St. Louis, with *Hetch Hetchy Valley, California*; *Bridal Veil Falls, Yosemite Park*; and *Tower Falls, Yellowstone Park*—the latter two unfinished at the artist's death.

There is also the Walker Art Center in Minneapolis with *Sunrise in Mid-Ocean* (1904) and *Summer Squall* (1889). The Fort Worth Art Center owns *Mists in the Yellowstone* (1908); the Dallas Museum of Fine Arts, *An Indian Paradise, Green River, Wyoming* (1911); the Museum at Yellowstone National Park, *Lower Falls of the Yellowstone* (1893?); and the Los Angeles County Museum of Art, *View of Venice* (1902). *The Petrified Forest* (1904) hangs in the Orton Hall Library at Ohio State University in Columbus. A like though smaller treatment of that theme (1907) belongs to the Santa Fe Railroad in Chicago; the same collection also contains *Grand Canyon of Arizona* (1914). Two Morans hang in the First National Bank of Midland, Tex.: *Fairmount Park, Philadelphia* (1871) and *Grand Canal, Venice* (1905). The Lauren Rogers Library and Museum of Art in Laurel, Miss., owns two others: an untitled Venetian scene and *Sunset, Long Island Sound* (1907). *Tantallon Castle, North Berwick, Scotland* (1910) hangs in the Copley Memorial Hospital in Aurora, Ill. The Drexel Institute of Technology in Philadelphia owns *The Ripening of the Leaf* (1864). Also, it is said that work by Moran can be found at the museum of the Grand Canyon National Park.

Oils by Moran may thus be seen in almost every part of the country, though Oklahoma seems to lead other states in numbers. In addition to the museum holdings in Tulsa are several groups of Morans in private collections about the state. In Ponca City Mrs.

Jay Paris owns the impressive *Ponce de León in Florida, 1512,* also called *Ponce de León Treating with the Indians* (1877). In addition four other Morans hang in Mrs. Paris' house, scenes from Long Island, Italy, Arizona, and Florida. In Bartlesville, Mr. J. Edgar Rice has five oils by Moran: three are Venetian scenes, one shows the Rock Towers of the Virgin River, and still another the Vernal Falls of Yosemite. Once there was a sixth oil in the collection, a Grand Canyon sunrise, but Mr. Rice gave it to one of his family.

In Oklahoma City, Mrs. Frank Buttram owns five oils, including *Children of the Mountain* (Opus 20, 1866?), which hung at the Paris Universal Exposition in 1867. The others include a Venetian scene, two marines, and a view of Yosemite Valley. Mr. Harvey P. Everest, of the same city, has three Morans, depicting the Grand Canyon, Venice, and the Virgin River. Those of Mr. and Mrs. Joe N. Champlin, of Enid, comprise a Long Island scene, a Venetian moonrise, still another view of Venice, and a fantasy on a theme from the *Odyssey—Ulysses and the Sirens* (1901). All belonged to the collection of the late Herbert Hiram Champlin; two additional paintings from that collection have also remained in the family, one with Dr. Paul Champlin, of Enid, and the other with Mrs. Don Welch, of Tulsa. Mr. Bailie Vinson, of Tulsa, owns three Morans, including *The Hermit Mission* (1916) and *Rainbow over the City* (1893). *Yosemite Falls* (1922) belongs to Mr. Eugene B. Adkins. And the collection of Mr. C. R. Smith, of Tulsa and New York, includes Moran's *Golden Hour* (1875), *Blue and Green Landscape, Long Island* (1900), *Idaho Tetons* (1895), and *Virgin Canyon, Utah* (1916).

Two old friends of the Moran family in New York City hold between them a total of eight oils by the artist: Mr. Albert Gallatin with four; and his sister, Mrs. William W. Hoppin, with the same number. Mr. Thomas Gallatin, of Manhasset, L.I., owns *The Headwaters of the Gallatin River, Montana* (1896); while *The Opal Venice* (1892) belongs to a relative, Mr. George Cammann, of Darien, Conn.

A most enthusiastic collector was the late Charles R. Morley, of Mentor, Ohio. It is understood that he had acquired over a dozen

Morans, some of them late works, and that the Morley estate retained a number after the collector's death, though whether until the present time has not been learned. The collection has been described as a varied one, with Venetian scenes, Arabian Nights fantasies, Long Island sunsets, and Western landscapes. *The Desert View, Grand Canyon* (1920), which Morley purchased directly from Moran, was one of the last Canyon scenes the artist ever painted.

Western views have long been favorites with Moran's following, especially those of Grand Canyon. One of the most notable, the panorama of the chasm painted in 1892, and reworked sixteen years later and so dated 1892–1908, now hangs in the house of Mr. Graeme Lorimer, of Paoli, Pa. Professor Cloyd Marvin, president emeritus of George Washington University, has *Grand Canyon of Arizona at Sunset* (1909) hanging over his desk. Other persons with views of the Canyon include Mr. Stewart Harvey, of Santa Fe, Mrs. Charles E. Simpson, of Monterey, Professor Maurice Bloch, of Los Angeles, Miss Gertrude E. Gunn, of New York City, and Mr. Horace M. Albright, formerly director of the National Park Service. Among the three Morans owned by Mr. Benjamin P. Alschuler, of Aurora, Ill., is the view of a side canyon. Mrs. Thomas C. Murphy, of Red Oak, Iowa, owns *Coconino Forest, Arizona* (1907), one of two pictures retained from a large group of Morans once assembled by her father-in-law, the late Thomas D. Murphy. Mrs. W. E. Wrather, of Washington, D.C., and the E. de Golyer estate in Texas hold Green River scenes, while the Loury collection in Los Angeles is said to include *Index Peak—Storm and Mist* (1914). As for Mexican views, one is the property of Mr. and Mrs. Lewis Kayton, of San Antonio. Another, *Ruins of an Old Church—Cuernavaca* (1903), was until recently the property of Miss Florence Hill, of Pasadena; but as I write, it glows on the walls of the Kennedy Galleries in New York.

Also popular with collectors are Moran's Venetian paintings. Those whose locations I have learned, aside from ones already mentioned, belong to Mr. and Mrs. Alvin A. Horwitz, of Wichita Falls, Tex.; Dr. M. Laurence Montgomery, of San Francisco; Mr. J. Ed Hart, of Greenville, S.C.; Mr. Fred Seely, of Cincinnati; Mr.

Benjamin P. Alschuler, of Aurora, Ill.; Mrs. John S. Benedict, of Pasadena; Mr. Robert C. Carr, of San Angelo, Tex.; and Mr. Floyd Ard, Jr., of Abilene, Tex.

The oils of still other private owners range from early work to late, from romantic naturalism to sheer fantasy. There is *Spit Light, Boston Harbor* (1857),[5] which has been in the family of Mr. A. Ilsley Bradley, of Cleveland, for three generations. There is a Long Island view called *Pastoral Landscape with Windmill* in the possession of Mrs. Charles Good, of Chicago. There is another Long Island landscape in the hands of Mrs. William R. Adams, of New Canaan, Conn. There is the *Moonlight and Icebergs, Mid-Atlantic* (1910) of Mr. and Mrs. Charles T. Davies, of Wyomissing, Pa.; A *Windy Hilltop—Amagansett* (1901), property of Mr. David B. Goodstein, of New York City; *Swiss Alps*, owned by Mr. H. K. Babbitt of Washington—one of the paintings Moran called *Children of the Mountain* (for he painted two, according to an autobiographical sketch[6]); and the moody, melancholy *Haunted House* (1858) that belongs to Mr. Lawrence A. Fleischman, of Detroit. With such variety, it is no wonder that Moran appeals to such a varied range of people.

"He has always appealed; his appeal never dies," one dealer told me recently. "We always like to carry Morans. But now they're much too hard to find." A number of galleries that sold them in the past report not having listed many in recent inventories—the Findlay and the Newhouse galleries of New York are cases in point. M. Knoedler's, M. R. Schweitzer, Berry-Hill, Robert S. Sloan, Roman & Galka, Babcock, Hirschl & Adler and Hammer galleries have all had Morans during the period of my investigation; but the most active New York dealer, as far as Morans are now concerned, is Kennedy Galleries. At the moment eight oils are available there, and the gallery has handled a total of eighteen in recent years. Activity at Parke-Bernet has been called an index of the movement of a painter's work. If

[5] Possibly the same picture as *Waiting for the Tide*, exhibited at the Pennsylvania Academy of the Fine Arts in 1858.

[6] Moran to Editor, *American Cyclopaedia*, December 17, 1874, in MS Division, Library of Congress.

statistics given me are complete, some fifty Morans have been auctioned there since 1938, not a high figure, considering the prolific output of the artist. It would seem that many owners are happy with their paintings by Moran and tend to retain them.

II. WATER COLORS

Some of Moran's most exquisite work was done in water colors, but he was less prolific in that medium and largely abandoned it during the last twenty years of his life. Information on his water-color drawings is frequently harder to secure than data on his oils and, when compiled, seems scanter in detail. I have information on about three hundred water colors, many of them completely finished works; the others, as far as I could ascertain, were usually more finished than quick sketch notes. But in the end this figure must remain an arbitrary one; it is often hard to draw the line between a finished work and a rougher sketch or study, and the problem is complicated by Moran's having displayed certain of his quick sketches without their character being so designated in the catalogues.

In certain quarters the water colors enjoy a higher prestige than the oils and are in greater demand. Perhaps owing to the difficulty of securing data on those whose whereabouts are not known, my notes contain a somewhat higher proportion of water colors with recorded locations than of the oils paintings. Many are now in museums, and again the Gilcrease Institute takes the lead. It owns seventeen finished water colors dealing with Yellowstone scenes, ranging in size from 7¾ inches by 11¼ inches to 13½ inches by 19½ inches, the majority dated in 1872. Most of these make up the series Moran prepared for William Blackmore, the British capitalist who traveled with Dr. Hayden's corps in 1872. However, the largest of the Yellowstone water colors in the Gilcrease collection—*The Great Blue Pool at Firehole Basin*—is dated one year later than the Blackmore set. Other aquarelles to be seen there are *On the Lookout*, a genre Indian subject, and *Bridge of Three Waters, Pass of Glencoe, Scotland*. There is also an almost complete series of monochrome wash drawings on themes from Hiawatha, dated 1875 and 1876. Though they are held as part of the large assortment of Moran's

field sketches noticed in Section III below, they must be mentioned here because of their superior finish. Also in Tulsa, at the Philbrook Art Center, is a fine water-color drawing of the Upper Yellowstone Falls, closely duplicating the Gilcrease's version of that scene.

The next most extensive holding of water colors belongs to the Museum at Yellowstone Park. They comprise twenty-two field sketches, twenty from Moran's journey in 1871, one from his Teton trip in '79, the other from his trip in '92. Though they have the character of spontaneous sketches, they warrant separate listings here because of their historical importance. Two water-color sketches of the Tetons and one of Fort Hall belong to the Museum at the Grand Teton National Park; the Jefferson National Expansion Memorial has five of the National Park scenery; while several at the Museum at Cooper Union deserve notice in this section, especially *The Cliffs of the Rio Virgin, Southern Utah* (1873), *South Dome, Yosemite* (1873), *Cliffs of Green River* (1879, and *The Hacienda of San Juan, Mexico* (1892).

In the National Collection of Fine Arts at the Smithsonian one finds *Shin-Au-Av-Tu-Weap—God Land, Canyon of the Colorado, Utah*, which Fritiof Fryxell has called "a finished water color and one of the finest of the artist's."[7] There are at least six others there, including an untitled sketch of an Indian pueblo which serves as frontispiece for a volume of William H. Holmes's "Random Records." Fryxell also locates a water-color view of Yellowstone in the Graphic Arts Division. Other institutions with Moran water colors include the Corcoran Gallery, the Norfolk Museum, the Philadelphia Museum of Art, the Newark Museum, the Salmagundi Club in New York City, the Brooklyn Museum, Guild Hall in East Hampton, the Wadsworth Atheneum in Hartford, Amherst College, the Museum of Fine Arts in Boston, the Cleveland Museum of Art, the Davenport Municipal Art Gallery, and the Fort Worth Art Center.

Individuals with water colors by Moran include Mr. Albert Gallatin, of New York City; Mr. Byron S. Harvey, of Chicago; Mr. Law-

[7] F. M. F[ryxell], List dated October 16, 1935, D7, Moran Papers, Gilcrease Institute.

rence Fleischman, of Detroit; Mr. F. Edgar Rice, of Bartlesville, Okla.; Mr. Roger S. Philips, of Rowayton, Conn.; Mr. Carl S. Dentzel, director of the Southwest Museum, Los Angeles; Mrs. Arnold Dana, of Greenwich, Conn.; Mr. George Cammann, of Darien, Conn., and Mr. G. A. Heckel, of New York City. The most arresting water color that I have seen is *The Roc's Egg*, also called *Sinbad and the Roc*, now in the M. R. Schweitzer Gallery in Manhattan— a dazzling picture, full of clear blues and yellows, reminiscent of Turner. Moran water colors may also be found at present at the Knoedler and the Kennedy galleries.

III. FIELD SKETCHES AND STUDIES

Moran never tired of noting his impressions of landscape effects. In 1911, when seventy-five years old, he remarked concerning an impending trip to California: "I have hundreds of sketches of the Rockies and the Sierra Nevadas, for I have been making them for years, but I want still more. I want some typical winter scenes."[8] He continued doing his outdoor "memory jogs," though in reduced numbers, almost until his last illness: his final pencil drawings were made in 1923. Six years before, he had begun to disperse his studio collection, and after his death Ruth Moran dispersed it further. The bulk may now be found divided among several museums, amounting to nearly a thousand items. What proportion this may be of the total number Moran made can only be guessed at. The largest share is at the Gilcrease Institute, an assortment of over six hundred pieces. They were done in pencil (436 are pencil sketches alone), as well as in pen and ink, crayon, chalk, charcoal, sepia, and various washes and water colors. In addition, the Gilcrease Institute owns several of the artist's sketch books, of various dates.

The Moran Collection at the East Hampton Free Library contains 188 sketches, mostly in pencil, emphasizing Long Island scenes, plus a sketchbook dated 1880; while Guild Hall across the street owns a few pen and ink drawings. The Museum of the Decorative Arts at Cooper Union has over ninety sketches not specified above, and the Moran Collection at the Jefferson National Expansion Me-

[8] New York *Evening World*, June 12, 1911.

morial contains fifty pencil sketches and at least fifteen black-and-white wash drawings. There are three pencil sketches in the Moran collection at the Grand Teton National Park, and the M. & M. Karolik Collection at the Boston Museum of Fine Arts includes at least ten studies and sketches not indicated above. Scattered drawings may also be found at the following institutions: the Brooklyn Museum; the Princeton Art Museum; Amherst College; the Washington County Museum of Fine Arts, at Hagarstown, Md.; the Corcoran Gallery in Washington; and the Carnegie Institute of Technology in Pittsburgh.

IV. ETCHINGS

Ruth Moran once said her father had etched about one hundred plates,[9] possibly an exaggeration. The basic list of his works in this medium is found in the catalogue that Christian Klackner published for a sale of Moran etchings in 1889. This brochure describes seventy-four etchings by Moran and reproduces one unlisted item as its frontispiece. Early in his career the artist made at least five etchings by the glass cliché process. He also made at least six etchings at dates too late for the Klackner checklist, while an etched study of sassafras trees, made in 1880, seems to have escaped the compiler's attention; all of which amounts to a total of only eighty-seven plates, a figure which, moreover, takes into account several states of certain of the plates. *Twilight* (K3), for instance, is listed for 1878 as a pure etching; it appears again for 1888 (K4) as an "impression with mezzotint added." A similar instance is noticed in *The Pass of Glencoe*, 1886 (K50), which appears again (K68) as "Mezzotinted in 1888."

Mrs. Moran made at least four plates after works by her husband; and in the 1870's Peter Moran began a series of steel etchings after Moran's illustrations for *Hiawatha*. These seem to be rare now. I have seen listings of several individual items from the series but have not run across all that Peter Moran apparently completed. At least one print from the series belongs to the Gilcrease Institute.

The largest group of Moran's etchings is found in the Print Division of the New York Public Library—fifty-seven different items,

9 MS Notes, Frick Art Reference Library, New York City.

plus a few duplicates. The second largest group is at the Gilcrease Institute, some fifty or more different items, along with many duplicates. The next largest group forms a part of the Ferris Collection, held by the Graphic Arts Division of the Smithsonian. Other institutions with Moran etchings include the Metropolitan Museum, the Boston Museum of Fine Arts, the Corcoran Gallery, the IBM Gallery, the East Hampton Free Library, Guild Hall in East Hampton, the Long Island Historical Society, the Montclair Art Museum, the National Academy of Design, the Library of Congress, and the Jefferson National Expansion Memorial. And there are etchings, of course, in a number of private collections.

V. CHARCOAL DRAWINGS

A few charcoal drawings survive, on both canvas and paper. I have the titles of forty-two, but I cannot be certain that all exist in their own right. Before painting in oil, Moran often made a charcoal sketch on canvas. Sometimes he took photographs of such designs, before painting over them, thus suggesting more charcoal drawings than actually exist. No doubt a number of those whose photographs I have seen were painted over and thus destroyed. Locations of such drawings, either the originals or replicas in photographic form, include the East Hampton Free Library, the Gilcrease Institute, Cooper Union, the Jefferson National Expansion Memorial, the Grand Teton National Park Museum, the Yellowstone National Park Museum, and Knoedler's Gallery in New York City.

VI. LITHOGRAPHS

Moran seems to have made his lithographs during his early career, his first stone dated 1859. Within a decade practically all of his work in this medium had been done, though some of his pictures were later duplicated by other lithographers. By the time he turned from the process he had executed at least twenty-five black-and-white lithographs, many of which were published by James McGuigan of Philadelphia, some in a portfolio entitled *Studies and Pictures*. At least one print issued by McGuigan, *A View of Swarthmore College*, was finished in color by hand. Moran may have returned to the

process on rare occasions decades later to make monochrome copies of certain of his paintings. The probability is, however, that most of such work, possibly all of it, was done by other hands. Lithographs by Moran may now be found at the Gilcrease Institute, the East Hampton Free Library, the Print Division of the New York Public Library, and the Graphic Arts Division of the Smithsonian Institution. Lithographs possibly by Moran of later paintings are held by the Gilcrease Institute and the Museum at Grand Teton National Park.

The best known of his works in lithographic form are not his own prints, but the fifteen chromos published by Louis Prang in Dr. Hayden's *Yellowstone National Park and the Mountain Regions of Portions of Idaho, Nevada, Colorado and Utah.* Moran is said to have supervised this work, though to what extent has not been ascertained. The portfolio appeared in a limited edition and is now scarce, having been broken up in many cases, owing to the greater demand for separate prints. The locations of Prang chromos, either in sets or individual prints, include the Gilcrease Institute, the Print Division of the New York Public Library, the Library of Congress, the U.C.L.A. Library, the Boston Museum of Fine Arts, the East Hampton Free Library, the Museum at Cooper Union, the Museum at Grand Teton National Park, the Bancroft Library, the Jefferson National Expansion Memorial, and the Henry E. Huntington Library and Art Gallery at San Marino, Calif. Eugene B. Adkins, of Tulsa, also owns a complete portfolio.

VII. METAMORPHOSES

It is not known how many of these curious amusements Moran made (newspaper or magazine portraits transformed into landscapes by pencil, wash and Chinese white); apparently many were lost. The Moran collection at the East Hampton Free Library includes 152, and there are ten at the Gilcrease Institute.

VIII. ILLUSTRATIONS

Ruth Moran estimated that her father had made at least 1,500 illustrations over a period of thirty years.[10] At least two-thirds were

10 *Ibid.*

designs for wood engravings, wash drawings made with India ink and Chinese white directly on the blocks and thus destroyed when engraved. One proof found at the East Hampton Free Library is inscribed thus: "The Catawissa Valley, one of my earliest drawings on wood. T. Moran, 1853."[11] As he had not then developed a signature device, it is hard, if not impossible, to recover many of his first woodblock designs. According to Fryxell, Moran did considerable work of this character in the earlier period; most of his illustrations were executed in the thirty-year span from 1853 on. After 1883 he continued only sporadically as an illustrator, though he did not completely end this facet of his career until 1900. Thereafter he was more concerned with selling reproduction rights to his paintings, usually for art calendars, but a few of them appeared as illustrations in periodicals and books. The most notable use of this kind occurred in a series of travel volumes by Thomas D. Murphy, which offered twenty-four different color plates of Moran's work between 1910 and 1925.

Beginning in 1871, *Scribner's Monthly* accepted more of Moran's designs than any other magazine. At least 339 wood engravings in its pages bore his signature. Then in November, 1879, he noted in his account book: "This is probably the last drawing I shall ever make for *Scribner's*."[12] Nothing more of his appeared for the next two years; then a single design was used in Volume XX (1881). When *Scribner's* became the *Century*, he contributed at only rare intervals, perhaps no more than fifteen illustrations, including wood engravings (one after a painting by himself), wash drawings, and charcoal or crayon sketches. Meanwhile he had sent some fourteen or fifteen drawings on wood to Scribner & Co. for the *St. Nicholas* magazine, and his records show that by the end of 1883 he had made forty-one designs for *Harper's Monthly*, as well as five for *Harper's Weekly*. The last were of the Yellowstone, and of superior quality.

Yet the best of Moran's magazine work was done for the *Aldine*, for which he furnished at least thirty-nine large drawings on wood

[11] Envelope 12, Moran Collection, East Hampton Free Library; Fryxell (ed.), *Thomas Moran*, plate between pp. 20 and 21.
[12] Notebook 1877–82 (G), Moran Papers, Gilcrease Institute.

between 1872 and '78. In addition the magazine ran a large engraving of his painting *The Watering Place*. Other periodicals for which he provided occasional illustrations included the *Art Journal* (New York edition), the *American Art Review*, the *Colorado Tourist*, the *Fine Arts Journal*, the *Illustrated London News*, and the *Magazine of Art*.

The finest of Moran's work for books appeared in Volume II of *Picturesque America* (1874), edited by William Cullen Bryant. The twenty-three wood engravings, divided among three articles, were of a quality to match his work for the *Aldine*, and they were reprinted many times. Volume I of that sumptuous gift book carried also a steel engraving of his drawing of the Upper Yellowstone Falls. To a score of less flamboyant books of the parlor-table type, including volumes by Hawthorne, Longfellow, and Whittier, Moran contributed no fewer than 130 drawings on wood; "the neatest little landscapes [in the words of Sinclair Hamilton] for the gift books of the period."[13] Later, too, he illustrated books of poems by two close friends with a total of forty or more pictures, both in wash and in pen and ink. Moran made the drawings for one of these volumes in 1895 and '96, but they were delayed in publication until the year of his death.

Meanwhile he had also contributed to government documents. Two reports by Dr. Hayden had run twenty of his wood engravings, and Major Powell made even more extensive use of his work. The Major's several reports, plus Captain Dutton's study of the Grand Canyon District, contained a total of thirty-nine of Moran's engravings, arranged in various combinations, repeating the cuts in volume after volume, besides reprinting several others from *Picturesque America*. Also, Moran made a large sepia painting of the Kaibab sector of the Grand Canyon for Dutton's Atlas.

He also illustrated guidebooks and various pieces of travel literature. He was responsible for some thirty-seven wood engravings in volumes about Philadelphia. Several railroads engaged his services, and for them he designed about 125 wood engravings. His most extensive commission led to sixty-seven designs for J. G. Pangborn's

13 *Early American Book Illustrations and Wood Engravings, 1670–1870*, xlvii.

Picturesque B. and O. (1882–83), the subscription edition of which was produced in lavish gift-book style; but even better known was Henry T. Williams' *Pacific Tourist* (1876), a descriptive guide sponsored by the Central and Union Pacific railroads. It carried at least eighteen wood engravings by Moran. Later he accepted commissions from the Santa Fe, and its booklet *Grand Cañon of the Colorado River* (1900) reproduced ten of his wash drawings. Various popular travel books, such as Ernest Ingersoll's *Crest of the Continent* (1885), used over a hundred of his engravings, some of them reprints. Fifty-one of them alone adorned *The Great South* (1875), by Edward King.

Textbooks, too, engaged Moran's attention; histories and geographies for the most part, they used at least one hundred of his drawings; but he also contributed to McGuffey's Eclective Readers. The most distinguished publication of this class was *A Popular History of the United States* (1876–81) by William Cullen Bryant and Sidney Howard Gay. It contained one steel engraving after Moran and twenty-eight wood engravings bearing his device. In addition, a few art volumes ran his work, in particular etchings, as in the case of S. R. Koehler's *American Art* (1886). Sometimes his plates were printed in catalogues, such as that prepared for his own sale in 1886. At times these items were checklists of private collections scheduled for auction; also, now and then, Moran furnished plates for the yearly publications of the New York Etching Club. As for his wood engravings, two fine examples appeared in George W. Sheldon's *American Painters* (1882), and two in W. J. Linton's *History of American Wood Engraving* (1882).

In his work as illustrator Moran was fortunate in the co-operation of some of the finest engravers of the day: Linton himself, for example, as well as F. S. King, J. A. Bogert, P. Annin, F. Juengling, J. Filmer, E. Bookhout, J. Lauderbach, and John Karst, to name but a few. Often they did full justice to his neat and precise designs, an important aid in his achieving eminence as one of the ablest landscape delineators in the golden age of illustration. There are several collections of his illustrations to demonstrate the point: the East Hampton Free Library holds 445 examples of his work in this cate-

gory, mostly wood engravings but also a few steel engravings and reproductions of pen-and-ink or wash drawings, plus a number of color plates;[14] the Gilcrease Institute holds a varied miscellaneous assortment; so also does the Art Division of the New York Public Library; while the Jefferson National Expansion Memorial has fifty-nine wood engravings, plus reproductions of wash drawings, all chosen to represent scenes in the National Parks. A number of Moran's wood engravings may also be seen at the Parrish Art Museum in Southampton, Long Island; at the Frick Art Reference Library in New York City; and at the Museum of the Grand Teton National Park. The Carnegie Institute in Pittsburgh has a drawing made by Moran on a woodblock that was never engraved.

[14] The East Hampton Free Library has also a shelf of books that Moran illustrated.

BIBLIOGRAPHY

COLLECTIONS OF MSS AND SPECIAL MATERIALS

The text draws heavily on sources in the collections listed below, especially those in Tulsa, Oklahoma, and at East Hampton, Long Island. The location of the various materials determines the order of citation.

Cooper Union . . . , New York. Museum for the Arts of Decoration. Moran drawings and sketches with dates and notations.

Detroit Institute of Art, Detroit, Michigan. Archives of American Art. Assorted materials which, for the most part, duplicate items elsewhere. "The bulk of our Moran Papers is a microfilm copy of the material at the East Hampton Free Library. Of the other items a few belong to the Historical Society of Pennsylvania, and a few originals are here." (Garnett McCoy, archivist, to the writer, July 10, 1963.)

East Hampton Free Library, East Hampton, Long Island.

Thomas Moran Biographical Collection, comprising drawings and sketches, correspondence, memoranda, MS notes and drafts for a projected biography, articles, reproductions, clippings, photographs, scrapbook, guestbook, catalogues, and memorabilia. (This is the richest single collection pertaining to Moran.)

The Long Island Collection: Ruth B. Moran, "Notes on the Tile Club" (JG 104).

Findlay Galleries, New York.
 Moran file—photographs, clippings, notes, authentications, and catalogues.
Frick Art Reference Library, New York.
 Special Moran materials—photographs, pamphlets, clippings, brochures, MS notes, reminiscences and marginalia by Ruth Moran. (Much of this duplicates material in Moran collections elsewhere.)
Gilcrease Institute of American History and Art, Tulsa, Oklahoma.
 Moran Papers comprising correspondence, personal documents, diary fragments, memoranda and account books, miscellaneous notes, articles, clippings, photographs, picture lists, and authentications. (In biographical significance this collection is second only to that at the East Hampton Free Library.)
 Moran drawings and sketches with dates and notations (of help in the reconstruction of itineraries of sketching tours—the most extensive single collection of Moran sketches in existence.)
New York Public Library, New York. Art Division.
 "American Art Sales, 1866–1922" (MS).
 "American Landscape Painters: Scrapbook of Reproductions, etc.," dated 1930.
 Clipping file of Moran materials—reproductions, personal and family data, photographs, clippings of articles and reviews, sales data, and exhibition catalogues.
 "Inside File" of carded notes on individual pictures (with more than forty entries on works by Moran).
 ————. MSS Division.
 Century Collection: correspondence of Moran and F. V. Hayden with Richard Watson Gilder. Letters of Moran and Hayden are preserved in copy form in Gilder's Letter-Press Books.
 Frederick S. Dellenbaugh Collection: MS Journal of Almon Harris Thompson (Powell Survey), 1873. A number of details were cut when this diary was published in the Utah Historical Quarterly.
Pennsylvania Historical Society, Philadelphia. A few letters by

Thomas Moran scattered through several collections and of relatively slight importance.

Philadelphia, Pennsylvania. Free Library of Philadelphia. Miscellaneous Moran items—reproductions, photographs, prints and etchings scattered through several special collections.

M. R. Schweitzer Gallery. New York. Folders pertaining to Moran—reproductions, photographs, clippings and authentications (incorporating items from the DeForest Art Library).

Southwest Museum, Los Angeles.

Charles F. Lummis Papers—correspondence with Ruth Moran.

U.S. Capitol, Washington, D.C. Office of the Architect.

MS autobiographical sketch by Thomas Moran, dated 1910.

U.S. Department of the Interior. Office of the Secretary.

General Files: correspondence concerning the Moran paintings now hanging in the Interior Department Museum; also concerning the National Park Service Collection of Moran's work.

U.S. National Archives, Washington, D.C.

U.S. Census records (Record group 29): 8th Census (1860)—Pennsylvania. Vol. LXII, 219.

U.S. Customs Service records (Record Group 36)—Passenger Lists (that for the *Thomas P. Cope*, Philadelphia, May 31, 1844).

U.S. Geological Survey records (Record Group 57).

Director's Office: Letters Received (those of Moran to J. W. Powell).

Hayden Survey: Letters Received (correspondence of Moran with F. V. Hayden and James Stevenson; also, of Richard Watson Gilder with Hayden).

Powell Survey: Letters Received (correspondence of Moran with Powell and C. E. Dutton—Microcopy No. 156, Reels 1–10).

U.S. Interior Department. Records of the Office of the Secretary (Record Group 48).

Geological Survey: Miscellaneous Letters (Hayden).

U.S. National Park Service records (Record Group 79).

General File (July 31, 1923—August 18, 1924), Part 1.

U.S. State Department records (Record Group 59).

Passport Letters (Thomas Moran's passport application, June 5, 1866, with supporting statement concerning the naturalization of Thomas Moran, Sr.).

U.S. Library of Congress, Washington, D.C. MSS Division.

Thomas Moran to the Editor, *American Cyclopaedia*, December 17, 1874 (data for a biographical sketch).

U.S. National Park Service. Grand Teton National Park.

Moran drawings and sketches with dates and notations; fragment of diary, 1879 (original MS).

————. Jefferson National Expansion Memorial, St. Louis.

Moran drawings and sketches with dates and notations; scrapbook; notebooks and sketchbooks, autobiographical sketch (photostat), diary fragment, 1871 (original MS), and memorabilia. This collection, given by Ruth Moran to the National Park Service in 1935, was held until 1957 in the Museum at Yosemite National Park.

————. . . . Library, Washington, D.C.

Photographic reproductions of works by Thomas Moran in the Moran Collection of the U.S. National Park Service (Comp., Fritiof Fryxell), 2 vols.

A notebook register, partial and incomplete, of works by Moran (photostat).

————. Yellowstone National Park.

Moran drawings and sketches with dates and notations.

U.S. Smithsonian Institution. National Collection of Fine Arts.

Moran drawings and sketches with dates and notations; and "Random Records," MS autobiography of William H. Holmes.

Writer's files, New York.

Correspondence with various individuals and institutions concerning Thomas Moran and his work.

UNPUBLISHED MONOGRAPHS

Buck, Paul Herman. "The Evolution of the National Park System of the United States." M.A. thesis, Ohio State University, 1921.

Sachs, Samuel, II. "Thomas Moran—Drawings and Watercolors." M.A. thesis, Institute of Fine Arts, New York University, 1963.

Wilson, James B. "The Significance of Thomas Moran as an American Landscape Painter." Ph.D. dissertation, Ohio State University, 1955.

STATEMENTS BY THOMAS MORAN (exclusive of MS remarks, notes, diaries, memoranda, sketches, and letters contained in the collections listed above)

Moran, Thomas. "American Art and American Scenery," in *The Grand Canyon of Arizona*, by C. A. Higgins and others. Chicago, Passenger Department of Santa Fe Railroad, 1902.

————. Interview granted to Gussie Packard Dubois, "Thomas Moran Knows Nature and Paints It," *Pasadena Star-News*, March 11, 1916, p. 6.

————. "A Journey to the Devil's Tower in Wyoming" (Artists' Adventure Series), *Century*, Vol. XLVII, No. 3 (January, 1894), 450–55.

————. "Knowledge as a Prime Requisite in Art," *Brush and Pencil*, Vol. XII, No. 1 (April, 1903), 14–16.

————. Letter to a Mr. Cowan, Newark, October 21, 1875, in *Kennedy Quarterly*, Vol. III, No. 2 (October, 1962), 73.

————. Letter to Hon. T. O. Howe, chairman, Joint Committee on Library, Washington, January 18, 1878. Printed leaflet concerning *Ponce de León in Florida, 1512*. N.p., n.d.

————. Letter to C. Klackner, May, 1888, with description of etching, in *"The Gate of Venice," Etched by Thomas Moran, N.A.* Pamphlet. New York [Christian Klackner, 1888?].

————. "A New World," Appendix II: "The Grand Cañon" in Charles L. Lummis, *Mesa, Cañon and Pueblo*. New York and London, Century Co., 1925 (pp. 504–505).

————. "Plea for a National Art Gallery," *Brush and Pencil*, Vol. XII, No. 3 (June, 1903), 172–75.

————. Statements quoted by George W. Sheldon, *American Painters*. New York, D. Appleton & Co., 1879 (pp. 123–27).

BOOKS AND PAMPHLETS

American Artists and Their Works. 2 vols. Boston, S. W. Walker & Co. [1889].

American Etchings. Boston, Estes and Lauriat, 1886. A collection of twenty original etchings by Moran and others; descriptive texts by S. R. Koehler and others.

Armitage, Merle. *Operations Santa Fé: Atchison, Topeka and Santa Fé Railway System.* New York, Duell, Sloan & Pearce [1948].

Bancroft, H. H. *The Book of the Fair:* . . . *the Columbian Exposition at Chicago in 1893.* 2 vols. Chicago and San Francisco, Bancroft Co., 1895.

Barker, Virgil. *American Painting: History and Interpretation.* New York, Macmillan Co., 1950.

————. *A Critical Introduction to American Painting.* New York, W. E. Rudge for the Whitney Museum of American Art, 1931.

Barnes, Will C. *Arizona Place Names.* (University of Arizona *Bulletin* VI, No. 1, January 1, 1935.) Tucson, University of Arizona, 1935.

Bartlett, Richard A. *Great Surveys of the American West.* Norman, University of Oklahoma Press, 1962.

Beall, Merrill D. *The Story of Man in Yellowstone.* Caldwell, Id., Caxton Printers, 1949.

Benjamin, S. G. W. *Art in America: A Critical and Historical Sketch.* New York, Harper Bros., 1880.

————. *Our American Artists.* Boston, D. Lothrop & Co. [1879].

Bennett, Whitman. *A Practical Guide to American 19th Century Color Plate Books.* New York, Bennett Book Studios, 1949.

[Benson, Frances M., and others]. *Essays on American Art and Artists.* Temple Court, New York, Eastern Art League, 1896.

Berger, John A. *Fernand Lungren.* Santa Barbara, Calif., Schauer Press, 1936.

Bliss, Douglas Percy. *A History of Wood-Engraving.* New York, E. P. Dutton & Co., 1928.

Born, Wolfgang. *American Landscape Painting: An Interpretation.* New Haven, Yale University Press, 1948.

Brayer, Herbert O. *William Blackmore*. 2 vols. Denver, Branford-Robinson, 1949.

Brooks, Van Wyck. *John Sloan: A Painter's Life*. New York, E. P. Dutton & Co., 1955.

———. *Scenes and Portraits: Memories of Childhood*. New York, E. P. Dutton & Co., 1954.

Brown, Glenn. *History of the U. S. Capitol* (56 Cong., 1 sess., *Sen. Doc.* 60—Serial 3849), Vol. II. Washington, D.C., Government Printing Office, 1903.

Bryant, William Cullen, ed. *Picturesque America; or, The Land We Live In*. New York, D. Appleton, 1872 (Vol. I); 1874 (Vol. II).

Burroughs, Alan. *Limners and Likenesses: Three Centuries of American Painting*. Cambridge, Harvard University Press, 1936.

Caffin, Charles H. *American Masters of Painting*. New York, Doubleday, Page and Co., 1913.

———. *The Story of American Painting*. New York, Frederick A. Stokes Co., 1907.

Cahill, Holger, and Alfred H. Barr, Jr., eds. *Art in America: A Complete Survey*. New York, Reynal & Hitchcock, 1935.

Century Association, New York. *Reports . . . for the Year 1927*. New York, Century Association, 1927.

Chignell, Robert. *J. M. W. Turner, R.A*. London, Walter Scott Publishing Co., Ltd.; New York, C. Scribner's Sons, 1902.

Chittenden, Hiram M. *The Yellowstone National Park*. Cincinnati, Stewart & Kidd Co., 1912.

Clark, Eliot. *History of the National Academy of Design, 1825–1953*. New York, Columbia University Press, 1954.

Cooper Union for the Advancement of Science and Art. *Fifty-Eighth Annual Report*. New York, The De Vinne Press, 1917.

———. Museum for the Arts of Decoration. *Annual Meetings of the Council . . . "April Meeting, 1917."*

Cramton, Louis C. . . . *Early History of Yellowstone National Park*. Washington, D.C., Government Printing Office, 1932.

Darrah, William Culp. *Powell of the Colorado*. Princeton, Princeton University Press, 1951.

Dellenbaugh, Frederick S. *A Canyon Voyage*. New York and London, G. P. Putnam's Sons, 1908.

——. *The Romance of the Colorado River*. New York and London, G. P. Putnam's Sons, 1902.

Dorra, Henri. *The American Muse*. New York, Viking Press, 1961.

Dutton, Clarence E. *Tertiary History of the Grand Canyon District* (with Atlas) (48 Cong., 2 sess., *House Misc. Doc.* 35—Serials 2320–2321), Washington, D.C., Government Printing Office, 1882.

Fairman, Charles E. . . . *Art and Artists of the Capitol of the United States of America* (69 Cong., 1 sess., *Sen. Doc.* 95—Serial 8547) Washington, D.C., Government Printing Office, 1927.

Federal Writers' Project. *New York City Guide*. New York, Random House, 1939.

Fergusson, Erna. *New Mexico: A Pageant of Three Peoples*. New York, Alfred A. Knopf, 1951.

Flexner, James Thomas. *That Wilder Image: The Painting of America's Native School of Painting from Thomas Cole to Winslow Homer*. Boston, Little, Brown, 1962.

Foster, J. W., and Josiah D. Whitney. *Report on the Geology of the Lake Superior Land District*, Part I (Washington, D.C., Government Printing Office, 1850); Part II (Washington, D.C., Government Printing Office, 1851).

Freeley, Edwin T. *Philadelphia and Its Manufactures*. Philadelphia, Edward Young, 1858.

Fryxell, Fritiof, ed. *Thomas Moran: Explorer in Search of Beauty*. East Hampton, N. Y., East Hampton Free Library, 1958.

Gallatin, Albert. *The Pursuit of Happiness*. New York [Privately printed], 1950.

Gardner, Albert Ten Eyck. *Winslow Homer*. New York, Clarkson Potter, 1961.

Gilder, Richard Watson. *Letters of* . . . , edited by Rosamond Gilder. Boston and New York, Houghton Mifflin Co., 1916.

Goodrich, Lloyd. *A Century of American Landscape Painting, 1800–1900*. New York, Whitney Museum of American Art, 1938.

———. *Thomas Eakins: His Life and Work*. New York, Whitney Museum of American Art, 1933.

Hamerton, Philip Gilbert. *The Life of J. M. W. Turner, R.A.* Boston, Roberts Bros., 1882.

Hamilton, Sinclair. *Early American Book Illustrations and Wood Engravings, 1670–1870*. Princeton, Princeton University Press, 1958.

Hartmann, Sadakichi. *A History of American Art*. 2 vols. Boston, L. C. Page, 1902.

Hayden, F. V. *Annual Report of the U.S. Geological Survey of the Territories . . . 1874*. Washington, D.C., Government Printing Office, 1875.

———. *Preliminary Report of the United States Geological Survey of Montana and Adjacent Territories*. Washington, D.C., Government Printing Office, 1872.

———. *The Yellowstone National Park and the Mountain Regions of Portions of Idaho, Nevada, Colorado, and Utah*. Boston, L. Prang & Co., 1876.

Higgins, C. A., and others. *The Grand Canyon of Arizona* (pamphlet). Chicago, Passenger Department of Santa Fe Railroad, 1902.

Hitchcock, Ripley. *Etching in America*. New York, White, Stokes & Allen, 1886.

Huth, Hans. *Nature and the American*. Berkeley and Los Angeles, University of California Press, 1957.

Ingersoll, Ernest. *The Crest of the Continent*. Chicago, R. R. Donnelly & Sons, 1885.

———. *Knocking Round the Rockies*. New York, Harper & Bros., 1883.

Isham, Samuel. *The History of American Painting*. New York, Macmillan Co., 1905.

Jackman, Rella Evelyn. *American Arts*. Chicago, Rand McNally & Co., 1940.

Jackson, Clarence S. *Quest of the Snowy Cross*. Denver, University of Denver Press [1952].

Jackson, William H. *Picture Maker of the Old West*. Text by Clarence S. Jackson. New York, C. Scribner's Sons, 1947.

———. *The Pioneer Photographer*. In collaboration with Howard R. Driggs. Yonkers-on-Hudson, World Book Co., 1929.

———. *Time Exposure*. New York, G. P. Putnam's Sons, 1940.

James, George Wharton. *The Grand Canyon of Arizona*. Boston, Little, Brown & Co., 1910.

———. *In & Around the Grand Canyon*. Boston, Little, Brown & Co., 1900.

King, Edward. *The Great South*. Hartford, American Book Co., 1875.

Koehler, S. R. *American Art*. New York, London, Paris, and Melbourne, Cassell & Co., Ltd., 1886.

———. *Etching*. New York, Cassell & Co., 1885.

———. *Original Etchings by American Artists*. New York and London, Cassell and Co., Ltd., 1883.

LaFollette, Suzanne. *Art in America*. New York and London, Harper & Bros., 1929.

Larkin, Oliver W. *Art and Life in America*. New York, Rinehart & Co., 1949.

Linton, William J. *The History of Wood-Engraving in America*. Boston, Estes and Lauriat, 1882.

Low, Will H. A. *A Painter's Progress*. New York, C. Scribner's Sons, 1910.

Lummis, Charles F. *A Bronco Pegasus*. Boston and New York, Houghton Mifflin Co., 1928.

———. *Mesa, Cañon and Pueblo*. New York & London, Century Co., 1925.

McCracken, Harold. *Portrait of the Old West*. New York, McGraw-Hill, 1952.

Maidstone Club, East Hampton, N. Y. *Fifty Years of the Maidstone Club, 1891–1941*. East Hampton, The Maidstone Club, 1941.

Marshall, James L. *Santa Fé: The Railroad That Built an Empire*. New York, Random House, 1945.

Mather, Frank Jewett, Jr., Charles Rufus Morey, and William

James Henderson. *The American Spirit in Art* (Vol. XII in *Pageant of America*). New Haven, Yale University Press, 1927.

Matthiessen, F. O. *American Renaissance.* New York, Oxford University Press, 1941.

Monaghan, Jay, ed., and Clarence P. Hornung, art dir. *The Book of the American West.* New York, Julian Messner, Inc., 1963.

Montgomery, Walter, ed. *American Art and American Art Collections.* 2 vols. Boston, E. W. Walker & Co., 1889.

Moran, Edward. *Land and Sea.* [Philadelphia, H. B. Ashmead, 188–?].

Mott, Frank Luther. *A History of American Magazines.* 4 vols. Cambridge, Harvard University Press, 1938–57.

Muir, John, ed. *Picturesque California.* 2 vols. New York and San Francisco, J. Dewing & Co., 1888.

Mumey, Nolie. *The Teton Mountains.* Denver, Artcraft Press, 1947.

Murphy, Thomas D. *Seven Wonderlands of the American West.* Boston, L. C. Page, 1925.

Muther, Richard. *The History of Modern Painting.* Rev. ed. 4 vols. London, J. M. Dent & Co.; New York, E. P. Dutton & Co., 1907.

Neuhaus, Eugen. *The History & Ideals of American Art.* Stanford, Calif., Stanford University Press, 1931.

———. *William Keith, the Man and the Artist.* Berkeley, University of California Press, 1938.

———. *World of Art.* New York, Harcourt, Brace and Co., 1936.

New York Etching Club. *Twenty Original Etchings.* Introduction and description of plates by S. R. Koehler. New York and London, Cassell and Co., Ltd., 1885.

Overton, Jacqueline M. *Long Island's Story.* Garden City, N. Y., Doubleday, Doran & Co., 1929.

Pangborn, J. G. *The New Rocky Mountain Tourist.* Chicago, Knight and Leonard, 1878.

———. *Picturesque B. and O., Historical and Descriptive.* Chicago, Knight and Leonard, 1882.

Peters, Harry T. *America on Stone . . . a Chronicle of American Lithography.* Garden City, N. Y., Doubleday, Doran & Co., 1931.

Piper, John. *British Romantic Artists*. London, Collins, 1946.

Powell, John Wesley. *Canyons of the Colorado*. Meadville, Pa., Flood & Vincent, 1895.

———. *The Exploration of the Colorado River*. Ed. by Wallace Stegner. Chicago, University of Chicago Press, 1957.

———. *Exploration of the Colorado River of the West and Its Tributaries*. Washington, D.C., Government Printing Office, 1875. (Also as 43 Cong., 1 sess., *House Misc. Doc.* 300—Serial 1622.)

———. *Report of Special Commissioners on the Condition of the Ute Indians of Utah; the Paiutes of Utah, Northern Arizona. . . .* In collaboration with G. W. Ingalls. Washington, D.C., Government Printing Office, 1874.

———. *. . . . Report on the Survey of the Colorado of the West*. Dated April 30, 1874. (43 Cong., 1 sess., *House Misc. Doc.* 265— Serial 1621.) Washington, D.C., Government Printing Office, 1874.

Raynolds, William F. *Report on the Exploration of the Yellowstone and the Country Drained by That River*. (40 Cong., 2 sess., *Sen. Exec. Doc.* 77—Serial 1317.) Washington, D.C., Government Printing Office, 1868.

Ransome, Arthur. *Oscar Wilde*. New York, Mitchell Kennerley, 1913.

Rattray, Jeannette Edwards. *East Hampton History, Including Genealogies of Early Families*. East Hampton, N.Y. [No publisher cited], 1953.

———. *East Hampton Literary Group*. Undated pamphlet.

———. *Three Centuries in East Hampton*. [East Hampton, N.Y.], East Hampton Star Press, [1937].

Remington, Frederic. *Pony Tracks*. New York, Harper & Bros., 1895.

Richardson, Edgar P. *American Romantic Painting*. New York, E. Weyhe [1944].

———. *Painting in America*. New York, Thomas Y. Crowell Co., 1956.

Richardson, James. *Wonders of the Yellowstone*. New York, Scribner, Armstrong and Co., 1873.

Rogers, W. A. *A World Worth While: A Record of 'Auld Acquaintance.'* New York and London, Harper & Bros., 1922.

Ruskin, John. *The Art of England*. Lectures given in Oxford. Sunnyside, Orpington (Kent), George Allen, 1884.

———. *Modern Painters*. 5 vols. J. Wiley, 1860–62.

Saint Gaudens, Homer. *The American Artist and His Times*. New York, Dodd, Mead and Co., 1941.

Sartain, John. *The Reminiscences of a Very Old Man, 1808–1897*. New York, D. Appleton and Co., 1899.

Scholes, James Christopher. *History of Bolton*. Ed. and completed by William Pimblett. Bolton, England, *Bolton Daily Chronicle*, 1892.

Seabury, Samuel. *Two Hundred and Seventy-Five Years of East Hampton, Long Island, New York; a Historical Sketch*. East Hampton, N. Y., "Published for the community," 1926.

Shankland, Robert. *Steve Mather of the National Parks*. New York, Alfred A. Knopf, 1951.

Sheldon, George W. *American Painters*. New York, D. Appleton and Co., 1879.

———. *Hours with Art and Artists*. New York, D. Appleton and Co., 1882.

———. *Recent Ideals of American Art*. 2 vols. New York and London, D. Appleton and Co., 1890.

Shelton, William Henry. *The Salmagundi Club . . . a History*. Boston and New York, Houghton Mifflin Co., 1918.

Sherman, Frederic F. *Landscape and Figure Painters of America*. New York, Privately printed, 1917.

Singer, H. W. *Die Moderne Graphik*. Leipzig, E. A. Seemann, 1912.

Sipes, William B. *The Pennsylvania Railroad*. Philadelphia, Passenger Department of Pennsylvania Railroad Co., 1875.

Slatkin, Charles E., and Regina Shoolman. *Treasury of American Drawings*. New York, Oxford University Press, 1947.

Stegner, Wallace E. *Beyond the Hundredth Meridian: John Wesley Powell and the Second Opening of the West*. Boston, Houghton Mifflin Co., 1954.

Stevens, Nina Spalding. *A Little Journey from New York to the*

Grand Canyon of Arizona by Five Artists and Their Friends, November Nineteen Ten. Pamphlet printed for private distribution.

———. *A Man & a Dream: The Book of George W. Stevens* [Hollywood, Calif., Hollycrofters, 1940].

Stevens, William Oliver. *Discovering Long Island.* New York, Dodd, Mead & Co., 1939.

Stites, Raymond S. *The Arts and Man.* New York and London, McGraw-Hill, 1940.

Stone, Julius F. *Canyon Country.* New York and London, G. P. Putnam's Sons, 1932.

Strahan, Edward [Earl Shinn]. *The Art Treasures of America.* Philadelphia, G. Barrie, 1880.

———. *The Masterpieces of the International Exhibition, 1876.* Philadelphia, Gebbis & Barrie, 1876.

Sutro, Theodore. *Purchase of Historical Paintings . . . Feb. 22, 1910. Statement of Mr. T. Sutro of New York.* Washington, D.C. [Government Printing Office], 1910.

———. *Thirteen Chapters of American History Represented by the Edward Moran Series of Thirteen Historical Marine Paintings.* New York, Privately printed, 1905.

Sweet, Frederick A. *The Hudson River School and the Early American Landscape Tradition.* Chicago, Art Institute of Chicago, 1945.

Taft, Robert. *Artists and Illustrators of the Old West: 1850–1900.* New York and London, C. Scribner's Sons, 1953.

———. *Photography and the American Scene, A Social History, 1839–1889.* New York, Macmillan Co., 1938.

———. *The Pictorial Record of the Old West.* Reprinted from the *Kansas Historical Quarterly.* Topeka, Kansas Historical Society, 1946.

Taylor, Mrs. H. J. (Rose). *Yosemite Indians and Other Sketches.* San Francisco, Johnck and Seeger, 1936.

Tebell, John. *George Horace Lorimer and the Saturday Evening Post.* Garden City, N.Y., Doubleday & Co., 1948.

Tilden, Freeman. *The National Parks.* New York, Alfred A. Knopf, 1954.

Townsend, J. Benjamin. *100: The Buffalo Fine Arts Academy, 1862–1962*. Buffalo, N.Y., The Buffalo Fine Arts Academy, 1962.

Tevelyan, G. M. *English Social History*. London, New York, and Toronto, Longmans, Green and Co., 1942.

Trumble, Alfred. *Representative Works of Contemporary American Artists*. New York, C. Scribner's Sons, 1887.

———. *Thomas Moran, N.A.; Mary Nimmo Moran, S.P.E.* Pamphlet. New York, 1889.

Tuckerman, Henry T. *Book of the Artists: American Artist Life*. New York, G. P. Putnam's Sons, 1867.

U.S. National Park Service. *Proceedings of the National Parks Conference Held at Washington, January 2 and 6, 1917*. Washington, Government Printing Office, 1917.

Van Dyke, John C. *American Painting and Its Tradition*. New York, C. Scribner's Sons, 1919.

———. *The Grand Canyon of the Colorado*. New York, C. Scribner's Sons, 1920.

Van Rensselaer, M. G. *American Etchers*. New York, F. Keppel & Co., 1886.

Walker, John, and Macgill James. *Great American Paintings, 1729–1924*. London, New York, and Toronto, Oxford University Press, 1943.

[Walters], Clara E. Clement, and Laurence Hutton. *Artists of the 19th Century*. Boston, Tichnor & Co., 1880.

Weitenkampf, Frank. *American Graphic Art*. New York, Henry Holt & Co., 1924.

———. *How to Appreciate Prints*. New York, C. Scribner's Sons, 1921.

———. *Manhattan Kaleidoscope*. New York and London, C. Scribner's Sons, 1947.

Williams, Henry T., ed. *The Pacific Tourist*. New York, H. T. Williams, 1876.

Yellowstone National Park. Brochure, with opinions concerning the Hayden-Moran portfolio-book *The Yellowstone National Park* . . . published by L. Prang & Co. [Boston, Prang, 1876?].

MAGAZINE ARTICLES

"The Academy of Design," *Scribner's Monthly*, Vol. X, No. 2 (June, 1875), 251–52.

"American Landscapes: the Discovery of Nature, Thomas Moran (1837–1926)," *Kennedy Quarterly*, Vol. IV, No. 3. (April, 1964), 124–25.

"American Painters—Peter Moran," *Art Journal* (London), n.s., Vol. XVIII (February, 1879), 26–27.

"Art" (concerning *The Chasm of the Colorado*), *Appleton's Journal*, Vol. XI, No. 271 (May 30, 1874), 700.

"Art," *Public Opinion*, Vol. II, No. 42 (January 29, 1887), 341–42.

"Art at the San Diego Exposition," *American Magazine of Art*, Vol. XXVIII, No. 10 (October, 1935), 595.

"Art Gallery in New Paramount Theatre," *American Art News*, Vol. XXV, No. 13 (January 1, 1927), 7.

"Art Notes," *Critic*, Vol. VIII, No. 113 (February 27, 1886), 108.

Baur, John I. H. "A Romantic Impressionist: James Hamilton," Brooklyn Museum *Bulletin*, Vol. XII, No. 3 (Spring, 1951), 1–9.

Benjamin, S. G. W. "Fifty Years of American Art, 1828–1878," *Harper's Magazine*, Vol. LIX, No. 352 (September, 1879), 481–96.

———. "A Pioneer of the Palette: Thomas Moran," *Magazine of Art*, Vol. V (February, 1882), 89–93.

———. "Present Tendencies of American Art," *Harper's Magazine*, Vol. LVIII, No. 346 (March, 1879), 481–496.

———. "Tendencies of Art in America," *American Art Review*, Vol. I, Part 1 (1880), 105–10; 196–202.

Benson, Frances M. "The Moran Family," *Quarterly Illustrator*, Vol. I, No. 2 (April–June, 1893), 67–84.

Bourke, John G. "Bourke on the Southwest," ed. Lansing B. Bloom, *New Mexico Historical Review*, Vol. X, No. 4 (October, 1935), 271–322.

Breuning, Margaret. "Thomas Moran," *Magazine of Art*, Vol. XXX, No. 2 (February, 1937), 115.

"Brilliant Western American Color Plate Book," *Month at Good-*

speed's Book Shop, Vol. XXVII, Nos. 4–5 (January–February, 1956), 87–88.

Bromley, Isaac H. "The Wonders of the West—I: The Big Trees and the Yosemite," *Scribner's Monthly,* Vol. III, No. 3 (January, 1872), 261–77.

Buckley, Edmund. "Thomas Moran: A Splendid Example of American Achievement in Art," *Fine Arts Journal,* Vol. XX, No. 1 (January, 1909), 9–17.

Buek, Gustave H. "Thomas Moran," *American Magazine,* Vol. LXXV, No. 3 (January, 1913), 30–32.

———. "Thomas Moran, N.A., the Grand Old Man of American Art," *Mentor,* Vol. XII, No. 7 (August, 1924), 29–37. Reprinted in part in Fritiof Fryxell, ed., *Thomas Moran: Explorer in Search of Beauty,* 63–71.

Burroughs, Louise. "The Moses Tanenbaum Bequest," *Bulletin* of the Metropolitan Museum of Art, Vol. XXIV, No. 6 (June, 1939), 137–38.

Butler, Howard R. "Thomas Moran, N.A.—an Appreciation," *American Magazine* of Art, Vol. XVII, No. 11 (November, 1926), 558–60.

Caffin, Charles H. "The Seventy-Sixth Annual Exhibition of the National Academy of Design," *Harper's Weekly,* Vol. XLV, No. 2300 (January, 19, 1901), 74.

Carter, S. N. "First Exhibition of the American Art Association [Society of American Artists]," *Art Journal* (New York), n.s. IV (April, 1878), 124–26.

Cary, Elizabeth Luther. "The Morning of American Etching," *Parnassus,* Vol. IV, No. 3 (March, 1932), 5–7.

Champney, Lizzie W. "The Summer Haunts of American Artists," *Century,* Vol. XXX, No. 6 (October, 1885), 845–60.

"The Chasm of the Colorado," *Scribner's Monthly,* Vol. VIII, No. 3 (July, 1874), 373–74.

Clark, Eliot. "Studies by American Masters at Cooper Union," *Art in America,* Vol. XV, No. 4 (June, 1927), 180–88.

———. "The Hudson River School of Painters," *Scribner's Magazine,* Vol. LXV, No. 4 (October, 1918), 509–12.

Coleman, Hugh W. "Passing of a Famous Artist, Edward Moran," *Brush and Pencil*, Vol. VIII, No. 4 (July, 1901), 188–92.

Comstock, Helen. "In Recognition of Thomas Moran," *Connoisseur*, Vol. XCIX, No. 425 (January, 1937), 38–39.

[Cook, Clarence]. "Art," *Atlantic Monthly*, Vol. XXX, No. 179 (August, 1872), 246–47; also Vol. XXXIV, No. 203 (September, 1874), 375–77.

[———]. "Art at the Capitol," *Scribner's Monthly*, Vol. V, No. 4 (February, 1873), 493–500.

Critic, Vol. X, No. 164 (February 19, 1887), 92.

———. Vol. XLVI, No. 1 (January, 1905), 10.

Darrah, William C. "John K. Hillers," *Utah Historical Quarterly*, Vol. XVII (1949), 495–97.

"The Dean of American Painters," *Current Opinion*, Vol. LXXVII (October, 1924), 447, 480.

De Montaigne, A. "A Pen-Picture of Mary Nimmo Moran," *Art Stationer*, July, 1888. Reprinted with corrections in Fryxell, ed., *Thomas Moran: Explorer in Search of Beauty*, 41–48.

Dodge, Julia M. "An Island of the Sea," *Scribner's Monthly*, Vol. XIV, No. 5 (September, 1877), 652–61.

Draper, Benjamin Poff. "Thomas Moran, Painter, Adventurer, and Pioneer," *Art in America*, Vol. XXIX, No. 2 (April, 1941), 82–87.

"Etchings at Klackner's," *Critic*, Vol. XIV, No. 272 (March 16, 1889), 135.

Evans, Raymond. "The McGuffey Readers," *Magazine of Art*, Vol. XLI, No. 7 (November, 1948), 274–75.

Everett, Morris T. "The Etchings of Mary Nimmo Moran," *Brush and Pencil*, Vol. VIII, No. 1 (April, 1901), 3–16.

"Exhibition of Paintings by the Society of Men Who Paint the Far West at the Albright Art Gallery," *Academy Notes*, Vol. XI, No. 2 (April, 1916), 62–63.

F., R. "Moran and the Changing Western Landscape," *Art News*, Vol. XXV, No. 17 (January, 23, 1937), 20.

"The Father of the National Parks—Thomas 'Yellowstone' Moran," *Los Angeles Saturday Night*, Vol. XLIV, No. 16 (January, 9, 1937), 5.

"Finding Moran," *Art Digest*, Vol. II, No. 19 (August, 1928), 6.

"Fine Arts," *Nation*, Vol. XXIV, No. 607 (February 15, 1877), 107.

"A Foggy Morning in New York Bay," *Aldine*, Vol. VIII, No. 3 (March, 1876), 83.

Foote, Mary Hallock. "A Diligence Journey in Mexico," *Century*, Vol. XXIII, No. 1 (November, 1881), 1–14; No. 3 (January, 1882), 321–33.

Francis, Henry S. "The Dorothy Burnham Everett Memorial Collection," *Bulletin* of the Cleveland Museum of Art, Vol. XXV (June, 1938), 124–30.

Fryxell, Fritiof. "The Mount of the Holy Cross," *Trail and Timberline*, No. 183 (January, 1934), 3–9, 14.

————."Thomas Moran: An Appreciation," Sierra Club *Bulletin*, Vol. XIX, No. 3 (June, 1934), 56–57.

————. "The Thomas Moran Collection of the National Parks," *Yosemite Nature Notes*, Vol. XV, No. 8 (August, 1936), 57–60.

————. "Thomas Moran's Journey to the Mount of the Holy Cross in 1874," *Trail and Timberline*, No. 203 (September, 1935), 103–105.

————. "Thomas Moran's Journey to the Tetons in 1879," Augustana Historical Society *Publications*, No. 2 (1932), 3–12. Reprinted in *Annals of Wyoming*, Vol. XV, No. 1 (January, 1943), 71–84.

Gerdts, William H. "The Painting of Thomas Moran: Sources and Style," *Antiques*, Vol. LXXXV, No. 2 (February, 1964), 202–205.

————. "People and Places of New Jersey [section on Mary Nimmo Moran]," *Museum*, n.s. XV, Nos. 2–3 (Spring–Summer, 1963), 24.

"The Geysers of the Yellowstone," *Harper's Weekly*, Vol. XVI, No. 796 (March 30, 1872), 243.

Gilder, Richard Watson. "The Old Cabinet," *Scribner's Monthly*, Vol. IV, No. 2 (June, 1872), 242.

Gillespie, Harriet Sisson. "Thomas Moran, Dean of American Painters," *International Studio*, Vol. LXXIX, No. 327 (August, 1924), 361–66.

"Glories of Southern Utah," *Aldine*, Vol. VIII, No. 1 (January, 1876), 34–35.

Godfrey, Elizabeth H. "Thumbnail Sketches of Yosemite Artists," *Yosemite Nature Notes*, Vol. XXIII, No. 7 (July, 1944), 64–68.

Hamp, Sidford. "Exploring the Yellowstone with Hayden, 1872: Diary of Sidforth Hamp," ed. Herbert O. Brayer, *Annals of Wyoming*, Vol. XIV, No. 4 (October, 1942), 253–98.

Hathaway, Calvin S. "An Introduction to the Collections of Drawings," *Chronicle* of the Museum for the Arts of Decoration of the Cooper Union, Vol. II, No. 4 (June, 1952), 95–121.

Hayden, Ferdinand V. "The Hot Springs and Geysers of the Yellowstone and Firehole Rivers," *American Journal of Science and Arts*, 3rd ser. III (February–March, 1872), 105–15; 161–76

——. "The Wonders of the West—II: More about the Yellowstone," *Scribner's Monthly*, Vol. III, No. 4 (February, 1872), 388–96.

"The Heritage of the National Academy," *Art News*, Vol. XL, No. 19 (January 15–31, 1942), 13–16.

Howell, J. V. "Ferdinand V. Hayden: Surveyor of the Yellowstone," *American Scene*, Vol. V, No. 1 (1963), 11–20.

"Hudson River School," *Life*, Vol. XIX, No. 11 (September 10, 1945), 82–87.

Huguenin, Dr. Charles A. "Thomas Moran, Painter, Etcher," *Long Island Forum*, Vol. XVII, No. 12 (December, 1954), 223–24, 233–34.

Huth, Hans. "The American and Nature," *Journal* of the Warburg and Courtauld Institutes, Vol. XIII, Nos. 1–2 (January–June, 1950), 101–49.

Huxley, Aldous. "Unpainted Landscapes," *Encounter*, Vol. XIX, No. 4 (October, 1962), 41–47.

"Idaho Scenery," *Aldine*, Vol. VIII, No. 6 (June, 1876), 194–96.

Isham, Samuel. "American Landscape Painters," *Mentor*, Vol. I, No. 26 (August 11, 1913), 1–11, and Plate IV.

"Isles of the Amazon," *Aldine*, Vol. VIII, No. 7 (July, 1876), 223.

J., A. P. "River Scenery of Pennsylvania," *Aldine*, Vol. IX, No. 5 (1878), 156–61.

Jackson, William H. ". . . With Moran in the Yellowstone," *Appalachia*, Vol. XXI, No. 82 (December, 1936), 149–58. Reprinted in Fryxell, ed., *Thomas Moran: Explorer in Search of Beauty*, 49–61.

"James Hamilton, N.A., 1819–1878," *Old Print Shop Portfolio*, Vol. XI, No. 10 (June–July, 1952), 219–20.

Jayne, Horace H. F. "Moran and His 'Florida Landscape,'" *Pharos* (Summer, 1964), no pagination.

"The Juniata," *Aldine*, Vol. VIII, No. 8 (August, 1876), 264–65, 266.

Kellogg, Louise Phelps. "Wisconsin at the Centennial," *Wisconsin Magazine of History*, Vol. X, No. 1 (September, 1926), 3–16.

Koehler, S. R. "The Works of the American Etchers: Mrs. M. Nimmo Moran," *American Art Review*, Vol. II, Part 1 (1881), 183.

———. "The Works of the American Etchers: Peter Moran," *American Art Review*, Vol. I, Part 1 (1880), 149–51; II, Part 2 (1881), 164.

———. "The Works of the American Etchers: Thomas Moran," *American Art Review*, Vol. I, Part 1 (1880), 151; II, Part 2 (1881), 104.

Kurtzworth, Harry Muir. "Art Leads to Parks," *Los Angeles Saturday Night*, Vol. XLIV, No. 33 (May 8, 1937), 2.

L., E. T. "The New York Etching Club," *Art Journal* (New York), n.s. VI (June, 1880), 186–87.

L., J. W. "Moran: An American in the British Tradition," *Art News*, Vol. XXXVIII, No. 37 (June 15, 1940), 12, 15.

Ladegast, Richard. "Thomas Moran," *Truth*, Vol. XIX, No. 9 (September, 1900), 209–12.

"Lake George," *Aldine*, Vol. VII, No. 4 (April, 1874), 73–75

Langford, Nathaniel P. "The Ascent of Mount Hayden," *Scribner's Monthly*, Vol. VI, No. 2 (June, 1873), 129–57.

———. "The Wonders of the Yellowstone," *Scribner's Monthly*, Vol. II, Nos. 1 and 2 (May and June, 1871), 1–17 and 113–28.

"Los Angeles: Moran Centenary," *Art News*, Vol. XXXV, No. 35 (May 29, 1937), 18.

Lummis, Charles F. "The Artists' Paradise," (I and II), *Out West*, Vol. XXVIII, No. 6 (June, 1908), 437–51; Vol. XXIX, No. 2 (September, 1908), 173–91.

M., G. F. "Thomas Moran's Great Painting, 'Ponce de Leon,' " *Art News*, Vol. XXI, No. 24 (March 24, 1923), 1, 12.

Mastai, M.L D'Otrange. "Landscapists of the South Fork: I," *Connoisseur*, Vol. CLII, No. 618 (August, 1963), 281–84.

M[echlin], L[eila]. "Contemporary American Landscape Painting," *International Studio*, Vol. XXXIX, No. 153 (November, 1909), 3–14.

"Mr. Pratt Presents Moran's Masterpiece to the National Gallery," *Art Digest*, Vol. II, No. 20 (September, 1928), 1.

Moran, John. "Artist-Life in New York," *Art Journal* (New York), n.s. VI (February, April, 1880), 57–60; 121–24.

Moran, Ruth B. "Thomas Moran: An Impression," *Mentor*, Vol. XII, No. 7 (August, 1924), 38–52. Reprinted without plates in Fryxell, ed., *Thomas Moran: Explorer in Search of Beauty*, 37–40; also with revisions and "Further Notes" in *Yosemite Nature Notes*, Vol. XV No. 8 (August, 1936), 62–64.

———. "The Real Life of Thomas Moran" (Letter to the Editor, November 9, 1926), *American Magazine of Art*, Vol. XVII, No. 12 (December, 1926), 645–46.

"Moran, Thomas, N.A." (Obit.), *American Art Annual*, Vol. XXIII (1926), 337.

"Moran in Washington," *Art Digest*, Vol. XI, No. 9 (February 1, 1937), 17.

"Moran Pictures Draw Crowds to Government Gallery," *Newsweek*, Vol. VIII, No. 7 (August 15, 1936), 21.

"Moran's 'Mountain of the Holy Cross,' " *Aldine*, Vol. VII, No. 19 (July, 1875), 379–80.

"Moran's 'Mountain of the Holy Cross,' " *Scribner's Monthly*, Vol. X, No. 2 (June, 1875), 252–53.

Morris, Harrison S. "Philadelphia's Contribution to American Art," *Century*, Vol. LXIX, No. 5 (March, 1905), 714–33.

Morton, Frederick W. "Thomas Moran, Painter-Etcher," *Brush and Pencil*, Vol. VII, No. 1 (October, 1900), 1–16.

"New Britain Enriches Its Collection," *Art Digest*, Vol. XVIII, No. 20 (September 1, 1944), 6.

"A New Departure in American Art," *Harper's Magazine*, Vol. LVI, No. 336 (March, 1878), 764–68.

"Notes: a Landscape by Turner [*Conway Castle*]," *Art Journal* (New York), n.s. V (1879), 64.

"Notes: The American Art Association [Society of American Artists]," *Art Journal* (New York), n.s. IV (February, 1878), 94–95.

"Painter of the Western Scene," *Antiques*, Vol. XXXI, No. 3 (March, 1937), 136.

Paris, W. Francklin. "The National Academy of Design," *Hall of American Artists, New York University*, Vol. VII (1952), 13–23.

Parker, Robert Allerton. "The Water-Colors of Thomas Moran," *International Studio*, Vol. LXXXVI, No. 358 (March, 1927), 65–72. Excerpts reprinted in Fryxell, ed., *Thomas Moran: Explorer in Search of Beauty*, 77–84.

Pattison, James W. "Buek Collection of Water Colors—Historic, Artistic, Complete," *Fine Arts Journal*, Vol. XXIV, No. 6 (June, 1911), 353–77.

———. "Some Artists Represent, Some Interpret Nature," *Fine Arts Journal*, Vol. XXIII, No. 6 (December, 1910), 351–66.

"Peter Moran (1841–1914)," *Kennedy Quarterly*, Vol. V, No. 3 (May, 1965), pp. 171–90.

"The Pictured Rocks of Lake Superior," *Aldine*, Vol. VI, No. 1 (January, 1873), 14–15.

"Pictures by Mr. Moran," *Critic*, Vol. XXX, No. 783 (February 20, 1897), 132.

Powell, John Wesley. "The Cañons of the Colorado," *Scribner's Monthly*, Vol. IX, Nos. 3–5 (January–March, 1875), 293–310, 394–409, 523–37.

———. "An Overland Trip to the Grand Cañon," *Scribner's Monthly*, Vol. X, No. 6 (October, 1875), 659–78.

P[roctor], C[harles] C. "Interpreters of the Western Scene from the Hudson River to the Rocky Mountains," *American Scene*, Vol. II, No. 3 (Fall, 1959), 6–7.

"Public Picks Moran's 'Lower Manhattan from Communipaw,' " *Art Digest*, Vol. XV, No. 4 (November 15, 1940), 17.

Raymond, Rossiter W. "The Heart of the Continent: The Hot Springs and Geysers of the Yellowstone Region," *Harper's Weekly*, Vol. XVII, No. 849 (April 5, 1873), 272–74.

Remington, Frederic. "Policing the Yellowstone," *Harper's Weekly*, Vol. XXXIX, No. 1986 (January 12, 1895), 35–38. Reprinted in *Pony Tracks*.

"Romantic Flow of the Hudson," *Art News*, Vol. XLIV, No. 2 (March 1–14, 1945), 11–12, 32.

S., W. H. "Thomas Moran on His 87th Birthday," *Osborne Bulletin*, January 12, 1924.

Sears, John V. "Art in Philadelphia," *Aldine*, Vol. VIII, No. 4 (April, 1876), 112–13; No. 9 (September, 1876), 283–84.

"A Scene in the Tropics," *Aldine*, Vol. IX, No. 8 (1879), 265.

"The Scenery of Southern Utah," *Aldine*, Vol. VII, No. 16 (April, 1875), 306–307.

"Scenes in Fairmount Park," *Art Journal* (New York), n.s. IV (January, 1878), 1–6.

Schuyler, Montgomery. "George Inness: The Man and His Work," *Forum*, Vol. XVIII (November, 1894), 301–13.

S[heldon], G. W. "American Painters—Edward Moran," *Art Journal* (New York), n.s. VI (September, 1880), 257–59.

[———]. "American Painters—Thomas Moran," *Art Journal* (New York) n.s. V (February, 1879), 41–43.

"Shop Talk [*In the Teton Range*, 1881]," *Antiques*, Vol. LXIII, No. 4 (April, 1953), 314.

Simpson, William H. "Thomas Moran—the Man," *Fine Arts Journal*, Vol. XX, No. 1 (January, 1909), 18–25.

"Sketches That Went to Congress," *American Scene*, Vol. I, No. 1 (Spring, 1958), 4–5.

[Smith, F. Hopkinson]. "The Tile Club at Play," *Scribner's Monthly*, Vol. XVII, No. 4 (February, 1879), 457–78.

Smith, Willis. "Thomas Moran, *Grand Teton Nature Notes*, Vol. III, No. 2 (1927), 15–17. Reprint of Moran's Diary of the Teton trip, 1879, pp. 17–21.

Spindler, Adaline B. "Isaac L. Williams, Artist and Portrait Painter," Lancaster County [Pennsylvania] Historical Society *Papers*, Vol. XVI, No. 9 (1912), 261–69.

Stedman, Edmund Clarence. "The Raymondskill," *Aldine*, Vol. V, No. 8 (August, 1872), 154–55.

Stevens, George W. "The Artistic Value of the Buek Collection," *Fine Arts Journal*, Vol. XXIV, No. 6 (June, 1911), 379–85.

Stevens, Nina Spalding. "A Pilgrimage to the Artist's Paradise," *Fine Arts Journal*, Vol. XXXIV, No. 2 (February, 1911), 105–13.

Steward, J. H. "Notes on Hillers' Photographs of the Paiute and Ute Indians Taken on the Powell Expedition of 1873 (with 31 Plates)," Smithsonian *Miscellaneous Collections* 98, No. 18 (1939), 1–23.

"A Storm in Utah," *Aldine*, Vol. VII, No. 9 (September, 1874), 175.

Sweet, Frederick A. "Painters of the Hudson River School," *Antiques*, Vol. XLVII, No. 3 (March, 1945), 158–61.

Teetor, Henry Dudley. "The Mountain of the Holy Cross: a Study of a Historical Painting," *Magazine of Western History*, Vol. XI, No. 1 (November, 1889), 3–8.

"Thomas Moran," *Aldine*, Vol. IX, No. 8 (1879), 265.

"Thomas Moran (1837–1926)," *Kennedy Quarterly*, Vol. III, No. 2 (October, 1962), 72–74.

"Thomas Moran (1837–1926)," *Kennedy Quarterly*, V, No. 3 (May, 1965), pp. 247–50.

"Thomas Moran: He Sold a Nation's Wonders to Its People," *Art Digest*, Vol. XI, No. 8 (January 15, 1937), 10.

"Thomas Moran: The Milch Galleries," *Art News*, Vol. XXV, No. 12 (December 25, 1926), 9.

"Thomas Moran's 'Grand Canyon of the Yellowstone,' " *Scribner's Monthly*, Vol. IV, No. 2 (June, 1872), 251–52.

"Thomas Moran's 'Mountain of the Holy Cross,' " *Aldine*, Vol. VII, No. 19 (July, 1875), 379–80.

"Thomas Moran's Water-Color Drawings," *Scribner's Monthly*, Vol. V, No. 3 (January, 1873), 394.

Thompson, A. H. "Diary of Almon Harris Thompson, Geographer,

Explorations of the Colorado River of the West and Its Tributaries, 1871–1875" (ed. Herbert E. Gregory), *Utah Historical Quarterly*, Vol. VII, Nos. 1–3 (January–July, 1939), 3–100.

"Utah Scenery," *Aldine*, Vol. VII, No. 1 (January, 1874), 14–15.

Van Rensselaer, M. G. "American Etchers," *Century*, Vol. XXV, No. 4 (February, 1883), 483–99.

"Views in Vermont," *Aldine*, Vol. VII, No. 6 (June, 1874), 115.

W., J. B. F. "The Society of American Artists," *Aldine*, Vol. IX, No. 9 (1879), 275–82.

"The Watering Place," *Aldine*, Vol. IX, No. 8 (1879), 242.

Weitenkampf, Frank. "American Scenic Prints," *International Studio*, Vol. LXXVII, No. 314 (July, 1923), 284–89.

———. "Some Women Etchers," *Scribner's Magazine*, Vol. XLVI, No. 6 (December, 1909), 731–39.

[———]. "A Thomas Moran Centenary," *Bulletin* of the New York Public Library, Vol. XLI, No. 2 (February, 1937), 127–28. Reprinted in Fryxell, ed., *Thomas Moran: Explorer in Search of Beauty*, 73–75.

White, C. A. "Ferdinand Vandiveer Hayden, 1839 [*sic*]–1887," *National Academy of Science Biographical Memoirs*, Vol. III (1893), 395–413.

Wilkins, Thurman. "Thomas Moran, 'Artist of the Yellowstone,' " *American Scene*, Vol. V, No. 1 (1963), 22–37, 57–58.

Wiswall, Mrs. E. A. "Art at the Capitol," *Aldine*, Vol. VII, No. 11 (1874), 212–13.

Wolf, Henry. "The Rise and Decline of Wood Engravings," *Academy Notes*, Vol. IV, Nos. 2–3 (July–August, 1908), 26–28, 42–45.

"The Yellowstone Landscape at Washington," *Nation*, Vol. XV, No. 375 (September 5, 1872), 157–58.

"Yellowstone Man," *Time*, Vol. XXIX, No. 3 (January 18, 1937), 45–46.

"The Yellowstone National Park . . . ," *American Journal of Science and Arts*, 3rd series, Vol. XIII (March, 1877), 229–30.

"The Yellowstone Park," *Harper's Weekly*, Vol. XXXII, No. 1392 (August 25, 1883), 535, 537.

SELECTED ENCYCLOPEDIAS

Appleton's Cyclopaedia of American Biography. New York, D. Appleton and Co., 1888. Contains composite sketch of Edward, Thomas, Mary N., Peter, Percy, and Leon Moran.

Dictionary of American Biography. New York, Charles Scribner's Sons, 1943. Contains sketches of Edward, Peter, and Thomas Moran, by William H. Downes.

National Cyclopaedia of American Biography. New York, James T. White Co., 1909.

New York Historical Society. *Dictionary of Artists in America, 1564–1860.* Comp. by George C. Groce and David H. Wallace. New Haven, Yale University Press, 1957.

MISCELLANEOUS CATALOGS

American Art Galleries, New York. *The Private Collection of Thomas B. Clarke of New York.* Exhibited . . . December 28, 1883, to January 12, 1884 [New York, American Art Galleries, 1883].

———. *The Private Art Collection of Thomas B. Clarke, I: Painting.* Descriptive notes by William A. Coffin. New York, American Art Galleries, 1899.

American Society of Painters in Water Color, New York. Catalogues of Exhibitions 1873–74 to 1901–1902.

Anderson Galleries, New York. *American Water Colors: The Collection Formed by the Late G. H. Buek.* Sale: November 4, 1927. New York, Anderson Galleries, 1927.

Biltmore Salon, Biltmore Hotel, Los Angeles. *Moran Memorial Exhibition.* September 27 to October 17, 1937.

Blake, William P. *Report of the U.S. Commissioners to the Paris Universal Exposition,* Vol. I, Washington, D. C., Government Printing Office, 1870.

Boston Museum of Fine Arts. *M. & M. Karolik Collection of American Water Colors & Drawings, 1800–1875.* Comp. by Henry P. Rossiter. Exhibition: October 18, 1962–January 6, 1963. 2 vols. Boston, Museum of Fine Arts, 1962.

Bowdoin College Museum of Art. *The Portrayal of the Negro in American Painting.* Brunswick, Me., Bowdoin College, 1964.

Buffalo Fine Arts Academy, Albright Art Gallery. *Catalogue of an Exhibition of Paintings by The Society of Men Who Paint the Far West.* February 9–February 27, 1916 [Buffalo, 1916].

———. *Catalogue of Paintings and Sculpture in the Permanent Collection.* Edited by Andrew C. Ritchie. Buffalo, N.Y., Fine Arts Academy, 1949.

California Pacific International Exposition, San Diego, 1935. *Illustrated Catalogue of the Official Art Exhibition.* San Diego, Frye & Smith, 1935.

California, University of, at Riverside. *Thomas Moran, 1837–1926.* Exhibition: April 17–June 17, 1963. Text by William H. Gerdts and others. Riverside, Calif., University of California, 1963.

Carnegie Institute, Department of Fine Arts, Pittsburgh. *Survey of American Painting.* October 24–December 15, 1940. Pittsburgh, Carnegie Institute, 1940.

Clinton Academy, East Hampton, N.Y. *Memorial Exhibition: Paintings and Etchings by Thomas Moran, N.A.* July 18–August 7, 1928.

Cooper Union . . . New York, Museum for the Arts of Decoration. *An Illustrated Survey of the Collections.* New York [Cooper Union], 1957.

Corcoran Gallery, Washington, D.C. *American Processional: 1492–1900.* Washington, D.C., Corcoran Gallery, 1950.

Denver Art League. *Catalogue of Pictures of Thomas Moran Exhibited under the Auspices of the Denver Art League.* Christmas, 1892.

Evansville Public Museum. *Homer and Moran.* February, 1948. Evansville, Ind., Evansville Public Museum, 1948.

Faulkner Memorial Art Gallery, Free Public Library, Santa Barbara, Calif. *Loan Exhibition: Paintings and Etchings by Thomas Moran.* Santa Barbara, Calif., Faulkner Memorial Art Gallery, 1937.

Heckscher Museum, Huntington, L.I., N.Y. *American Painting.* Huntington, N.Y., n.d.

———. *The Moran Family* (June 5–July 25, 1965).

Heckscher Park Art Museum, Huntington, Long Island. *Huntington Fine Arts Building.* Huntington, N.Y., n.d.

Jackson, William H. . . . *Descriptive Catalogue of the Photographs of the United States Geological Survey of the Territories for the Years 1869 to 1875.* Washington, D.C., Government Printing Office, 1875.

Klackner Gallery, New York. *A Catalogue of the Complete Etched Works of Thomas Moran, N.A., and M. Nimmo Moran, S.P.E.* Exhibition: March, 1889. New York [Klackner Gallery], 1889.

Kraushaar Galleries, New York. *Pictures by Thomas Moran, N.A.* Original verses by Edith M. Thomas. February 8, 1897.

Los Angeles Art Association. *Thomas Moran, N.A.: Centenary Exhibition* . . . (*Los Angeles Art Bulletin,* Vol. III, 1937), May, 1937.

Milch Galleries, New York. *Water Color Sketches of Thomas Moran.* December 20, 1926–January 8, 1927. New York, Milch Galleries, 1926.

Museum of Modern Art, New York. *Romantic Painting in America.* Text by James Thrall Soby and Dorothy C. Miller. New York, The Museum . . . , 1943.

National Academy of Design, New York. Catalogues of the Annual (Spring), Autumn and Winter Exhibitions, 1866–1926.

——. *Catalogue of the Permanent Collection* . . . *1826–1910.* New York, The National Academy, 1911.

——. *Our Heritage, a Selection from the Permanent Collection of the National Academy.* Exhibition: January 8–February 7, 1942. New York, The National Academy, 1942.

National Gallery of Art, Washington, D.C. *Thomas Moran Memorial Exhibit.* January 17, 1937.

New York Etching Club. Catalogues of Exhibitions, illustrated with original etchings, 1882–89, 1893–94. New York, New York Etching Club, 1882–89, 1894.

——. *A Publication by the New York Etching Club with Catalogue of Etching Proofs Exhibited at the National Academy of Design.* 3 vols. New York, New York Etching Club, 1891–93.

Newark Museum Association. *Paintings in the Newark Museum.* Second list. Newark, N.J., Newark Museum Association, 1926.

Newhouse Galleries, New York. *A Loan Exhibition of Paintings by Thomas Moran, N.A. To Commemorate the Centenary of His Birth* . . . January 12–30, 1937. New York, Newhouse Galleries, 1937.

Ortgies & Co., New York. *Catalogue of the Pictures in Oil and Water Colors by Thomas Moran.* Sale: February 24, 1886. New York, [Ortgies & Co., 1886].

Panama-Pacific International Exposition, San Francisco. *Catalogue DeLuxe of the Department of Fine Arts* . . . Ed. by John E. D. Trask and J. Nilsen Laurvik. 2 vols. San Francisco, Paul Elder and Co., 1915.

———. *Official Catalogue of Exhibitors* . . . San Francisco, Wahlgreen Co., 1915.

Paris Universal Exposition, 1867. *Complete Official Catalogue.* English version. 2nd ed. London, and Paris, 1867.

Prang, L. & Co., *Catalogue of an Unusual Collection of Water-Color and Oil Paintings Purchased from Time to Time for Reproduction by L. Prang & Company.* Sale: February 16–18, 1892. New York, American Art Association, 1892.

Rutledge, Anna Wells, ed. *Cumulative Record of Exhibition Catalogues: The Pennsylvania Academy of the Fine Arts, 1807–1870.* Philadelphia, American Philosophical Society, 1955.

Walker, Thomas B. *Catalogue of the Art Collection of T. B. Walker.* Minneapolis, Minn. [Privately printed], 1900.

Walker Art Center, Minneapolis. *Alphabetical List of Artists with Biographical Sketches* [Minneapolis, Walker Art Center], 1927.

———. *American Water Color and Winslow Homer.* Text by Lloyd Goodrich. Minneapolis, Walker Art Center, 1945.

———. *A Survey of Water Color—United States of America from 1870 to 1946.* Minneapolis, Walker Art Center, 1946.

MISCELLANEOUS PUBLIC DOCUMENTS

Congressional Globe, XLV (42 Cong., 2 sess., 1872), Part VI (Appendix), 811.

Congressional Record, IV (44 Cong., 1 sess., 1876), Part II, 1873, 1967; Part III, 2035, 2129, 2185–86.

"To provide for the transfer of the paintings 'The Grand Canyon of the Yellowstone' and 'The Chasm of the Colorado' from the United States Capitol to the Department of the Interior." U.S. Public Law 603, 81 Cong., 2 Sess., (Approved July 10, 1950).

"Transfer of Capitol Paintings to the Department of the Interior," with a letter concerning Thomas Moran from the Capitol Architect 81 Cong., 2 sess., *Sen. Rpt.* 1525, Calendar No. 1536, April 27, 1950 (Serial No. 11368).

NEWSPAPERS

This list cannot be held to cover certain newspaper items that contributed to the text; that is, inadequately identified clippings in Envelope No. 179 (Moran Collection, East Hampton) and in scrapbooks held by the East Hampton Free Library and the Jefferson National Expansion Memorial. The contents of these scrapbooks duplicate each other; I have examined both; but when citing material from them in my notes, I have mentioned only the scrapbook at East Hampton as the source.

California
- *Los Angeles Evening Herald*
- *Los Angeles Times*
- *Pasadena Star*
- *Pasadena Star-News*
- *San Francisco Bulletin*
- *San Francisco Chronicle*
- *Santa Barbara Morning Press*

Colorado
- Denver *Rocky Mountain News*

District of Columbia
- *Washington Chronicle*
- Washington *Evening Star*

Illinois
- *Chicago Evening Post*
- *Chicago Daily Tribune*

Massachusetts
 Boston *Daily Advertiser*
 Boston *Christian Science Monitor*
 Boston *Daily Globe*
 Boston *Saturday Evening Gazette*
Missouri
 Kansas City Star
New Jersey
 Newark Daily Advertiser
 Newark Evening Courier
New York
 Brooklyn Daily Eagle
 East Hampton Star
 New York American
 New York *Daily Graphic*
 New York Herald
 New York Herald-Tribune
 New York Evening Post
 New York *Sun*
 New York Times
 New York Tribune
 New York Evening World
 New York World
 New York World-Telegram
Oklahoma
 Oklahoma City *Daily Oklahoman*
 Tulsa Daily World
Pennsylvania
 Philadelphia Public Ledger
Wisconsin
 Madison *Wisconsin State Journal*
Wyoming
 Cheyenne Daily Leader
Great Britain
 Bolton Daily Chronicle
 Bolton Evening News

Edinburgh *Scotsman*
Illustrated London News
London *Times*
Manchester Guardian

INDEX

Acámbaro, Mexico: 170
Ácoma, N.M.: 212, 226, 237
Ácomita, N.M.: 220
Acres, Bob: 14
Adams, J. A.: 53
Adams Creek (Pennsylvania): 47
Adirondack Mountains (New York): 7, 52
Adventures of Captain Bonneville, The (Irving): 127
Afghanistan: 178
Agassiz, Louis: 232
Alamosa, N.M.: 154
Alastor (Shelley): 26–27
Alder Gulch (Montana): 60
Aldine: 68, 75, 79, 81, 84, 88, 102, 103, 113, 212; quoted, 32, 33, 46, 47, 55, 78, 121
Algic Researches (Schoolcraft): 30
Alleghenies: 149
Allegheny Mountains: 46
Allegheny Station, Va.: 150
Alph, the sacred river: 5
Alps: 6, 51
Alta, Utah: 124
Amagansett, L.I., N.Y.: 139, 180
America: 115, 185; *see also* United States
American art: 7, 242
American Art Association: 186
American art establishment: 113
American Art Gallery: 133
American artists: 218, 222–23
American Art Review: 132
American Cyclopaedia: 10

American Falls, Niagara: 145
American Fork Canyon (Utah): 124
American Lithographic Company: 205
American Painters (Sheldon): 209
American Pre-Raphaelites: 35
American Water Color Society: 141
Anacapa Street (Santa Barbara, Calif.): 235
Angangueo, Mexico: 169
Anglo-American art styles and techniques: 7
Antwerp, Belgium: 190, 191
Apache Indians: *see* Jicarilla Apache Indians
Appaquogue (L.I., N.Y.): 180
Apple Jack (John Karst): 147ff.
Appleton Company: 74
Appletons: 95
Arabian Nights: 208, 215
Arizona: 106, 122, 198, 199, 226
Arkansas River: 97, 100
Around the World with General Grant (Young): 157
Art Institute of Chicago: 207
Artist Point, Yellowstone Canyon (Wyoming): 65
Art Union of Philadelphia: 17
Arundel, Sussex, England: 41
Arundel Castle (Sussex, England): 38
Arvin, Newton: quoted, 55n.
Athens, Greece: 26
Atlantic Monthly: 58, 93
Atlantic Ocean: 7, 141
Atoyac, Mexico: 168

Avon, vale of, Scotland: 160
Avondale Castle (Scotland): 159
Aztecs: 224

Baalbek, Lebanon: 26–27
"Babbling Waters, Valley of" (Mu-
koon-tu-weap, or Little Zion Can-
yon) (Utah): 81
Babylon, Babylonia: 26–27
Bad Lands (South Dakota): 60, 204
Bad Lands (Utah): 75, 163
Bahama Islands: 166
Baiae, Italy: 50, 55
Bainbridge, Capt. Augustus H.: 124ff.
Bainbridge, Mrs. Augustus H.: 129
Baltimore, Md.: 13, 147
Baltimore and Ohio Railroad: 146, 152
Bannock War: 125
Barbison school: 9, 48, 49, 120, 183
Barker, Virgil: 8, 34
Barnum, P. T.: 148
Barnum's circus: 148–49
Barranca, N.M.: 154
Barrie, Sir James: 43
Bass, William: 216
Baudelaire, Charles Pierre: 48
Bear River: 75
Beaver, Utah: 79
Bell, Dr. William A.: 103, 154
Bell, Mrs. William A.: 102–103
Belle Fourche River (Wyoming): 200
Ben (the B. & O. man): 146ff.
Ben Cruachan, Scotland: 236
Benjamin, S. G. W.: 27
Bernhardt, Sarah: 144
Berry, "Pete": 216, 219, 228
Berry's Camp (Grand Canyon): 199
Bierstadt, Albert: 9, 68, 72, 101, 111
Big-Sea-Water (Gitchee Gumee, or Lake
Superior): 30
Big Spring, Stewart Canyon (Arizona):
86
"Big Trees and Yosemite, The" (Brom-
ley): 75
Biltmore Salon (Los Angeles, Calif.):
239
Bissell, W. A.: 199
Blackfoot Indians: 127
Blackmore, William: 70, 73, 75
Blaine, Speaker James G.: 60
Blair Athol (Colorado): 153

Blue Lakes, Idaho: 213
Blue Ridge, of Virginia: 149, 150
Blumenschein, Ernest L.: 228
Bolivar, Pa.: 46
Bologna, Italy: 51
Bolton, Lancashire, England: 10, 11, 40,
43, 59, 161
Bolton *Journal* (Bolton, England): 159
Booth, Edwin: 144
Booth Theatre Building (New York
City): 144, 174
Borbonica, Museo (Naples, Italy): 50
Borda Gardens (Cuernavaca, Mexico):
220
Bordentown, N.J.: 57
Borg, Carl Oscar: 234, 239
Borghese, Villa (Rome, Italy): 50
Born, Wolfgang: 9, 205
Boston Museum of Fine Arts: 141
Boteler's Ranch (Montana): 62, 66
Bouguereau, Adolphe William: 50
Boulder Canyon (Colorado): 95
Bourke, Capt. John C.: 129, 130n., 199
Boy Emigrants, The (Brooks): 157
Bozeman, Mont.: 61
Bremen, Germany: 187
Brera Gallery (Milan, Italy): 51
Briarhurst (residence of Dr. William A.
Bell): 103, 154
Bridgehampton, N.Y.: 135
Bridger, Jim: 60
Bright Angel Canyon (Arizona): 237
Bright Angel Trail (Grand Canyon):
226, 228
British art tradition: 7, 22
British cotton industry: 10
British Isles: 165, 227
Brittany, France: 178
Broadway (New York City): 177, 186
Brobdingnag: 84
Brock's Monument (Niagara Falls): 145
Bromley, Mr. (English art dealer): 161
Bromley Art Gallery (Bradshawgate,
England): 159
Brooklyn, N.Y.: 141, 231
Brooklyn Daily Eagle: 185
Brooklyn Museum of Art: 8
Brooks, Noah: 157
Brooks, Van Wyck: 232
Brown, John: 148
Brown and Bigelow: 195

Brush and Pencil: 221, 224
Bryant, William Cullen: 74, 157
Bryce Canyon (Utah): 239
Buek, Gustave H.: 205, 216, 218, 221, 227; describes Moran, 230
Buell Lane (East Hampton, L.I., N.Y.): 174
Buena Vista, Mexico (battleground): 172
Buffalo Peaks (Colorado): 97
Bunce, O. B.: 74
Bunce, William Gedney: 186
Bunner, A. F.: 142
Burano, Italy: 188, 191, 194
Burlingame, E. L.: 74, 75
Burns, Robert: 42
Buskill River (Pennsylvania): 134
Butler, Howard Russell: 234
Byron, Lord George Gordon: 51

C. C.: *see* Clarence Cook
Caffin, Charles A.: 214
Caleme (Swiss painter): 7
California: 233, 238
Camden Station (Baltimore, Md.): 147
Campagna, the (Italy): 50
Campanile of St. Mark (Venice, Italy): 187, 191
Campo Santo (Venice): 187, 194
Camp Wykoff (L.I., N.Y.): 211
Canale di San Marco (Venice, Italy): 187
Canal of the Giudecca (Venice): 187
Cannon, George Q.: 77
Canon City, Colo.: 100
Canyon Creek (Idaho): 126
Canyon Voyage, A (Dellenbaugh): 89
Cape Hatteras, N.C.: 166
Capitol, U.S. (Washington, D.C.): *see* U.S. Capitol (Washington, D.C.)
Capon, Va.: 149
Caracalla, Baths of (Rome, Italy): 50
Cardigan Bay (Wales): 165
Cardigan Castle (Wales): 165
Caribbean Sea: 108
Carmel, Calif.: 232
Carr, Comyns: 164
Cary, Elizabeth Luther: quoted, 134, 193–94, 195
Cascade Creek (Yellowstone): 64, 65
Castle Geyser (Yellowstone): 66

Cataract Canyon (Arizona): 198
Cathedral Rock (Yosemite, Calif.): 225
Catlin, George: 17
Catorce, Mexico: 172
Cavendish Square (London, England): 161
Cave of the Winds (Colorado): 154
Cedar City, Utah: 79
Celaya, Mexico: 170, 172
Celtic Christianity: 160
Centennial Exposition, Philadelphia (1876): 102, 104, 112
Central High School (Philadelphia, Pa.): 18
Central Pacific Railroad: 74
Central Park (New York City): 145
Century: 133, 202
Century After, A: Picturesque Glimpses of Philadelphia (Strahan): 157
Century Club (New York City): 180, 225
Chama River (New Mexico): 155
Champney, J. Wells: 108
Channel Islands (California): 209, 235
Chapel River (Michigan): 32, 34
Chapelle, la (the Grand Chapel): 32–33
Chapultepec (Mexico City, Mexico): 168
Charles II, Stuart (king): 36
Charles Town, W.Va.: 148
Chase, Harry: 142
Chase, William M.: 79, 117, 137, 145, 151, 186
Cheyenne, Wyo.: 74, 200
Cheyenne Canyon (Colorado): 153
Cheyenne Daily Leader: 203
Chicago, Ill.: 147, 151, 195, 199, 215, 227
Chicago Fair: 205
Chicago Lake (Colorado): 95
Childe Harold (Byron): 51
Childe Roland: 29
Chioggia, Italy: 188, 194
Chippewa myths: 30
Chirimoya, Gap of (Mexico): 171
Church, Frederick Edwin: 5, 68, 101, 222
Cinnabar, Mont.: 203
Cinnabar Mountain (Yellowstone): 63
Civil War (U.S.): 36, 57
Civitavecchia, Italy: 50

Clark, Eliot: quoted, 85, 131, 182n., 230
Clarke, Thomas B.: 172, 174, 196
Clarks Fork (Yellowstone River): 203
Claude Lorrain (Claude Gelée): 9, 38, 39, 48, 50
Clear Creek (Colorado): 96
Clemens, Samuel L. (Mark Twain): 55
Clinton Hall (New York City): 3, 5
Clouds Peak (Wyoming): 203
Clyde River (Scotland): 160
Coconino Forest (Arizona): 216, 227
Colburn, J. E.: 77, 79, 80, 88; quoted, 80–81, 84
Cole, Thomas: 54
Coleridge, Samuel Taylor: 4, 27
Cologne, Germany: 191
Colorado: 60, 76, 116, 120, 154, 156, 198, 200, 212, 220, 226
Colorado Chiquito (Arizona): 198
Colorado River: 72, 76, 87, 122, 205
Colorado Springs, Colo.: 153
Colorado Tourist: 152
Comanche Canyon (New Mexico): 155
Comanche Point (Grand Canyon): 199
Cona River (Glencoe, Scotland): 160
Conemaugh River (Pennsylvania): 46
Congress, U.S.: see U.S. Congress
Conkling, Senator Roscoe: 136
Connoisseur: 183
Constable, John: 40, 41
Continent (Europe): 51; see also Europe
Conway, Wales: 164, 226
Conway Castle (Turner): 132, 162, 189
Conway Castle (Wales): 36, 164
Cook, Clarence: quoted, 4–5; his criticism of The Chasm of the Colorado, 93
Cook, George Cram: 176
Cook, Jay: 3, 59, 68, 70, 75
Cooke & Co.: 59
Cooper Union: Museum, 167n., 233; Council, 233
Corcoran Gallery (Washington, D.C.): 92, 101, 111
Córdoba, Mexico: 168
Corinne, Utah: 59
Cornwall, England: 227
Corot, Jean-Baptiste Camille: 7, 48–49, 121, 131, 183 & n., 236

Cortez, Hernando: 172
Cortissoz, Royal: quoted, 182–83
Cottier Collection: 49
Cottonwood Wash (Utah): 82
Couse, E. Irving: 228
Covington, Va.: 150
Cowper, William: The Task, 21
Cox, Kenyon: 151
Cozens, Alexander: 210
Crescentville, Pa.: 42
Crest of the Continent, The (Ingersoll): 152
Criccieth Castle (Wales): 165
Critic: quoted, 116, 141, 160, 183, 208, 211, 225
Crompton, Samuel, "mule" of: 10
Cromwell, Oliver: 160
Cross Creek (Colorado): 99, 101
Cross Creek Canyon (Colorado): 98, 101
Crossing the Brook (Turner): 38
"Cross of Snow, The" (Longfellow): 102
Crow Indians: 58
Cuba: 211
Cubism: 232
Cucumber Falls (Pennsylvania): 151
Cuernavaca, Mexico: 220, 236
Cummings, E. E.: 176
Curtis Building (Philadelphia, Pa.): 205–206

Daingerfield, Elliott: 227
Dakota Bad Lands: 60
Dante Alighieri: 57, 114, 169
Darien, Nicaragua: 70n.
Darley, F. O. C.: 50
Daubigny, Charles François: 48, 120, 131, 142, 183
Death on a Pale Horse (West): 17
De Forest, Lockwood: 234
De Kay, Helena (Mrs. Richard Watson Gilder): 113–14
Delano, J. S.: 96, 99
Delaware River: 26, 39, 43, 46
Dellenbaugh, Frank S.: 89
Denver, Colo.: 95, 96, 100, 152, 199, 200, 211
Denver and Rio Grande Railroad: 100, 102, 152, 156
Denver Art League: 211

Desert View (Grand Canyon): 238
De Soto Discovering the Mississippi: 111
Devil's Den (Yellowstone): 64, 68
Devil's Gate (Utah): 75
Devil's Punch Bowl (Colorado): 153
Devil's Slide (Utah): 75
Devil's Slide (Yellowstone): 63
Devils Tower (Wyoming): 200–203, 237
Devonshire, England: 227
Diaz de la Peña, Narcisse Virgile: 48, 142
Dieppe, France: 48
Digges, Dudley: 176
Discovery of California, The (Bierstadt): 111
Doane, Lt. G. C.: 66
Dodge, Henry N.: 157
Dolores Hidalgo, Mexico: 171
Dolwyddelan, Wales: 165
Donner Lake (California): 75
Donner party: 123
Donner Pass (California): 123
Doré, Gustav: 89
Doria Gallery (Rome, Italy): 50
Double Headed Shot Keys: 166
Dover, Kent, England: 41
Downs, the (Sussex, England): 41
Drake, Alexander W.: 67
Dreiser, Theodore: 176
Ducal (Doge's) Palace (Venice, Italy): 187, 194
Dumbarton Castle (Scotland): 31
Düsseldorf, Germany: 115
Dutch school: 7
Dutton, Clarence E.: 89–90, 90; quoted, 79, 84, 86, 93
Duveneck, Frank: 185

Eagle River (Colorado): 97
Eagle Rock (Virginia): 149
Eakins, Thomas: 118–19; quoted, 25
Earle, James S.: 17; gallery of, 43
East, the: 29
East Cliff (Hastings, East Sussex, England): 41
Eastern mountains: 29
East Hampton, L.I., N.Y.: 135, 137, 141, 165, 174, 176, 186, 188, 189, 192, 204, 215, 226, 233, 235, 238, 240; described, 136

East Hampton Beach (L.I., N.Y.): 138
East Hampton Free Library: 242
East Hampton Star: 192
Easton, Pa.: 131
Eaton, Wyatt: 114
Echo Canyon (Utah): 74
Edmunds, Senator George Franklin: 55
Egyptians: 224
Egypt Lane (East Hampton, L.I., N.Y.): 138
El Capitan (Yosemite): 75
Elko, Nev.: 125
Elliot and Company: 102
El Tovar Hotel (Grand Canyon): 205, 226, 227, 233
Emerald Pool (Yellowstone): 207
Emma Mine (Utah): 124
Enchanted Mesa (Kat-zí-mo) (New Mexico): 212
England: 7, 10, 15, 36, 41, 48, 159, 162, 192, 224, 226; *see also* British Isles *and* Great Britain
Estheticism: 36, 158
Etching (Koehler): 140
Etching, glass cliché: 131
"Etching craze": 132, 141; end of, 143
Europe: 7, 52, 158, 218, 230
Evanston, Wyo.: 66
Excelsior (Longfellow): 157

Fairman, Col. (sculptor): 105–106
Fairmont Park (Philadelphia, Pa.): 57, 104
Fairplay, Colo.: 97, 100
Fairy, the (J. G. Pangborn): 147ff.
Falling Springs (Virginia): 150
Family Magazine: 53
Far West, the: 74, 75, 108, 121, 198
Feltville, N.J.: 120
Fernandez de Taos, N.M.: 154
Ferris, Elizabeth (Moran): 71 n.
Ferris, J. L. Gerome: 71 n.
Ferris, Stephen J.: 71 n., 131, 177
Fighting Tememaire, The (Turner): 38
Fillmore, Utah: 79
Fingal's Cave (Staffa, Scotland): 161
Firehole Basin (Yellowstone): 66, 72
Five Mile River (L.I., N.Y.): 180
Flagstaff, Ariz.: 198, 199
Florence, Italy: 50

Florian's Café (Venice, Italy): 185
Florida: 108, 111, 189
Fontainebleau, France: 48
Foote, Mary Hallock: 166; quoted, 169, 170
Fort Ellis, Mont.: 61, 65
Fort George Island, Fla.: 108ff., 189
Fort Hall, Idaho: 66, 124, 128, 129
Forthill Bridge (Bolton, England): 40
Fortieth Parallel Exploration (King Survey): 58
Fortín, Mexico: 168
Fort of the Americans (Bueva Vista, Mexico): 172
Fort Pond (Montauk, L.I., N.Y.): 139
Fort Wingate, N.M.: 220
Fountain Geyser (Yellowstone): 207
Four Lakes (Madison, Wis.): 105
14th U.S. Infantry: 124
Foster, Ben: 228
Foster, Birket: 131
Foster, J. W.: quoted, 30–31
Fowler, George: 192
France: 115, 224
Frederick Junction, Md.: 147
Frémont, Col. John Charles: 27
French academicians: 50
French art: 50
French school: 218
Fresh Ponds (L.I., N.Y.): 180
Frontenac, Count Louis de Buade: 52–53
Front Range (Colorado): 200
Fulda (S.S.): 187

Gallatin, Albert: 115n., 183n., 206n.
Gallatin, Frederic: 206n.
Gallatin, Mrs. Frederic: 183n.
Gallatin Valley (Montana): 61
Gallery of Modern Art (New York City): 8, 103
Gallup, N.M.: 200
Gap of Chirimoya (Mexico): 171
Garden of the Gods (Colorado): 95, 154
Gardiner River (Yellowstone): 63, 67
Gardiner River, East Fork (Yellowstone): 203
Gardiner's Bay (New York): 139
Gardner, Mrs. (hotel manageress): 136
Gardner's Hotel (East Hampton, N.Y.): 136
Gate of Venice (Venice, Italy): 194

Gay, Snyder Howard: 157
Georgetown, D.C.: 111
Georgia: 121
Georgia Gulch (Colorado): 156
Georgica Pond (East Hampton, L. I., N.Y.): 174, 179
Germany: 187, 224
Gérôme, Jean Leon: 50
Ghost House (Fort George Island, Fla.): 110
Gifford, R. Swain: 137, 139
Gifford, Sanford R.: 72, 115
Gilcrease, Thomas: 175
Gilcrease Collection: 160
Gilcrease Institute (Museum): see Thomas Gilcrease Institute of American History and Art
Gilder, Richard Watson: 57, 58, 73, 113–14, 202; quoted, 67, 68–69, 91
Gilder, Mrs. Richard Watson: see De Kay, Helena
Gillette, Wyo.: 200, 202
Giorgione: 186
Giotto di Bondone: 114
Giovanelli Palace (Venice, Italy): 186
Gitchee Gumee: see Lake Superior
Giudecca (Venice, Italy): 187
Glacier Point (Yosemite): 75
Glaspell, Susan: 176
Glass cliché etching: 131
Glen Canyon (Utah): 88
Glencoe, Pass of, Scotland: 160, 165
Glen Eyrie (Colorado): 153, 212, 220
Goat Island (Niagara Falls, N.Y.): 145
Godey's Lady's Book: 20
Golden Gate (Yellowstone): 203, 207
Golden Songs of Great Poets: 157
Gondola (owned by Moran): 191–93
Goose Creek (Wyoming): 203
Goose Pond, or Town Pond (East Hampton, L.I., N.Y.): 135, 165, 192, 240
Goupil's Gallery (New York City): 70, 92
Grafton, Utah: 80
Grand Canal (Venice, Italy): 187, 188, 194
Grand Canyon of Arizona, The (Santa Fe Railroad): 218
Grand Canyon of the Colorado (Arizona): 72, 76, 83ff., 88, 91, 94, 100,

122, 123, 163, 198, 206, 213, 216–19, 222, 225, 226, 232, 233, 237
Grand Canyon of the Yellowstone (Wyoming): 64, 68, 207
Grand Chapel (*la Chapelle*) (Michigan): 32–33
Grand Hotel (Venice, Italy): 187, 191
Grand Isle (Michigan): 31, 33
Grand Portail, le: see Great Cave
Grand Teton (Wyoming): 125
Grand Teton National Park (Wyoming): 241
Grand View Point (Grand Canyon): 199, 228
Grant, Gen. Ulysses S.: 55
Great Blue Spring (Yellowstone): 68, 207
Great Britain: 235
Great Canyon of the Yellowstone: *see* Grand Canyon of the Yellowstone
Great Cave (*le Grand Portail*) (Michigan): 32
Great Cut (Mexico): 166
Great Divide: 97, 153
Great Falls (Yellowstone): *see* Lower Falls (Yellowstone)
Great Geyser of Firehole Basin (Yellowstone): 68
Great Pond (Montauk, N.Y.): 139
Great Salt Lake (Utah): 59, 74, 75, 78
Great South, The (King): 108, 157
Greece: 224
Green Hotel (Pasadena, Calif.): 233
Green River: 30, 144
Green River (Wyoming): 59, 74, 157, 220, 236
Greenwich Village, N.Y.: 176, 179
Greenwood Park (London, England): 41
Groll, Albert L.: 228
Gross Clinic (Eakins): 118
Grosvenor Gallery (London, England): 164
Guanajuato, Mexico: 170
Guild Hall (East Hampton, N.Y.): 242
Gulf of Mexico: 167
Gulliver, Lemuel: 84
Gypsum Canyon (Utah): 122, 123

Hacienda San Juan (New Mexico): 200
Haden, Seymour: 142, 164

Half Dome, or South Dome (Yosemite): 75, 225
Hall, Eugene J.: 157
Hamerton, Philip: 10; quoted, 38
Hamilton, Duchess of: 159
Hamilton, Hamilton: 182
Hamilton, James: 18–19, 22, 27, 37; influence of, on Moran, 23–24
Hammond, Percy: 137
Hammondton, N.J.: 133
Hampshire, England: 164
Hanging of the Crane, The (Longfellow): 157
Hance, John: 216, 228
Hance's Canyon (Arizona): 198
Hance Trail (Grand Canyon): 199
Hanover Gallery (London, England): 142
Harlech, Wales: 165
Harlech Castle, Wales: 165
Harpers Ferry, W.Va.: 148, 149, 150
Harper's Magazine: 45, 57, 152, 156, 166
Harper's Weekly: 68
Harrison Boy's Grammar School (Philadelphia, Pa.): 16
Hart Building (Philadelphia, Pa.): 21
Hartford, Huntington: 103
Hartmann, Sadakichi: 143; quoted, 115
Harvey, Ford: 239
Harvey, Fred: 205
Hassam, Childe: 241
Hastings, East Sussex, England: 28, 41, 43, 48
Havana, Cuba: 166, 172
Havasupai: 198
Hawthorne, Nathaniel: 157
Hay, John: 55
Hayden, Dr. Ferdinand Vandiver: 4, 6, 22, 58, 65, 68, 70, 71, 72, 77, 95, 96, 124, 125, 203, 213; quoted, 5, 63, 64–65; description of, 60; geological career of, 60; Yellowstone article by, 67
Hayes, President Rutherford B.: 124
Hebrides, the (Scotland): 160
Heckscher Art Museum (Huntington, L.I., N.Y.): 8
Heep (settler): 80
Hell's Kitchen (New York City): 145
Hengist and Horsa: 41
Henry, E. L.: 137

"Hi, Betty Martin, Tiptoe Fine" (song): 136

Hiawatha (Manabozho): 30, 54–55, 102, 104, 159

Hiawatha, The Song of (Longfellow): 30, 34, 54, 132

Highlands, the, Scotland: 160

High Sierra (California): 72

Hillers, John K.: 81, 83, 88, 197

Hither Wood (L.I., N.Y.): 139

Hitz (gondolier): 191

Hogan and Schell (engravers): 145

Holland: 113, 120

Holland, J. G.: 157

Holland Funeral Chapel (Santa Barbara, Calif.): 240

Holmes, Oliver Wendell: quoted, 37

Holmes, William H.: 6, 90, 207, 238; quoted, 234

Holy Cross, Mountain of the (Colorado): 95ff.

Holy Cross Creek (Colorado): 98

Homer, Winslow: 113

Hook Pond (East Hampton, L.I., N.Y.): 138, 140, 174, 192

Hooper (Mormon bishop): 77

Hopi Indians: 121

Hopi Point (Grand Canyon): 227

Hornung, Clarence P.: quoted, 242

House of Representatives, U.S.: *see* U.S. House of Representatives *and* U.S. Congress

House of Usher: 28

Howells, William Dean: quoted, 187

Hudson River school: 53, 68, 104, 115, 222, 233, 242

Humboldt Plains (Nevada): 75

Humboldt Valley (Nevada): 124

Hunt, Holman: 35

Hunt, William M.: 146

Huntington, Collis P.: 55

Huntting, Phoebe Parsons Statton Conklin: 136, 138

Huxley, Aldous: 4; quoted, 8

IBM Corporation art collection: 8

Impressionism: 9

Index Peak (Wyoming): 203, 237

Indian Creek (Pennsylvania): 151

Indian Encampment (Bierstadt): 68

Indians (in *Ponce de León in Florida*): 110

Inferno (Dante): 169

Ingersoll, Ernest: 152ff.

Inness, George: 39, 115, 142, 144, 197, 223

Inness, George, Jr.: 216ff.

Iona, Scotland: 160

Isabey, Eugene: 58

Isle of Wight, England: 36, 41

Italy: 50–51, 212, 224

Ixtaccihuatl Peak (Mexico): 168

Jackson, William H.: 6, 22, 63, 65, 70, 73, 74, 76, 96, 152ff., 199, 200ff., 212; quoted, 61, 61–62, 214

Jackson Lake (Wyoming): 129

Jacksonville, Fla.: 109

James, Henry: 158

Jaral del Berrio, Mexico: 171

Jefferson, Joseph: 114

Jefferson Market Police Court (New York City): 176

Jenkins, A. C.: 16

Jicarilla Apache Indians: 156

Johnstown, Pa.: 46

Kaibab Plateau (Arizona): 85, 86, 88, 199, 237

Kanab, Utah: 80, 83, 85, 86, 103, 123; description of, 81

Kanab Canyon (Arizona and Utah): 88, 89, 197, 198

Kanab Creek (Utah): 85

Kanab Desert: 86

Kanarra Canyon (Utah): 79

Kanarraville, Utah: 79

Kanosh, Chief: 79

Karst, John (Apple Jack): 147ff., 152

Kat-zí-mo, or Enchanted Mesa (New Mexico): 212

Kenabeek, the: 54

Kendago (Mohawk chief): 52–53

Kensett, J. F.: 142

Kensington, Pa.: 15

Keppler, Joseph: 141

Keseberg, Lewis: 123

Kilchurn Castle (Scotland): 43, 236

King, Clarence: 58, 72, 89, 123, 124, 162; quoted, 213

King, Edward: 108, 157

Kingsley, Captain (planter): 110
King's Peak (Utah): 78
King Survey: *see* Fortieth Parallel Exploration
Kirby, Thomas E.: 186
Klackner, Christian: 142, 190
Klackner's Gallery (New York City): 190
Knocking Round the Rockies (Ingersoll): 152
Knoedler and Company: 92
Krakatoa: 180
Kraushaar Galleries (New York City): 211
Koehler, S. R.: 132, 157, 189; quoted, 74, 133–34, 140, 173
Kurtz Gallery (New York City): 117

La Farge, John: 114, 151
Laffan, William (Polyphemus): quoted, 135
Laguna, N.M.: 156, 200, 212, 219, 237
Laja Valley (Mexico): 171
La Junta, Colo.: 219
Lake Como (Italy): 51
Lake Cuitzeo (Mexico): 170
Lake Huron: 33
Lake Mendota (Madison, Wis.): 106
Lake Monona (Madison, Wis.): 106
Lake St. Clair: 33
Lake Superior (Gitchee Gumee: Big-Sea-Water): 30, 34, 43, 54
Lake Tahoe: 75, 124
Lalla Rookh (Moore): 208
Lanarkshire, Scotland: 42, 159
Lancashire, England: 10, 40
Langford, Nathaniel P.: 6, 58, 63, 67, 73, 127
Laramie Plains (Wyoming): 74
Laredo, Tex.: 172
Last Arrow (J. A. Adams): 53 & n.
Laurel Leaves: 157
Leavitt's Art Rooms (New York City): 92
Lehi, Utah: 77
Leigh, Richard ("Beaver Dick"): 127, 128
Leigh, William R.: 217
Lewes, East Sussex, England: 41
Liber Studiorum (Turner): 21, 24
Liberty Cap (Yellowstone): 68

Lido (Venice, Italy): 191
Linnell, John: 142
Linton, William J.: quoted, 53n., 74
Lippincott, J. B., and Company: 20
Little Bighorn Canyon (Wyoming): 203
Little Bighorn River (Wyoming): 203
Little Cottonwood Canyon (Utah): 124
Little Juniata River (Pennsylvania): 46
Little Zion Canyon (Mu-koon-tu-weap, or "Valley of Babbling Waters"): 81
Liverpool, Lancashire, England: 12, 40, 159
Lledr River (Wales): 165
Llewellan the Great: 165
Locust Point, Md.: 147
London, England: 36, 40, 161, 226
Longfellow, Henry Wadsworth: 30, 54, 55, 102, 157, 162
Long Island, N.Y.: 40, 120, 135, 139, 141, 175, 181, 189, 215, 238
Long Island City, L.I., N.Y.: 135
Long Island Railroad: 135
Long's Peak (Colorado): 95
Lorimer, George Horace: 205
Lorimer, Graeme: 206
Lorrain, Claude: *see* Claude Lorrain
Los Angeles, Calif.: 199, 226, 239, 242
Los Angeles County Museum: 8
Los Olivos, Calif.: 239
Los Pinos Valley (Colorado): 156
Lotos Club (New York City): 180
Lower Falls (Yellowstone): 64, 65, 68, 207
Lower Geyser Basin (Yellowstone): 66
Luminism: 24
Lummis, Charles F.: 199, 205; quoted, 226
Lungren, Fernand: 234, 239
Luxembourg Gardens (Paris, France): 48
Luxembourg Palace (Paris, France): 48
Lyrics of Homeland (Hall): 157

Mabel Martin (Whittier): 157
"Mabs Grotto" (Yellowstone): 207
Macaulay, Thomas Babington: 160
Macbeth, William: 241 & n.
McCord, George H.: 216ff.
MacDonald clan: 160
McGuigan, James: 55

Madison, Wis.: 105ff., 108
Madison River (Montana and
 Wyoming): 61
Maidstone Club (East Hampton, N.Y.):
 179
Maine: 77 & n.
Mammoth Hot Springs (Yellowstone):
 63, 203, 207
Manabozho: see Hiawatha
Manhattan, N.Y.: 145, 233; see also New
 York City
Manito of Wampum (Megissogwan):
 54
Manitou, Colo.: 153, 219
Maravatio, Mexico: 169, 172, 173
Marble Canyon (Utah): 88
Margate, Kent, England: 41
Mariners Museum (Newport News,
 Va.): 193
Marryat, Capt. William: 146
Marseilles, France: 50
Martin, Homer: 115
Maryland: 13
Masefield, John: 176
Mastai, M. L. D'Otrange: quoted, 183
Mather, Stephen Tyng: 6, 234, 239
May Fair, London, England: 164
Mayflower (ship): 12
Mead, Elwood: 199
Megissogwan (Manito): 54
Meissonier, Jean Louis Ernest: 50
Mellon, Andrew: 225
Memorial Hall, Fairmont Park (Phila-
 delphia, Pa.): 104
Memphis, Egypt: 26–27
Metlac River (Mexico): 168
Metropolitan Museum of Art (New York
 City): 6, 8, 51, 130
Mexican War: 172
Mexico: 165, 166, 174, 220, 235, 236
Mexico City, Mexico: 167, 168, 220
Michoacán, Mexico: 169
Middle Canyon (Yellowstone): 62
Mifflin, Lloyd: 157
Milan, Italy: 51
Millais, Sir John: 35
Millboro Station, Va.: 150
Millet, Jean François: 49–50
Millford, Pa.: 47
Millier, Arthur: quoted, 8–9
Milton, John: 130

Miner's Castle (Michigan): 31
Miner's River (Michigan): 31
Minerva Springs (Yellowstone): 207
Mistress of the Manse (Holland): 157
Mitchell, Mrs. Alexander: 106
Modjeska, Helena: 114
Mohawk Indians: 52–53
Molo, the (Venice, Italy): 187
Monongahela Valley (Pennsylvania):
 150–51
Montauk, L.I., N.Y.: 137, 211
Montauk Point (New York): 139
Monterey, Calif.: 235
Montezuma: 168
Monument Park (Colorado): 95, 153
Monument Rock (Utah): 74
Moody Creek (Idaho): 126
Moore, R. E.: 133
Moore's Lake (Utah): 75
Moran, Annette Parmentier (Mrs.
 Edward): 71 n.
"Moran, clan": 45, 71 n.
Moran, Edward: 28, 71 n., 114, 142 n.,
 177; birth of, 11; paints Thomas P.
 Cope, 12; goes to Philadelphia, 13;
 beginning of career, 13–14; his encour-
 agement of brothers, 16–17; studio of,
 22–23; his trip to England (1861–62),
 36; finishes a picture by Thomas, 44
Moran, Elizabeth: 71 n.; birth of, 11
Moran, Emily Kelley (Mrs. Peter): 71 n.
Moran, John: 71 n.; birth of, 11; career
 as photographer, 11; quoted, 13–14
Moran, Leon: 71 n.
Moran, M. Nimmo: 134, 137; see also
 Moran, Mary Nimmo
Moran, Mary (sister of Thomas):
 birth of, 15
Moran, Mary Higson: marriage, 10; be-
 comes Roman Catholic, 10; influence
 of, 11–12
Moran, Mary Nimmo: 42, 48, 71 n., 114,
 131, 137, 138, 141, 143, 145, 159,
 162, 179, 189, 202, 240; description
 of, 42–43; first impressions of art, 43;
 progress in art, 45; tour of Italy (1867),
 50–51; Far Western trip (1872),
 74ff.; ailing health of, 75–76; letters
 to, quoted, 96ff.; visit to Madison
 (1876), 106; Florida trip (1877),

108ff.; at the Gilder Salon, 114; debut of, as etcher, 134; use of New Jersey scenery, 120; her signature "M. Nimmo," 134; success as etcher, 134–35; use of East Hampton scenery, 135; exhibitions of, 141; elected member of Painter–Etchers' Society of London, 142; joins B. & O. tour (1881), 149–50; receives Chicago Fair award, 207; last illness and death of, 211; see also M. Nimmo Moran

Moran, Mary Scott: 52, 162; see also Mary Scott Moran Tassin

Moran, Mollie: see Moran, Mary Nimmo

Moran, Paul Nimmo: 50, 71n., 121, 177, 179, 240; birth of, 43; visits Grand Canyon (1892), 198–99; death of, 226

Moran, Percy: 177, 208

Moran, Peter: 23, 71n., 121, 130n., 132, 156, 199; birth of, 11; etches T. Moran's Hiawatha designs, 55; Teton trip of, 123ff.

Moran, Ruth Bedford: 14, 107, 162, 164, 174, 178, 209, 212, 213, 216, 225, 227, 233, 234, 238, 240; quoted, 11, 13, 15 & n., 26, 33, 36, 42, 43, 58, 66–67, 115, 132, 135–36, 137, 194, 239, 241n.; birth of, 58; death of, 191, 242; illness of, 211

Moran: Sarah: 11

Moran, Thomas: 71n.; quoted, 62, 64–65, 77, 80–81, 85, 90, 99, 122, 151–52, 170–72, 174–75, 216, 218–19, 220, 221, 222, 223, 224, 230, 231–32, 233, 234; Yellowstone panorama (1872), 33ff., 68ff., 76, 102, 105; nickname of, 6, 76, 147; description of, 7, 12, 61, 98, 215; art opinions of, 7–8, 24, 37–38, 48–50, 117, 151–52, 218–19, 220, 221–22, 223, 224, 231–32; conservative techniques of, 8, 113ff., 231ff.; work evaluated by Arthur Millier, 9; work described by Wolfgang Born, 9; birth of, 10, 11; birthplace of, 10; paternal heredity of, 10; emigration to America, 12; artistic bent as boy, 16–17; encouraged by brother Edward, 16–17; apprenticeship of, 20–22; suffers rheumatic fever, 22; shares studio with Edward,

22–23; self-instruction, 24–25; use of memory, 25–26, 29; love of nature, 26, 29, 38; use of literary themes, 26–29; opinions of Eastern mountains, 29; trip to Lake Superior, 29–34; Romantic style of, 35; Pre-Raphaelite tendencies of, 36; trips to England, 36ff., 48, 159–65, 226–27; study of Turner, 37–38; called the "American Turner," 39; influence of Claude Lorrain on, 39–40; influence of Constable on, 40; influence of Turner on, 40; Americanism of, 42, 52, 218–19, 222–23; marriage of, 43; his mark for pot boilers, 44; use of opus numbers, 44; work as teacher, 44; work as illustrator, 44–45, 47, 57, 58, 67–68, 74–76, 88–89, 95, 100, 108, 109–10, 122, 145, 146ff., 151, 152, 157; love of music, 45–46; skill with violin, 45; conversation of, 46; field sketching of, 47; trips to Europe, 36ff., 48–51, 159–65, 185ff., 191ff., 212, 226–27; studies Lorrain, 48; visits Corot, 49; trips to Italy, 50–51, 185ff., 191ff., 212; opinion of Alps, 51; commitment as American painter, 52; illustrations for Hiawatha, 55, 104; work as lithographer, 55–56; trips to the Far West, 59ff., 74ff., 77ff., 96ff., 123ff., 198–204, 212, 220, 225, 226, 227–28, 235ff.; joins Hayden Survey (1871), 60; visits to the Yellowstone, 59–66, 203–204; al fresco cooking, 61–62; interest in photography, 62; his work with William H. Jackson, 63ff., 152ff., 199–204; inspiration from Yellowstone, 66–67; removal to Newark, 67; vitality of, 67; Yellowstone water colors, 67–68, 70–71; designs for L. Prang, 68; called "father" of National Parks, 70; chosen honorary member of Hayden Survey, 73; Mt. Moran named for, 73; trips to Yosemite, 75, 225; monogram (signature device) of, 75; trip to Maine, 77 & n.; travels through Utah, 59, 74–75, 77ff., 124, 156, 212; views on Indians, 82–83; trips to Grand Canyon of the Colorado, 84–85, 86ff.,

198–99, 216–19, 225, 226, 227–28, 238; criticism of Major Powell's report, 89; Grand Canyon panorama, 90 ff., 102, 105; taxes raised, 92; Florida trips, 108ff., 189; at the Gilder Salon, 114; membership in Society of American Artists, 114ff.; method of painting, 115–16; knowledge of form, 115; palette, 115–16; method of "keying up," 116–17; love of finish, 117; preference for Western scenes, 120; use of New Jersey scenes, 120–21; sketching in the Sierra Nevada (1879), 123–24; in the Wasatch Mountains, 124; trip to the Tetons, 124ff.; use of the Tetons, 129; use of glass cliché process, 131; as pioneer American etcher, 131 & n.; work as etcher, 132ff.; buys Turner's Conway Castle, 133; success at etching, 133–34; first visit to East Hampton, 136; preference for Grand Canyon and East Hampton, 136; etching themes of, 140ff.; preference for difficult subjects, 141; his Turneresque manner, 141; exhibits at New York Etching Club, 141; exhibits at Boston Museum of Fine Arts, 141; elected member of Painter–Etchers' Society of London, 142; high quality of etchings, 142; reproductive etchings, 142–43; B. & O. tour, 147ff.; Denver & Rio Grande tour, 152ff.; works illustrated by, 157; tour of Scotland, 159–61; friendship with Ruskin, 163; tour of Wales, 164–65; titles of paintings changed, 166n.; trips to Mexico, 167ff., 220–21; settles in Greenwich Village, 176; builds "The Studio," East Hampton, 176–77; protects trees with pistol, 177–78; his clubs, 180; use of Long Island themes, 180–81, 183–84; becomes Associate of the National Academy of Design, 182; becomes National Academician, 182; affinity with Barbizon school, 183, 236; marine paintings of, 185; auction sale of works, 186; studies icebergs at sea, 190; trips to Venice, 187–88, 191–92; gondola, 191–93; pre-

dilection for Venetian scenes, 188–89, 193; his Venetian scenes compared with Turner's, 193–94; his last picture shown at the National Academy, 195; work during 1890's, 196–97; 22nd Street studio, New York City, 197; his urge for perfection, 197; retouches old work, 197; trip to Devils Tower, 200–202; works on largest canvas, 206n.; liking for the fanciful, 208; "metamorphoses," 209–10; blot drawings, 210–11; effect of wife's death on, 212; revisits Southwest, 212, 226; revisits Idaho, 212; paints Shoshone Falls, 213–14; advertises Southwest, 220; his knowledge, 221; his plea for a new National Art Gallery, 224; dubbed Santo Tomás, 226; helps found Society of Men Who Paint the West, 228; called dean of American painters, 230; pictures forged in his name, 231; use of thumbprint on paintings, 231; color reproductions of works, 231; his resistance to avant garde methods and techniques, 231; his preference for the West, 233; gives sketches to Cooper Union Museum, 233–34; lends paintings to National Museum, 234; love of heights, 234; makes winter home in Santa Barbara, 235; his changing style, 238; his last outdoor sketching, 239; influenza, 239; his last illness, 240; death of, 240; burial in East Hampton, 240; religious views of, 240n.; centennial exhibition of his works, 242; posthumous reputation, 242; biographical collection, 242

———, works of, mentioned: Among the Ruins—there he lingered, 27; Absecon, 23; Ácoma, 221; After a Thaw—Communipaw Ferry, 112; Allingham Castle, England, 236; An Apple Orchard (etching), 140; Arabian Nights Fantasy, 208; At the Back of South Dome—Vernal Falls, 225; At the Well, 221; Autumn on the Conemaugh, 51–52; Autumn on the Wissahickon, 44; The Azure Cliffs of Green River, 103, 159; The Bathers, 121, 159; The

Bathing Pool, Cuernavaca, 236; A Bazaar (etching), 132; Bluebeard's Castle, 208; The Borda Gardens, Mexico, 236; The Breaking Wave, 138, 162; Bridal Veil Falls, 225; Bridge of Three Waters, Pass of Glencoe, 160; Bright Angel Trail, 221; Bringing Home the Cattle, Coast of Florida, 117–18; California Landscape, 235, 238; Cascade Falls, Yosemite, 225; Castle San Juan d'Ulloa [sic], 172; The Castle of San Juan d'Ulloa [sic], Vera Cruz Harbor, 185; Castles in Spain, 209; The Chasm of the Colorado, 90–94, 113; "Childe Roland to the Dark Tower Came," 29, 186; Children of the Mountain, 51, 57; The City of Mexico, 173; The City of Queen Marjáneh, 208, 209; The Cliffs Near Gallup, New Mexico, 237; The Cliffs of Montauk, 181; Cloud and Sunshine, 174; A Cloudy Day near the Coast, 184; Coast of Newfoundland, 28; Cockington Lane, Torquay, England, 227; Columbus Approaching San Salvador, 197; Conway Castle (etching), 132, 162, 189; Conway Castle (oil), 227; The Coyote (etching), 140; Dream City, 209, 235–36, 238; A Dream of the Orient, 104, 159, 185; Dream-Land, 54; East Hampton, 175; East Hampton, Long Island, 182; The Edge of Georgica Pond, 184; The Empty Cradle (etching), 82, 132; An English River (etching), 164; Enquiring the Way, 175; The Eternal Snows of Mount Moran, the Teton Range, 129; Evening on the Susquehanna, 43; Fiercely the Red Sun Descending, 55 & n.; Fingal's Cave, Isle of Staffa, Scotland, 161; First Ship, San Salvador, 23; The Fisherman and the Genii, 208; Five Mile River, 184; Fort George Island, 115; A Frosty Morning, 43; A Gala Day in Venice, 195; The Gate of Venice, 188; Gleaning from the Wreck, Montauk, 184; The Glory of Spring, 174; Golden Gate, Yellowstone, 207; The Grand Canyon, 237–38; The Grand Canyon (Hance Trail),

221; The Grand Canyon of the Colorado, 204–205; The Grand Canyon of the Yellowstone (1872), 3–5, 72, 93, 113; The Grand Canyon of the Yellowstone (1892–1901), 206; The Grand Portal of the Pictured Rocks, 34; A Greenland Glacier, 43–44; The Haunted House, 28, 131; The Head of Yellowstone River (etching), 132; Icebergs in the Atlantic, 227; In the Forest, Wissahickon (lithograph), 56; In the Teton Range, Idaho [sic], 130; Interior of Woods, 43; Kwasind, the Strong Man (wood engraving), 55; Laguna—Sunset, 220; Lair of the Mountain Lion, 237; La Rita, New Mexico, 220; A Lancashire Village, Twilight, 165; Landscape with Cattle, 175; The Last Arrow, 52–53; The Lava Beds of Idaho ("Childe Roland to the Dark Tower Came"), 29; Looking over Niagara Falls, 146; The Lotus Eaters, 208; Macbeth and the Three Witches, 29; Market Days in San Juan Abajo, 172; A Mexican Fiesta, 236; A Mexican Hacienda, Lake Cuitzeo, 172; Mid-Atlantic, 227; Mid-Ocean, Moonlight, 236; Mist in Kanab Canyon, 159, 197; A Misty Morning, Appaquogue, 184; Montauk Ponds, 139; Moonlight and Icebergs, Mid-Atlantic, 227; Moonlight in Mid-Ocean, 227; Moonrise on the Beach at East Hampton, 184; Moonrise on the Gulf of Mexico, 173; Morning (etching), 140; Morning at Vera Cruz, 172; The Mountain of Lodestone, 208; The Mountain of the Holy Cross, 100–101, 104–105, 107, 113, 154; Near Maravatio, 173; Near Southampton, 184; Niagara—from the Canadian Side, 146; A Norther in the Gulf of Mexico, 167; Nuremberg, 206n.; Oak Trees and Eucalyptus, 238; The Oaks, Long Island, 184; Okehampton, 43; Old Mexico, 166; On the Berry Trail, Grand Canyon of Arizona, 220; "On the Lone Chorasmian Shore," 27; On the Stour in Hampshire, England, 165; The Owls, 236; Path to the Village, Amagansett,

184; *The Petrified Forest*, 221, 226; *The Pictured Rocks from Miner's River*, 34; *The Pioneers*, 237; *The Plaza, San Juan Abajo, Mexico*, 172; *Ponce de León in Florida*, 1712, 110, 111–12, 159, 186; *A Piute Girl* (etching), 132; *The Pool* (at Maravatio), 173; *Pueblo of Ácoma, New Mexico*, 237; *La Primavera*, 235; *Pueblo*, 220; *The Pueblo of Walpi*, 159; *The Rainbow* (etching), 138; *Rangeley Stream*, 77n.; *The Rapids above Niagara*, 146; *The Receding Wave*, 227; *The Resounding Sea* (etching), 138; *Ripening of the Leaf*, 43; *Rock Rovers' Land* (wood engraving), 103; *Rock Towers of the Colorado* (or *The Glory of the Cañon*), 104, 123; *Ruins of an Old Church—Cuernavaca*, 221; *The Shoshone Falls of Snake River, Idaho*, 214, 238; *A Side Gulch of the Grand Cañon* (wood engraving), 122; *A Side Gulch of the Grand Canyon* (oil), 123; *Sinbad and the Roc* (water color), 208; *Sinbad Wrecked*, 208; *The Slave Hunt* (*Slaves Escaping Through a Swamp*), 42; *Solitude* (lithograph), 56; *Solitude* (oil), 209; *The South Shore of Lake Superior* (lithograph), 56; *The Southern End of Fort George Island* (wood engraving), 110; *Spectres from the North*, 190–91, 207, 238; *The Spirit of the Indian*, 54; *Spit Light, Boston Harbor, England*, 28; *A Storm in Utah* (wood engraving), 88; *Storm on a Rocky Coast*, 28; *Storm on the Beach at East Hampton* (*Blowing a Gale, East Hampton Beach*), 181; *A Stormy Day*, 184; *The Story of the Third Sheikh*, 208; *The Stronghold*, 236; *Studies and Pictures* (lithographs), 55–56; *A Study of Willow Trees* (etching), 132; *Summer Moonlight*, 43; *Summer on the Susquehanna at Catawissa*, 164n.; *Summer Squall*, 184; *Sunrise*, 208; *Sunrise in Mid-Ocean*, 227; *Sunrise on Lake Monona*, 106; *Sunset at Sea*, 227; *Sunset, Long Island*, 184; *Sunset near Lands End, Cornwall, England*, 227; *Sunset on Lake Mendota*, 106–107; *Sunset on Long Island Sound*, 159; *Sunset over a Moqui Town*, 121; *Swiss Alps*, 51; *Tantallon Castle, North Berwick, Scotland*, 227; *Three Mile Harbor*, 182–83; *Tintagel* (*King Arthur's Castle*), 227; *Toltec Gorge, Colorado*, 220; *The Transept* (sepia), 90; *Ulysses Deriding Polyphemus* (after Turner), 38; *Ulysses and the Sirens*, 208; *Under the American Falls at Niagara*, 146; *The Valley*, 208; *The Valley of the Rio Virgin*, 79, 103, 123, 159; *Venetian Seaport*, 185; *View of Lake Como*, 51; *View of Windsor Castle*, 43; *Walls of the Grand Cañon* (wood engraving), 122; *The Waterfall*, 27–28; *The Watering Place*, 121; *The Watering Place, Amagansett*, 184; *Welsh Mountains, near Conway*, 165; *Whirlpool Rapids, Niagara*, 145, 146; *The Wilds of Lake Superior* (*Western Landscape*), 34; *Windsor Castle*, 165; *A Windy Hilltop—Amagansett*, 183; *A Windy Hilltop —Gardiner's Bay*; *The Wissahickon in Summer*, 44; *Woodland Reflections*, 118; *The Yosemite Falls*, 238; *Yosemite Valley from Glacier Point*, 225; *Zion Valley, Utah*, 237

Moran, Thomas, Sr.: 10–11; sails for America, 12; sends for family, 12; takes family to Baltimore, 13; removal of family to Philadelphia, 13–14; insistence on education of children, 13–14

Moran, Wyo.: 73

Moran Bay, Jackson Lake (Wyoming): 73

Moran Canyon (Wyoming): 73

Moran family: 71n.

Moran Gallery, Guild Hall (East Hampton, N.Y.): 241

Morans Point (Arizona): 199

Morans Point (Yellowstone): 203

Morelia, Mexico: 169, 170

Mormons: 77

Morro Castle (Havana, Cuba): 166

Moulton and Ricketts (art dealers): 215

"Mountain-lying-down": *see* Kaibab Plateau

Mountain of the Holy Cross (Colorado):
95, 98, 99
Mount Corcoran (Bierstadt): 101
Mt. Hayden (Grand Teton): 73
Mt. Jackson (Virginia): 149
Mt. Leidy (Wyoming): 73
Mt. Lincoln (Colorado): 97
Mt. Lowe (California): 233
Mt. Moran (Wyoming): 73, 126; *see also* Tetons
Mt. Nebo (Utah): 78
Mt. Rosalie (Colorado): 200
Mt. Snowden (Wales): 165
Mt. Trumbull (Arizona): 83, 85, 86
Mt. Washburn (Wyoming): 64
Mt. Wilson (California): 233
Muir, John: 75, 226
Mu-koon-tu-weap (or Little Zion Canyon, Utah): 80
Munich, Germany: 113, 117
Munich school: 137
Murano, Italy: 188, 191, 194
Murphy cabin, Donner Pass (California): 123
Musician, the (John Karst): 153ff.

Napeague Beach (L.I., N.Y.): 139
Naples, Italy: 50
Naples, Bay of (Italy): 55
Nast, Thomas: 39
Nation: quoted, 66
National Academy of Design (New York City): 8, 85, 112, 113, 135, 141, 144, 156, 175, 182 & n., 189, 195, 207, 209, 214, 228
National Collection of Fine Arts: *see* U.S. National Collection of Fine Arts, Smithsonian Institution
National Gallery (London, England): 36, 40, 164, 226
National Gallery of Art (Washington, D.C.): *see* U.S. National Gallery of Art, Smithsonian Institution
National Ode, The (Taylor): 157
National Parks Conference (1917): 234
National Park Service: *see* U.S. National Park Service
Navaho Indians: 217
Neagle, John: 17, 29
Nebraska: 60
Nettleson, Gen. A. B.: 59

Neuhaus, Eugen: 9; quoted, 115
Nevada: 78, 103
Navado de Toluca, Mexico: 169
Newark, N.J.: 57, 67, 88, 101, 114, 120, 132, 133, 144, 145
Newark Museum (Newark, N.J.): 8
Newark Register: 91
Newberry Terrace, Grand Canyon (Arizona): 199
New Jersey: 120, 132
Newman, Francis William: 30
Newman, Cardinal John Henry: 30
New Mexico: 60, 154–56, 198, 200, 212, 220, 226
Newport News, Va.: 193
New York: 52
New York Art Guild: 189
New York Central Railway: 120
New York City: 3, 57, 71n., 92, 139, 143, 166, 179, 192, 213, 225, 242
New York Etching Club: 134, 141
New York Graphic: 82
New York Mirror: 53
New York Times: 77, 80, 93, 102, 181
New York Tribune: 95
New York University: 144
Niagara (Church): 101
Niagara (Falls), N.Y.: 87, 125, 145, 213
Nimiety: 4
North Dome (Yosemite): 75, 225
"Northern Lights, The": 57
Northern Pacific Railroad: 3, 59, 204
North German Lloyd line: 187
Northwest: 58
Norton, Charles Eliot: 162
Notch Mountain (Colorado): 95, 99, 101
Noyes and Blakeslee Gallery (New York City): 176

Oakland, Calif.: 75
Odyssey: 208
Ohio Pyle, Pa.: 151
Ohio State University: 226
Ojo Caliente, N.M.: 154
"Old Cabinet, The" (Gilder): 68
Omaha, Neb.: 74
"101" Ranch (Wyoming): 200
O'Neill, Eugene: 176
Orizaba Peak (Mexico): 167, 168

Orkney, Va.: 149
Oro, Colo.: 97
Ortgies and Co. (New York City): 186
Osbourn, Dr. Edward: 165, 176
Outremer: 113

Pacific Tourist, The (Williams): 157
Painted Desert (Arizona): 198
Painter–Etchers' Society of London: 142
Painters of the West: 239
Palace of the Caesars (Rome, Italy): 50
Palisade Canyon (Nevada): 75
Palmer, John W.: 157
Pam-Pigema: 128
Pangborn, J. G. (the Fairy): 147ff.
Pangborn, Mrs. J. G.: 149–50
Paris, France: 48–49, 50, 105, 113
Paris Exposition (1878): 113
Parissa Wampitts, Ariz.: 86
Park Range (Colorado): 97
Parliament, English: 164
Parliament, Houses of, London, England: 41
Parshall, De Witt: 227, 234
Pa-ru-nu-weap (Roaring Water Canyon, or East Fork of Virgin): 81
Pasadena, Calif.: 233, 234
Passaic Meadows, N.J.: 120, 132
Pau-Puk-Keewis (the Storm Fool): 33
Peacock Room: 158
Peale family (artists): 17
Pennsylvania Academy of the Fine Arts (Philadelphia): 17, 23, 34, 43, 47, 118
Permian: 86
Persia: 178
Petrified Forest (Arizona): 225
Phantom Curve (Colorado): 156
Philadelphia, Pa.: 12, 13, 26, 35, 42, 52, 71n., 104, 118, 205; Art Union of, 17; publishing center in, 20
Philadelphia artists: 17–18
Philadelphia School of Design for Women: 44
Philadelphia Society of Etchers: 71n.
Philbrook Art Center (Tulsa, Okla.): 8
Photography in field: 62
Pictured Rocks, Lake Superior (Michigan): 30, 33

Picturesque America (Bryant, ed.): 74 88, 95, 100, 122, 197
Picturesque B. & O. (Pangborn): 151
Picturesque California (Muir, ed.): 75
Pierre's Hole (Teton Basin): 126
Pike County, Pa.: 46
Pikes Peak (Colo.): 95
Pine Valley Range: 103
Pipe Spring (Arizona): 83
Pittsburgh, Pa.: 151
Piute Indians: 82–83
"Plains and the Sierra, The" (Burlingame): 74
Pleine aire: 115
Plum Creek (Colo.): 153
Poe, Edgar Allan: 28
Poetical Works of Henry Wadsworth Longfellow, The: 157
Point Isabel, Fort George Island (Florida): 110
Polyphemus (William Laffan): quoted, 135
Ponce de León, Juan: 109
Popocatepetl (Mexico): 168
Popular History of the United States, A (Bryant and Gay): 157
Portails, Les (Pictured Rocks), Lake Superior (Michigan): 30
Portmadoc, Wales: 165
Post-impressionism: 9
Potomac River: 147–48
Potthast, Edward: 227
Powell, Maj. John Wesley: 30, 72, 76, 78, 84, 86–87, 88, 89, 102, 121–22, 123, 124, 198; as special commissioner for U.S. Indian Bureau, 77; quoted, 81–82; describes view from Powell Plateau, 87; in re *The Chasm of the Colorado*, 92; at Gypsum Canyon, 122
Powell Plateau (Arizona): 86–87, 91, 93
Prang, Louis: 68, 163, 176, 212
Pratt, George D.: 217, 241
Pre-Raphaelite brotherhood: 35
Price, C. J.: 21
Price, C. J., & Co.: 21
Promised Land, L.I., N.Y.: 139
Public Gardens (Venice, Italy): 194
Pueblo, Colo.: 154

Queen Victoria: 142
Queens Canyon (Colorado): 153
Quidor, John: 28

Ramsgate, Kent, England: 41
Raritan Bay: 26
Raymonds Kill, Pa.: 47
Raynolds, Capt. W. F.: 60
Red Buttes, Wyo.: 74
Red Mountain Mining District, Colo.:
 156
Reed, John: 176
Regnault, Jean-Baptiste: 142
Rembrandt Club (Brooklyn, N.Y.):
 141
Remington, Frederic: quoted, 207
Renshaw, Arthur: 166ff.
Richardson, James: 157
Richmond, England: 41
Ricketts, R. R.: 227
Rime of the Ancient Mariner, The
 (Coleridge): 27
Río Grande: 155, 172
Río Grande Valley: 154
Ripley, Edward P.: 216
Riva, the (Venice, Italy): 194
Rivals, The (Sheridan): 14
Rivers of France, The (Turner): 21
Roaring Water Canyon (Pa-ru-nu-weap,
 or East Fork of the Virgin): 81
Rockbridge Alum, Va.: 150
Rock Cliff (Hastings, East Sussex, Eng-
 land): 41
Rock Enon Springs, Va.: 148–49
Rock Rovers' Land, Utah: 79
Rockville trail (Utah): 81
Rocky Mountain News: 100, 152
Rocky Mountains: 7, 52, 62, 76, 78,
 95, 120, 153, 161, 200, 203, 209;
 compared with Alps, 51
Rocky Mountain school: 68
Rome, Italy: 178
Rosa, Salvator: see Salvator Rosa
Rossetti, Dante Gabriel: 36
Rossiter, Henry P.: quoted, 68
Rousseau, Pierre Etienne Théodore: 7,
 48, 142, 183
Royal Academy (London, England): 36,
 102, 103, 144
Rungius, Carl: 228
Ruskin, John: 35, 133, 158, 161, 175,
 193, 232, 234; visits Moran's flat, 162,
 164; opinion on Moran's The Breaking
 Wave, 162–63; quoted, 163n.
Russia: 224
Ruysdael, Jacob van: 183

Sacred Poems (Willis): 44
Sag Harbor (L.I., N.Y.): 192, 193
St. Augustine, Fla.: 108
St. Clair Flats (Michigan): 33
Saint-Gaudens, Augustus: 114
St. Gotthard Pass: 51
St. Helena, tomb of (Rome): 50
St. James Hotel (Denver, Colo.): 200
St. Johns River (Florida): 108, 134,
 189
St. Luke's Chapel (East Hampton,
 N.Y.): 212
St. Mark's (Venice, Italy): 187, 194
St. Paul's Cathedral (London, Eng-
 land): 41
"Salamander" (drinking ceremony): 141
Salisbury Museum (England): 70
Salmagundi Club (New York City):
 180
Salmon River Range (Idaho): 126
Salt Desert (Utah): 75
Saltillo, Mexico: 172
Salt Lake City, Utah: 76, 88, 212
Salt Lake Valley (Utah): 75, 78
Salvator Rosa: 51
San Bartolomo, Mexico: 171
San Bartolomeo, Ponte (Rome, Italy):
 50
Sandown Castle (England): 41
San Francisco, Calif.: 231
San Francisco, Mexico: 171
San Francisco Mountain (Arizona): 87,
 198, 200
San Giorgio Maggiore (Venice, Italy):
 187, 194
San José, Mexico: 169
San Juan, N.M.: 155, 156
San Juan Abajo, Mexico: 170
San Juan County, Colo.: 156
San Juan de Ulúa (Vera Cruz, Mexico):
 167
San Juan mining region, Colo.: 152, 156
San Juan Mountains: 156
San Luis Park (New Mexico): 154
San Luis Potosí, Mexico: 171

San Michele (Venice, Italy): 187
San Miguel de Allende, Mexico: 170
Sansom Street School (Philadelphia, Pa.): 16
Santa Barbara, Calif.: 209, 234, 238, 239, 240, 242; Fiesta, 235; Mission, 235
Santa Clara Range: 103
Santa Fe Railroad: 198, 199, 205, 216, 227, 228; art collection of, 8
Santa Maria della Salute (Venice, Italy): 187, 194
Santa Ynez Mountains: 235
Santuario, Mexico: 171
Sartain, John: 18, 104, 131
Sassafrass Hill (L.I., N.Y.): 180
Saturday Evening Post: 20, 205
Sault Sainte Marie: 30
Sawatch Range (Colorado): 95
Sawkill Glen (Pennsylvania): 47
Scarlet Letter (Hawthorne): 157
Scattergood, David: 21
Scattergood and Telfer (engravers): 20–22, 44
Schaus & Co.: 102
Schell and Hogen (engravers): 145
Science Hall (University of Wisconsin): 106; burning of, 107
Schoolcraft, Henry Rowe: 30
Schuylkill River (Pennsylvania): 25, 26
Scotch Plains (New Jersey): 120
Scotland: 42, 159–61, 165, 227
Scotten, Samuel C.: 195
Scribner's Monthly: 57, 58, 63, 67, 68, 70–71, 89, 93, 108, 109, 122
Sea Spray (East Hampton, N.Y.): 177
Seine River (France): 48
Sentimental Tommy (Barrie): 43
Sentinel Rock (Yosemite): 75, 225
Shakespeare, William: 216
Shakespeare's Cliff (Dover, Kent, England): 41
Sheep Troughs (Utah): 80
Sheffield Museum (Sheffield, England): 163
Sheldon, George H.: 209
Shelley, Percy Bysshe: 26–27
Shenandoah Junction, Va.: 150
Shenandoah Valley (Virginia): 149
Sheridan, Richard Brinsley: 14
Sheridan, Wyo.: 203

Sherman, Gen. William Tecumseh: 55
Shirlaw, Walter: 114, 137, 177
Shoshone Falls (Idaho): 212
Shoshone Lake (Yellowstone): 65
Sierra Nevada (California): 72, 75, 123
"Silver San Juan": 156
Silverton, Colo.: 156
Simpson, William H.: 227; quoted, 216, 217, 219
Skeleton in Armor, The (Longfellow): 157
Sloan, John: 220
Small, William: 18–19
Smillie, James D.: 131n., 142
Smith, F. Hopkinson: 135; quoted, 139
Smith, George A.: 77
Smithsonian Institution (Washington, D.C.): 5, 8, 191, 224
Snake River: 66, 124–25, 212; south fork, 125
Snake River Range: 126
Society of American Artists: 114–15, 117, 118, 135, 182
Society of the Men Who Paint the West: 228
Soda Butte Creek (Wyoming): 203
Song of Hiawatha (Longfellow): see Hiawatha, Song of (Longfellow)
Songs of Nature (Palmer): 156
Songs of Yesterday (Taylor): 157
South, the: 108, 111
Southampton, England: 187
South Dakota: 204
South Dome: see Half Dome (Yosemite)
South End Burying Ground, East Hampton, N.Y.: 212
South Kensington Museum (Victoria and Albert Museum), London: 40, 164, 210
South Pacific: 180
South Park (Colorado): 97
Southwest: 121, 215, 218, 220, 228
Spain: 224
Spanish-American War: 211
Spanish Fork Canyon (Utah): 78
Spanish Peaks (Colorado): 219
Speaker, House of Representatives: 5, 111
Spit Light, Boston Harbor (England): 28
Springville, Utah: 78

Springville Canyon (Utah): 78, 88
Spruce Creek (Pennsylvania): 46
Staffa, Scotland: 161
Staten Island, N.Y.: 71n.
Staunton, Va.: 149
Stedman, Edmund Clarence: quoted, 46, 47
Stegner, Wallace: quoted, 59, 90
Stendahl, Earl: 240
Stevens, Nina S.: 240, 241n.; quoted, 227
Stevenson, James: 60, 70, 72, 73, 96, 97, 99, 127; quoted, 100
Stewart Canyon (Arizona): 86
Stillman, William J.: 35
Stoddard, Richard Henry: description of Moran, 7; quoted, 88
Storm Fool (Pau-Puk-Keewis): 33
Stour River (England): 41, 164
Strahan, Edward: 157
Strahorn, Robert: 152n.
Strathaven, Lanarkshire, Scotland: 42, 159
"Studio, the": building of, 176–77; description of, 178
Sully, Thomas: 17
Sunshine Fork, Yellowstone River: 203
Surry, England: 103
Susquehanna River: 26, 39
Switzerland: 187
Symons, Gardner: 228
Syracuse, N.Y.: 195

Tajo de Nochistongo, Mexico: see Great Cut, Mexico
Taos, N.M.: 155–56
Task, The (Cowper): 21
Tasmania: 71n.
Tassin, Mary Scott Moran (Mrs. Wirt de Vivier Tassin): 216, 238; see also Mary Scott Moran
Taylor, Bayard: 157
Taylor, Benjamin F.: 157
Taylor's Bridge (Idaho): 125, 128
Tennessee Pass (Colorado): 97
Tennis Club (East Hampton, N.Y.): 137–38, 179
Tenth Street Studio Building (New York City): 144, 176, 179
Teoloyucan, Mexico: 220

Teton Mountains (Wyoming): 3, 72, 73, 124ff., 241
Teton River: 126, 127
Thames River (England): 41
Thebes, Egypt: 26–27
Thomas Gilcrease Institute of American History and Art: 8, 191, 238
Thomas Moran: Explorer in Search of Beauty (ed. Fryxell): 242
Thomas P. Cope (ship): 12, 16
Thompson, Prof. A. H.: 80, 81
Thorp, Mrs. J. G.: 105
Three Lakes Canyon (Utah): 85
Three Mile Harbor (L.I., N.Y.): 138–39, 180
"Thrums," Lanarkshire, Scotland: 43
Tile Club (New York City): 135, 136, 137, 139
Tillotson family: 159
Toledo, Ohio: 195
Toledo Art Gallery (Museum): 227, 240
Toledo mine (Utah): 124
Toltec Gorge (Colorado): 156
Toluca, Mexico: 169
Tongue River (Wyoming): 203; cliffs of, 203
Toquerville, Utah: 79, 103
Torcello, Italy: 188, 191, 194
To-ro-weap (Arizona): 84–85
Tower Creek (Yellowstone): 63
Tower Falls (Yellowstone): 63, 140
Town Pond (East Hampton, N.Y.): see Goose Pond (East Hampton, N.Y.)
Tremadoc Bay (Wales): 165
Truckee River: 75
Trumble, Alfred: quoted, 71n., 138 140, 142–43
Tucabaya, Mexico: 169
Tuckerman, Henry: quoted, 52, 53
Turner, Joseph Mallord Williams: 7, 9, 21, 24, 28, 36, 38, 41, 43, 69, 103, 132, 133, 141, 142, 162, 185, 189, 193, 226, 236; experiments with children's blots, 210
Tussey's Mountain (Pennsylvania): 46
Twain, Mark: see Clemens, Samuel L.
"Twelve Apostles" (Moran family): 71n.
Twin Lakes (Colorado): 100
Tyre, Phoenicia: 26–27

THOMAS MORAN: ARTIST OF THE MOUNTAINS

Uinta Indian Agency: 85
Uinta Mountains: 75
Union army: 60
Union County, N.J.: 121
Union Pacific Railroad: 59, 66, 74, 123
United States: 224
U.S. Bureau of American Ethnology: 123
U.S. Capitol (Washington, D.C.): 5, 111, 147
U.S. Congress: 5, 6, 60, 70, 105, 111
U.S. Expedition to Darien: 71n.
U.S. Geological Survey: 123, 125, 205
U.S. House of Representatives: see U.S. Congress
U.S. Indian Bureau: 77
U.S. National Collection of Fine Arts (National Museum, Smithsonian Institution): 6, 198, 207, 238, 241
U.S. National Gallery of Art, Smithsonian Institution: 225
U.S. National Park Service: 6, 70, 107, 225, 234, 241
U.S. Senate: 93
Universal Exposition (1867), Paris: 51–52
University of Wisconsin: 106
Unupits Pacavi (Witches' Water Pocket), Ariz.: 83–84
Upper Falls (Yellowstone): 64, 74, 207
Upper Geyser Basin (Yellowstone): 66
Upper Library Hall (Newark, N.J.): 92
Usher, House of: 28
Utah: 7, 76, 77, 88, 106, 122, 124, 163
Utah Southern Railroad: 77

"Valley of Babbling Waters" (Mu-koon-tu-weap), or Little Zion Canyon): 81
Valley of Diamonds (Arabian Nights): 208
Vandermarck Creek (Pennsylvania): 47
Venetian Fish Market (Chase): 186
Venice, Italy: 29, 51, 71n., 104, 167n., 184, 185ff., 187, 220, 238
Vera Cruz, Mexico: 166n., 167, 174
Vermilion Cliffs (Utah): 79, 80, 86, 103
Veta Mountain (Colorado): 154
Veta Pass (Colorado): 154
Victoria (Queen): 10, 142

Victoria and Albert Museum (London): see South Kensington Museum (London)
Villa Borghese (Rome, Italy): 50
Virginia City, Mont.: 60, 66
Virgin River: 79, 80
Virgin Valley: 80
Vishnu Temple (Grand Canyon): 199, 205
Voyageurs, the: 30–31, 32

Wagner, Richard: 9
Wasatch Mountains (Utah): 75, 78, 124, 156
Wales: 164–65, 226
Walker Art Center (Minneapolis, Minn.): 8
Wanero (Ute chief): 78
Warwickshire, England: 227
Washburn, Gen. (of Montana): 58, 60, 66
Washington, D.C.: 3, 5, 70, 123, 147, 198, 205, 234, 242
Water Lily (boat): 109
Waterloo Bridge (London, England): 41
Waterman, Catherine H.: 16
Watson, Forbes: quoted, 230–31
Weaving: 11
Webber's Canyon (Utah): 74
Weitenkampf, Frank: quoted, 56–57, 131–32, 141
Weldon, C. D.: 137
Wendt, William: 228
West, Benjamin: 17
West, the: 5, 6, 51, 57, 59, 235
Western exploration (government surveys): 123
West Indies: 116
Weston Ranch (Colorado): 97, 100
West Temple of the Virgin (Utah): 80
Whirlpool, Niagara Falls (New York): 145
Whirlpool Rapids, Niagara: 145
Whistler, James McNeill: 158, 161, 164, 185, 232
White, Sanford: 114
White House (Washington, D.C.): 124
White Mountains (Nevada): 78
Whitman, Walt: 114

Whitney, Josiah Dwight: quoted, 30–31
Whitney, William Dwight: quoted, 96
Whittier, John Greenleaf: 157
Wild Band Water Pocket (Arizona): 83
Wilde, Oscar: 130, 158, 162
Williams, Ariz.: 219, 227
Williams, Frederick Ballard: 227
Williams, Henry T.: 157
Williams, Isaac L.: 18, 29–34
Willis, N. P.: 44
Willmore, Pa.: 46
Willow Creek (Idaho): 128
Wilson, Alexander: 17
Winchester, Va.: 148
Windsor Castle (England): 40
Wisconsin: 105ff.
Wisconsin, Women's Centennial Committee of: 105
Wissahickon River (Pennsylvania): 25, 26, 39, 43
Witches' Rocks (Utah): 74
Witches' Water Pocket (Unupits Pacavi) (Arizona): 83–84
Women's Centennial Committee of Wisconsin: 105
Wonders of the Yellowstone (Richardson): 157
Woodblock designing: 20–21
Wood engraving: 20–21
Woods, L. W.: 96, 97, 98, 99
Wordsworth, William: 4, 240n.
World's Columbian Exposition (Chicago, Ill.): 199

Worthington, Mr. (of Georgetown, D.C.): 111
Wright Building (Washington, D.C.): 111
Wuthering Heights (Brontë, E.): 139
Wyoming: 60, 130, 198, 199

Yavapai Point, Grand Canyon (Arizona): 237
Yellowstone: 4, 22, 52, 72, 75, 88, 100, 156, 163, 213, 225, 237; Basin, 61; Grand Canyon, 64, 65, 68; Lake, 65, 68, 203; Lower Falls, 3; Museum, 241; Park, 70, 73, 199; river, 60, 62, 68, 203; Upper Falls, 64, 74, 207; Upper Geyser Basin, 66
"Yellowstone" (Thomas Moran): 147ff.
"Yellowstone, The Wonders of the" (Langford): 58
Yellowstone Park, and the Mountain Regions of Portions of Idaho, Nevada, Colorado, and Utah (Hayden and Prang): 68
Yosemite, Calif.: 225, 235; Museum, 242; Valley, 70, 75, 225
Youghiogheny River: 151
Youghiogheny Valley: 150
Young, Brigham: 77
Young, John Russel: 157
Y.M.C.A. Building (New York City): 144

Ziem, Felix François George Philibert: 7
Zion Canyon (Utah): 26, 80–81, 239; National Park, 81
Zola, Emile: 223

The text for *Thomas Moran: Artist of the Mountains* has been set on the Linotype in 11-point Electra, a face known for its inherent charm of design. Two points of leading between lines give added legibility. The paper on which the book is printed bears the University of Oklahoma Press watermark and has an effective life of at least three hundred years.